AI WEIWEI
SPATIAL MATTERS

AI WEIWEI
SPATIAL MATTERS

Art Architecture and Activism

Edited by Ai Weiwei and Anthony Pins

The MIT Press
Cambridge, Massachusetts

FOREWORD

Who is Ai Weiwei? The question has been asked with such frequency as to render itself irrelevant. Deified by his most zealous internet followers and loathed to the point of disappearance by his political enemies, the fervent extremes surrounding Ai Weiwei evince his deeply polemical status as a Chinese national and a prominent international figure.

For many, his biography is eminently familiar. Born the son of the revolutionary poet Ai Qing in 1957, Ai grew up in China's far north-west desert under the harsh conditions of his father's exile. At the end of the Cultural Revolution he returned to Beijing, only to relocate to New York City until 1993. On 3 April 2011, he was arrested in Beijing's Capital International Airport for unsubstantiated 'economic crimes' and subsequently detained in an unknown location for eighty-one days. In the years between, Ai Weiwei emerged as a crucial instigator in China's cultural development, an architect of a modest yet distinctly vernacular Chinese modernism, and one of the nation's most vocal political critics – a prodigious figure in the digital realm.

The breadth of Ai's various engagements, both in scale and subject matter, has varied widely over the past decade and a half. Whether operating in the realm of art, architecture, or social activism, Ai's work has invariably been linked with themes of space that are inherently embedded with aesthetic, social and political significance. These notions, alternately dealing with the physical presence of measurable area and the arena of psychosocial interactions, transcend disciplinary specification and spill into the messy amalgam of actions that comprise daily life. It is for this reason that the commonality of space – a broad, overarching term – may be an optimal lens through which to unify and evaluate Ai Weiwei's activities.

Ai's works frequently occur along interdisciplinary lines. He uses works of architecture to spark cultural dialogue, explores notions of heritage and material value to generate ideas of architectural consequence, and deploys social media as the foundational tool to organize elaborate works of art. Sophisticated and complex, the development of his oeuvre demonstrates a growing command of scale and modes of production as integral facets of increasingly ambitious projects. Consciously leveraging materiality, iconography, and technique as means of critical response and juxtaposition, descriptions of Ai's work often suggest the hand of a master tactician, constantly strategizing the appropriate methods and media to engage the world around him. As is often the case for Ai, China's current milieu finds itself a central instigator of these themes.

As a result, this publication is organized into five sections of increasing scale that survey Ai Weiwei's extensive engagement with themes of spatial consequence. The work encompasses the artist's room-scale installations at the turn of the century, his architectural career as an individual practitioner and a collaborator, his film and photographic investigations of Chinese urbanism, and his digital activism. Though Ai often claims to pursue his projects as a way to stave off boredom, the breadth and overlap of this work does not suggest the tinkering of an idle mind. Rather, Ai brings a keen intellectual perspective to each of his projects that simultaneously engages them on their own terms, and envisions their broader potential. For this reason, the work contained in this publication can both be understood in isolation, and through its tacit connections to his other works throughout the book.

CONTENTS

14 *The Retrospective*, Hans-Ulrich Obrist

INHABIT

32 *A Handful of Dust,* Chin-Chin Yap

38 Forever, 2003

44 Fragments, 2006
 A Dialogue, Ai Weiwei and Nataline Colonnello

54 Template, 2007

62 Installation Piece for the Venice Biennale, 2008
 Venice Beijing London (Excerpt), Charles Merewether

70 Chandeliers, 2002–2007
 A Brief History of Light (Excerpt), Karen Smith

82 With Milk ... Find Something Everybody Can Use, 2009
 Change You Can See, Laurent Gutierrez and Valérie Portefaix

94 Sunflower Seeds, 2010
 Everything is Necessary, Brendan McGetrick

BUILD

112 *Entries from Ai Weiwei's Blog*, Ai Weiwei

126 *In The Realm of Architecture*, Reto Geiser

138 *The Nudged Vernacular: An Architecture of Resistance*, Anthony Pins

152 Studio-House, 1999

160 In Between, 2000–2001; Concrete, 2000

164 Yiwu River Dam and Ai Qing Memorial, 2002–2003

172 Courtyard 105, 2004–2005

180 Courtyard 104, 2004–2005

190 Nine Boxes, 2004

196 Three Shadows Photography Art Centre, 2005

208 241 Caochangdi, 2007

218 Red No.1 Art Galleries, 2008

COLLABORATE

228 *Entries from Ai Weiwei's Blog*, Ai Weiwei

236 *A Conversation with Ai Weiwei*, Jo-Anne Birnie Danzker

244 *Architecture on the Move*, Bert de Muynck

256 Beijing National Stadium, 2002–2008

270 Jinhua Architectural Art Park, 2004–2007

286 Ordos 100, 2008

294 Tsai Residence, 2005–2008

300 Art Farm, 2006

INVESTIGATE

308 *Entries from Ai Weiwei's Blog*, Ai Weiwei

326 *Fragments, Voids, Sections, and Rings*, Adrian Blackwell and Pei Zhao

334 Beijing, 2003; Chang'An Boulevard, 2004; Beijing: Second Ring, 2005; Beijing: Third Ring, 2005
 Duration Within Time (Excerpt), Charles Merewether

340 Provisional Landscapes, 2002–2008

354 Beijing National Stadium Construction, 2002–2008

372 Terminal 3, 2005–2007
 Becoming, Brendan McGetrick

ENGAGE

396 *Entries from Ai Weiwei's Blog*, Ai Weiwei

404 *A Fairytale Becomes Reality*, Fu Xiaodong

412 *A Talk with Ai Weiwei,* Mathieu Wellner

422 *'The Net of Love Cannot Be Blocked'*, Daniela Janser

428 *The Danger Artist*, Wyatt Mason

444 *Going Viral: The Memetic World of Ai Weiwei*, An Xiao Mina

452 Study of Perspective, 1995–2008

458 Documentaries, 2007–

466 Jiading Malu (Shanghai Studio), 2008–2011

490 Mermaid Exchange, 2010

496 Ai Weiwei and Social Media, 2005-

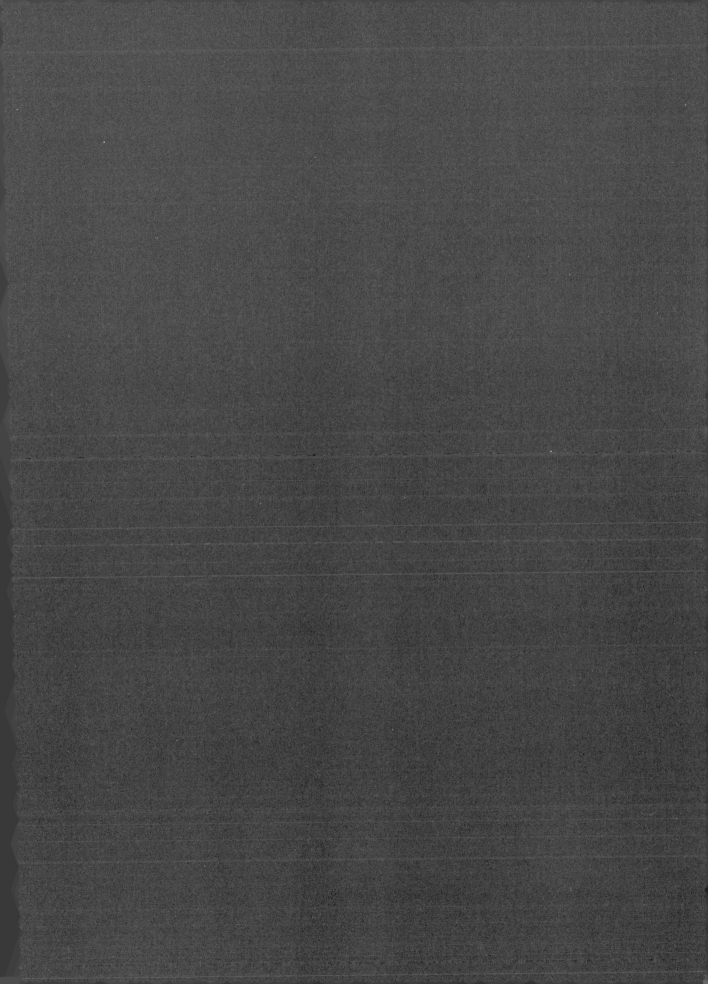

THE RETROSPECTIVE

Hans Ulrich-Obrist

HUO: Can you tell me about your childhood and how it all started – your awakening as an artist?

AWW: Well, I was born in 1957. My father, Ai Qing, was a poet. As I was growing up he was criticized as a writer and punished and sent away to the Gobi desert in the north-west. So I basically spent sixteen years of my childhood and my youth in the Xinjiang Province, which is a remote area of China, near the Russian border. Living conditions were extremely harsh, and education was almost non-existent. But I grew up within the Cultural Revolution, and we had to exercise and study criticism, from self-criticism to political articles by Chairman Mao and Karl Marx, Lenin and such. That was an everyday exercise and formed the constant political surroundings. After Chairman Mao died I got into film university, at the Beijing Film Academy.

HUO: In this province the living conditions were harsh but I suppose because of your father, who was an extraordinary poet, you were also surrounded by his knowledge and literature. How was your relationship with him?

AWW: My father was a man who really loved art. He studied art in the 1930s in Paris. He was a very good artist. But right after he came back he was put in jail in Shanghai by the Kuomintang. So while in jail for three years he couldn't paint, of course, but he became a writer. He was heavily influenced by French poets – Apollinaire, Rimbaud, Baudelaire, you know, all this group of people – and he became a top figure in contemporary language poetry, but even then he couldn't write, it was forbidden in communist society. As a writer he was accused of being an anti-revolutionary, anti-Communist Party and anti-people, and that was a big crime. During the Cultural Revolution he was punished with hard labour and had to clean the public toilets for a village of about 200 people. It was quite a severe punishment for what he had done. He was almost sixty and he had never done any physical work. So for five years he never really had a chance to rest, even for one day. He often joked, he said, 'You know, people never stop shitting.' If he stopped one day, the next day's work would be exactly doubled and he wouldn't be able to handle it. He physically worked hard but he really handled this

job well. I often used to go and visit him at those toilets, to watch what he was doing. I was too small to help. He would make this public area very clean – extremely, precisely clean – then go to another one. So that's my childhood education.

HUO: So no discussions with him about literature and art?

AWW: He would often talk about it. You know, we had to burn all his books because he could have got into trouble. We burned all those beautiful hardcover books he collected, and catalogues – beautiful museum catalogues. He only had one book left, which was a big French encyclopaedia. Every day he took notes from that book. He wrote Roman history. So he often taught us what the Romans did at the time – you know, who killed whom, all those stories – in the Gobi desert, which is so crazy. Soon he lost the vision in one of his eyes because of a lack of nutrition. But he talked about art, the impressionists. He loved Rodin and Renoir, and he often talked about modern poetry.

HUO. Did your father resume his work later on?

AWW: In the 1980s he regained his honour. He was rehabilitated and very popular again. He became head of a writer's association. And he started to write like young people do, like a younger man. He was really passionate and a very nice man.

HUO: Is he still alive?

AWW: He passed away in 1996. His illness was what brought me back from the United States in 1993. He passed away when he was eighty-six.

HUO: You grew up in the province. Then when you were about twenty you moved to Beijing, where you enrolled in school.

AWW: That was right after Chairman Mao died. Nixon had been to China a few years earlier, and

they realized they couldn't survive this communist struggle. You know, the United States were considered as an enemy, but that's more historical. What really endangered China was Russia, the big bear right above China. Russians and Chinese never trusted each other. So I think that's why, when Chairman Mao signalled the United States, Nixon and Kissinger had this so-called 'ping pong diplomacy'. After that, in 1976 a big earthquake in Tangshan killed 300,000 people in one night. And the same year, Mao died and three top leaders died – Zhou Enlai and another one. So China was becoming homeless, literally. The ideology collapsed, and the struggle failed and didn't know where to go. Politically it was an empty space. That's also the period when I had just graduated from high school. I spent some time in Beijing accompanying my father to treatments for his eye. I started to do some artworks, mostly because I wanted to escape the society. So I had a chance to learn some art from his friends.

HUO: Who were these people?

AWW: They were a group of literary men or artists who belonged to the same category as my father – they all became what's known as the 'enemy of the state' and then had nothing to do because all of the universities did not open. Many of them are still considered socially dangerous and, like my father, politically still haven't had a chance to be rehabilitated. Basically they're professors and very knowledgeable men and literary men or artists, good artists. They had a huge influence on me.

HUO: How was it at that time, in the late 1970s, with regard to Western art? What were its influences? Were there books or illustrations?

AWW: There were almost no books. The whole nation was to have no single book. I got my first book on van Gogh, Degas and Manet and another one, Jasper Johns, from a translator. His name was Lian Sheng Yee. He married, I think, a woman from

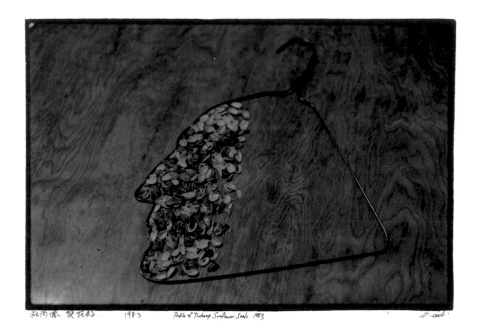

New York Photos, 1983–1993
*Profile of Duchamp, Sunflower
Seeds*, 1983
C-print

Germany, and so he had a chance to get those books, and he gave them to me. He thought, 'Ah, this kid loves art.' And those books became so valuable. You know, everyone shared them in Beijing – this very little circle of artists. Everybody read those few copies. It's very interesting that we all liked the post-impressionists but we threw the Jasper Johns away because we couldn't understand it. We asked, 'What is this?' about the American flag or a map.

HUO: It went into the garbage?

AWW: Straight to the garbage. From the education we received at that time we had no clue as to what this was. There was no university education in the Cultural Revolution. They followed the socialist rules, in the Russian style.

HUO: There was no knowledge of Marcel Duchamp or Barnett Newman?

AWW: No, absolutely nothing. The knowledge stopped at cubism. Picasso and Matisse were the last heroes of modern history.

HUO: This is fascinating: there was a limited range of knowledge and hardly any information or books, and yet between the late 1970s and the 1980s there was a dynamic avant-garde in China, of which you were a key protagonist. Somehow, in very few years, it went from nothing to everything. What happened during that period? There was no information, there was still a lot of oppression and difficulty, and yet in this resistance somehow an incredible generation formed and became to China what the 1960s generation was to Europe and America, when the Western world experienced this incredible expansion of art at the time – Andy Warhol, Joseph Beuys.

AWW: I'm very glad you pointed this out. We are a generation that had a sense of the past, which is the time of the Iron Curtain and of the communist struggle. It was a tough political struggle – it was against humanism and individualism and there was, as you know, strong censorship of anything not coming from China. It was even more severe than in North Korea today. The only poetry you could recite was about Chairman Mao. Every classroom, every paper we read was about Chairman Mao, his language and his image. But we all knew what happened before

that in the 1920s and 1930s. We all knew about our parents' fights for a new China, a modern China with a democracy and a science. And then suddenly they had a chance, in the late 1970s and early 1980s, to rethink that part of history. We started to realize that the lack of freedom and freedom of expression is what caused China's tragedy. So this group of young people started to write poetry and to make magazines, adopting a democratic way of thinking. We started to act really self-consciously and with a self-awareness to try to achieve this – to fight for personal freedom.

It was like spring had come. Everybody would read whatever book they had. There were no copy machines, so we would copy the whole book by hand and give it to a friend. There was a really limited amount of 'nutrition' and information, but it was passed on with such effort and such a passionate

New York Photos, 1983–1993
Ai Weiwei, Williamsburg, Brooklyn, 1983

love for art and rational political thinking. That was the first genuine moment of our democracy.

HUO: I always felt that it was like a new avant-garde movement, like Fluxus or dadaism in Europe. How did people meet? Was there a bar or a school?

AWW: There was a wall. We called it 'the Democratic Wall'. People could post their writings or thoughts on the wall. We used to meet there. And there was a very small circle – China has a huge population, but there were only maybe less than a hundred people who were so active. There were about twenty or thirty magazines we were writing every night, and we had to print them and post them on the wall.

HUO: Did you make these magazines yourself?

AWW: I did some. I drew a cover by hand for a poet who, at that time, was the best poet. Every cover I drew by hand. So we published books, but then in 1980 Deng Xiaoping came up and repressed the movement. He denounced the wall. He was so afraid of social change – they wanted to have some change, but they didn't want anybody to denounce the communist struggle.

HUO: Did you start to make artworks at the time? What is your very earliest artwork?

AWW: I started as a painter. I made drawings, a lot of drawings. I would spend months in the train station because there were so many people there, they were like free models for me – of course at that time there was no model and no school. So I would just stay in the train station to draw all those people who were waiting there.

HUO: Do you still have these drawings?

AWW: I think my mother threw away most of them. You know, being an artist was not a prestigious practice at that time. I also spent time in the zoo, making very nice drawings of the animals. That was my starting point.

HUO: What were your earliest paintings like?

AWW: They were mostly about landscapes, in the fashion of Munch – or some were even in the fashion of Cézanne. You can clearly see it. I remember at the end of the school, the teacher would give a critique to every student but he purposely left me alone.

HUO: You were in your own world.

AWW: Yes, I was very clearly already on my own. I left school before I got to graduate – to go to the United States, in 1981.

HUO: What prompted you to go to the United States?

AWW: In my mind I already thought New York was the capital of contemporary art. And I wanted to be on top. On the way to the airport my mom said things like, 'Do you feel sad because you don't speak English?', 'You have no money' (I had $30 in my hand), and 'What are you going to do there?' I said, 'I am going home.' My mother was so surprised, and so were my classmates. I said, 'Maybe ten years later, when I come back, you'll see another Picasso!' They all laughed. I was so naive, but I had so much confidence. I left because the activists from our same group were put in jail. The accusation was that they were spies for the West, which was total nonsense. The leaders of the Democratic Movement were put in jail for thirteen years, and we knew all these people, and we all got absolutely mad and even scared – you know, 'this nation has no hope'.

HUO: And so you arrived in the United States. At the time there were very different tendencies – a neo-expressionist, neo-figurative wave and at the same time neo-geo and appropriation art. How did you fit into this New York art world?

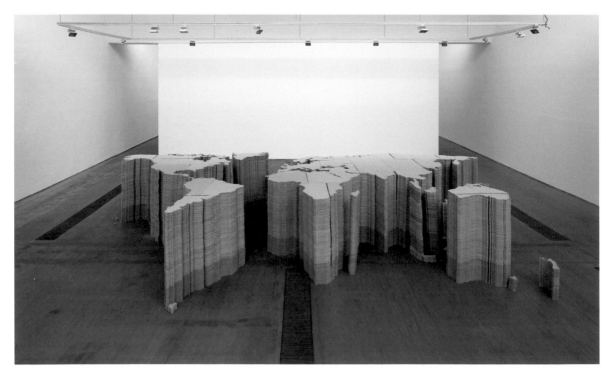

World Map, 2006
Installation at the 15th Biennale of Sydney, Australia
Cotton and wooden base
100 x 800 x 600 cm

AWW: At the very beginning I studied English. I was so sure I would spend my whole life in New York, I told people this was the last place I would be for the rest of my time (even though I was just in my twenties). When my English was okay, I enrolled in the Parsons School of Design. My teacher was Sean Scully. He liked Jasper Johns, who had just had a show with a series of new works at Leo Castelli at the time. The first book I read was *The Philosophy of Andy Warhol (From A to B and Back Again)*. I loved that book. The language is so simple and beautiful. So from that I started to know all. I became a fan of Johns, and then I got introduced to Duchamp's thinking, which was my introduction to modern and contemporary histories like dada and surrealism. I was so fascinated with that period and of course what was going on in New York. It was, as you said, the early 1980s neo-expressionism, which I practised a little bit but really didn't like. My mind is more about ideas, so I really liked conceptualism and Fluxus. But of course at that time it wasn't popular at home. The 1980s were so much about neo-expressionism. You had to attend those galleries and also the East Village. And there was such a big mix and also a struggle. You started asking yourself what kind of artist you wanted to be. Then Jeff Koons and the others came out with such a fresh approach. I still remember Koons' first show with all those basketballs in the fish tanks. It was just next door in my neighbourhood, the East Village. And I liked that work so much, and the price was very low, $3,000 or something. I was so fascinated by that.

HUO: When did you start working with sculpture and installation?

AWW: I did my first sculpture in 1983, if you could call it sculpture. Later I used something like a coat hanger to make Duchamp's profile (*Hanging Man*, 1985). By that time I had already done violins (*Violin*, 1985), and I had attached condoms to an army raincoat (*Safe Sex*, 1986). It was about safe sex

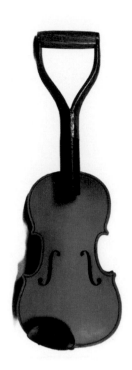

Violin, 1985
Handle of a shovel and violin
63 x 23 x 7 cm

because around that time everybody was so scared about AIDS. People had just recognized the disease and had more fear than knowledge about it. I really wanted to work with everyday objects – it was the influence of dada and Duchamp – but I didn't do much. There are only a few objects left because every time I moved – and I moved about ten times in ten years in New York – I had to throw away all the works.

HUO: The *Violin* is interesting because it's very much related to surrealism. Does it still exist?

AWW: Yes, that's true. It's so funny – it's a commentary about an old time under the present conditions.

HUO: You were still painting at that time. There are the three portraits of Mao: *Mao 1–3* (1985). When did you decide to stop painting?

AWW: Those were the last paintings I did. I did those Maos, and it was somehow like saying goodbye to the old times. I did the group over a very short period, and then I just gave up painting altogether.

HUO: How about drawing? I saw a lot of drawings in your studio. Is drawing still a daily practice?

AWW: The early drawings I made were more for training myself in how to handle the world with the very simple traces of a mark. That can be enjoyable. I did the best drawings, so even my teachers at the time loved them. They'd say, 'This guy can draw so well', but there is always the danger of becoming self-indulgent. If you see drawings made by Picasso and Matisse, you see they keep drawing because they can just do it so well. I don't like that kind of feeling, so whenever I begin to feel okay then I try to refuse it and escape from it. Later on I made drawings with different methods. I take photos everyday, which, to me, is just like drawing. It's an exercise about what you see and how you record it. And to try to not use your hands but rather to use your vision and your mind.

HUO: I see you always have your little digital camera with you. You photograph a lot and that's also a form of drawing, almost like a sketchbook. We could call them 'mind drawings'. When did you start taking photographs?

AWW: I started in the late 1980s in New York, when I gave up painting. There were only fifty top artists at that time, with Julian Schnabel and those people. I had to attend all those openings and those galleries, and I knew that there was no chance for me. So I started to take a lot of photos, thousands of photos, mostly in black and white. I didn't even develop them. They were all there until I went back to Beijing. I developed them ten years later. Taking photos is like breathing. It becomes part of you.

HUO: That's like a blog before the blog.

AWW: Much later, about two or three years ago, they set up this blog for me – I didn't even know what to do. I realized I could put my photos on it, so I put up almost 70,000 photos, at least a hundred photos a day, so that they could be shared by thousands of people. The blog has already been visited by over four million people. It's such a wonderful thing, the internet. People who don't know me can see exactly what I've been doing.

HUO: So now it's basically just a continuum of hundreds of thousands of images, and it's an ever-growing archive. But do you continue to draw? I'm very interested in the link to calligraphy, this fluid

Safe Sex, 1986
Coat on a hanger, condom, wooden box
155 x 100 x 11 cm

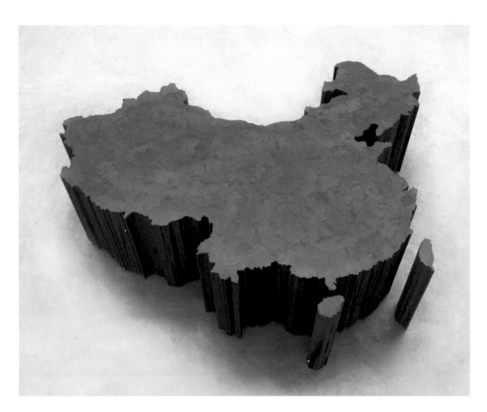

Map of China, 2004
Ironwood from a dismantled
temple of the Qing Dynasty
(1644–1911)
51 x 200 cm

calligraphy and the kinds of geometry and fragments and the layering and composing of space. Zaha Hadid once told me that there's really a link between calligraphy and current computer drawing.

AWW: Calligraphy is the trace of a mind, or maybe an emotion or thought. Now, with a computer you have photo images, you have the radio. Calligraphy is no longer the matter of hand. I do interviews, hundreds of interviews a year. There are all kinds of sources: newspapers, magazines, television, on all matters — art, design, architecture, social political commentary and criticism. I think we have a chance today to become everything and nothing at the same time. We can become part of a reality but we can be totally lost and not know what to do.

HUO: You mentioned criticism. In your early days writing was very important. You've had this link to poetry and you're still writing a lot.

AWW: I like writing the most. If I have to value it against all human activities, writing is the most interesting form, because it relates to everybody and it's a form that everybody can understand. During the Cultural Revolution we never had a chance to write, besides writing some critical stuff, so I really like to pick up on that, and the blog gives me a chance. I did a lot of interviews with artists, just simple interviews. I asked about their past, what's on their minds, and I also wrote. So in the blog I did over 200 pieces of writing and interviews which really put me in a critical position — you have to write it down, it's black and white, it's in words, and they can see it, so you really have no place to escape. I really love it, and I think it's important for you, as a person, to exercise, to clear out what you really want to say. Maybe you're just empty, but maybe you really have to define this emptiness and to be clear.

HUO: Your blog and your work make a lot of things public. Do you have any secrets? What is your best-kept secret?

AWW: I have a tendency to open up the personal secrets. I think, being human, that both life and death have a secret side but there's the temptation to reveal the truth and to see the fact that you need some courage or understanding about life or death. So even if you try to reveal or open yourself, you're still a mystery, because everybody is a mystery. We can never understand ourselves. However we act or whatever we do is misleading. So in that case, it doesn't matter.

HUO: Now, we're still in New York, we are in the 1980s, and at a certain moment you decided to go back to China. Was that a planned decision or did it have to do with, as you said, your father getting ill? I spoke to I.M. Pei, who said that when he left for the United States it was a departure without return. He became an American architect and didn't go back. So what about this idea of exile – temporary exile or permanent exile?

AWW: I stayed in New York. I gave up my legal status because I knew I was going to stay there forever, so I become an illegal alien. I tried to survive by doing any kind of work that came to hand – I did gardening at the beginning, and housekeeping. At that time my English was quite bad. Then I did carpentry, I did framing work, I had a printing job, I did all sorts of work just to survive, but at the same time I knew I was an artist. It became like a symbolic thing to be 'an artist'. You're not just somebody else, but an artist. But I wasn't making so much art. After Duchamp, I realized that being an artist is more about a lifestyle and attitude than producing some product.

HUO: More like an attitude?

AWW: More like an attitude, a way of looking at things. So that freed me, but at the same time it put me in a very difficult position – I knew I was an artist but didn't do so much. So the few works we see today are probably the only works I did. I was just wandering around. I didn't have much to do. And after a while it became very difficult, because I was

Black, White, and Grey Cover Books, 1994, 1995, 1997

so young. On the one hand you want to do something, to be somebody, but at the same time you realize it's almost impossible, economically and culturally. It was an excuse for me to go back to China and to take a look, because for the past twelve years I hadn't written back home and had never visited. I didn't have a good relationship with my family. There was some distance. The question was, if I had to go back, this was the moment. So in 1993 I made a decision and just packed everything and moved back.

HUO: How did you find China changed?

AWW: 1989 was the crackdown of the student movement: Tiananmen. I had no illusions about China, even though everybody told me that China had changed so much and that I should take a look. Some things had changed, some things hadn't changed. What changed was that there was more beauty in the centre. It was a little bit looser about the economy. There was a little bit of free enterprise, but there was still a strong struggle, the ideology. And what hasn't changed is the Communist Party – it's still wide, still kills today. There's still censorship, there's no freedom of speech, just the same as when I left. It's crazy. It's really such a complex set of conditions. And you realize the society has so many problems and the change is so small and so insignificant and so slow. After I got back, I still felt there wasn't much to do there, so I started working on three books.

HUO: That's the beginning of the famous books.

AWW: Yes. The *Black Cover Book* (1994) is the first one, then the *White* (1995) and the *Grey* (1997).

HUO: I saw them in an exhibition at the Victoria and Albert Museum in London about design in China. They're almost like cult books now.

AWW: There are so many artists who have been influenced by those three books, and so I tried to make a document or an archive for what was going on, and at the same time to promote a conceptual base for the art rather than just art on canvas on easels. So I forced artists to write a concept, to explain what is behind their activity. At the very beginning they were not used to it, but some knew how to do it. I also wanted to introduce Duchamp, Jeff Koons and Andy Warhol and some conceptual artists and the essential writings to China.

HUO: Was this the beginning of your curatorial endeavour? You could say these books are also curatorial projects and that you've curated ever since.

AWW: Yes, it's curatorial. So around 1997–1998 we created this China Art Archives and Warehouse, the first alternative space for contemporary art in China. Before that all the works were sold in hotel lobbies, and framing shops were just for the tourists and foreign embassies. So we did it and tried to justify the space and the institution to show what was happening. And then later, by 2000, I curated another show, *Fuck Off*, in Shanghai. I think we met before that.

HUO: Yeah, we met for the first time in the late 1990s.

AWW: At that time you were so young and so fresh, and I still remember the evening we were in an artist's home, I think – many people gathered to see you.

HUO: I remember. That first trip was essential to me. I'd like to stay a little bit more with the *Black*, *White* and *Grey* books. Looking at these books today they appear like avant-garde manifestos, to some extent. We live in a time where there are fewer manifestos. Dadaism and futurism, for example, both had manifestos in the early twentieth century, but still in the 1960s there was this whole new avant-garde idea – Benjamin Buchloh always spoke about the whole idea of the manifesto. Do you think there is still space for this kind of movement?

AWW: I think art always has a manifesto, any good art, as with the dada movement or early Russian constructivism or early Fluxus in the 1970s, all those things that people did. It's an announcement of the new, an announcement to be part of a new position or a justification, or to identify the possible conditions. I think that's the most exciting part about art. Once you make a manifesto you really take some risks. You have to put yourself in a condition. You have to be singled out because it's the nature of the manifesto.

HUO: In architecture, manifestos are a very different thing. You started, at a certain moment, to venture into architecture. Did it begin in America or

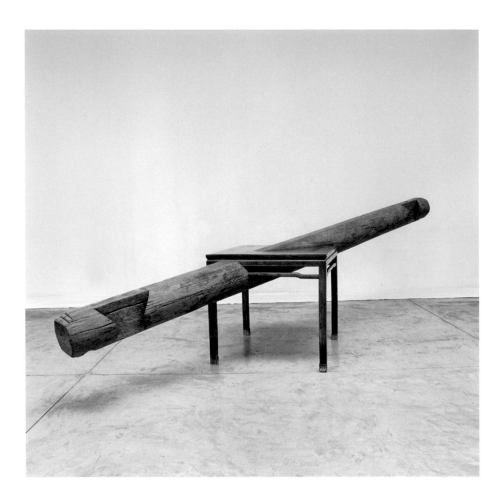

<u>Table and Beam</u>, 2002
Beam and table, Qing
Dynasty (1644–1911)
160 x 406 x 90 cm

did it start when you went back to China? When I met you in the 1990s you were already in a double practice – as both artist and architect.

AWW: I didn't start consciously. I remember two instances I had with architecture. First was discovering Frank Lloyd Wright, only because he did the Guggenheim, and that beauty we hated because ... you know, no painting could be hung there. (That was then, but now I think it's very interesting. It's just like a parking lot type of thing). The second was when I bought a book by Wittgenstein, the writer-philosopher. He did this building for his sister in Vienna. I saw that book and thought, 'Oh, this guy can build a house for his sister', so I bought that beautiful book. Those are the only two instances in New York that I had a relationship with architecture.

After I came back I lived with my mother in Beijing. In 1999 I decided to have my own studio. So I walked into this village and asked the owner of the village if I could rent some land. He said, 'Yes we have land', so I said, 'Can I build something?' He said, 'Yes, you can build.' It was illegal, but they didn't care. So I rented the land, and one afternoon I made some drawings, without even thinking about architecture. I just used pure measurement for the volume and proportions and put in a window, a door. Then six days later we had already finished it, and then I moved in.

This was the time when China started to build a lot, but many of the buildings were very commercial and came from just one single kind of practice. So a lot of magazines noticed, 'Oh, we can build differently, here's this guy who builds with very limited resources,

for a very low price, by himself.' It became a very widely exposed building in China. People started asking me to do work for them, some big commercial projects. So I decided, 'This is so simple. You just use your common knowledge and you don't have to be an architect to build', because I think that the so-called 'common knowledge' and everyday experience are so lacking in academic studies. I had a chance, and I had nothing else to do, so I started a practice. I formed this company, FAKE Design. In China the word 'fake' is pronounced 'fuck'. We have done about fifty projects in the past seven years. All kinds of projects, from urban planning to interior design.

HUO: Most of them are built, right?

AWW: Ninety per cent of them are built.

HUO: You have built more in nine years as an artist than many architects in a lifetime.

AWW: Yes, it's true, we build more than most architects in their lifetime.

HUO: What an achievement. But not only have you built a lot, but you have also curated the most visionary architecture projects. When we spoke last time for *Domus*, you were curating an architecture village, almost like *Weissenhofsiedlung* from the 1920s in Stuttgart, in which modern architects build a street. Now you're working on an even bigger architecture project involving 100 architects. Could you talk a little bit about this? Curating architecture is very different from curating art. Curating architecture is production of reality.

AWW: Yes, I love the words 'production of reality'. Architecture is important for a time because it's a physical example of who we are, of how we look at ourselves, of how we want to identify with our time, so it's evidence of mankind at the time. After the first venture into architecture, I fell very much in love with this activity. It relates so directly

to politics and reality. Then I realized that it's very important for China and for the world to be introduced to each other. So many young architects are produced in the West but have no chance to build their work, and their knowledge can never be exercised. Education itself has failed because you only just theoretically talk about architecture, and this becomes another kind of architecture. I thought it would be best to have them take part in global activities, the reality. Also in another way it is important to balance the view of architecture. It's not just education through the examples of so-called masterpieces. It's also the study of real locations, real problems, and needs to include the undesirable conditions like high speed or vast developments or low-cost architecture. I think those are important factors of architecture but aren't always being consciously brought out.

HUO: Low-cost architecture – that's like low-cost airlines.

AWW: Yes, or rough architecture, which is fine. It's all about human struggle and the reality of the condition rather than being a utopian thing. That's why I try to curate the architecture projects, to try and bring as many young people from all over the world as possible, because they all want to exercise

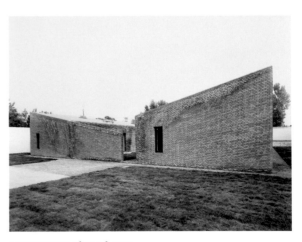

Courtyard House (Ma Jia), 2006
Beijing, PRC

their own mind and their own problems. The problems are their own problem. Any problem is everybody's problem, so you just have to participate. And if you have no chance to participate, this is a pity!

HUO: So that leads to your biggest project, the one with 100 architects in Inner Mongolia.

AWW: Yes. A developer asked me to help build this town in Inner Mongolia. They said, 'We think you're the one that can make things happen.' I said yes. I thought about it because I had announced that I would totally give up architecture because I had so much work to do. But I thought, 'Okay, I can do it, but only if I'm in the position of curating it, because I don't care if I actually build one myself. I don't have that ego anymore, but I know many great minds, young minds, who would love to do something and this is the chance.' So he understood me. He said, 'Whatever you say is fine.' So I asked Jacques [Herzog] and I said, 'Jacques, you know this is a big project, but your participation is to give me the list of names.' And Jacques understood immediately. I don't think it required much explanation. Soon after, he provided a list of names. So we contacted those 100 people, and they all agreed to come. The first sixty are already there, and a group of thirty are going next month. There will be a total of 100 architects who, maybe with their partners, will make 200 or 300 people gathering in this Mongolian town, in the middle of the desert. They're going to start to build there. It will be ready in two years' time.

HUO: What a miracle!

AWW: I think finally we realized this kind of miracle can happen in a short period of time, and I do have an impact, not only for those architects who are participating but also for the people of the world to see the possibilities. I think that's what's good about it.

HUO: This is a very special moment in your work because we started out with China and then New York and now, fifteen years later, after leaving New York,

you're back to New York with a big exhibition, which just opened last week at Mary Boone. It goes full circle – as a young artist you went to see exhibitions at Mary Boone, and now you're exhibiting there too.

AWW: It's so funny. It's such an unbelievable circumstance. In the 1980s I used to go to Mary Boone to see what was going on, and one day, years later, I was walking in Beijing and got a phone call from Mary, and she said she would like to have a show with me. I was so happy I immediately accepted. It's so strange, the whole feeling. In New York you think you can never ever do it, and then many years later it becomes possible. Karen Smith curated the show, and it turned out to be a big, well-received show, and so many people went to see it and talked a lot about it. Mary was so very happy about the collaboration. She asked me to do a chandelier, and I hesitated because I have done several before. But I like to work within demands or requirements, so I made a chandelier that is falling down from the ceiling and landing on the ground (*Descending Light*, 2007). We did the whole thing so quickly, I didn't even have time to really assemble it completely. We just had to send all the parts to New York, and over twenty people assembled it in the gallery. Now it looks fantastic there.

HUO: So it's really the idea of light falling. It's a descendence.

AWW: Yes, it's really about that.

HUO: It's also a follow-up from a great piece I saw in Liverpool, *Fountain of Light* (2007), which was about the Russian avant-garde.

AWW: I think the early Russian avant-garde had a great mind. They had such imagination and innovation about what the coming century was going to be about. Of course, there was a lot of utopian thinking, and many things stayed utopian rather than becoming a reality. So when I was offered this project in Liverpool I immediately thought about Vladimir Tatlin's *Monument to the Third International*. It would come

as a commentary or a pun about the beginning of the industrial age, during which England was an important factor, and the beginning of the information age and globalization. So I decided to make this light fountain floating in the water.

HUO: It's also so interesting because you made it at the beginning of the twenty-first century, and when Tatlin did it, it had to do with the future and with the twentieth century. Now we're in 2008, already eight years into the first decade, which is nearly over. It doesn't really have a name yet – 'zero zero?' It's a very strange moment. So how do you see the future? Are you optimistic?

AWW: When we talk about the future we become too naive – whatever we say is not going to be happens, so whatever happens is beyond whatever we can imagine. It's just so crazy.

HUO: When I was looking at your book *Works 2004–2007* last night I became aware once more of all the different production practices present in your work. We've spoken about your sculpture installations. There are so many fascinating aspects that have started to unfold over the last couple of years. I remember two years ago I saw *Bowl of Pearls* (2006) for the first time in your studio. We are living in the digital age, when we're accumulating

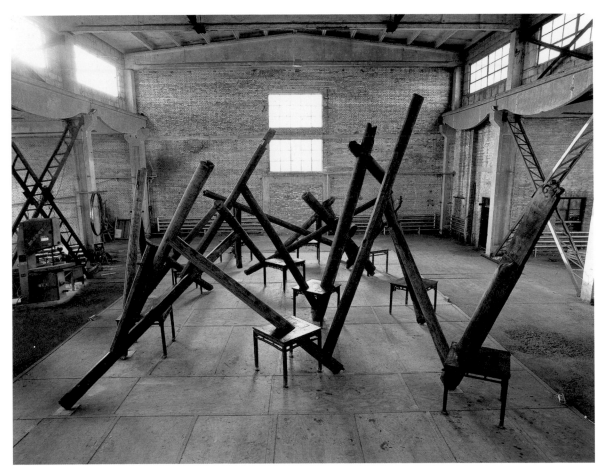

Through, 2007–2008
Ironwood, Qing Dynasty (1644–1911)
Tables, parts of beams and pillars from
dismantled temples
550 x 850 x 1380 cm

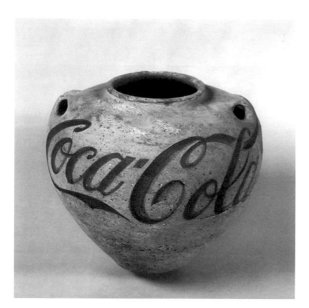

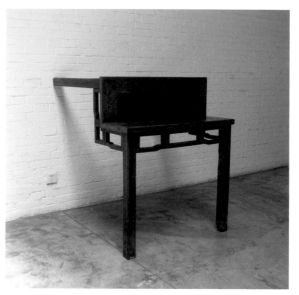

Han Dynasty Urn with Coca-Cola Logo, 1994
Urn, Western Han Dynasty (206 BC–24 AD), paint
25 x 28 x 28 cm

Table with Two Legs on the Wall, 1997
Table, Qing Dynasty (1644–1911)
90.5 x 118 x 122 cm

more and more archive material but not necessarily memory. A lot of your works are about memory. There is *Coca-Cola Vase* (1997) but then at the same time there is also work with furniture, like *Table with Two Legs on the Wall* (1997), which revisits memory in an interesting way. Could we talk about memory? Eric Hobsbawm was saying to me the other day that we should protest against forgetting.

AWW: Yes, because we move so fast that a memory is something we can grab. It's the easiest thing to just attach to during fast movement. The faster we move, the more often we turn our heads back to look on the past, and this is all because we move so fast. The work in the catalogue may be just one-tenth of my activities. On the one hand I take art very seriously, but the production has never been so serious, and most of it's an ironic act. But anyhow, you need traces, you need people to be able to locate you, you have a responsibility to say what you have to say and to be wherever you should be. You're part of the misery and you can't make it more or less. You're still part of the whole fascinating condition here. I work now in a different sense, but it's really just traces, it's not important. It's not the work itself. It's

a fragment that shows there was a storm passing by. Those pieces are left because they're evidence, but they really cannot construct something. It's a waste.

HUO: A waste? Because you call them fragments, these fragments, no?

AWW: It's weird, because you call something something else. For example, an old, destroyed temple: you know the old temple was beautiful and beautifully built. We could once all believe and hope in it. But once it has been destroyed, it's nothing. It becomes another artist's material to build something completely contradictory to what it was before. So it's full of ignorance and also a redefinition or reconsideration. All those Neolithic vases are from 4,000 years ago and have been dipped into a Japanese-brand industrial household paint, and they become another image entirely, with the original image hiding in thin layers (or thick layers) of this paint. People can still recognize them, and for that reason they value them, because they move from the traditional antique museum into a contemporary art environment, and they appear in auctions or as some kind of collector's item.

HUO: Besides the fragments and the waste, a sort of monumental junkyard piece here plays a role. At documenta, seeing your Fairytale (2007) and looking at your blog, increasingly I came to think that your blog is actually a social sculpture in a Joseph Beuys kind of sense. Do you see yourself as a social sculptor, and is there a link to Beuys?

AWW: I think you're the first one who has recognized that in the digital age virtual reality is part of reality, and it becomes more and more influential in our daily lives. Think about how many people use or are addicted to it. And of course all activities or artworks should be social. Even in the medieval age they all carried this message of a social and politically strong mind. From the Renaissance to the best of contemporary art, it's about, as you said, the manifestos and our individuality. Especially today I think it's unavoidable to be social and political. So in that sense I think Beuys made a very good example to initiate his pupils. I know very little about Beuys because I studied in the United States, but Warhol did it in his own ways: his factory, his announcements about 'popism', about portraits, about production, the interviews he did – nothing could be more social than that, I think.

HUO: Now we've spoken a lot about your manifold projects, but what we haven't spoken about is my favourite question, your yet-unrealized projects. I think I've asked you before, but I think I'll have to ask you today again. What are your yet-unrealized projects?

AWW: I think it would be disappearing. Nothing could be bigger than that. After a while everybody just wants to disappear. Otherwise, I don't know. So far, practically speaking, I will have a show in Haus der Kunst in Munich next year, so I have to prepare for that and several other shows. I don't know. I don't know what's going to come out, how it's going to be handled.

HUO: Dan Graham once said that the only way to fully understand artists is to know what music they listen to. What kind of music are you listening to?

AWW: I don't listen to music at home. I have never in my life turned on music. I'm not conscious of music. I can appreciate it, I can't analyse it, and I have many friends in music, but I never really turn on to music. Silence is my music.

HUO: What is your favourite word?

AWW: My favourite word? It's 'act'.

HUO: What turns you on?

AWW: The unfamiliar reality. The condition of uneasiness.

HUO: What turns you off?

AWW: Repetition.

HUO: What's the moment we are all living for?

AWW: The moment where we lose our consciousness.

HUO: What profession other than yours would you like to attempt?

AWW: To live without thinking about professions.

HUO: Hypothetically, if heaven exists, what would you like to hear God say when you arrive?

AWW: 'Oh! You're not supposed to be here.'

The interview 'Hans Ulrich Obrist in Conversation with Ai Weiwei' first appeared in Ai Weiwei, edited by Karen Smith, Hans Ulrich Obrist, and Bernhard Fibicher, and published by Phaidon in 2009.

Inhabit

Transformations of Iconography, Materiality, and Space

A HANDFUL OF DUST

Chin-Chin Yap

It would be redundant to cast Ai Weiwei in the flattering light of an iconoclast, deconstructionist, or even dust-breeder in the neo-dadaist tradition. Amid a growing tide of globalization contingent upon the categorization of freedom, Ai Weiwei stands as one of the last arbiters. He understands all too well Michel Foucault's notion that freedom is not oppositional to power; rather, they are necessarily related, engaged and overlapping in the same discourse. This philosophy is manifest not only in his art but also in the other roles he has taken on in the art community as architect, curator, and editor.

Post-1949 China remains a maelstrom, particularly in the spheres of art and culture. The inherent dissonance in structures – of language, of self and society, of sites of authority and resistance – is a recurring theme of contemporary artists, as evident in the favoured tropes of Tiananmen Square, Mao's visage and the human figure. While such art is a necessary and valuable social discourse, it often tends to trap itself in labyrinthine identity politics,

and Ai is one of the few who is clearly informed as to the ultimate narcissism in such an approach. His oeuvre, like others, dismantles the grand narratives of Chinese tradition. Unlike his peers, he accomplishes this not through the depiction of dislocation and ennui, but rather through the creation of an ordered disorder. In this state, conventional conceptions of time and Euclidean space are thrown into disarray, and from this emerge phalanxes of objects – an eclectic range from Neolithic tools 10,000 years old to the most commonplace coal hives used today in northern China – stripped of their standard identities and reconfigured as a question about integrity and objectivity. These conceptual works – immaculate, brazen, and ironic – reflect upon the brilliance and perils of civilization as a whole.

Ai Weiwei's name is a negating prefix which calls up the imminent, or unforeseen. He was born in Beijing in 1957, the son of Ai Qing (1910–1996), one of China's best-known contemporary poets. Born to a Zhejiang

land-owner and raised by a foster nurse, Ai Qing studied painting at Hangzhou's acclaimed West Lake Academy of Fine Arts and then spent two years in Paris, which proved formative to his literary tastes and revolutionary sensibilities. From the 1930s onward he was extremely popular and prolific; imprisoned by the Kuomintang from 1932 to 1935, he was thereafter taken up as a communist literary celebrity until the anti-intellectual campaign of 1957. That year Ai Qing's entire family was sent to Xinjiang in China's barren north-west. Ai Weiwei was just a year old, and this experience of hardship over the next twenty years was formative in the young artist's attitude of resistance and detachment. In 1978, the political winds changed yet again and the family returned to Beijing under new auspices. Ai Qing was lauded with titled positions, including membership in the Standing Committee of the National People's Congress, and continued to gain international acclaim in his literary career.

Upon his return to the Chinese capital Ai Weiwei enrolled in the Beijing Film Institute. Together with other young artists who experimented with forms embracing the progressive values of Western abstraction and impressionism, he formed the Stars Group in 1979. The Stars' first, unauthorized exhibition took place right outside the China Art Gallery. Their work was neither obviously subversive nor political in content, but their mandate was unified by their rejection of state-sanctioned propaganda art. A cry was sounded for an inherent need for individual freedom in artistic expression. One year later, the Stars' first official exhibition opened at the China A11 Gallery. Forty thousand people came to witness this occasion, an occasion which would prove a seminal event in the history of contemporary Chinese art. However, dissipated by bleak domestic prospects and the siren call of foreign lands, the group did not stay together long. Many of the Stars members left China in the following years, some never to return.

In 1981 Ai Weiwei headed for the United States, embarking on a twelve-year sojourn during which he attended New York's Parsons New School of Design and the Art Students League for varying periods of time. He would remain in New York until 1993. In New York he discovered an affinity for the work of artists such as Jasper Johns, Marcel Duchamp, and Andy Warhol. He saw in their exhilaration for new artistic concepts a method by which his own work could disengage itself from historical complexity. He began experimenting with a range of new mediums in this vein, taking up utilitarian everyday objects he found around him. Violins, shovels, raincoats, and black leather shoes emerged as favoured motifs. It became quickly apparent that the young artist's fledgling

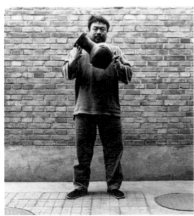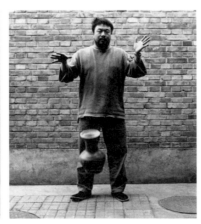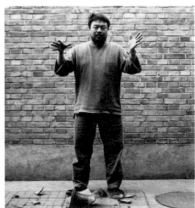

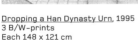

Dropping a Han Dynasty Urn, 1995
3 B/W-prints
Each 148 x 121 cm

vocabulary involved an object-based strategy of conceptual redefinition and an instinctive, seemingly effortless transgression of conventional categories of space and utility. In his hands, commonplace materials assume abstract forms challenging ingrained habits of sight and function. The iconic *Violin* merges a violin's body with a shovel handle, while the dada-inspired sensory conflation *Tire and Salted Fish* presents the olfactory as well as visual juxtaposition of an unconventional pair of objects. In these early works the influence of dada masters, in particular Duchamp, and use of found objects and the renegotiation of function and identity remain strongly visible.

The architect's eye for materials and perspective was also sharpening, as evident in the 1988 solo exhibition at Art Waves/Ethan Cohen. In *Five Raincoats Holding Up a Star* the central star is formed by nothing and freed through the heavy raincoats which lie prostrate in a drab puddle around its periphery. Also in this exhibition were Ai Weiwei's casual, almost fey homages to Rose Sélavy, in which profiles of his muse emerge from cracks in glass and in the kink and bend of a coat hanger, a visual counterpart to Apollinaire's calligrammes. As Harriet and Sidney Janis said of Duchamp a century ago, 'he has worked out a system that has produced a new atmosphere in which irony functions like an activating element, causing a pendulum-like oscillation between acceptance and rejection, affirmation and negation, and rendering them both dynamic and productive'.[1] Likewise, Ai Weiwei's works in the 1980s had already set the foundation for an artistic philosophy based upon transgressing the socially assigned relevance of commonplace materials.

He decided to return to Beijing in 1993, and there proceeded to undertake several projects which would prove critical to the development of experimental art in China. The intellectual climate was still thawing after the Tiananmen crackdown in 1989, and artists within China had minimal access to information about international developments in art. Despite this, the contemporary art scene was burgeoning, albeit under harsh and mostly underground conditions. Artists from various parts of China were gathering in a north-eastern suburb of Beijing that would become known as the East Village. Ai Weiwei embarked on publishing the *Black Cover Book* (1994), *White Cover Book* (1995), and *Grey Cover Book* (1997), the first publications to showcase work in progress and documents by many of these artists. Apart from interviews and personal documents of Chinese artists working both abroad and in China, these books also contained writings by contemporary Western artists such as Warhol, Duchamp, and Jeff Koons, which were then inaccessible at best within the mainland. At that time, underground publications were distributed mainly within the artists' community. These books were immensely influential in disseminating information on contemporary art within China and abroad. Ai Weiwei's other influential project in this period was the co-founding of China Art Archives and Warehouse in conjunction with Hans van Dijk, Frank Uytterhaegen, and the Ghent-based Modern Chinese Art Foundation. Their aim was to showcase experimental, alternative art and young artists. Neither had received extensive exposure or institutional support before then, as the system for promoting artists and their work remained heavily state-guided. Today, China Art Archives and

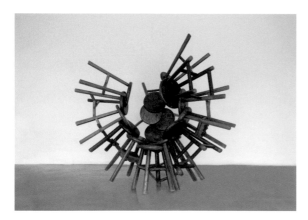

Grapes, 2008
16 stools from Qing Dynasty (1644–1911)
167 x 180 x 157 cm

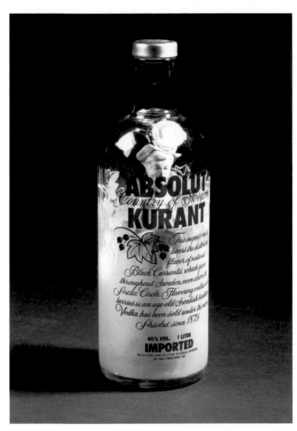

Tang Dynasty Courtesan in a Bottle, 1994
Clay sculpture from Tang Dynasty (618–907), glass bottle
23 x 8 cm

Warehouse has hosted some of the most challenging contemporary art exhibitions featuring promising young artists.

In terms of sheer provocation, however, the exhibition that received the most airtime in the recent history of contemporary Chinese art was *Fuck Off* in 2000. Curated by Ai Weiwei and Feng Boyi, the exhibition took place in Eastlink Gallery and a warehouse at 1133 West Suzhou River Road at the same time as the Shanghai Biennale. *Fuck Off* featured forty-eight artists, emerging and acclaimed. Their intense work grappled head-on with the raw, undiluted matter of contemporary art and society – a far cry from the relatively orthodox works displayed at the Biennale. Moreover, the curatorial approach challenged the very system it saw as governing artists and art production, calling for the need to 'search

for the way in which art lives as "wild-life"' in order to promote diverse, independent and critical stances towards the production of contemporary art. Spectacularly anti-authoritarian in its sensibilities, the closing line of the exhibition catalogue states: 'Perhaps there is nothing that exists "on-site", but what will last forever is the very uncooperativeness with any system of power discourse.'

With his relocation to Beijing, Ai Weiwei's own works also took on a new level of confrontation in scale and symbolic import. His previous works in New York strove for some degree of ubiquity, and indeed anonymity in their choice of materials and deliberate distancing from specific cultural agendas. The closest one comes to any sort of agenda, perhaps would appear to be a comment on alternative lifestyles borne out by the raincoat installations. In the period dating from the mid-1990s, the scale of his works increases dramatically and the works themselves become more boldly fraught with cultural signifiers. Dual strands of resistance and the question of authenticity emerge as leading, interrelated themes. Ai began to work with Ming and Qing Dynasty furniture and ceramics dating from the Neolithic period, turning these prized touchstones of Chinese heritage into ironic questions about contemporary power conflicts of authority and cultural worth. Notably, the artist refuses the privilege of making final judgements, preferring to pose questions through his manipulation of these materials which runs the gamut from preservation (*Tang Dynasty Courtesan in a Bottle*, *Still Life*) to irreversible destruction (*Dropping a Han Dynasty Urn*) to reconstruction with a cubist wink (the *Furniture* series). The categories often blur into each other, as for example with the work *Whitewash*. There is also a fourth category which should perhaps be included in parenthesis: perfectly constructed fakes of porcelain vessels (*Blue and White*) prized for their imperial imprimatur. These works raise several issues about the culture of replication. Apart from forged commodities of deceptive exchange-value, two

alternative perspectives exist where the replica is of equal purported value to the original (as affirmed by Duchamp with regard to readymades), or even greater value (as in the case of certain blue-and-white porcelain designs which originated in China and were widely copied by the Europeans and Japanese in the eighteenth century).

All in all, two lasting statements emerge from these collective works: the first being the subjective authenticity of artefacts and, thereby, the questionable authority vested in them, particularly in a culture where these objects functioned primarily as status symbols within meticulously delineated structures of power and domination. The second statement to emerge is more affirmative and

centre. Both are joined as effortlessly as a thread through a needle's eye. Like dream objects which retain an impossible yet totally natural relationship, they exist in the nth dimension where 'the whole is stable within instability'.[2] Similarly, in *Forever* (2003) arrested motion is a key component of the abstract form, whereby a certain freedom and weightlessness ensues from the forty-two bicycles' amputated frames and perfunctory seats. In this sculpture of interlocking frames, bicycle seats function both as the feet and crown. The topmost seven appear triumphantly flaglike and yet are devoid of practical purpose, robbed even of conventional function and motion as they crown the circumference of a ride which loops back on to itself. Conversely, the seats on the bottom are unglamorously transformed into pedestals for the

It would be redundant to cast Ai Weiwei in the flattering light of an iconoclast, deconstructionist, or even dust-breeder in the neo-dadaist tradition. Amid a growing tide of globalization contingent upon the categorization of freedom, Ai Weiwei stands as one of the last arbiters.

glistening wheels, practically becoming the key centres of gravity bearing the full weight of the forty-two frames. While Duchamp's *Bicycle Wheel* functioned as a lone centre of motion,

mysterious, and stems from Ai's focus on utilitarian objects and his revelation of the primary refinement of their manufactured forms. This is realized through a deliberate reconfiguration of the conventional coordinates of time, space, and motion within which the objects exist. The sources of tension generated through this reconfiguration transmute the objects into forms of unconventional coherence. The Escheresque play of the *Furniture* series (1997–1998) upturns the axis of the Euclidean world through touchstones of Ming and Qing Dynasty furniture pieces. A more pointed illustration of negotiable power is *Table and Beam* (2002), where the massive four-metre beam materializes in the charged air to slice through a Ming Dynasty table at a forty-five degree angle. As if wood were water, the table's surface closes around and locks the invading beam within its

spinning or still, Ai's bicycles have transmuted into an organism rather than an atom. It becomes a single-minded, sensuous form bound not by gravity but rather by the exultant vectors of appropriated motion.

The implications of these works leave us both disarmed and uncertain in the trappings of our own worlds. They posit liberation – that of essential paradox and structural revolution – through a non-attractive disorder of the known physical and temporal structures we reside within. Yet, this liberation is one we can only glimpse through the looking-glass of Ai's works. Of voyeurism in Duchamp's work, Kynaston McShine writes: 'The voyeur then has no choice but to be both exalted and melancholy. For him there is voluptuousness and sadness, desire and frustration. Art becomes a

liturgical kind of mystery with a beauty that causes despair, a despair that disillusions but enlightens. This art of self-reflection and silence where even the shadows are given life has an extraordinary elusiveness.'[3] It is these same shadows that Ai calls upon. Even as his work approaches abstraction through a minimal and highly ordered aesthetic, it speaks most powerfully through utilitarian forms resembling the DNA of civilization: figures and configurations we reside within without entirely understanding why. Perhaps, in the end, we are capable of apprehending only these shadows.

From around 2000, Ai Weiwei's increasing forays into the realm of architecture have also led to greater scale and abstraction in his sculptural works. He recalls his first potential with architectural problem-solving skills as the instance when his father, descending the steps into their underground bunker in Xinjiang, bumped his head against the too-low ceiling. The boy then proceeded to deepen the chamber so that his father could stand upright within the space. Two decades later, Ai designed his own residence and the China Art Archives and Warehouse complex in north-eastern Beijing. Now, the artist assertively exploits the conventions of architecture in his large-scale works. The dramatic scale of these works sensorily intoxicates and overwhelms the human viewer, who must first apprehend and experience the work before intellectual comprehension takes place. The six-metre high *Chandelier* (2002), nested within layers of scaffolding, was exhibited outdoors during the First Guangzhou Triennale held in 2002. Like a knave seeking treasure, the viewer must navigate this manmade forest of rusting iron to approach the oversize gem within, becoming part of the very experience of 'prison and palace and reverberation'.[4] *Concrete* (2000) invokes a spatial language that recalls fellow architect Tadao Ando's concept of 'stillness' to evoke spirituality from within space. Swelling skyward like a daunting, unknown monolith, the austere sculpture's interior is startling, extreme

in its purity of sensation: all sky, concrete, and the invisible rush of running water beneath. Approaching spectacle through stillness, these works stride the boundaries between art and architecture, leading the viewer to consider the materialist conventions of each and their mutual discourse.

Despite the abstract and often clinical nature of Ai Weiwei's works, they remain acutely germane to the world in all its raw, atonal complexities, declining to close themselves off in self-contained aesthetic systems. His philosophy and aesthetic vocabulary, like that of most established artists over time, evolves through the concerns and challenges they choose to articulate. What remains constant, however, is the obsessive intrigue with the contours of materials and space: this poor, wondrous detritus of our lives and accepted history that we can only make, and lose ourselves in the making of. Here the strand of artistic engagement meets his role as facilitator, recognizing that the purest form of freedom cannot preclude the possibility of its own negation. In a time where creation seems weary of crisis, art – and even thought – frequently ends itself either rooted in intellectual paradigms or reacting against them. Can art still propose ideas which do not live within such paradigms? Dare we taste blood; dare we bear the twin burdens of love and autonomy? As he considers the myths of modernism that we live within, Ai Weiwei in turn proffers the looking-glass to each of us.

1. Harriet and Sidney Janis, 'Marcel Duchamp, Anti-Artist', in *View: The Modem Magazine*, Series V, no.1, March. 1945. Reprinted in Jospeh Masheck (ed.), *Marcel Duchamp in Perspective*, Da Capo Press, 2002.

2. John Ashbery, 'Self-Portrait in a Convex Mirror', *Self-Portrait in a Convex Mirror: Poems*, Penguin, 1992.

3. Kynaston McShine, 'La Vie en Rose', in Anne d'Harnoncourt and Kynaston McShine (eds.), *Marcel Duchamp*, Museum of Modern Art, 1973.

4. T.S. Eliot, *The Waste Land*, Boni and Liveright, 1922.

This article was originally published in *Ai Weiwei Works: 1993–2003* published by Timezone 8 in 2003.

Galerie Urs Meile
Beijing, PRC
2003

FOREVER

Ai Weiwei's installation *Forever* recalls themes familiar from his works of a more intimate scale. Extending his exploration into the appropriation of the readymade object, *Forever* is a composition of forty-two stacked bicycle frames arranged end-to-end in a circular form. Strictly expounding upon the neo-dadaist theme, the work can be described as a meaningless abstraction, 'a sculpture made possible though emptying out the functionality of its object'.[1] The work, however, evades such reductive explanation and exhibits the artist's pop sensibilities through both the bicycle's iconography and its serial deployment. Derived from the name of the Shanghai-based manufacturer that has produced the nation's most popular bicycle since 1940, the work's title is reiterated in the sculpture's circuitous form, a loop to which there is no beginning or end. Playful though the naming is, the proliferation of bicycles suggests a more pointed reflection on the place of the individual in Chinese society. The bicycle was once the nation's predominant mode of transportation. Today, the vast urbanism of the contemporary Chinese metropolis has left it marginalized in its diminished utility, social status, and the cyclist's increasing peril amid China's permanent congestion. This waning significance is reflected in the extent to which the sculpture's autonomy – its presence as a discrete object – subjugates the value of any particular bicycle to the composition as a whole. In making the end of one unit indiscernible from the next, the bicycle is accepted as an iconic object of everyday Chinese life, marginalized and transformed into a cog in a giant geometric structure.[2]

With architectural design already comprising a significant amount of the artist's output, Ai's shift to larger scales may have been inevitable. *Forever*'s large but conventional sculptural composition is keenly proportioned and engages its architectural surrounds in a manner only hinted at in his *Furniture* series. Cordoning off the sculpture's interior, the indistinguishable tessellation of frames produces a complex palisade that has no

1. Charles Merewether, 'At The Time', in Urs Meile (ed.), *Ai Weiwei: Works 2004–2007*, Galerie Urs Meile, 2007, p.177.

2. Jonathan Napack, 'Ai Weiwei,' in Charles Merewether (ed.), *Ai Weiwei: Works, Beijing 1993–2003*, Timezone 8, 2003, p.42.

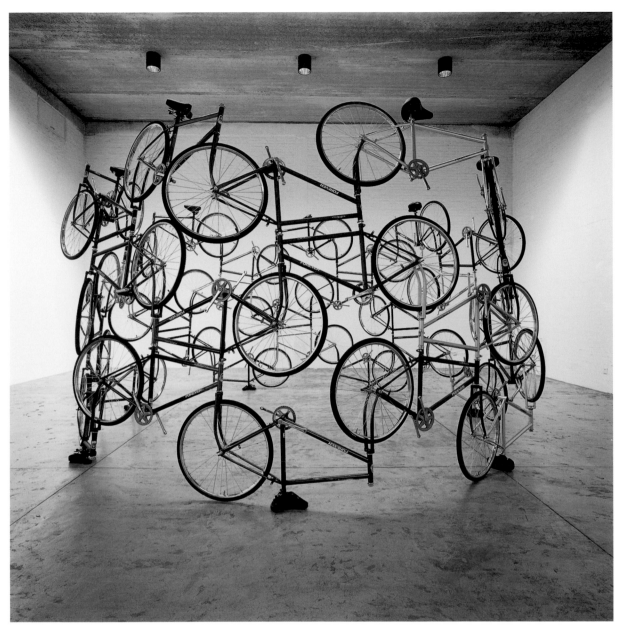

Forever, 2003
42 bicycles
275 x 450 cm

apparent point of weakness. The viewer is allowed to see into and through its enclosure, but not physically occupy the centre. Against the static gallery walls, the visual play of layered frames and radiant spokes is both alluring and confounding. Such dynamic effects suggest a sculpture about to lurch into motion, reactivating the defunct bicycles at any moment. Rather than bolt on a linear course, the prescribed circular track evokes only an ill-conceived carousel in which half the riders find themselves oriented upside down – an appropriate metaphor for the state of confusion that contemporary China often finds itself in.[3]

Though a dramatic shift in scale and proliferation, *Forever* has its roots in Ai Weiwei's long-standing investigation into the appropriation and alteration of functional objects. Beginning during his period abroad in the United States, the initial efforts in this regard trace the well-worn territory of early dada readymades. Works such as *Violin* (1985), *Safe Sex* (1986), and *One Man Shoe* (1987) each exhibit a combinatory impulse infused with Ai's own impish brand of Duchampian wit. In these pieces, the object's functionality is rendered useless through either its radical alteration, as in *One Man Shoe*'s symmetrical fusion of a pair of Oxfords, or in the removal of the object's desirability. Embedded with questions of authorship and authenticity, these techniques are augmented by merging objects from high or everyday culture with those of low culture. In the perversely humorous *Safe Sex*, a piece developed at the height of the AIDS epidemic, Ai cheekily fashions a condom at the groin level of a raincoat to form a wordplay between colloquial and formal language. In *Violin*, the neck of the delicately crafted instrument is replaced with the handle of snow shovel. As the latter piece demonstrates, the symbolic value of the original is often enhanced by such combinations, especially where mass-produced objects converge with those wrought by hand.[4]

Just as *Violin* is forthright in its homage to Duchamp's 1915 piece *Shovel (In Advance of a Broken Arm)*, *Forever* is transparent in tracing its associations to the French dadaist's *Bicycle Wheel* (1913). While Duchamp's wheel – a single tireless rim carried by a bicycle fork affixed to a stool – relied heavily upon the scrutiny of the pedestal to alert the viewer to the act of appropriation, Ai Weiwei requires only the Duchampian reference to achieve similar effect. For Ai, Duchamp's influence was instrumental not only

3. Carole Lauvergne, *Ai Weiwei*, exh. cat., Modern Chinese Art Foundation, 2004, p.8.

4. Merewether 2003, p.177.

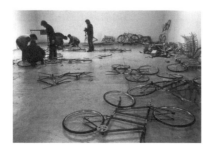 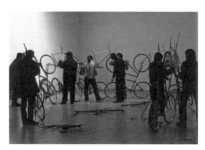

Installation of <u>Forever</u>, 2003 at Ai Weiwei Studio

Inhabit

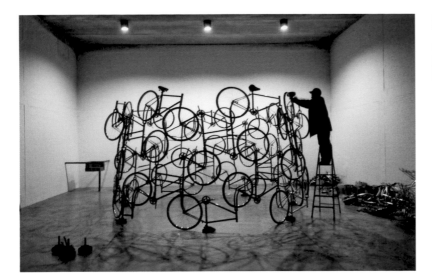

Installation of <u>Forever</u>, 2003 at Ai Weiwei Studio

Next page:
<u>Forever Bicycles</u>, 2011
1,200 bicycles
262.8 x 95.7 m

in opening new avenues of artistic production, but in providing a path away from the overtly political expressions that entangled many of his Chinese peers in narrow iconoclasm. Challenging the notions of originality and authorship, Ai credits Duchamp with revealing to him that 'art could be anything, even a personal act of existing', a position notably distinct from the established conception of art under the early communist regime's emphasis on the reification of the state.[5] The critic Karen Smith notes:

> The subversion of art to his life and goals return Ai to the sphere of Duchamp, yet given his Chinese heritage, it actually aligns him more closely with the great men of letters through China's long dynastic history, who did not distinguish between 'pictures' or 'words' as functions of the social responsibility they took as their duty in life, and which frequently used both pictures and words as a means of impeaching the state.[6]

As both a constructive and conceptual framework, the giant bicycle structure proved to be an expandable system. Confirming the project's linguistic play, Ai's later iteration, *Forever Bicycles* (2011), literally appears to expand into infinity. The repetitive progression of layers of 1,200 bicycle frames is a construction of monumental proportions and complexity that explodes into space and recedes to an unseen horizon. The perspectival effect privileges a frontal view that amplifies the spectacle of reflective surfaces. Only by occupying a passageway underneath the sculpture does comprehension of its structure avail itself to the viewer. By this time the sculpture's initial effect has subsided and a new sensation emerges — the realization of one's own vulnerability while standing beneath a towering wall of tenuously connected bicycles.

5. Karen Smith, 'Giant Provocateur', in Hans Ulrich Obrist, Karen Smith, and Bernhard Fibicher (eds.), *Ai Weiwei*, Phaidon, 2009, p.49.

6. Smith 2009, p.85.

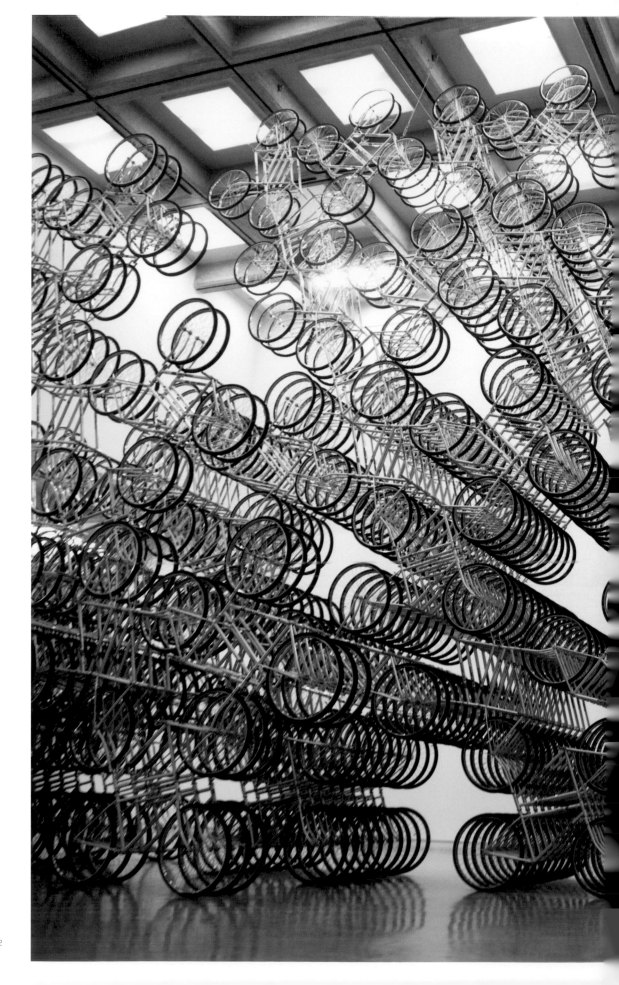

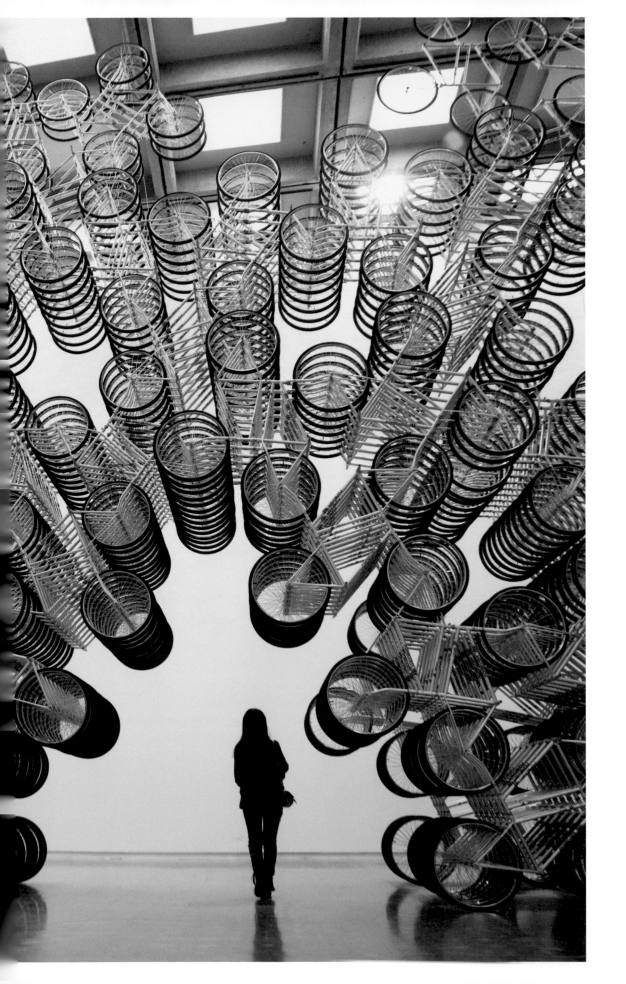

Galerie Urs Meile
Beijing, PRC
2006

FRAGMENTS

A DIALOGUE

Ai Weiwei and Nataline Colonnello

NC: This is your first one-man show in China after so many years. What do you think would be a suitable title for it?

AWW: The first thing that comes to my mind is 'fragments'. Something similar to 'pieces', 'clippings', or 'leftovers' from a body, or an event … material, history, or memory; it's something broken or left over, fragmented or useless.

NC: This body of work deals with Beijing and its development; so, if on one hand, the past is being destroyed day by day, on the other, there are many new things coming in. This situation concerns not only the capital, but also the whole of China. Don't you think that 'fragments' or 'clippings' only includes a portion of this idea?

AWW: 'Fragments' is a metaphor, not a value judgement of these objects; it's like deciphering the DNA of an animal from a single hair. The title *Fragments* alludes to a previous condition or to the original situation. We are witnessing dramatic historical movement, you can call it social change; a simultaneous big transformation that we are all in together. It has a destructive and, at the same time, creative nature. To me, it's just a changing of forms and a remoulding of our lives, our experience, or our behaviour.

NC: In the exhibition *Fragments* opening in April 2006 at Galerie Urs Meile, Beijing, you will present your installation *Fragments of a Temple* (2005), and three of your recent videos: *Beijing: Chang'an Boulevard* (2004), *Beijing: The Second Ring* (2005), and *Beijing: The Third Ring* (2005). All these works are associated with architecture, urbanization, Chinese culture, tradition and contemporaneity. In my opinion, these works are suited to be shown simultaneously, as they cover a broad spectrum of topics linked to China's peculiar historical, socio-political and economic development.

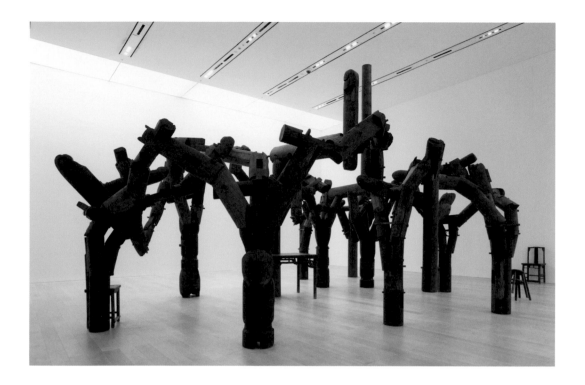

AWW: Yes, they have a unique dialogue with Beijing's current conditions; the wood I employed for my installation is fragments of pillars and beams from hundreds-of-years-old dismantled temples originally located in the south of China. I bought these architectural components from a furniture dealer; they were originally intended to be recycled for furniture making. They are of an incredibly hard, weighty wood called ironwood (*tieli*). These pillars and beams were moved piece by piece from Guangdong Province to Beijing. Of course, many smaller pieces were left over from my previous sculptures, so I used the remaining fragments in this recent installation. I gave my assistants very vague instructions: I told them, 'I need all those pieces reconnected.' It was a rather blurry programme, and eight of my carpenters worked independently for half a year to bring the installation to the present condition. This work began more than 100 years ago, and I don't think it is fully realized yet … it is just resting in this stage.

Fragments of a Temple isn't exactly my design, but that of the carpenters who have been working with me for eight years. They considered what I would have liked to do with those previously unused wooden pieces, and the result is more interesting than what I would have designed myself. Of course, there's little artistic judgement in it, and I purposely left it open, free from contemporary ideas about sculpture and installation – I left it to the carpenters to decide. When I asked them what they were doing, they told me they were making a dragon. I thought to myself, 'I'm not so interested in dragons', and only later discovered they made it according

Fragments, 2006
Ironwood, Qing Dynasty
(1644–1911) table, chairs,
parts of beams and pillars
from dismantled temples
500 x 850 x 700 cm

to some hidden rules, where all the structure's eleven poles are placed on the borders of a imaginary map of China. It's not apparent, but they insisted that if you could look at the installation from the top you would see it. I can't really imagine it, but I trust that they are very precise, they drew a big map and lined the eleven poles on the borders. That's how it was reconstructed in my studio. I find it very ironic that when the carpenters tried to predict or guess what I might find valid, they put me at a distance from any artistic judgement. In that way I was able to appreciate their independent thinking.

Three videos I did in late 2004–early 2005 are conceptually similar to *Fragments of a Temple*. Lines drawn on a map determined the locations where the videos would be filmed. I gave this concept to my photo assistant, Zhao Zhao, and told him that I needed one-minute shots; I instructed him to use the video recorder like a camera, telling him to simply press the record button and make one-minute exposures. I told him that whatever happens in from of the lens would be okay. He worked for months on these three projects, the entire winter. We chose the wintertime because there's no other season that shows Beijing in such a clear way. During the entire filming process I saw never on site. I saw the footage when he brought it to be analysed, which was mostly for technical discussion, never anything artistic. These three videos are conceptual rather than visual, in fact, even the editing was given to the professional editors. I never even saw the footage on the monitor. But certainly they make a strong visual impact: this strict, rational – even illogical – behaviour is so precisely disciplined and it works in tandem with the randomness of the subjects.

NC: Talking about *Fragments of a Temple*, it looks like a kind of résumé, a sum of past works you created with furniture, a realized installation to which your carpenters contributed more actively to, not only with manual labour, but conceptually. They have followed all the stages of your works for so many years and are so well trained in traditional Chinese carpentry techniques. They know how to solve specific problems and how to handle the materials, which is usually *tieli* wood and/or ancient furniture. What is amazing is how their accumulated skills and the experiences gained through dealing with various technical difficulties, and these difficulties to which they are used to coping with, all culminate in this work.

Workers install <u>Fragments</u> at Galerie Urs Meile in Caochangdi, Beijing

Fragments of a Temple is an architectural masterpiece based on ex-perimentation and rigour; at first glance it appears chaotic and puzzling, but it is actually extremely complex. It is very strange what happens in this work: parts seem randomly placed without specific reason, but at a closer look the different components reveal elaborate balance relations and a mastery of the theory of joints; for example, the case of the huge pillar standing on the top of the whole installation, or in the unexpected intersections pierc-ing the furniture and blocking them in the skeleton of the entire, massive framework. If on the one hand *Fragments of a Temple* is a gathering of dis-carded parts from your previous works; on the other, it includes all of your past wood installations. It is similar to a pre-historic, makeshift construc-tion or a temporary building; it is a very strong work, and in its solidity it also paradoxically conveys a sense of transience and uncertainty. It takes on the whole history of China.

A plan view of <u>Fragments</u> reveals the outline of China mapped into the organization of the temple beams

AWW: It's interesting that you mention that. The original temple was built according to a very moral, very aesthetic and strict order. But now the same material is rearranged in a random and temporary way, in an irrational and illogical structure. It has this big, gaping wound; you don't know whether it's alive or not. Each piece is joined differently, each is a different size, and each has a different angle. None of them have any rational need to be connected one another; but at the same time, each one is precise and requires crafts-manship to be shaped so definitely, so precisely, and so-called correctly.

Elevation 1: 0° Rotation

Elevation 2: 15°

Elevation 3: 30°

Elevation 7: 90°

Elevation 8: 105°

Elevation 9: 120°

Elevation 13: 180°

Elevation 14: 195°

Elevation 15: 210°

Elevation 19: 270°

Elevation 20: 285°

Elevation 21: 300°

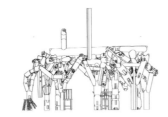

Elevation 4: 45°

Elevation 5: 60°

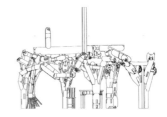

Elevation 6: 75°

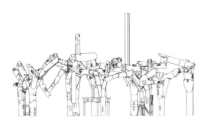

Elevation 10: 135°

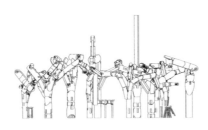

Elevation 11: 150°

Elevation 12: 165°

Elevation 16: 225°

Elevation 17: 240°

Elevation 18: 255°

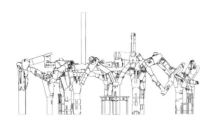

Elevation 22: 315°

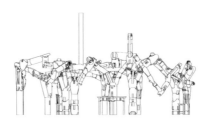

Elevation 23: 330°

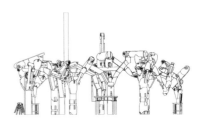

Elevation 24: 345°

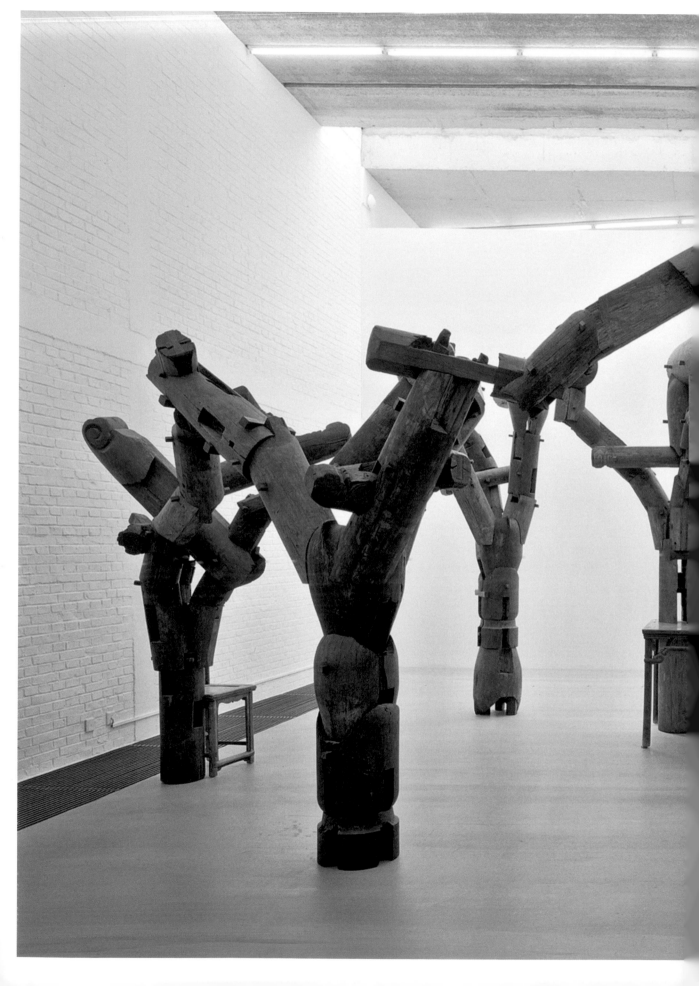

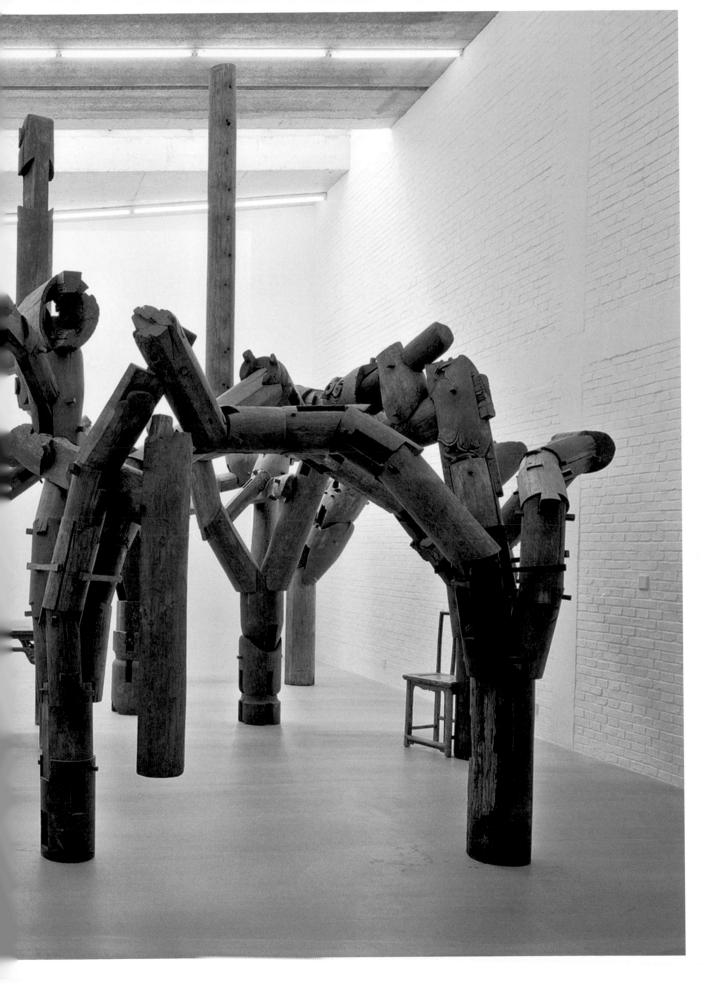

NC: Right. I would say that each single fragment in your installation somehow reminds me of the people, the cars, and the buildings you find in your three videos. While the videos are shot in a simple and calm way, everything in them is moving independently from its surroundings, running with the same frantic speed of the immense, varied Beijing. And in your installation different components, which similarly have no relation, are joined together; but in this instance they are static, fixed in a certain form and locked in the weight of the wood itself.

AWW: Everybody knows, each architectural element in a temple has a precise order. The fragments I used in my installation are from three or four different temples, so everything is wrongly connected and misfit. The fragments serve no purpose to each other, and the whole structure serves no purpose.

NC: Was it a kind of challenge for your carpenters to produce it?

AWW: At the very beginning I had to resort to hired help and many of my carpenters quit, despite the fact I paid them a much higher salary and I never rushed them. They quit because many of them didn't know what their job was for. There is a very simple logic driving everybody to work: What is it all for? You need to know why the table needs to be cut in a certain way, why I need such a perfect workmanship, why the patina should be kept and hidden joints should not be showing; you have to understand why it has to be reconstructed in that particular way. Later on, many of the carpenters started to enjoy the work because it became a lifestyle, they started to make that perfection in itself a challenge. Once they created something interesting you didn't have to tell them 'why', their relationship to their work became synchronized like two people ice-skating, they perfectly matched each other.

NC: As you said, you like to set a certain distance between yourself and your recent works. You entrusted other people with the further development of *Fragments of a Temple* and with your video works. Why is that at the moment?

AWW: I started to think that in order to make myself feel that a work is more interesting, I needed not to be too involved in it. In this way I can always be surprised by the result. For this reason I started working with different kinds of skilled labour and traditional technical masters, for example in the ceramic and the tea pieces, which are all crafted by very qualified Chinese traditional workers. To me, it's interesting to have very loose control or no control at all, to disappear somewhere and to see how far the work can go by itself. Of course, those pieces are going to be shown in cultural industries, museums, galleries, etc. and I think that distance makes my work challenging. It provides for more possible results and sets up a new status for artworks that can be reproduced or mass-produced. They could be factory made – but they are made for a different reason and with a different kind of control.

NC: But there is still a firm conceptual structure within these works, the whole installation has a framework, even if it seems illogical. Your videos have a structure as well, which is also highly disciplined. Both of your works question China and its transformation.

AWW: Nobody can avoid the signatures of the time, even if you're trying to. The only difference is that these works bear their own nature as well as my initial input. Even though I contributed very definite creative input, I tried to let each work's own nature develop. A carpenter knows better about the wood, the tea-maker knows more about the tea, it's collective wisdom. The reasons why the Second Ring Road and the Third Ring Road were built are very different, yet it looks as if they were built for me, so that I could make these videos. I filmed the Second Ring Road on cloudy days and the Third Ring Road on sunny days, I think it's interesting that I only needed to make one such decision... I've put in a minimal effort and the project already shows a very strong character.

NC: In your videos everything is continuously changing in the sense that each exposure records the same view for only one minute. The setup of *Fragments of a Temple* in the exhibition space is also conceived as a work-in-progress. Since the work will be mounted and taken apart slowly, piece after piece, it will therefore be subject to an unceasing process of construction and dismantlement for the entire length of the show. I think that this resembles Beijing, the ever-changing city in which you live. What I would like to ask you is: what do you think about this city?

AWW: If I were a soldier, life in Beijing would feel like I was always watching a castle or a giant mountain. I try to win it over, which is impossible. But, in a way, it's more symbolic to me, it's a big monster, gigantic and with its own reasons: political or economical; madness or love; happiness and sadness all together. Tragedy, history, ideology, stupidity and wrongdoing: everything is in here, and it's a big, big monster to me. I think that by being here we can feel each other, but at the same time, just by being here, you also have a respect for it. You can only guess what is going to happen, and whatever happens will always surprise you. This is always very interesting.

The interview, 'A Dialogue: Nataline Colonnello and Ai Weiwei about the Exhibition Fragments', was conducted on 6 January 2006 in Beijing and published in the exhibition catalogue, *Fragments,* by Galerie Urs Meile.

The Great Lawn, *documenta XII*
Kassel, Germany
2007

TEMPLATE

A wry paradox surrounds Ai Weiwei's sculptural installation, *Template*. On one hand, the commission was one that Ai himself described as 'not that interesting'.[1] Appearing opposite *Fairytale* – Ai's mobilization of 1,001 Chinese citizens in a grand life-as-art performance – *Template* served to assuage exhibition coordinators at *documenta XII* who requested a static, tangible work to which they could affix the artist's name. To that end, Ai's towering eight-finned sculpture is a respectfully acquiescent reprisal of themes familiar to his own oeuvre. On the other hand, *Template*'s unexpected collapse only days after its unveiling levelled the sculpture's upright pose. Bereft of its original purpose, the monumental edifice no longer registered the artist's presence at *documenta*. Instead, it was imbued with new characteristics. Through its structural instability and the implied kineticism of its resting state, *Template* emerged from the collapse more closely akin to *Fairytale* and the piece's accompanying 1,001 Ming and Qing Dynasty chairs – indeterminately arranged and part of an unpredicatable performance.

Originally erected on the exhibition's south lawn, *Template* consists of eight mammoth panels sheathed in alternating arrangements of Ming and Qing Dynasty doors. The architectural remnants, recovered from destroyed houses in Shanxi Province in northern China, comprise a porous laminate five layers thick that is connected by mortise-and-tenon joints. Revisiting conceptual territory explored in *Fragments* and the *Furniture* series, Ai's invocation of traditional tradecraft reasserts the utility and cultural value of both technique and artefact alike. These pieces, carrying with them 'evidence of our past activity', are brought into a contemporary context that the artist finds representative of 'a mixed, troubled future; a void space'.[2]

In *Template*, the void is a physical construct. The interior profile of each of the sculpture's massive wings is eroded away, shaping half of the outline of a Chinese temple form. When joined at the centre, the composite effect of each two-dimensional outline takes on spatial characteristics and the implied volume of an ancient temple appears. Exported abroad and

1. Fu Xiaodong, 'A "Fairytale" Becomes Reality', in Lee Ambrozy (ed.), *Ai Weiwei's Blog: Writings, Interviews, and Digital Rants, 2006–2009*, MIT Press, 2011, p.125.

2. Cited in '1=1000', interview by Nataline Colonnello, *ArtNet*, 10 August 2007, http://www.artnet.de/magazine/11000/, accessed 20 April 2012.

Wing A Composite

Wing E Composite

Wing B Composite

Wing F Composite

Wing C Composite

Wing G Composite

Wing D Composite

Wing H Composite

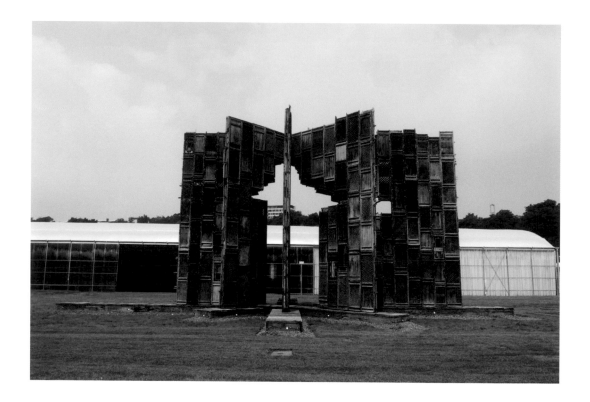

Template, 2007
documenta XII, Kassel
Wooden doors and windows
from destroyed Ming
and Qing Dynasty houses
(1368–1911)
720 x 1200 x 850 cm

Previous page:

Elevations of each layer
comprising Template's eight
fin-shaped components

3. '1=1000'.

4. Beatriz Colomina, 'I
Dreamt I Was a Wall', in
Rachel Whiteread et al.,
*Rachel Whiteread: Transient
Spaces*, Guggenheim
Museum Publications, 2001,
p.72.

represented in negative, the temple is emptied of all religious significance. Ai intends for the viewer to be surrounded by a space that is fictional, abstract and ethereal. The temple, he claims, is a contemplative space, one 'where you can think about the past and future…. The selected area – not the material temple itself – tells you that the real physical temple is not there, but constructed through the leftovers of the past.'[3]

The hollow void at the centre of the temple is reminiscent of Rachel Whiteread's investigations into cognitive relationships with positive and negative architectural space, only in reverse. Whereas Ai reveals the absent building in its negative form by constructing a framework from which to infer its absent architectural qualities, Whiteread's plaster casts of architectural interiors manifest the negative spatial qualities of soon-to-be-demolished enclosures as a physically present object. The difference lies not only in how each artist chooses to invoke the absence of the architectural edifice, but how they inscribe the trace matter of its bygone occupation. For Whiteread, 'casting a space is to reveal its secrets…. [it is] an interrogation of space: violently pulling evidence out of it, torturing it, forcing a confession'.[4] In *Template*, however, no interrogation is necessary. The outlined temple is merely an abstraction, the hypothetical shape of a rapidly diminishing social institution that the artist has employed to convey the space's functionality and its attendant values. It is the temple screens themselves that bear witness to a history of dramatic violence, carrying with them the scars of their past.

Unlike Ai, Whiteread prefers to abstain from overt political gestures, using architecture as a surrogate to reveal humanist relationships to the body, memory, and history that are contingent upon the particularities of a physical site. Implicitly critical of industrial housing production and real estate markets, the universal themes of *Template* more closely invoke the polemical verve of American artist Gordon Matta-Clark's deconstructivist incisions. In the reductivist operations he performed on suburban residences and warehouses, often cutting away large sections of floor and facade, Matta-Clark, like Whiteread, sought to reveal the unseen or subdued elements of architectural construction. This revelation, however, served as a gesture of liberation to free suburban home dwellers from the capitalist desire to compartmentalize the middle class into standardized units of habitation.[5] Matta-Clark remarked that 'by undoing a building, I open a state of enclosure which has been preconditioned not only by physical necessity but by the industry that [proliferates] suburban and urban boxes as a context for ensuring a passive isolated consumer'.[6] Rather than free architecture from its suppressed state, Ai Weiwei collects architectural pieces after they have been oppressed and discarded. In appropriating artefacts cast off by the market's creative-destructive impulse, Ai holds the fragments for reference rather than nostalgic lament. In doing so, the fragments are allowed to breathe life anew.

Though it attempted to cultivate a spiritual vitality within the sculpture's enclosed centre, *Template* remained conceptually distant from the indeterminate framework posed in Ai's other *documenta XII* submissions. The 1,001 Ming and Qing Dynasty chairs distributed about the exhibition grounds, for example, revelled in *Fairytale*'s participatory chaos. While *Template* remained in a fixed location, the chairs' mobility allowed an infinite number of positions and configurations, permitting social arrangements to fluctuate at the whims of exhibition visitors. The chairs also enabled palpable confrontations with the value assumptions ascribed to historical artefacts, allowing visitors to use the ancient chairs casually and without condition. *Template*, meanwhile, remained a large construction whose monumentality was somewhat half-hearted.

Initially erected indoors, the structure was designed only to bear its own weight – the plans did not take into account the significant lateral forces it would encounter on site. The eight fins emanating from a single node were shaped like a sideways turbine, primed to be torqued. In early June, only days after the exhibition's opening, a strong windstorm grounded

5. Lisa Dennison, 'A House Is Not a Home: The Sculpture of Rachel Whiteread', in Rachel Whiteread et al., 2001, p.36.

6. Gordon-Matta Clark, quoted in Andrew Causey. *Sculpture Since 1945*, Oxford University Press, 1998, p.200.

Installation of <u>Template</u> at *documenta XII*

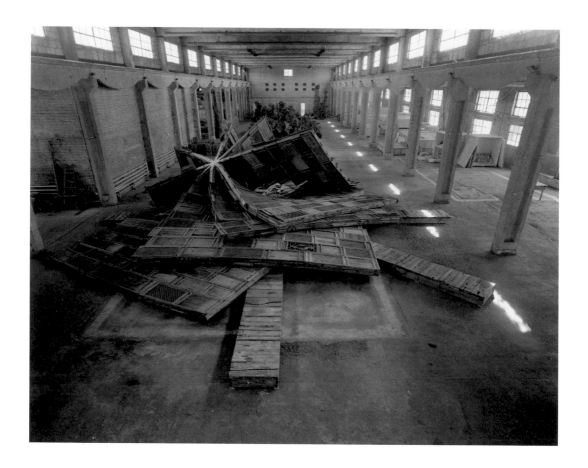

Template, 2007
Collapsed
Wooden doors and windows
from destroyed Ming
and Qing Dynasty houses
(1368–1911)
422 x 1106 x 875 cm

the installation, violently twisting the structure about its central axis. The sculpture was fragmented and splintered temple pieces took on discordant trajectories. From various angles the resultant shape resembled the levelled remains of tornado wreckage or possibly the oversized carcass of a dried octopus. Whatever the visual metaphor, allusions of destruction and entropy were easily applied to the sculpture's unexpected turn.

Surveying the wreckage, Ai gleefully declared the sculpture reborn, better still. *Template*'s fortuitous collapse had instilled the sculpture with the qualities that it had originally lacked: movement, vitality, and the unknown. Its tortured resting state provides an arresting spectacle underlined by instability. It also raises questions of authorship, authority, and value. For Ai, the downed sculpture surpasses its original in artistic quality. Taking steps to reconstruct the collapsed sculpture from a series of elevation drawings, *Template* was granted an extended life in the dismantling and reassembling of its deconstructed form. As representational tools, the drawings are serviceable yet imprecise in their description of each door and window frame's location. With each new exhibition, the sculpture is at variance with the installation before. Though slight and imperceptible, these differences ensure that no two installations are ever the same.

Inhabit

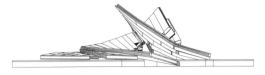

Elevation A

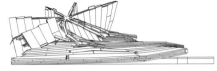

Elevation E

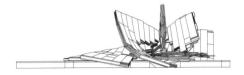

Elevation B

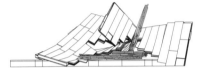

Elevation F

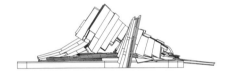

Elevation C

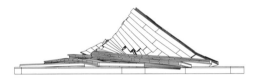

Elevation G

Elevation D

Elevation F

Above:
Elevations of the collapsed sculpture used for its reconstruction at Ai's "So Sorry" exhibition at the Haus der Kunst in 2009

Left:
Plan of collapsed <u>Template</u>

Next page:
The collapsed sculpture in Ai Weiwei's studio annex in Beijing

INSTALLATION PIECE FOR THE VENICE BIENNALE

VENICE BEIJING LONDON (EXCERPT)
Charles Merewether

In the work created by Herzog & de Meuron and Ai Weiwei entitled *Installation Piece for the Venice Biennale* (2008), we can see the way in which the concept of the architectural begins to inform not simply the shaping of the installation but, like *Through* (2008), is informed by the sense of its occupancy, of its belonging to those who enter its midst. This sense of the physicality of presence of the viewer is a critical shift in Weiwei's work over the past several years whereupon the sculptural remains of central importance but its resolution is no longer purely dictated in terms of the visual. Occupancy becomes critical to its being. Structurally, the form is an architectural frame if not a palimpsest of a building, but is to be seen inside another space – inside out, one might say. Through the occupancy of another space, it transforms the existing space. What is outside has been interpreted by someone from outside already, as it were, and brought inside into a space reconfigured as a modernist cube.

In its initial manifestation in the artist's studio, the work invoked Venice in its reference to the arching bridges across the canals and long narrow passages of pathways echoed in the shooting forms of bamboo arching across the space. The work appears grounded in a play of reference, echoing the winding long canals and streets that pattern the city of Venice whilst equally recalling a disappearing China. In the Venice elaboration of the concept, however, the project is pared back to its most elemental forms – no bridge and nothing that could be easily associated with Venice or so directly to China itself as metaphor. A set of rhythmically interlacing bamboo poles pass through, and belong as a structural element of, the bamboo-made chairs. Acting as joining points, they become a syntactical link or pause in the multiplicity of lines or pathways. Leading in different directions, they offer any number of options or directions to be taken. It is precisely in this sense of infinite extension that the work supersedes its figurative references, becoming closer to the figural or an abstract form that celebrates the play of abstraction across the field.

During this time Weiwei also produced a new work for his inaugural London exhibition at Albion. The work is composed of twelve sets of bamboo poles that are fixed at each end by twenty-four blue and/or white vases. They occupy the space by crossing one another vertically and horizontally. In one respect they recall the bamboo scaffolding used on building sites that creates a temporary structure wrapping around the building that will be constructed from within. But here, in a manner not dissimilar to the Venice work, the process itself appears inverted, whereby an already existing structure frames the bamboo structure. Moreover, anchored at each end by a porcelain vase, the long bamboo poles appear as supports, as if serving as a form of infrastructure. The use of porcelain vases recalls earlier work by Weiwei but here, for the first time, they are placed in conjunction with bamboo. The orchestration of an association between the most basic and widely applied material with the most refined 'china' in China recalls their common point of origin. The work is the production of space, a structured environment, whether it is experienced as relatively autonomous or embedded in the fabric of a city or village. Through the interaction of materials, Weiwei builds another space – the space of China now occupying the West. Technologies become critical here as the axis around which social relations between people become a critical form of communicative exchange.

While each of the Venice and London works follow in the trajectory of Weiwei's oeuvre, there remains nonetheless a formally shared authorship

Installation Piece for the Venice Biennale, 2008
Bamboo
600 x 1000 x 700 cm

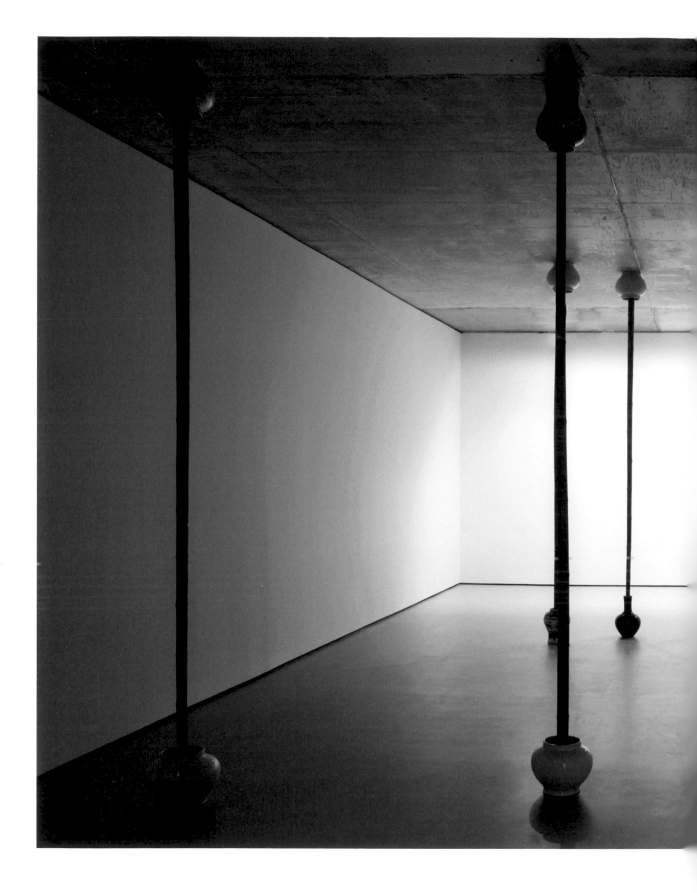

Inhabit

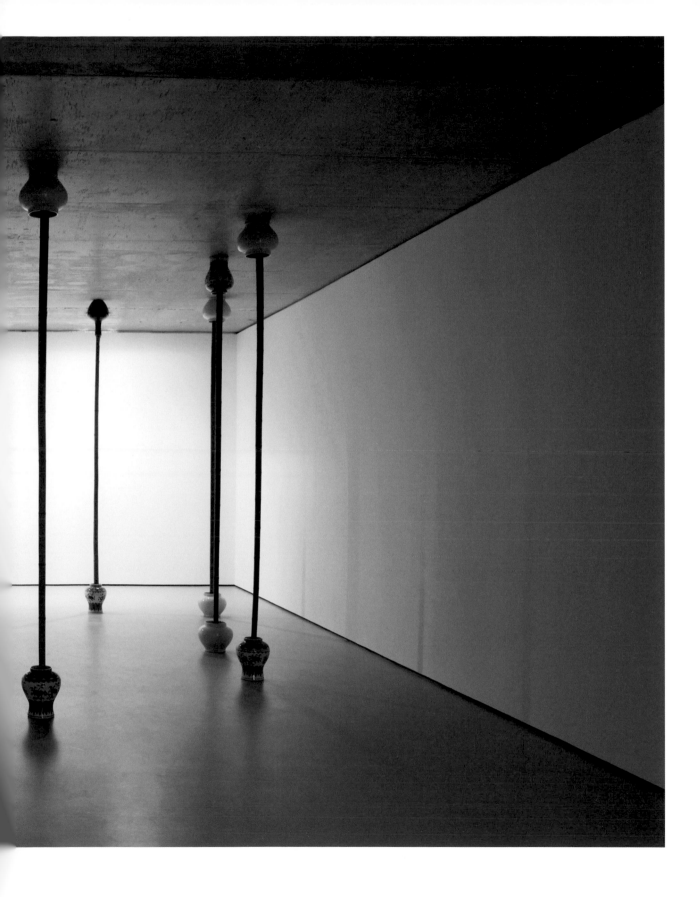

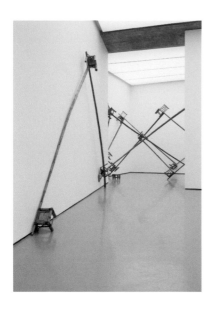

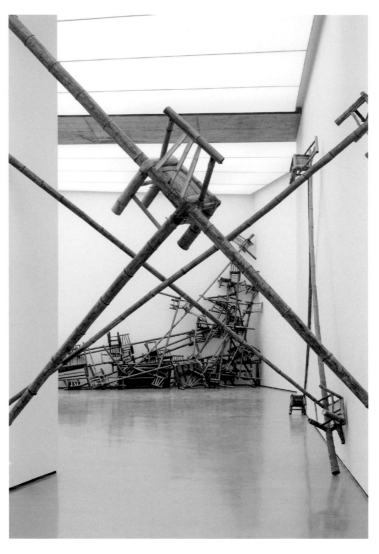

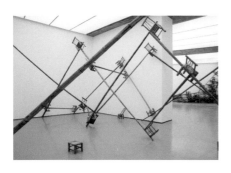

A version of <u>Installation Piece for the Venice Biennale</u> on exhibition in 2008 at the Albion Gallery in London

Previous page:
<u>Bamboo with Porcelain</u>, 2008
Porcelain, bamboo
White: 30 x 35 x 35 cm
Blue: 42 x 25 x 25 cm
Blue/white: 35 x 26 x 26 cm

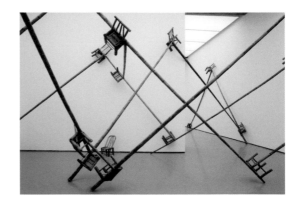

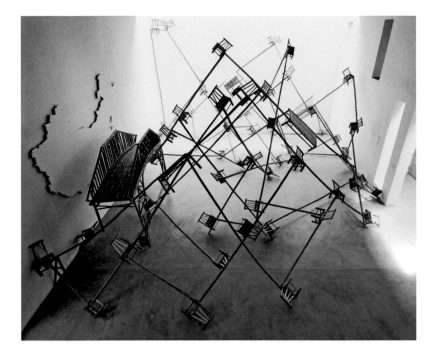

An early iteration of Installation Piece for the Venice Biennale at the China Art Archives and Warehouse in Caochangdi, Beijing

Next page:
Detail of Installation Piece for the Venice Biennale at the Albion Gallery, London, in 2008

between the architects and artist. The importance of this is to recognize the significance given to the exchange of ideas and the conceptual structure of the Olympic stadium and the two installation works. On the one hand, the stadium shows clear evidence of Weiwei's role in informing its design if one recognizes the increasing attention his recent work has given to the dynamism of form, as is evident in *Through* (2008) or more especially in the *Fountain of Light* (2007) which, paying homage to Tatlin's *Monument to the Third International*, is composed of a spiral floating chandelier with vertical pillars. On the other hand, the installations for Venice and London show the influence of the architects on Weiwei, in the reverse direction. This is most clearly evident in the formal dimension of their respective elaborations. Hence, the generative movement of each piece is to be found within its own axis and not in any point that is external to its form. As with the Stadium, the ground is nothing more than a base from which a dynamism is produced by not simply the upward movement of its diagonal lines but also by their constant reiteration as they redefine the lateral movement of that which it both forms and encloses. In the Venice and London pieces, the strong axis and points of juncture are both a point of orientation and a reiteration of a constant movement of lines.

This excerpt is from the essay, 'Venice Beijing London', which originally appeared in *Ai Weiwei: Beijing, Venice, London, Herzog & de Meuron*, published by Walther Konig in 2009.

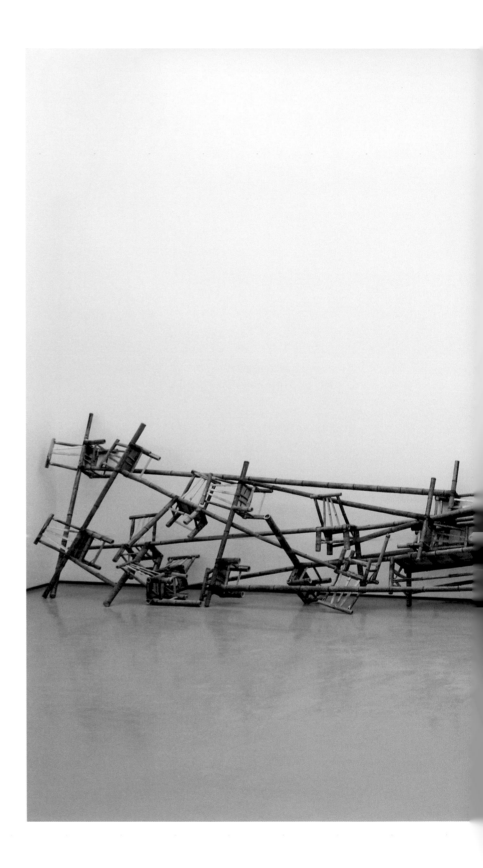

Inhabit

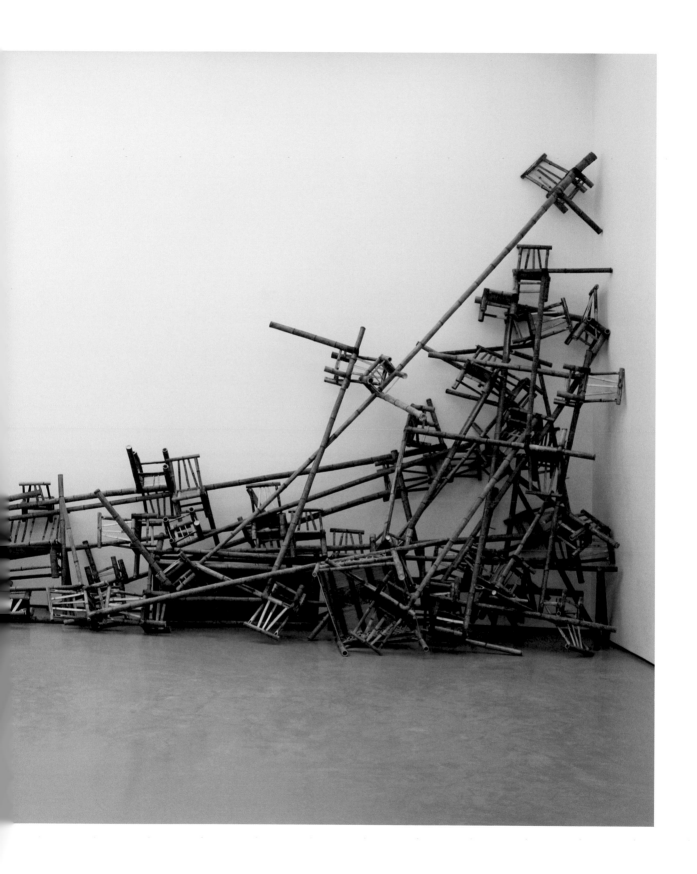

Installation Piece for the Venice Biennale

CHANDELIERS

A BRIEF HISTORY OF LIGHT (EXCERPT)
Karen Smith

Bricks and Bulb, 1984
Bricks, bulb
36 x 28 x 6 cm

Opposite page:
Chandelier, 2002
Glass crystals, lights, metal
and scaffoldings
530 x 400 cm
Guangzhou Triennale

Ai Weiwei's first experiment with light was a simple juxtaposition of a light bulb and two bricks, created in New York in 1984. In many ways, the use of light, or a light bulb, in this experimental assemblage was incidental. This was the period in which Ai Weiwei was discovering minimalism, and the work is the result of an intellectual curiosity exploring a thought-through form — pivoted on basic, utilitarian readymade objects. Interestingly, the bricks chosen for the piece were coarse grey breeze blocks — the grey colour similar to the tone and the proportions similar to the geometry that would be invoked in the architectural projects many years later. Indicating Ai Weiwei's interest in the aesthetic issues that Donald Judd obsessed over, the light bulb expands upon the appropriation of neon and fluorescent tubular strips that was found in the experimental works of the minimalists dating back to the 1960s. The impulse here focused primarily on a comparative of geometrical forms: the straight lines and neat angles of the solid rectangular bricks, and the soft, vibrating edges of the bulb. That accomplished, Ai Weiwei moved on, continuing to develop the line of thought and enquiry centred on minimal materials, evidenced in subsequent works like *Safe Sex* (1986), as well as the furniture pieces he produced after his return to China, and not least his defacing of various Han Dynasty pots with glorious new coats of modern paint.

The next physical light piece was produced in 2000, although one could argue that the series of photographs of an eclipse in progress which Ai Weiwei captured in 1998 are an extension of his investigation into the effects of light (and its absence) upon human emotion. Here, the image of an arresting natural phenomenon further echoes the notion of things hidden or concealed, injected into the *National Stadium Photographs*. The 2000 work can also be interpreted as more of a pure conceptual expression than an interest in the effects of light as art, and how it affects space and form, per se. This piece comprised the sculpting of neon strips to spell out the title of the exhibition *Fuck Off*, presented in Shanghai. Today, a similar piece greets all visitors to Ai

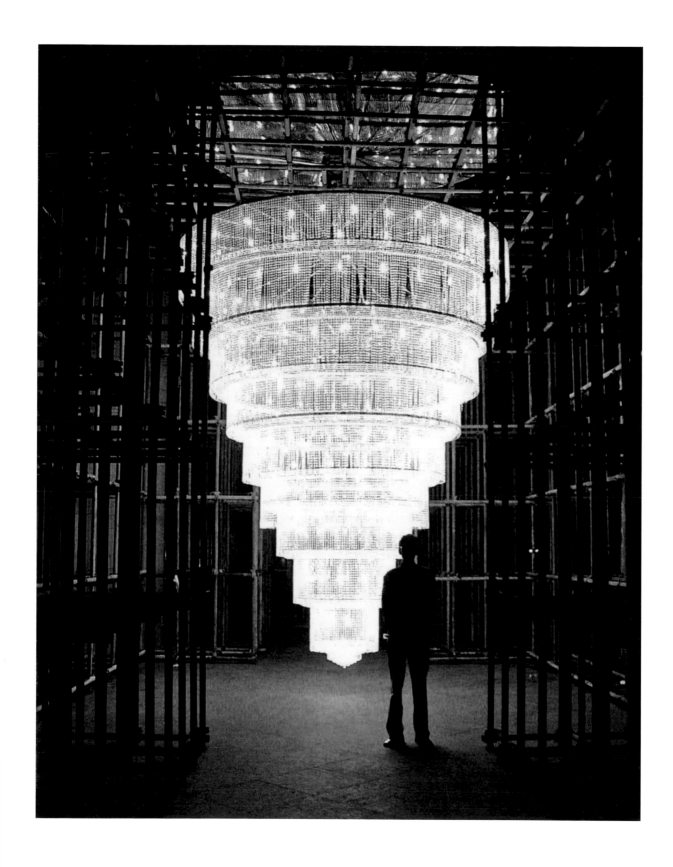

Boomerang, 2006
Glass lustres, plated steel, electrical
cables, incandescent lamps
700 x 860 x 290 cm
Asia Pacific Triennial of Contemporary Art
Queensland Art Gallery, Queensland,
Australia

Opposite page:
Boomerang, 2006
On exhibition at the Asia Pacific Triennial
of Contemporary Art

of wealth and taste: an object invested with magnificence, and all the decadent inclinations of the bourgeoisie. By analogy, then, where a chandelier is read as the embodiment of social status, it is not unreasonable to extrapolate the image of *Chandelier*, its form caged within a mass of scaffolding, as referencing those victims of the revolution – in particular those former landlords and capitalists – who were hung by the revolutionaries, and later the masses, whether at struggle sessions or the people's trials.

Mindful of each site in which he is invited to present a work, in 2006 Ai Weiwei designed his next monumental light for the Fifth Asia Pacific Triennial of Contemporary Art (APT), in Brisbane, Australia. This took the traditional chandelier into a new mode of expression, and created a site-specific piece perfectly suited to its setting. The descending scale of concentric rings was reoriented to approximate the oblique angled curve of a boomerang: a succinct bending of place and the form into a pertinent concept that also remained true to his practice and ethos. The work was commissioned for a new building that extended the site for the APT, effectively creating a 'doubling' of the original space, as an extension of the original site. This aspect was alluded to in the reflection of the *Boomerang* in the pool of water above which it was suspended. A third element was the magnitude of the funds spent on the building's structure, which again suggested a level of grandeur that begged a chandelier: the icing on the cake. As one commentator noted: 'The new Cathay, the western fantasy of the exotic East, is dazzlingly embodied in Ai Weiwei's *Boomerang* … The sumptuous tackiness and sheer size of this object are beyond the wildest dreams of Australian hotels and casinos.' Thus, *Boomerang* touched on a nest of controversies surrounding art and culture in that place at that moment. The influence of architecture was perhaps most pronounced in the next light project, which was produced for the exhibition *The Real Thing* at Tate Liverpool in the UK. The process of working through the problems that arose from the irregular structure of the Olympic stadium in Beijing, with creative engineers from the distinguished firm of Ove Arup, alerted Ai Weiwei to new possibilities of working with forms and structures that were previously considered impractical, if not impossible. In many ways, the stadium contained some structural similarities to the final form of *Fountain of Light*, itself based on Russian constructivist Vladimir Tatlin's *Monument to the Third International*, conceived in 1919. Like *Monument*, it featured a core element around which a secondary steel structure was hung or interwoven.

In invoking this form, a form which Tatlin designed to embody the grandeur of the new socialist ideology, Ai Weiwei took another socialist idea to task with a logic that is hard not to fault against the evidence of the spiral upon which the work and his idea pivots, and the hardship and regression enacted upon both Soviet and Chinese societies in the second half of the twentieth century, prior to their 'liberation' by new socialist-styled capitalism. The spiral shape that is the essence of Tatlin's *Monument* is a fundamental form in nature, but one rarely seen in architecture. For Ai Weiwei the

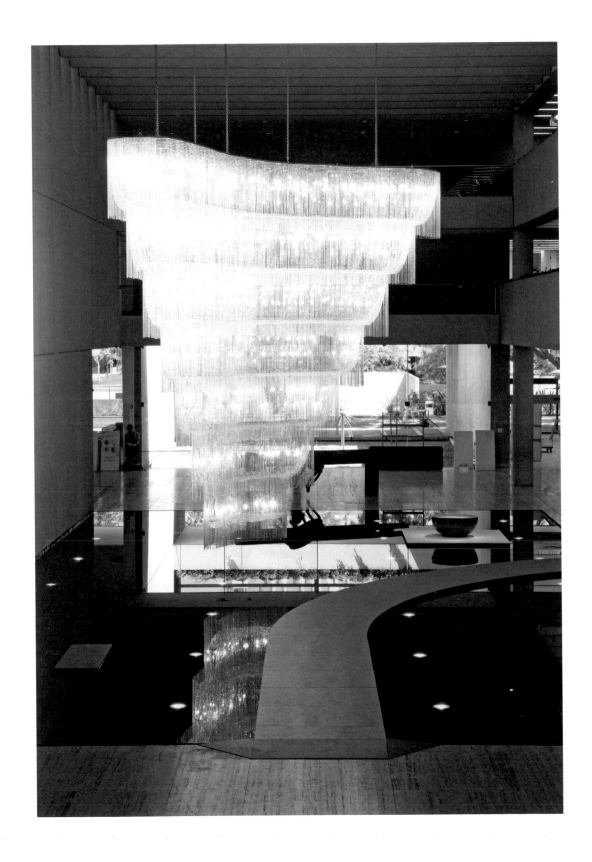

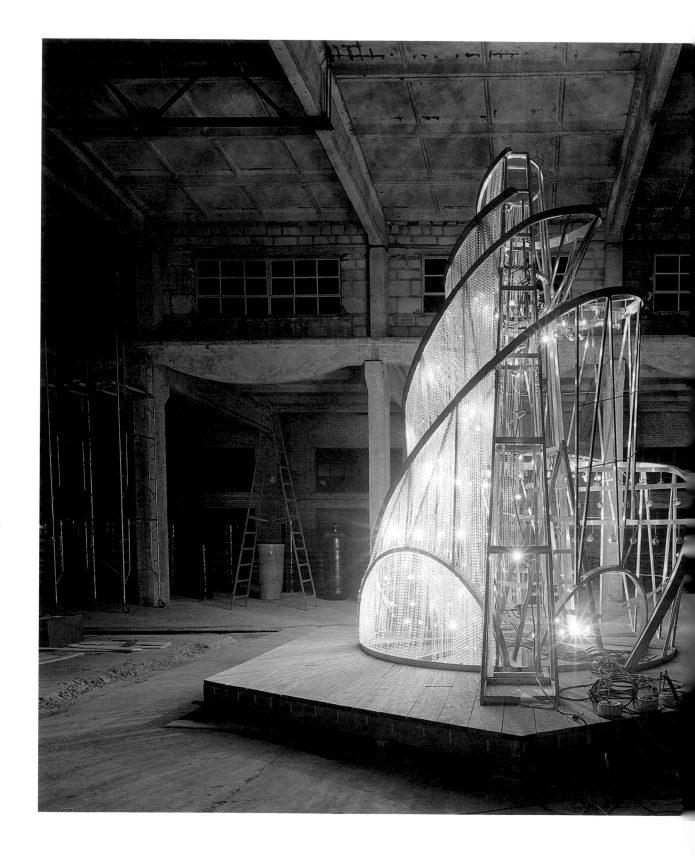

Inhabit

Fountain of Light, 2007
Steel and glass crystals
on a wooden base
700 x 529 x 400 cm
Tate Liverpool

Below:
Making of Fountain of Light

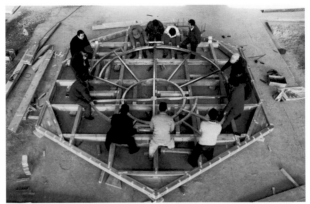

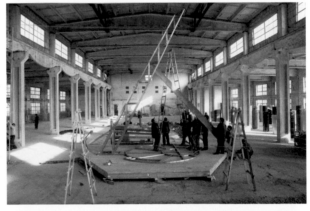

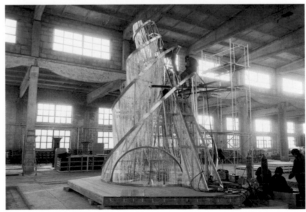

Model of <u>Descending Light</u>, 2007
Wire
20 x 33 x 20 cm

symbolism is perfect, for 'it ultimately goes nowhere'. If built, one would ascend the *Monument* moving in ever smaller concentric circles until reaching a finite cul de sac: a sentiment mirrored in a Chinese proverb that describes digging yourself into a hole as 'burrowing up into a bull's horn'. In Ai Weiwei's view, 'The form of the *Monument* defeats its symbolism: it becomes a metaphor for the way in which power ultimately collapses in upon itself. The rational mind is always in conflict with its romantic sentiments.'

Descending Light is the fourth work in what is now a grand series set in motion by *Chandelier*. A unique aspect of *Descending Light*, and indeed of the companion piece *Traveling Light*, is that it is not suspended in any conventional way: the work 'sits' on the floor, in a position that suggests it has fallen from on high, causing its natural flow to be distorted as it is forced to slump over itself. Unique, too, is the rich ruby red colour of the crystal beads that are strung across the parallel outer rims of the concentric rings. There are 60,000 of these crystals in total – an enormous number to attach by hand, which is what this work, in common with those that preceded it, required. Red has always been a colour of significance in China. Traditionally, it is the colour of celebration. It is also the tone of communism and Cultural Revolution fever; the colour of the national flag, which represents the blood spilled by martyrs to the Republic, and the triumph of communism over the former imperial-feudal system. That doesn't make red any less popular in China today, or any less symbolic in the eyes of the people. In fact, it merely adds to the complex layers of meaning associated with the colour. As with most things in China, nothing is ever black and white, so red can allude as much to pain and sorrow as to happiness and not suffer for it. It is particularly powerful here in *Descending Light*, firstly for the sheer magic of the visual allure it imparts to this magnificent ensemble, and secondly because colour is not normally a feature of Ai Weiwei's work, the only other notable exception being the modern housepaint hues of the pigments applied to the Neolithic pots. *Descending Light* employs this tone of red for different reasons; the allusion to precious stones, rubies, makes subtle insinuations about monetary value, rarity, and once again the opulence associated with the lifestyles of a wealthy elite. The question *Descending Light* seems to ask is exactly what these things represent in China, as well as in the modern world today.

Where *Descending Light* carries a distinct undertone of power, the second piece, *Traveling Light*, represents an extension of the interest in structure and juxtaposition of materials that continues to draw Ai Weiwei to architecture. *Traveling Light* is not a political metaphor for excesses of the bourgeoisie, or of the materialist desires and consumption power of China today. It is primarily about form, via an unusual juxtaposition of materials and textures that achieves something far beyond the function for which each of the elements was designed. At its core, however, is a reference to the past, and the impact of the present upon it. In form, *Traveling Light* centres on the deconstruction of a core element, reorienting a former function and adding

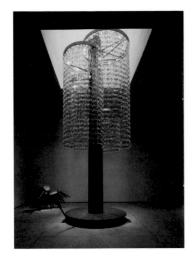
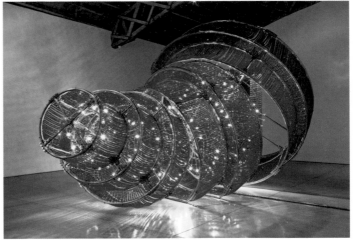

new features to astonishing new effect. Similar to *Table and Beam*, the main component here is a structural column salvaged from a Ming Dynasty temple, dating to approximately the fifteenth century. Its full height is 477 centimetres. For the convenience of moving it around and maintaining its stability, Ai Weiwei placed the work on a moveable trolley. This alone makes for a curious union of vertical and horizontal energies. The mortises approximately a third of the way from the top of the column, which once accommodated the tenons of the ceiling beams, now sprout arcs of steel, a distinctly contemporary substance by comparison with the age of this piece of wood and the long history of wood as a material in the hands of man. Similar to the alteration of the solid column that Ai Weiwei had also used in a number of works in the *Map of China* series, the beam is also partially hollowed out, this time to accommodate the light source that brings the piece to life. The effect of the work is at once modern – designed to make a statement about lighting and form – and at the same time has a rustic quality, entirely due to the presence of the column, that suggests an ancient example of totem art. Coming after *Boomerang*, viewers might wonder if Ai Weiwei was conscious of a similar melding of place and culture in a subliminal reference to American Indian culture, and by analogy its position and status relative to modern American society.

Left:
Traveling Light, 2007
Tieli wood, glass crystals,
lights and metal
477 x 224 x 177 cm
Mary Boone Gallery, New York

Right and next page:
Descending Light, 2007
Metal, glass crystals, lights
400 x 663 x 461 cm
Mary Boone Gallery, New York

This excerpt from the essay 'A Brief History of Light' originally appeared in the exhibition catalogue for *Illuminations*, a gallery show at the Mary Boone Gallery in New York in 2008.

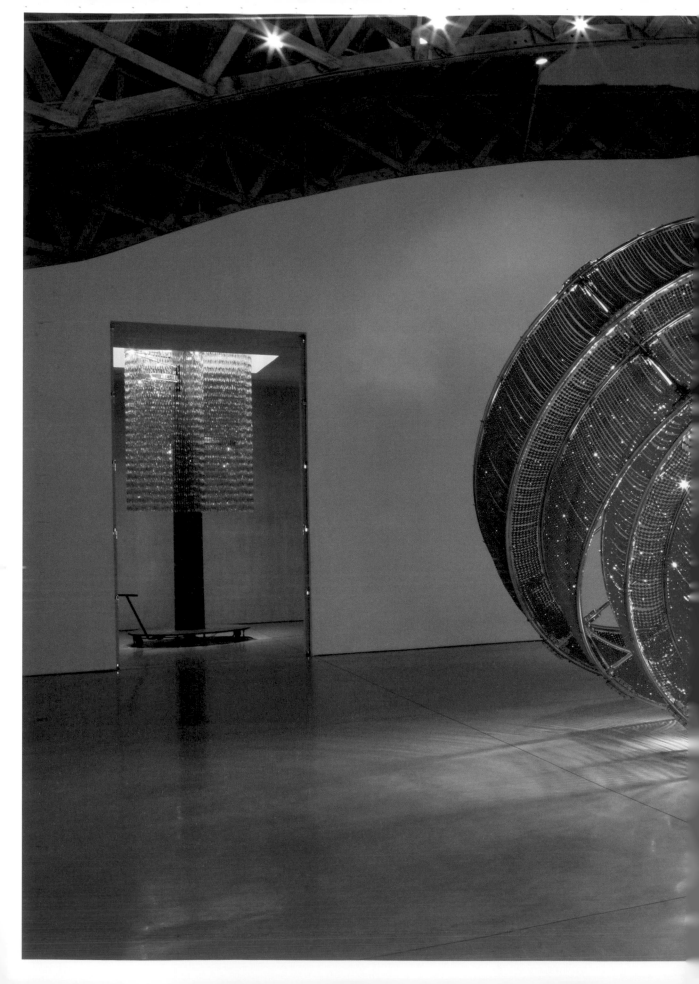

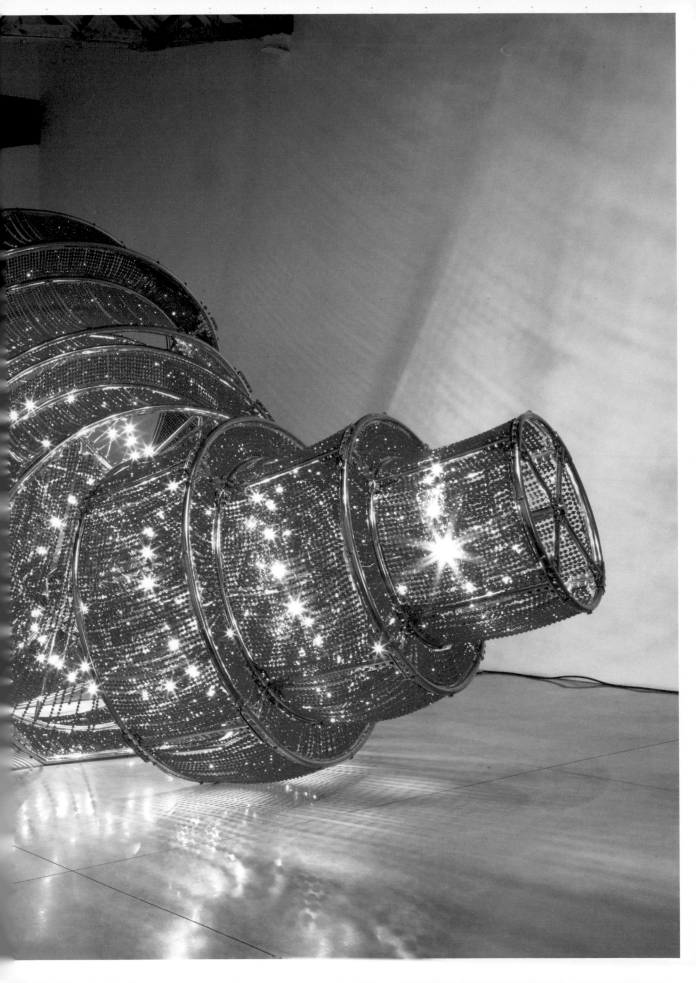

Inhabit

Mies van der Rohe Pavilion
Barcelona, Spain
2009

WITH MILK ... FIND SOMETHING EVERYBODY CAN USE

CHANGE YOU CAN SEE
Laurent Gutierrez and Valérie Portefaix

*Once you have put Ripolin on your walls you will be a master of yourself. And
you will want to be precise, to be accurate, to think clearly.*

Le Corbusier

In 1925, architect Le Corbusier published an article in his journal *L'Esprit
Nouveau*, 'A Coat of Whitewash, The Law of Ripolin',[1] where he specifically
referred to the principle of applying white coating as a 'moral act'. He pro-
posed to cover every surface with a new layer of white paint that would
bring – according to the architect – sincerity, equilibrium, truthfulness, har-
mony, and happiness. This strategy of replacement or permutation was part
of the modernist 'tabula rasa' and included in the logic of the erasure to be-
gin a new project on a new basis.

In 1920, Marcel Duchamp and Man Ray had made another proposition
embracing modernity. In the photograph entitled *Dust Breeding*, Man Ray
focused on the dust accumulated on Duchamp's *The Large Glass*, changing
the perspective of the artwork by imposing another layer while keeping the
original untouched.[2] The new perspective adopted on the spot by Duchamp
perfectly corresponds to the logic of *detournement*, or substitution, as a
natural part of change.[3]

In 2009, artist/architect Ai Weiwei's project *With Milk ... find some-
thing everybody can use*, for Mies van der Rohe's Barcelona Pavilion, can be
analysed as in continuity with Le Corbusier's proposal as well as Duchamp's
and Ray's, with the similar intention of changing the rules. In the first place,
Ai Weiwei started to refer clearly to art production as 'a moral act'. This
statement could easily find an echo in his ongoing commitment to involving
art with social justice. *With Milk ...*, then, is also in line with a series of works
the artist already produced around the idea of *detournement* – a principle

1. Le Corbusier, 'A Coat of
Whitewash, The Law of Ripolin',
L'Esprit Nouveau Articles,
Architectural Press, 1988.

2. *The Large Glass* is one
of Marcel Duchamp's
masterpieces produced
between 1915 and 1923.

3. *Detournement* is a
tactic development by the
Situationist International
group (1957–1972).

4. Extract from Ai Weiwei's
artist statement.

of altering the meaning of an original medium in order to change how we see
and cope with our environment.

> My intervention explores the metabolism of a living machine … In fact,
> the building is not static: the content of the two pools is replaced
> all the time, unnoticed to visitors … Upkeeping the condition of milk
> and coffee is the same as preserving a body, a demanding effort
> against light, air, warmth … In total, the two pools will be filled with
> sixty-five tons of milk and fifteen tons of coffee, which will be kept
> in the open air.[4]

The artist statement by Ai Weiwei for his recent intervention at the Barcelo-
na Pavilion is deliberately unspecific. Indeed, when asked about the reason for
filling up the two existing pools of the Pavilion – he replaced the water in the
two pools, one exterior and the other interior, with milk and coffee, respec-
tively – the artist replied by referring to it as an instrument to reveal change.

Change, or the possibility of change, is at the centre of Ai Weiwei's pro-
duction, both artistic and architectural. In this context, one cannot ignore the
fact that the artist can also work as an architect, curator, cultural and social
commentator and activist. Even though he never officially studied architecture
– nor art in the academic sense – Ai has been officially recognized in China as
being among the most inspiring architects of the last decade. Through sev-
eral small architectural projects, he has developed his own language that to
some degree resembles aspects of Mies van der Rohe's project for the Court
House (1934–1935). The main concept was to design a settlement of economi-
cal houses with individual gardens and courts on small plots. Ai Weiwei started
to apply this strategy in the district of Caochangdi, where he built a compound
of houses and artists' studios, including his own studio named FAKE. As uni-
formly regular as each site permitted, the small buildings vary in size, number
of rooms and distance from the street. In both cases, his peculiar usage of
brick for the buildings' enclosures provides the occupant with the potential to
play freely within, allowing and encouraging change to take place.

Right and previous pages:
With Milk ... find something
everybody can use, 2009
Pool with 65 tons of milk,
pool with 15 tons of coffee
Mies van der Rohe Pavilion,
Barcelona, Spain

Opposite page:
Ai Weiwei in front of the
forecourt pool filled
With Milk ...

Next page:
Preparation of the
forecourt at the Barcelona
Pavilion for the installation
of With Milk ...

Inhabit

Inhabit

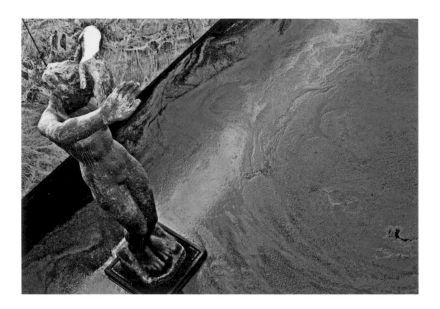

With Milk ... find something
everybody can use, 2009
Inner court pool with 15 tons
of coffee

5. Including: politics,
capitalism, technology,
religion.

6. Ai Weiwei, 'Changing
Perspective: Ai Weiwei with
Charles Merewether', in *Ai
Weiwei 1993–2003*, Timezone
8, 2003, p.32.

Changing the perspective of the original architecture has been a constant obsession in Weiwei's work. In the *Study of Perspective* series, the logic is to replace local architectural symbols with an even more purely symbolic figure – the middle finger pointing to the building or scene. Pointing at Tiananmen Square, Hong Kong's skyline, San Marco, the Eiffel Tower or the White House, his middle finger's gesture becomes symbolic evidence of a personal attitude towards official powers and institutional authority.[5]

By studying a simple decision we can get mixed results. With *Whitewash* (1993–2000) I painted a group of Neolithic pieces with industrial paint so that the original texture was covered up by a meaningless colour. To see the change is significant to me. At the same time, even though it becomes suddenly hard to judge, the value of the original pieces remains, but under the white piece.[6]

While the original characteristic of the Pavilion remains in the opposition and dialogue between sculpture and architecture (structure), Ai Weiwei begins to transform this central opposition into that of solid and liquid. All we see when visiting the Pavilion is a solid structure that articulates various fluid sequences between the interior and the exterior entrance and patio. In fact, the visitor pays very little attention to the presence of the two pools that occupy almost a third of the entire surface of the Pavilion. They serve as a horizontal counterpart to the imposing materiality of the marble walls, continuing them through the reflection in the water, with the pools perhaps seen as mirror images of the architecture. They serve to reflect both the movement of the visitors and the very static Georg Kolbe sculpture entitled *Morning*. Is the coffee a direct reference

to this beautiful gesture of a stretching body? Good morning, wake up; this is the beginning of a brand new day! If the answer is 'yes', then the change could be understood as a rectification of van der Rohe's original intention to place Kolbe's other sculpture of *Night* in the outdoor pool. Intentionally or not, the act of linking *Morning* with coffee and *Night* with milk establishes a clear understanding of architecture as a part of the solid and sculpture linked to the liquid. In this way, change is understood as the logic of re-establishing a possible original.

In this proposal, Ai Weiwei goes beyond the *readymade* by proposing a *readythere*, focusing more on the time and context of the artwork than on its specific materiality being displaced or concealed. Intervention in the monument questions its weight as a key reference not only of van der Rohe's work but also of twentieth century architecture. *With Milk* ... infiltrates time and, to a certain point, restores the temporary condition of the Barcelona Pavilion. When something is replaced – a surface, a ground – a condition is revealed that was previously unseen by the viewer. When water is replaced by milk and coffee, the new liquid reveals another experience – not only visual but also sensorial with its smell and potential taste. The neutrality of water as the most generic material, and sometimes free (depending on the weather), synchronizes with a certain inertia found in the Pavilion. The two pools are now at the centre of the plan. The liquid surface has lost its reflective power, now absorbing the surrounding architecture.

With Milk ... echoes Ai's *Soft Ground* installed in the Haus der Kunst in Munich. By placing a comfortable rug on top of the cold stone tiles, imitating the original colour tone and pattern of the stone, he created a disruption in the linear history of the building. The new layer of surface is also soundproof; therefore, history becomes a written element to be read as a map of traces left by events and people who have occupied the floor since 1937.

Visitors are always an active part of an installation. Although they are subjected to a set of behaviour patterns dictated by the exhibition system, their position leaves a substantial trace in this system. This was one of the starting points of Ai Weiwei's social-conceptual project *Fairytale* for *documenta XII*, in Kassel, Germany. 1,001 participants from various regions and backgrounds were invited for a week to the world's most prestigious exhibitions. Beyond the complex selection process, *Fairytale* extended the ambition of the exhibition to remote Chinese regions, creating a set of difficult bureaucratic procedures and time constraints as obstacles to meeting the opening date. The point was:

> How to make everybody feel that all this is made for him or her, for each individual, and to enable the participants to have a very detailed and carefully planned trip that is free. How to make sure that they have the absolutely correct conditions for travelling and being in this *documenta* as viewers and at the same time as part of the work. I see the whole process as the work itself. I see what kind of hopes, what

With Milk ... find something everybody can use, 2009
The base of Georg Kolbe's *Morning* in the inner pool filled with 15 tons of coffee

kind of worries, what kind of frustrations … and waiting, and antici-
pating … then the dream, then imagination, then … maybe surprise.[7]

The experience of 'being part of' was central to *Fairytale*. The 1,001 visitors
introduced a new form of migration – not for production (migrant worker) or
consumption (tourism), but cultural exchange. Visitors become the contempo-
rary pilgrims of the show.

The individual experience, to see and to be seen within a given struc-
ture, is the very principle of the Barcelona Pavilion, where visitors are re-
flected in the dark glass with the sky and the trees appearing behind them.
Blending the interior to the exterior, the glass architecture became the apex
of twentieth-century modern architecture. The vertical plans, precisely dis-
secting space with its infinity mirror effect, continue in the horizontal liquid
surface of the two pools. With Ai Weiwei's intervention, the plan is back. The
new layer of milk absorbs the static view of architecture. The logic is abso-
lutely efficient. The milk pool has as its virtue the ability to neutralize the re-
flective power of the vertical plan while the coffee pool plunges the visitor
into an abyssal darkness. The black coffee absorbs the black marble, while the
white milk denies the architecture.

Throughout his artistic development, Ai Weiwei constantly refers to
Marcel Duchamp as a reference and a source of inspiration – for example,
his early work in New York or the frequent references to Duchamp in the
Black Cover Book and *Grey Cover Book*.[8] Most of his artistic production can
be traced back to this constructed dialogue with the master. Among those
strategies of the *detournement*, as defined by Situationist International, is
one of the most important influences on Ai Weiwei.

The idea of *detournement* is used not only to recreate another mean-
ing through the imposition of a new one, but also to reveal what might have
been missing from the beginning. The contrast reference to an ideal ori-
gin of things is present in many of Ai Weiwei's projects and echoed in the
name of his office: FAKE. The proposal of origin and authenticity is then in-
tegrated into the position adopted by the artist, essentially activated by a
constructed memory. In other words, all Ai Weiwei's work on archaeological
stone tools, vases, and wooden furniture deploys the logic of the *detourne-
ment* in order to reconstruct an artificial mythology.

Duchamp's *LHOOQ* readymade from 1919 and 1965's *LHOOQ Shaved*,
where the artist added a little moustache to a postcard of the *Mona Lisa*,
are some of the best examples of this strategy. As a coincidence, this piece
by Duchamp is echoed by Ai in the Mies van der Rohe Pavilion where water,
HOO–H2O, is not only at the centre of the artistic project, but also in the way
he proposes another condition that will forever change the original's intent.
Who has seen Duchamp's *Mona Lisa* with a moustache without thinking of the
shaving process that might return Da Vinci's original? Those who have seen
the pools filled with milk and coffee will never see the Mies van der Rohe mas-
terpiece without bearing in mind the substance missing from the Pavilion: life.

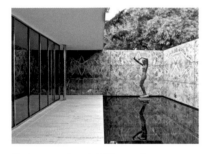

The inner court pool at Mies van der
Rohe's Barcelona Pavilion

7. Ai Weiwei, interview by
Nataline Colonnello, *ArtZine*,
2008.

8. Ai Weiwei, *Black Cover
Book*, published in 1994,
White Cover Book, published
in 1995, *Grey Cover
Book*, published in 1997 –
everything starts and ends
with Duchamp.

9. Grey refers here to
architecture without life.

10. A reference to the
melamine found in many
dairy products sold in China.

With Milk … makes visible the very nature of the Mies van der Rohe Pavilion and the lack of the human dimension behind much of modern architecture. The black of the coffee and the white of the milk reintroduce life into the grey architecture.[9] It can also be seen as conceptually connected with Ai's recent research project that tried to identify all the schoolchildren who disappeared after the 2008 Sichuan earthquake. With this investigation, he began seriously to engage with social justice in his work, creating irritation and animosity within the Chinese government. The grey in this case is to be found in the dust that covers both the thousands of missing children as well as the information held back by the Chinese government.

With Milk … endows the water with materiality, changing the liquid's original condition to a solid substance. Therefore, it makes this liquid not only more visible but also more stable and safe, with the added ambiguity of making it programmatically unstable. This instability, or simply, 'upkeeping the condition of milk and coffee', might also refer to the recent contaminated milk scandal experienced by the people of China in 2009.[10] As time passes, with the help of the wind blowing the scent of coffee into the air, dust and dancing leaves from the surrounding trees accumulate on to the milk, creating strange patterns and uncertainty, thus giving a new obscure dimension to the pools. That is until someone comes and cleans it again … change that resonates like déjà-vu. This is a condition of history, conflicting efforts to stabilize, while everything revels in that very instability. Paradoxically, Ai Weiwei is constantly searching for ways to create and celebrate this instability – to make it visible – and then to produce means to control it. With this last project, his answer is following up the linear process of life until a new event comes and spoils it again.

The primary materials of Mies van der Rohe's Barcelona Pavilion: travertine, tinian, verd-antique and onyx dorée

The essay 'Change You Can See' originally appeared in *With Milk … find something everybody can use*, published by Actar in 2010.

Inner court pool with 15 tons of coffee

Next page:
With Milk … in the forecourt pool at the Barcelona Pavilion

SUNFLOWER SEEDS

EVERYTHING IS NECESSARY
Brendan McGetrick

I arrive at Ai Weiwei's studio on a weekday in June. It's a warm, uncharacteristically clear morning in Beijing and I find Ai sitting outside in a T-shirt and shorts with three young assistants. We exchange pleasantries and then the talk turns to business. I've been invited to write about a new work that Ai is developing. I know where it will show and when the show opens, but very little else.

What little I do know is based on a chance conversation I had weeks earlier with Inserk Yang, one of Ai's collaborators. He'd spoken about the work in impressive, unclear terms. It was a very, very big production, he'd said. That didn't surprise me. Ai has done some big projects in the past, and the venue seemed to demand a tribute of scale. When I asked what the content was, Inserk was cagey, but he gave a clue. 'It's not something,' he said, 'it's many things.'

Ai is more direct. Ceramic sunflower seeds, he says, 100 million of them, each handcrafted and spread across the floor of Tate's Turbine Hall like stones in a Zen garden. I'm not sure how to respond. Sunflower seeds. I search my thoughts for some personal associations and come up empty. But I know enough about Ai's work to see where they fit in. For years, he'd been rendering commonplace objects in precious materials – coal hives in bronze, junk doors in marble, and watermelons, backscratchers and even urine in porcelain. The sunflower seed is next in line. There must be a connection.

'I think it's interesting that you're not an art writer,' the artist says, 'you can talk about other things.' Like a commissioning editor, Ai begins offering possible angles: 'The social involvement is important,' he comments. 'I like that the project involves so many people.' Then, 'It's made in a very traditional location.' Finally, 'Each piece seems identical, but they're all different.'

We head inside to see a mock-up of the installation. I'm not sure what to expect. What I find is hard to describe. The floor is covered in an unidentifiable, granulated grey matter, about 10 cm thick. I try to place its look, but

Inhabit

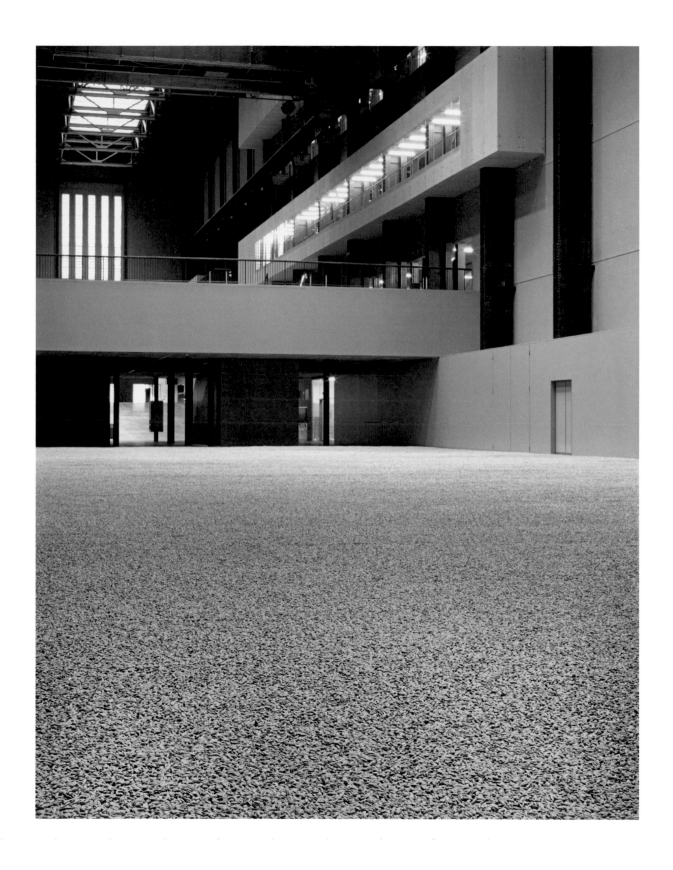

Detail of <u>Sunflower Seeds</u>,
2010
Porcelain, paint

Previous page:
<u>Sunflower Seeds</u>, 2010
Porcelain, paint
100 million porcelain
sunflower seeds at Turbine
Hall, Tate Modern, London

again draw a blank. It doesn't look like seed to me. From a distance, it appears totally generic, a kind of placeholder substance, something you might use to pave a driveway or line a coat. We don't spend much time in the studio. After briefly stomping on the seeds, I accept the assignment and say goodbye.

I return to the studio a couple of days later. It's early morning and the place is mostly deserted, but Ai has been up for hours already. I find him at his computer, enthusiastically composing a tweet. Beside him is a plastic bag with a few steamed dumplings inside. He hands it to me, and I watch him type.

I'm better informed this time. In the forty-eight hours since our last meeting, Inserk has sent me a PDF entitled, '1 = 125,000,000'. It's an illuminating read — part proposal, part polemic, part memoir — penned by Ai in passionate, imperfect English and intended to explain the installation to its commissioners, envisaging a total of 125 million seeds.

'The times I grew up,' it begins, '[the sunflower] was a common place symbol for the People, sunflower faces the trajectory of the red sun, so must the masses' feeling toward the communist party.' Beside the text are the lyrics to a children's song of the time:

When the Chairman goes past waving
Brilliant sunshine fills our breast

When the Chairman goes past waving
Countless sunflowers bloom towards the sun …

Chairman Mao, Chairman Mao
You are the reddest red in our heart!

I have a weakness for Cultural Revolution stories, so I decide to start our sunflower seed discussion there. Ai obliges.

'When we grew up,' he says, 'the communist society had a very limited vocabulary. We didn't have many images, besides the hammer and sickle, Chairman Mao's books … probably ten images or less defined that time. Everywhere – in children's books, on posters and in newspapers – we saw the same images, and one of the most important was the idea that Chairman Mao is the sun and we're all sunflowers. The idea was to represent how loyal people should be during the Cultural Revolution. It's a very, very nice image.' I ask for more.

'Even in the remote part of Xinjiang Province where I grew up, if Chairman Mao uttered a new instruction from Beijing in the afternoon, by the next days we'd all wake up to the sounds of drums and cymbals, and people would march in the streets, shouting this new sentence. 'We have to insist on class struggle!' or something like that. Then we'd dance and shout this slogan. It was very brutal.' Ai takes a bite of dumpling and offers the bag to me again. It's early still, and the office is empty, just us and an orange cat who is enthusiastically ripping up a sheet of newspaper by the door. Outside, several conversations are taking place and beyond that the changing sound of construction. I ask how it felt to be part of these events. 'As children we felt a kind of release of our pressure and anger,' he says. 'Because you could really yell out, even though you didn't know what it meant. It was a strange way of surviving.'

'After this slogan was announced, the commune would organize its own gathering, and everybody had to attend, from old to young. Every commune had a big hall for this. Ours was empty, like a gallery, but huge and rough, made from red bricks. The floor was direct, and there were no chairs, so everyone brought a stool from home. Then they'd sit down and start to eat sunflower seeds from their pockets.' He finishes his dumpling. 'Because they had to do something. Normally those meetings made everybody nervous, because nobody knew what would happen. So people ate sunflower seeds

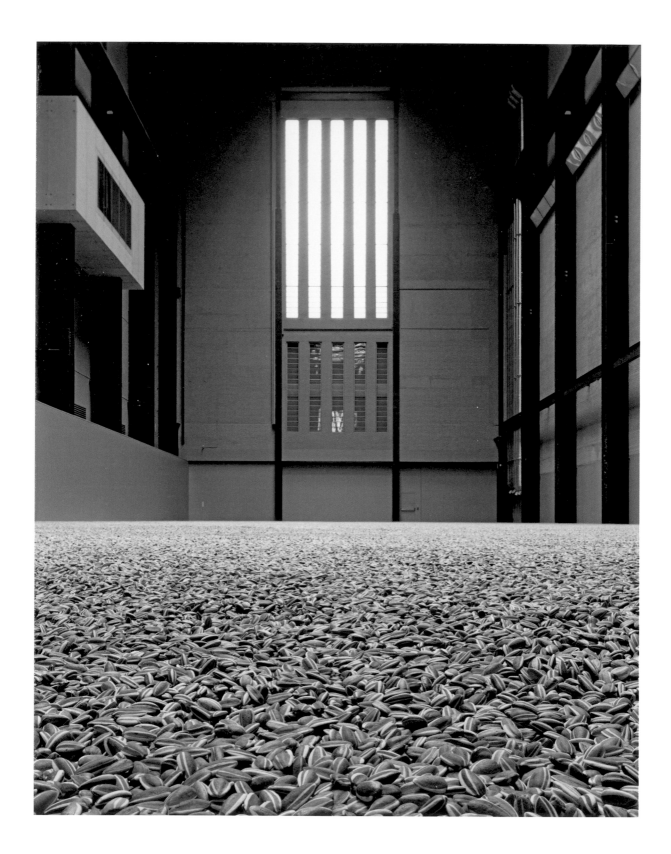

Inhabit

and everybody would have a pile of shells in front of them and you could see immediately who was the most skilled, because their pile would be much bigger. My mother can eat them very quick. And her shells would be very clean, never cracked – like a bird.'

What were you doing during these meetings? 'The children would sit there watching the adults' activities. I normally felt very sleepy – sleepy mixed with scared. Because my father would always be singled out. They'd say, "OK, let's bring all the counter-revolutionaries onstage!" and some people would have to stand up and be insulted. There were ten to twelve people in the village like this. They were from the five bad categories: former landlords, rich peasants, counter-revolutionaries, bad elements, and rightists. My father was a rightist. Those people are the enemies of the state and the people. And their children are also bad.' All this he says with the detached, deadpan expression with which he often describes his work. But, as in his work, there seems to me so much smouldering beneath the flat surface of this anecdote. Within a single childhood memory, so much insight into the spirit of a time: the radical reduction of symbolism, the atmosphere of uncertainty, the threat of violence and frequency of celebration, the fervour and sanctimony, the deliberate opaqueness of the directives, providing their author plausible deniability and their enforcers maximum creative licence, the pseudo-statistical identification of five 'bad categories' and transfer of guilt to children. And somewhere within all this, the humble sunflower seed – snack, symbol and sedative.

'That's all they had,' he says, and I'm not quite sure what he means. 'The seeds were the only little treasure they had.' He is speaking with objectivity but his tone has softened. 'Sunflower seeds were a part of conversation; it was a very natural act. On the train, on the bus, waiting for the bus, everywhere. Of course, at weddings and any celebration, you'd see them. You'd feel a natural connection eating them with someone.' One of Ai's assistants comes in with news of an upcoming appointment. I think I'm beginning to get it: during the Cultural Revolution, the sunflower seed was a kind of peace offering. In an atmosphere of pitched ideological struggle, it soothed and built intimacy. I begin to wonder if, despite its revolutionary symbolism, the sunflower didn't subvert Mao's fundamentalist programme, and whether the sharing of seeds wasn't a form of passive resistance – a way for would-be adversaries to acknowledge their common humanity, a subtle means for even the most zealous Maoist witchhunter to show compassion for a bad element like Ai Weiwei. 'But of course,' Ai continues, 'it was all unconscious. You wouldn't think about who'd passed them to you.' And there the conversation cuts off, overtaken by the artist's obligations. I pledge to return the next day to spend some time testing his mock-up.

When I arrive the next morning, the compound is already active. An antique dealer has laid out several pieces of Neolithic pottery in a column along the wall. A brown dog is inspecting a mound of bubble wrap by the front

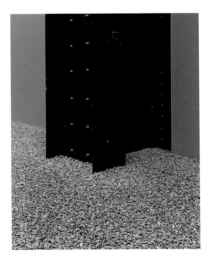

<u>Sunflower Seeds</u>, 2010
Porcelain, paint
100 million porcelain
sunflower seeds

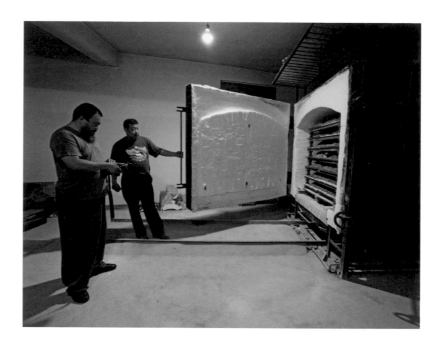

gate. Ai is conversing with a middle-aged man who is holding a life-sized replica of a surveillance camera carved out of marble. The artist orders a few adjustments, then leads me into his studio and on to his latest work.

I ignore the visual this time and focus on hearing. Each step produces a satisfying crunch. It's a familiar sound, disarming and rural, evocative of country lanes and gravel driveways, and the more I walk, the richer the accent becomes. Different motions produce different effects. A sweep of the legs brings a thin, shimmering sound; less natural, almost digital. A kick scatters seeds in all directions, each landing with its own trebly tone depending on the distance. I grab a handful and shake. They clack like dice. I drop them back. They sputter and snap like a Geiger counter. I pick one up and take a look. Almond shape, slightly thicker than the sunflowers seeds I've encountered in nature. Clearly ceramic – smooth, hard and off-white – with a pointed oval painted in a charcoal-coloured ink on each side. It is coated in a light powder that stays with me after I've dropped the seed. I begin to wonder about the social involvement that Ai mentioned.

The production of the seeds is taking place in Jingdezhen, a small city in the south famous for its porcelain. All of Ai's ceramic works are produced there and from what I've heard there's a small army racing to complete this one. To understand this work, I think I need to see the process. I find Ai and he offers to set up a visit. Coincidentally, Liu Weiwei, his long-time collaborator and the man responsible for the seeds, is at the house. 'He's leaving tonight,' Ai says. 'Can you go tomorrow?'

Jingdezhen is the pottery centre of China and the original home of the world's porcelain industry. It has held this position for hundreds of years and changed remarkably little even amid the turmoil of imperial

transition, foreign invasion, communist revolution and post-communist reform. It owes its preeminence partly to geology: Jingdezhen has a natural advantage over China's other ceramic-producing cities due to its ample, easily accessible supplies of clay and feldspar, the essential ingredients of porcelain. The low, rocky hills surrounding the city have been mined continuously for generations and yet these raw materials are almost never in short supply. The miners have to dig deeper now, their work is more dangerous, but it continues to yield the precious minerals on which the city's reputation and livelihood depend.

To reach one of these mines, Liu Weiwei drives an hour or so outside of the city. In Jingdezhen, the line between urban and country is sharp, and crossing it feels like time travel. The high rises and sooty buses and busy people disappear and you suddenly find yourself in a medieval world of rice and tea, lethargic oxen and stooped labour. The air feels cleaner; the stink of the city – exhaust, spilled fuel and sulphur – is replaced by the earthy smell of wet roots and peels. The buildings are made of wood and roughly mortared brick, and even those that are undergoing expansion have an air of decay. As you drive further, the road gradually decomposes until you find yourself on a narrow dirt lane that stops abruptly before a heap of broken rock.

The mine itself is fairly unremarkable. The entrance is inconspicuous: just a small arched opening on the side of a hill, below a sign that reads, 'Safe Production'. The ground is tracked to allow for mine carts, and the roof drips water. According to Liu, the shaft extends for two kilometres, but we don't take more than a few steps in. I had hoped to speak to someone, but the place seems deserted. The only indication that the site is still active is a small shrine built by the miners. A slight scent of incense still hangs around it, so I assume it's been in recent use. A small sign above it reads, 'Ask and ye shall receive.' I ask Liu what the miners wish for. He says, 'Safety,' and we leave.

On the train from Beijing I'd read an account of the porcelain manufacturing process written by a missionary stationed in Jingdezhen in the early eighteenth century. It is a fascinating text, a mixture of ethnography and industrial espionage in which the author describes in detail the arduous process through which hunks of raw rocks were turned into the milky

The extraction and
preparation of clay
mud used for porcelain
production in Jingdezhen

Small bricks of porcelain
clay are produced and
stored on shelves

chinaware coveted by his European readers. It describes Jingdezhen as a marvel of mass production – a city given over to a single industry, operating at an enormous scale through entirely pre-industrial means.

I'd read the piece mostly for entertainment, assuming that the procedures it described were long since outdated. This is not the case. Not far from the mine is a small plant where the excavated rock is processed. I suppose you would call this place a refinery, although that terms evokes heavy industry and air pollution. This place is not like that; it's all-natural. Its heaviest piece of equipment is a wooden, water-powered machine that pounds porcelain stone into powder. Liu's assistant says that this device has been in use for over a thousand years, and it looks that way. He explains how it works. The pieces of stone are first broken with iron hammers, then the fragments are collected in mortars where trip hammers pulverize them. The hammers rise and fall based on a system of levers connected to a small water wheel. A stream feeds the wheel and provides perpetual motion. It is a clean, efficient operation that apparently requires very little human supervision, because the plant is empty.

Making powder constitutes step one of the refinement process, and there are several others, the products of which are visible in piles and stacks along the walls and on the floor. To understand these, I rely on the missionary account, which, despite its 300-year age, I now assume is still relevant:

> The powder is then put into a great vessel filled with water, and stirred vigorously with an iron shovel. When it has been allowed to stand several minutes, a kind of ream forms at the top, four or five fingers thick; this they take off and put into another vessel full of water. The mixture in the first vessel is stirred up several times, and each time they remove the scum that gathers on the top, until nothing is left but the larger particles, the weight of which makes them sink to the bottom; these are finally taken out and again pounded.

This skimming process produces a thick paste, which resembles meringue. Enormous gobs of it are laid out on tarps in the centre of the plant. This paste is then thrown into moulds, which are a kind of large and wide wooden box, the bottom of which is a bed of bricks with an even surface. Over this brick bed a coarse cloth is stretched, up to the sides of the case; this cloth is filled with the paste, and soon afterwards it is covered with another cloth on top of which a layer of bricks is laid evenly, one by the side of the other. This helps to squeeze out the water more quickly without losing any of the porcelain material which, as it hardens readily, takes the shape of the bricks. Before it has become quite hard the paste is divided into little bricks, which are sold by the hundred.

These soft, off-white bricks are stored on racks and lined up on the floor. From here they are shipped to porcelain factories, where the powder is further refined, then mixed with clay to form a cohesive, camel-coloured

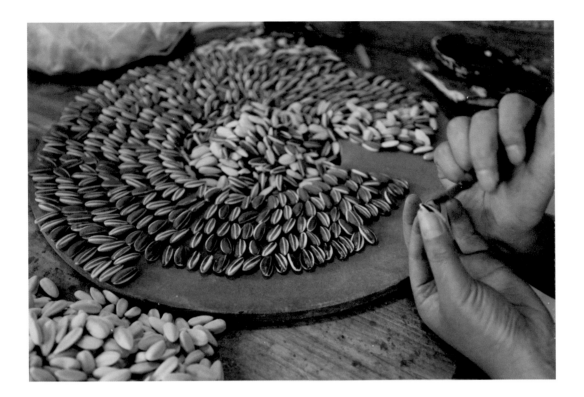

Making of <u>Sunflower Seeds</u>
in Jingdezhen, PRC, 2010

material that I will watch Liu hand-press into a sunflower-shaped mould later that day.

Liu is forty-nine. He has a plump face and a low, gravelly voice with a slight lisp. He speaks in short declarative sentences and dresses in casual luxury brands. He was once a dealer of Chinese antiquities, but now spends most of his time creating porcelain artworks for Ai Weiwei. The courtyard of his home is filled with fruits of their collaboration: a cobalt blue orb ('Ai showed me beautiful photos of these on a beach in Miami'), an oil droplet ('It was supposed to be bigger, but it always cracked, so the size had to be reduced'), human organs ('The most difficult piece we've ever done'), a grid of interlocking tubes ('These are in an exhibition in Basel right now').

He doesn't speculate on the significance of the work, and says that he and Ai don't discuss it. He considers himself a producer and he does his work with care. He's happy to work with Ai. They've been friends for sixteen years and the collaboration is a natural extension of that friendship. It started small and gradually built up, each successful realization leading to another. 'You could say he's my boss,' Liu says that night over tea in his courtyard, 'but he's never bossy to me. We're friends first.'

It's my final day in Jingdezhen and we've been through all the major production steps, except one. Why this was left till last I don't know, since it's the step I'm most curious to see. Back in Beijing, Ai had spoken passionately

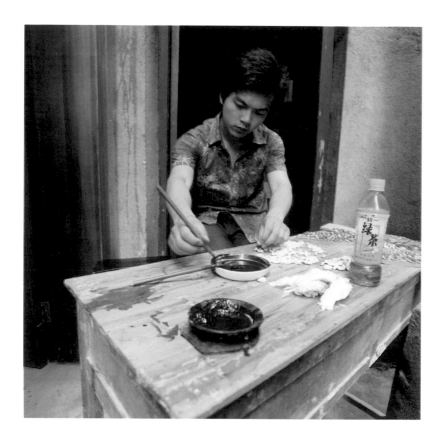

about the painters. 'Each one is different,' he said. 'You show it through your own control of the brush and your breath and your own body gestures. You pick a seed up and you put on ink, more ink or less ink, lightly or thickly painted. Then you have to turn it over and place it down. It's such a beautiful act.'

The painting takes place in an unfurnished two-storey house on a leafy street somewhere in Jingdezhen. We pull up in Liu Weiwei's van and one of his assistants immediately starts unloading sacks of unpainted seeds from the back. Through the windows we can see groups of women – only women – hunched over plywood tables. The air outside is filled with the smell of alcohol-based ink and the soft sound of female chatting. We enter without introduction. When the women notice the visitors, they become quiet, diligent.

Before each of them is a pile of blank ceramic seeds, like the ones we've just brought over. I'm not sure where to look, so I watch the woman closest to me. She's wearing black jeans and a slim-fitting polo shirt with bright stripes. Like most of the painters, her hair is black and tied back. To her right is a shallow bowl of black ink and beside that an identical bowl filled with water; to her left is a flat wooden ring half covered with painted seeds. She places a finished seed on the ring and immediately picks up a blank one. She holds it in her left hand, between the thumb and index finger. Her right holds the brush, which she grips like a pen. As she paints, both hands work

Inhabit

in tandem, the left gently gliding the seed beneath the brush while the right holds it steady. She ends each stroke with a slight upward flick of the wrist. Four strokes and one side is done.

Liu Weiwei is no longer in the house. He is outside discussing the work with a woman whom I presume to be a supervisor of some kind. They're bent over a sack of painted seeds. Some are OK, he says, but some are not. The bad ones can't be used. Across the street is another house where more painters are working. It's dingier than the first one and not as well ventilated. The women inside range in age from late teens to early forties. They're sloppier than the other group, and chattier.

I start asking questions.

> Q: Do you know what these seeds are for?
> A: Adornment.

One word, then back to painting. I've started off on the wrong foot. I try another approach.

> Q: Is it hard work?
> A: It's OK, the time is flexible. We can also work at home.

Maybe this more sympathetic question has warmed the atmosphere, because all five women now look up from their seeds.

> Q: Are you all painters?
> A: Not all.

> Q: What did you do before this?
> A: Some of us used to paint porcelain.

> Q: So this is much simpler than that?
> A: Yeah, it's easy once you know how to do it.

> Q: How many do you paint in a day?
> A: Two- to two-and-a-half kilos. On average, each one of us has painted over 500 kilos.

500 kilos. At about 700 seeds per kilo that's 350,000 seeds. 2.8 million brush strokes. It's hard to fathom in this tiny, ink-scented room. I take another shot at discussing the significance of their work.

> Q: Do you know where these are going and what they'll be used for?
> A: No, we don't know, but we know they'll be used to make money.

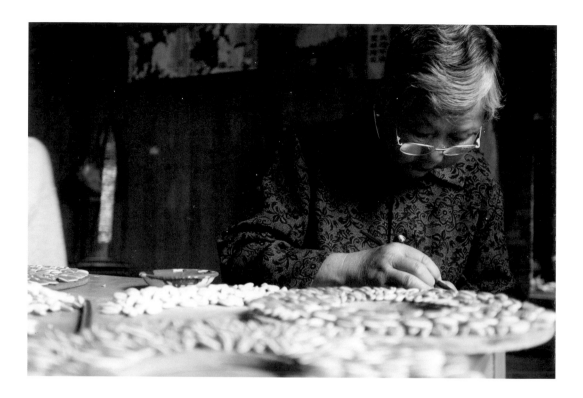

Making of <u>Sunflower Seeds</u>
in Jingdezhen, 2010

Another brief, withering response. And again, my impulse is to retreat to tame personal queries.

> Q: After all this, do you still like sunflower seeds?
> A: Yes. These are more beautiful than real ones. Hahaha …

An icebreaker! I try to probe deeper.

> Q: How do you feel about doing this work?
> A: To me, if people understand art, they might enjoy it.

As we head back to his house, Liu Weiwei begins to speak about himself. He doesn't have creative aspirations of his own, he says. Although he's one of Ai's co-creators, Liu is foremost a businessman and he describes his creations not as works of art but feats of production. From this perspective, the sunflower seeds are his masterpiece: never has a single project required this much investment, organization and overseeing. 'I had to buy five vans to transport the seeds,' he says as we pull up to his front gate. Then, with less emphasis, 'More than a thousand people have worked on this.'

A thousand? And this for a production that, from what I've seen, barely uses electricity. I ask how he maintains quality with such a large team. He says, 'We have many people taking care of quality. We're very strict. If we

see bad ones, we just throw them away. That's a loss for me, but we have to be tough on this, otherwise it would be hard to control.' I'm finding my emotions somewhat hard to control. Despite its superhuman scale, nothing in this production is automated. The seeds are handcrafted: the porcelain stone is excavated by hand, pulverized, and mixed by hand. The clay is hand-pressed into millions of pieces that are baked and dumped into large sacks that, despite being made of woven Polypropylene, appear to be hand stitched. These are placed in vans and hand-delivered to studios, where each piece is painted by hand, then sent back for another firing, after which it's hand-polished and dried. For someone like me, a digital labourer whose work is based on remote communications and impossible-to-understand search algorithms, the directness, intimacy and raw human power of this production is overwhelming.

When I get back to Beijing, I go to visit Ai again. I tell him I've seen the manufacturing process and am amazed that it's so productive and so low-tech. That's what makes Jingdezhen special, he says; it hasn't lost its primitive ways. 'In culture you see in Jingdezhen, there's really no deficiency.' As before, he's speaking objectively, but not without feeling. 'You can be handicapped or weak, but still there's something to do and, by doing it, something beautiful can come.' He pauses, as if to make certain that he possesses all the correct words to say what he wants to say. 'Value isn't just measured by competition – that creates too much waste. The tradition you see there was the same a thousand years ago, during the Song Dynasty. It survives because it's so efficient. It doesn't need electricity. Everything that's done is necessary. You cannot beat it.'

It's an unusual argument: an ancient social philosophy expressed through the concerns of the modern business leader – reducing waste, increasing efficiency, saving energy, adding value … But this apparent

Workers paint
Seeds by hand in a workshop
in Jingdezhen, PRC

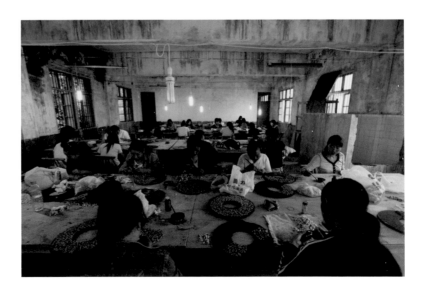

mismatch is to be expected; it's simply one of the dozens of incongruities that spring to mind when considering his sunflower seeds — millions of pieces of ceramic, mass-produced but handmade, inspired by communist symbolism but sponsored by a capitalist conglomerate, produced through pre-modern methods and displayed in a post-industrial space. The overlap between supposed opposites is fertile ground for Ai. He is continuously exploring it, intervening in it, inviting others in. It's an area strewn with preconceptions and misunderstandings, and its impurity is what attracts the artist. As Ai speaks, it dawns on me that his installation is essentially an elaborate device for producing this condition inside the Turbine Hall; all of it — the mining, the moulding, the painting, the five vans, the thousands of workers, the 100 million seeds — all of it amounts to a single attempt at creating an environment in which incompatibilities meet and multiply.

In the hope of developing the thought, I ask Ai a final question. He's taking a photo of my T-shirt. I say, 'How do you think the visitors are going to react?' He replies, 'I don't know.' Silence. I remember the painter's response when I asked her to speculate on the work, and in that instant of reverie Ai has posted his picture of my shirt on Twitter. Then, as if fulfilling a terms of use agreement, he responds some more. 'I think people will be charmed … when they first enter the hall they'll think it's real, then realize it's not real, then they'll wonder if it's machine-made or hand-made or painted.' He looks blankly at a group of students fidgeting in the doorway. 'Those things all affect perception. We only remember a piece by the way it made us question our original concept. I feel very charmed by that.'

Workers install <u>Sunflower Seeds</u> in the Turbine Hall at the Tate Modern in London

Opposite page:
<u>Sunflower Seeds</u>, 2010
Installed in the Turbine Hall at the Tate Modern

The essay 'Everything is Necessary' originally appeared in the *Sunflower Seeds* exhibition catalogue published by Tate Publishing in 2010.

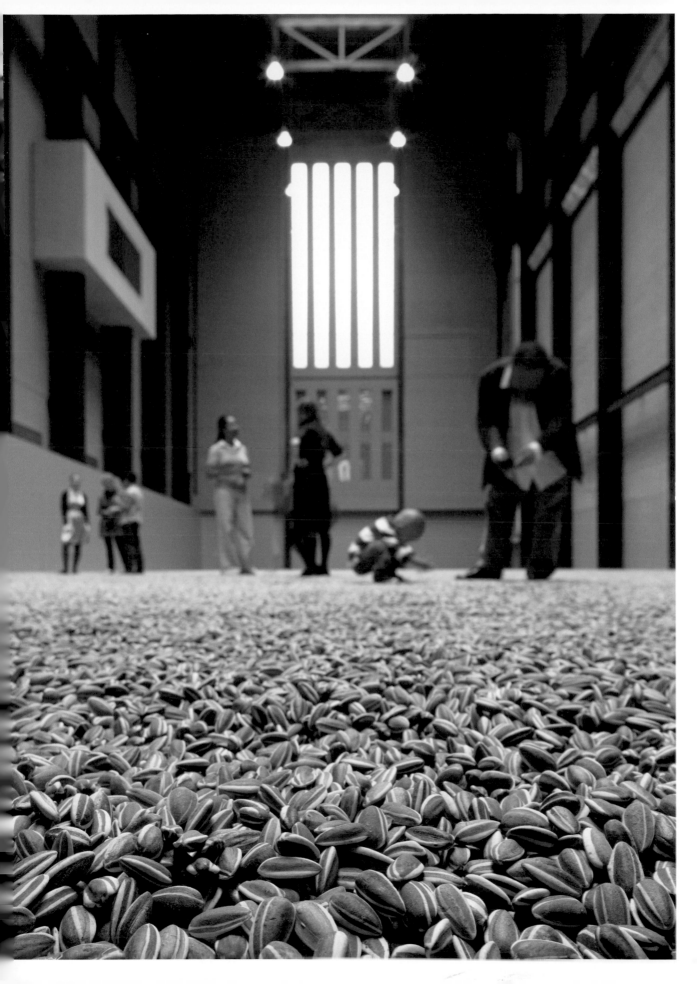

Build

Village Architecture and the Critical Vernacular

Entries from Ai Weiwei's Blog

With Regard to Architecture
Posted: 22 January 2006
Written: 20 February 2004
Translated by Philip Tinari

Architecture has always been and will always be one of man's basic activities. This basic activity has and will always move in step with the basic human need for survival.

The essence of architecture lies in the search to satisfy the demands of human survival and in the desire to transform people's conditions of existence. This could be a demand for safety, comfort, desire, or individualization. Similarly, this could be a demand to display power, to pursue volition, to express a fear of God, to manifest one's morals. As different architectural forms attempt to regulate people's different manners of activity, these forms simultaneously tell people who they are. They tell people that they are different from other people. They tell them what their place is. They tell them what kind of ideals are theirs. Architecture can also be silent. It can stay aloof of the popular words of this world, like a stone statue buried in a riverbed.

The many efforts that people make when creating architecture represent an understanding of their own place within the natural world, of order, and of potential. The essence of this understanding is a reflection of people's worldview. It is a reflection of the philosophy of the age, of political ideals, of aesthetics. But all of this is displayed in a material form. This gives architecture functions of display and of cognition at the same that it possesses dimensions, materials, functions, and form. No matter what type of architecture from what time or place one considers, they all reveal who the builder was; they reveal the meaning of this architectural action, what kind of building it is, how the builder interpreted and depicted the conditions of things, how he saw possibilities, how he made necessary choices, how he regulated our manners of behaviour and our ideals, how he got rid of outdated clichés, how he told people, 'things can also be this way, this is better for everyone; it is more interesting, it is more convenient, and it causes us to be even more different from the past'.

People live. People act. At the same time that they live and act, they also interpret the possibilities of life and the possibilities of action. Living and acting are people's basic activities. Living and acting have always been and will always be accompanied by suspicion, hesitation, and incertitude. Striving to bring oneself closer to that which is essential, observing the meaning of his personal fate, or describing the logic of one's actions can all turn a builder into a disaster victim who must shut his eyes in the darkness, which might be the only way he can finally see anything.

A building more resembles a necessary action; only then might it attain its directive or have some sort of meaning. Observe a child's happiness in playing on a sandy beach – the entire significance behind his or her happiness lies in the action of participating in a transformation that is taking place. Among the delights of construction, this is real significance.

Any well-founded architecture or any urban plan is like a person's behaviour. There is no way to cover up a person's inherent nature; they could be wicked, crazed, inimical, narrow-minded, or ill-meaning. Similarly, we can see how people express their good-hearted desires and appease their soul by means of cities and architecture. But what we see more frequently is how people mutilate themselves, how they are filled with enmity, how they worship deities. This is why, when entering a city, I sometimes say, the people here are crazy, they cannot be fortunate, for the people here have no way of understanding the natural order. They have no means of feeling the sun's rays, raindrops, or the wind against the exterior surface of a building. They lack mysterious light or fast-changing shadows, they have no complicated space or form, no comprehensive understanding, no frankness of attitude, no tiny details. People here are numb. They are crude, or they cling to styles, methods, and expressions that never change. Architecture is not the theory, skills, styles, and schools promulgated by architecture institutes; architecture is the appropriate manifestation of morals. It is the ultimate manifestation. It must rid itself of doctrinal ties and sensibilities. It must become itself.

Although any morally despicable person can cater to a similarly jaded era, good architecture must necessarily come from good morals. Ultimately, architecture is an

interpretation. It can also be an attitude toward dealing with things; thus, we can call either it sincere or insincere. Good architecture is necessarily provided with good judgement while architecture of muddled character and low tastes stems from a muddled mind. Good architecture necessarily has spiritual implications, because the way in which we view the world and the conclusions we arrive at determine who we are. Good architecture cannot be duplicated, it inevitably possesses innate beauty, it cannot be copied. It is one time only.

Modernism is not a fad, nor is it is a style or trend. Modernism is an attitude toward life, a worldview. It is a system for people to decipher both today and tomorrow. Among many types of cultural thought, only the modernist manner of thinking is effective; it is effective across all realms of cultural behaviour. Aside from modernism's methods of comprehension and analysis, all other foundations and attempts are unilateral, temporary, or provisional. This includes all those stale platitudes that attempt to invoke the banner of modernism. Authentic modernism's understanding of people and its evaluation of society are developing, uncertain, and unknown; they are also relative. Modernism with a critical edge excludes all previously formed conclusions, including modernism itself.

All love is self-love. All interpretation self-interpretation. The value of interpretation is that through it, one might expose reality, or explain oneself. But interpretation is also a reality, and its practice is likewise an event. Reinterpreting a very common truth is one of the delights of our game. It is necessary to spare no pains in interpreting, for no matter how we change, we are all forever expounding on a basic truth. No matter whether or not we are willing, repetition is unavoidable.

To speak of beautiful dreams and grand ideals is safe – you could go on forever. But to realize them through action is dangerous. You will stumble over the first stone that lies in front of you. Action cannot be accomplished with imagination. Action can only be executed with actions. Interpretations or understanding of behaviour are merely interpretation and understanding; they do not have a deeper meaning. 'Action' and 'nonaction' are the same. With regard to certain problems, we have few choices.

Here and Now
Posted: 10 May 2006
Translated by Lee Ambrozy

I was born in a courtyard on Beijing's east side called Tofu
Alley. We accompanied my father when he was 'demoted' and
sent to do physical labour in Dongbei province, and moved
into the home of a lumberjack in the Dongbei forest. Later
we were transferred to Xinjiang, and moved into Soviet-style
housing; when we were placed into our company of troops,
we first lived in a dormitory, and then in an 'earthen pit' – a
ditch dug into the ground and covered with branches and mud.
When we vacated it, it was turned into a pigpen. After that we
lived in a guest house, what they call an 'inn' today.

Later, when I went to the United States, I lived in a
Philadelphia townhouse; in the Berkeley Bay Area I stayed
in someone else's home, on a hillside overlooking the San
Francisco bay. I've also lived in a young men's club, which
was a room under the rafters of a building. In New York, I
lived in an artist's warehouse-style studio. Because I was a
self-funded student, cash was tight; I either stayed someplace
cheap, or I lived with someone else. All together I've moved
almost twenty times. In New York I also lived in a long
underground apartment; a television drama about New York
was filmed there.[1]

Soon after I moved back to Beijing, I lived in a court-
yard home, and now I live in my studio. In terms of residen-
tial dwellings, I've lived in essentially every possible variety.
Travelling in Europe I stayed in family-style bed-and-break-
fasts and boutique hotels; in Italy I lived in a 300-year-old
home whose furniture and furnishings hadn't been altered
over the years, and I've bedded down in a friend's cas-
tle and in luxurious casinos. With the exception of a pris-
on camp, I've been in virtually every kind of structure.

The house I live in today relatively suits my liking,
because it suffices all the potential ways that I might spend
each day. It allows me to do things as I please: if I want to
move around in the middle of the night, I do. I eat when I want
to, there is freedom in everything. My studio is only a few
steps away, and it's convenient for me to chat with friends. It
is a flexible space.

When I hear words like 'sleek' or 'chic' in relation to design, I can't but think they are medical terms, something like 'diabetes' or 'nephritis'. I hate those words, although I rather like 'simple', which is employing implicit methods to effectively deal with things in a straightforward way. Because I am a rather simple person, the activities that I encounter don't require me to use my intellect, and I'm very fortunate that, generally speaking, nothing requiring the heavy use of my intellect comes my way. The affairs of architecture and interior design are quite simple, as you merely need to rely on intuition and the simplest craft to complete your task. Basic materials and treatments are sufficient to satisfy our sense of happiness. Just like cooking: you don't need to throw all your spices into the pot; vegetables boiled in plain water can also taste good, because the essential nature, colour, and flavour are provided by the sun, the air and the earth.

The cats and dogs in my home enjoy a high status; they seem more like the lords of the manor than I do. The poses they strike in the courtyard often inspire more joy than the house itself. Their self-important attitudes seem to be saying, 'This is my territory', and that makes me happy. However, I've never designed a special space for them. I can't think like an animal, which is part of the reason why I respect them; it's impossible for me to enter into their realm. All I can do is open the entire home to them, observe, and at last discover that they actually like it here or there. They're impossible to predict.

My design possesses a special characteristic: it has leeway and possibility. I believe this is freedom. I don't like to force my will upon other people, the ways you allow space and form to return to its fundamental states allow for the greatest amount of freedom. This is because fundamental things cannot be erased, and outside of that, I don't believe anything else should be added. Perhaps all you need to give any space a memorable feeling and look is a lamp, a table and chair, and a glass. Why must you insist on making everything in a certain style? Why must you add a fireplace? And why must the floor tiles have a pattern. I think all of this is pointless. No designer can draft human emotions, they have their own paths, and like the direction of a cat's next step, I am powerless to predict such things.

Like walking at the seaside, if you see a pretty shell you might collect one or two, or you'll pick up a few interesting stones. A chair that has been passed down over hundreds of years will similarly arouse your curiosity. You can observe the chair and imagine the postures or the ideas of previous generations, but I wouldn't advocate it or flaunt it for this reason. I don't believe that aside from being able to satisfy my curiosity, such a chair has any genuine value.

In most circumstances there is no one influencing me. I have many books, and a decent understanding of ancient Chinese vessels, no matter if they are wooden, bronze, or jade. But, most of my efforts go into forgetting these things, avoiding taking the same path, or saying what has already been said, and attempting to contribute a new way of looking at the situation in everything that I do. There can be no substitute for the 'here and now'. It is the most important element in every kind of art, architecture, and design.

I don't like Beijing, it is unfit for human habitation. It was not designed for the here and now, or we might say that in this here and now, the city's developments lack a human dimension. I didn't use to like nature, because the nature I knew was cruel. The place that I lived in when I was a child had no electricity, and it lacked sanitary conditions. When you went to the bathroom, you only needed to walk a dozen metres from the front door, and you could relieve yourself anywhere. The sandstorms were incredible, and the winters were cold enough to freeze you solid. Humans are moving gradually towards developing civilization, which will have its own set of problems, but comparatively speaking, these ought to be fewer than those accompanying a lack of civilization.

Accuracy is not the highest standard in design, and high accuracy is frequently deliberately mystifying. Whether in architecture, interior design, writing or even in speech, everything has its particular details, style, method, or sentiment. This is a kind of language, it can be meticulous, it can also be boorish, but these are not critical standards. Good or bad design depends on whether or not it possesses a conceptual framework derived from the designer's worldview, aesthetic cultivation, and judgement on basic things. The thing most often lacking in design is actually common

sense, including large concepts like good and evil or right and wrong, and down to little details like materials, craft, or the capacity to determine the value of one's design. The precondition for having such common sense is many years of experience – engineering, aesthetic, and social experience.

I've written before on my appreciation of space. Space is intriguing, because while it can be materialized, it simultaneously has psychic implications. Many people think that a tall, big space is ideal, but that isn't always the best. Small spaces have their small ambience, low has a low atmosphere, narrow has its own narrow feeling – every space has its special characteristics and each space has its own potential.

I've yet to see decent designers emerge in China; most lack a clear understanding of the here and now. As to what kind of era we are situated in, what kind of times we've been through, and what times will we see in the future, they haven't thought clearly through any of these questions, yet they are extremely proud, and only because their work is related to the arts. Generally speaking they are satisfied with merely superficial understanding, they lack the essential attitude needed for work, and their aesthetics are muddled. This is despite the fact that interior design has existed for already several years in China, beginning in the early Great Hall of the People and developing into private homes, and finally into second-homes or villas. Designers today should clearly recognize their status and obligations, avoid previously existing styles, and create a stylistic schema that at once belongs to the local environment and is related to the experience of the native people. Such a system could be small, and even if they elaborated clearly on merely one or two issues within the entire work, that would be a great improvement.

Say what you have to say plainly, and then take responsibility for it. Or, speak when you have the chance, don't waste your limited space saying something meaningless; this is what concerns me. However, this actually is pointless: I'm not interested in fame, and I have no illusions about the fact that all manner of social critics work within an extremely limited framework that can bring you honour or destroy your name. I'm also not too interested in the public's criticism of me; I'm one part of the public and my critique of myself is not interesting.

I have no regrets, and I've never exerted any great efforts. I became aware of many things only after I finished working on this or that project. For instance, when I finished building my house, I learned that I was an architect; I like to have fun, and after I made some things, people said I was an artist; because I like to talk, people say that I'm on top of trends or that I'm up-to-the-minute. But all of these things emerged from my most fundamental needs, because I'm a human and therefore I think, and because I don't want to conceal my opinions. I won't admit my mistakes were my own, I think they must be the will of heaven, and because I haven't the time to understand everything completely, how could I be dissatisfied? If you think about it carefully, perhaps all news is good news.

In fact, the ego is having self-confidence, and trusting in the inherent power of life. Such a power can resist education or ideals, everything. This power serves a great function, and every person has it. My life is characterized by: having no plan, no direction, and no goals. Some people wonder, how can that be okay? But in truth, this is very important: I can throw myself into the things that I like, and because there are no obstacles, I can never be trapped.

After I finish working on the architecture projects that I've committed to, I will not accept additional projects. I dislike the entire process, and I could be doing something else, perhaps something that I lose at instead. This kind of success makes me embarrassed; after all, it's the general 'inferiority' pervading the profession that makes me successful – what am I still doing in this field? I've got to get one foot out the door, and not do any more architecture-related projects because there are so many other things to do, like fold a man of paper or go skipping stones. It is like taste in cuisine, which is always changing: one minute Guangdong cuisine is fashionable, and it's Sichuan the next, but we will always have our favourite dishes, our favourite soup. When everyone can distinguish what they like best, this world will be an interesting one, and people will say with conviction, 'This is what I like.' If everyone blindly followed trends, the world would become incredibly boring, for lifestyle is everyone progressing towards their own place, doing the things they are most willing to do.

Returning to one's self is the most important, and most difficult thing to do; after so much struggle, suffering, poverty and ideological duress, educational debauchery, and aesthetic decay, reality is already riddled with gaping wounds. Even though returning to the primal self is difficult, it is important indeed.

Ordinary Architecture
Posted: 22 June 2006
Translated by Philip Tinari

Architecture serving as a home is a place filled with one's individual character. Different from the concocted meaning of 'home', it is an independent, inclusive entity that deserves to be respected. It embodies the free will of all those therein and may represent the modern pursuit of comfort and the independent mind.

The interior and exterior are linked through a relationship that joins them as an integral entity. In any such structure, mutual respect and communication exist between the home and its environment, the street, the neighbourhood, and everyone who lives there together. The logic of its construction is intrinsically organic and everything derives from a common origin. It achieves true power through this fact, allowing it to refuse to imitate a single architectural style, a single cultural form.

A house that serves as a 'home' is an illumination on life; it tells people of the possibility of a certain life – that is, that life can be simple and real. But this sort of new possibility necessarily changes, and is necessarily filled with creativity. It must be interesting and fresh, safe and unpredictable. The comfort and safety of a home is derived from the self-confidence and self-respect of the people who dwell there, as well as from the richness of their creative powers. These qualities are derived from a frank and sincere attitude about life and from a contented state of being. The inhabitants possess the ability to experience and endure completely new, modern experiences, to narrate their attitudes and ideals regarding life: tolerance, distinction, bravery, richness.

A home is life's basic necessity; it reflects life's basic character and possibility. In addition, it should give materi-

al form to life's most basic qualities and potential. It is also a complete philosophical proposition; it expresses who we are.

If I were to use only one sentence to describe the characteristics of my design, I would only say that I do not create difficulty. No matter what one chooses to do, various possibilities will always present themselves. In truth, such possibilities are precisely the various difficulties. I am simply trying to return to the most basic of possibilities, and to minimize difficulties. I put forth as little as possible – this is the most basic feature of my house. This is also the most basic characteristic of the majority of my architecture. It is not a strategy. Strategy is one of your choices, and you can always use a different strategy. This can be understood as one characteristic of my actions: I am willing to do everything as simply as possible. If I must create or carry out a mistaken action, I will make sure that this mistake is as elementary as possible. I am willing to return to the most initial state. I am never willing to cross this line. If I cross it, I will return to the beginning and commence anew.

I believe that the concept of a proactive Chinese domicile is nonexistent. A special mode of behaviour has taken shape resembling regional dialects; it exists because difficulties in transportation have created obstacles to communication. But without the joy of communication, it is difficult to form a systematic, effective praxis. China is currently replete with incompetent, self-styled architects working inside this system. They are designing for seemingly complicated problems, but in fact creating obstacles to the obvious and salient. If such people did not exist, our architecture would be better, and the city would possess a greater strength. But this group of people represents authority, they have the absolute right to speak. So in speaking of the term 'Chinese domicile', we could say that it is a composite term signifying ignorance, confusion, inanity, corruption, vulgarity, impudence. These traits constitute the contemporary, so-called Chinese domicile.

There are absolutely no modern strategies embedded in the concept of the Chinese domicile. We all live in the modern era and any strategy could be a modern strategy. Today's modern era encompasses the meaning of the life of every

person, every village, every town, every city, and even of the whole country. Our native land has long since abandoned its traditional concept of home (*jia yuan*); this concept of the traditional home is no longer valid. We no longer have land, no longer have relatives and friends, no longer have memory, no longer have real ideals, no longer have real enterprises. This is precisely the puzzle we now confront. Our conditions today are still inferior to what they were after the war. After the war there were wounds, and you still could feel sorrow for relatives and friends who had died. Now, there are too many facts awaiting clarification.

The Chinese people are unwilling to discuss these questions, and if you are unwilling to discuss these questions, you become a beast, a walking corpse. So what kind of modern strategies can we rely on? Every day, people very busily attempt to solve all problems, yet all of these problems were created by their incompetence. The structural system surrounding the Chinese home has rendered it unable to adapt and improve itself. Suspended in this state, it maintains absolute power. Its every judgement and every decision are the root of this society's various calamities. What remains is only an issue of size, and of whether this calamity is ongoing, or will it be stopped? Yet, even if it is stopped, it will be replaced by another disaster.

This is the general background. Next, we should discuss education, the state of society, social aesthetics, knowledge of personal history, and knowledge of the state of this society. What is the current condition of Chinese architecture? The position of society, societal formations, the shape of the economic upswing, its potential and the obstacles that it may encounter, its structure, etc. Who are the people that constitute these abstractions? In the end, how many urban residents are there, really? How many peasants? How many workers?[2]

Now, you may see that as people speak of the Chinese domicile, they are only discussing the homes of those 'wealthy first few' – the portion of the population which has become wealthy before the poor masses – but they do not discuss how those people became wealthy or whether they will continue to be prosperous, nor do they discuss the nature

of the relationship between their wealth and the poverty of other people.[3] If such questions are not mentioned, isn't it true that to discuss the Chinese domicile we must discuss the survival conditions for the majority of Chinese people? What kinds of possibilities are open to them? Are there effective means for improving and resolving the difficulties they face? What are the basic problems of habitation and the most basic ideas about the 'home'? This is an issue that no one discusses or researches. When even the most basic conditions are unclear, how can one do anything? You must investigate what is possible and what is not.

In this sort of situation I feel hopeless about architecture in China. I have accepted a few projects, and the design activities are basically revising other people's plans. I am especially capable of solving problems; for me, solving problems has always been the most important, most basic characteristic of my personality. What is the problem? Where does it appear? How can I solve it?

I do not want to follow a Chinese style, and I do not believe that China still maintains any styles or traditions to speak of. For example, it is entirely possibly that the Forbidden City could be Vietnamese or Indian. I don't believe it has any relation to us today – it belongs to the monarchs, to centralized state power, to tourists. It is merely the Beijing of films. This is to say that people who still speak of roof tiles, roof brackets, and mortise-and-tenon frameworks when discussing Chinese architecture are unfit to present themselves within this industry. On these grounds I think that we are merely using local materials and are putting forth a familiar attitude toward local history, politics, and lifestyles as a means of dealing with something. I don't desire that my architecture should have any apparent cultural characteristic.

I don't care if my buildings have any cultural characteristics, and I don't care about 'culture'. The sorts of things I care about are efficiency, reason, and suitability to one's identity.

I believe that if you do things, you necessarily have a method. This is simply another system and the logic that it creates. For example, take a handrail: no matter whether it is ten centimetres or one centimetre wide, its function

is already fulfilled. The characteristic embodied by the logic of this handrail could be 'thick, heavy, and stable'. But also it could be 'dangerous'. It cannot be denied that danger is likewise a basic situation in which people find themselves. Sometimes, I am simply reawakening people's consciousness and mindfulness toward danger. This danger and mindfulness toward it comprise just one necessary part of architecture. All architectural standards say that safety is a human necessity, but as far as I am concerned, awareness of danger is actually a part of the human predicament and quality of life; it is an element that architecture cannot ignore. This is a philosophical interpretation, not an interpretation based on architectural standards. ·

There is no such thing as a standard person or two people who are completely alike, so there should not exist two buildings that are exactly the same. People determine standards, and standards don't tell us anything, other than when to abandon thought and emotion.

I think that the meaning of home changes entirely with different people. For example, if an individual feels that he is special, his home may be an uncomfortable place to other people. I believe that I am an absolutely ordinary person, so the majority of people who come to my home will be comfortable when they see many ordinary things. They can enter audaciously, they can walk into any space that they would like to enter. Being 'ordinary' is my most fundamental trait, and ordinary can have its own individual traits. My architecture is ordinary architecture.

1. *A Native of Beijng in New York* (*Beijing ren zai Niuyue*) was a popular television drama in China that first aired in 1993. It was partially filmed in Ai's underground apartment in the East Village at 52 Seventh Avenue.

2. Urban 'floating populations' of migrant labour, many of whom have lived in cities such as Beijing for years, and laws regarding registration and *hukou* have made estimating urban populations an onerous challenge. The *hukou* is a contemporary Chinese family registry that can can be dated back to ancient China. Originally developed for the purposes of taxation, conscription, and social control, in modern society the *hukou* also serves as a means to control and monitor internal migration. Many preferential policies are allotted to those in possession of the highly coveted Beijing (or urban) *hukou*: social welfare, medical insurance, education, and pension benefits; many employers will only hire individuals with a Beijing *hukou*, and without it primary students can only study temporarily and are subject to high fees. The difficulty of obtaining an urban *hukou* for rural residents has created a permanent underclass citizenry in Chinese cities.

3. According to Deng Xiaoping's economic theory, in order for the nation to prosper, the nation should 'let a portion of the people get rich first'.

All posts from Ai Weiwei's blog were edited by Lee Ambrozy and published in *Ai Weiwei's Blog: Writings, Interviews, and Digital Rants, 2006–2009* by MIT Press in 2011.

IN THE REALM OF ARCHITECTURE

Reto Geiser

It seems curious to write an essay about the architectural oeuvre of someone who despite completing over sixty projects would never consider himself to be an architect and who allegedly has 'no fascination left for architecture'.[1] Perhaps, it is exactly this wavering inconsistency of activities and statements which makes the persona of Chinese all-rounder Ai Weiwei so rich and fascinating, and at the same time extremely elusive. Who is Ai Weiwei? Is he an artist, a photographer, a curator, a gallerist, a publisher, a web blogger, a political activist, a design consultant, an urbanist or maybe still an architect after all?[2] Even if we are tempted to do so, it seems hard if not impossible to nail down this versatile, chameleonesque character to a single one of these fields of activities. While the repressive Chinese authorities consider him a dissident to be kept under permanent surveillance, and whose insurgent rants needed to be silenced, Ai Weiwei himself repeatedly stresses that he operates as an artist. For Ai, art is a way of 'approaching the world',[3] that allows him to seamlessly oscillate between various disciplines,

and to take diverging points of view. 'I actually never really separate those things: art, architecture, design and even curating,' he claims, 'to me they are just different angles or different ways to talk about the same things.'[4] Consequently, Ai's architectural practice cannot be considered in isolation, but has to be related to his larger artistic project, and especially his multifaceted collaborations, in order to reveal how these spheres of interest and action relate to one another and mutually inform each other.

While Ai Weiwei is predominantly known as an artist, his modus operandi does not differ much from the long-established currents of architectural practice. Collaboration is a key principle in all of his activities. The nature of many of Ai's projects and commissions – both artistic and architectural – transcends the scope and scale of the artefact crafted by an individual and consequently requires a significant level of cooperation, organization, and entrepreneurship. According to Ai, 'the most original thinking is done by individuals, whereas the most powerful object is

always created by collective wisdom.'[5] Not long ago, this conviction was manifested to an extreme in Ai Weiwei's *Sunflower Seeds* installation at Tate Modern, where he piled up over 100 million handcrafted ceramic sunflower seeds to an abstract, gravel-like, greyish surface.[6] While Ai is the mastermind behind this operation that critically reflects the iconic meaning of the sunflower as a representation of the cultural and political background of the Cultural Revolution, more than a thousand people in the city of Jingdezhen were involved in the careful and fully manual production of the seeds over the course of about two and a half years.[7]

Reflecting this monumental undertaking and its impact on the common perception of the artist as an individual creator, Andy Warhol's 'Factory', which pursued a 'highly social mode of production' by means of its rudimentary assembly line, immediately comes to mind.[8] Not only Ai Weiwei's work is based on such a division of labour; the Warholian approach to art production has set a precedent for a whole series of contemporary artists, including Damien Hirst, Olafur Eliasson and Carsten Höller, all of whom engage such experts as architects, engineers, physicists, and chemists, along with producers, publicists, or economists.[9] In many ways, such perfect orchestrations of intelligence, labour, and craft culminating in an exceptional work also correspond to an ideal definition of architectural practice. A 'fuzzy amalgamation of ancient knowledge and contemporary practice', as Rem Koolhaas once put it, architecture has to negotiate the knowledge and skills of a variety of individuals and fields with the socio-political, economic, and cultural demands of the real world.[10] Comparably, Ai's architectural projects and large-scale installations alike require a meticulous organization of planning and production processes and are dependent on a smooth interplay between all individuals and entities involved. Ai therefore not only acts as an artist and an architect, but also a manager, a businessman, and the director of a medium-size company that engages with cultural production. His position as a generator, initiator and delegator is also reflected in his indifference toward construction sites, which seems surprising from an architect's point of view: 'Most of the buildings are located within five minutes' walk of my place, although I never paid a visit to the building site during construction. The craftsmen understood the design and I know that they are doing things right.'[11]

The buzzing base of Ai Weiwei's widespread collaborations, the centre of operations and exchange, is his Studio-House located in Caochangdi, a village in proximity to the old airport expressway by the Fifth Ring Road in the north-east of Beijing. The central element of this compound is a large courtyard, which is defined by an enclosing wall, a small pavilion-like structure that serves as an office space, and the T-shaped main building that defines and encloses the back end of this space. This composition of well-proportioned solids and voids, and the monochromatic homogeneity of the exterior surfaces which are rarely punctured by apertures, as well as the central lawn which is flanked by bamboo and broad-leafed trees, form the stage for Ai's sweeping activities. From meetings with journalists, curators and clients, to social encounters with collaborators, colleagues and friends, to the assembly and at times museum-like installation of prototypes and artworks – as can be traced in a number of photographs published in catalogues – the house that was initially built as the artist's home easily adopted the character of a public space with Ai Weiwei's growing fame.

Without any architectural training, Ai supposedly designed this beautifully unpretentious brick construction in an afternoon, sketched it on a napkin without measurements, and had it built in less than 100 days.[12] The project, inspired by common vernacular architecture, is reduced to essential qualities of architecture; the main emphasis is put on proportion and materiality as the most basic ingredients. An exposed concrete frame, filled with

red brick on the inside and covered with a layer of locally fired blue-grey brick on the exterior, structures the house and provides the interior spaces with an open and permeable character. The comparatively rough construction, the basic details, and the selection of affordable local materials formed the precondition for this project to become an architectural prototype, adapted and transformed not only by Ai himself for such projects as the China Art Archives and Warehouse, Courtyard 105, Galerie Urs Meile, the Three Shadows Photography Art Centre, or the Red Brick Galleries (all located within walking distance in Caochangdi), but also copied and imitated by inhabitants of the neighbourhood.

Triggered by the design of the Studio-House, and with a growing number of architectural commissions, Ai eventually established an office called FAKE Design – in his typical way juggling with the English term for imitation and 'fa-ke', which in its Mandarin pronunciation sounds like 'fuck'. A perfectionist and an excellent critic, Ai immediately teamed up a group of highly skilled and devoted architects at his studio, which allowed him to take on a number of commissions in the immediate environs of his house and increasingly also at remote places in China and abroad, working on all scales from building to city to landscape. In parallel, Ai began to intensify architectural collaborations outside of his office, most notably his work on the National Stadium in Beijing and the Jindong New District with Herzog & de Meuron, and a continuing series of projects with Basel-based HHF architects.

The collaborative nature of Ai Weiwei's practice can probably be most literally traced in an ongoing project entitled the Ai Weiwei House. With the final goal to create a 'total work of art', each component of this project is developed within the confines of a precise field of action and held together by Ai's artistic and curatorial guidance. As opposed to the typical notion of the Wagnerian *Gesamtkunstwerk* – a concept established in the nineteenth century and adopted by a whole generation of architects including Henry van de Velde, Peter Behrens, Charles Rennie Mackintosh, and Frank Lloyd Wright – it is not the aim of the project to abolish 'a firm distinction between the frame and the artefacts being framed'.[13] It is in fact an attempt to precisely arrange and select spaces, objects, and artworks, with the intention to avoid an overdetermination of the interiors, and to allow for gaps, inconsistencies and interferences that potentially open up opportunities and refer to other universes. Ai Weiwei will be therefore collaborating with various specialists in different fields, from architecture to furniture and product design, to textile design and ceramics, among others, in order to create the individual components that in their entirety will constitute the Ai Weiwei House. The starting point of this project, that will potentially merge Ai's conceptual art and architecture practices in a way and on a scale unprecedented in his oeuvre, is the design of a series of residential buildings called Five Houses, which are conceived in collaboration with HHF architects. The proposed structures are based on the sequential repetition of a well-proportioned unit, a typology that can be found in earlier conceptions of both Ai and HHF. This consistent reduction to the most basic elements including light, space and proportion allows for a maximal flexibility and variability of the proposed buildings and forms the precondition for a successful amalgamation with the other artefacts.

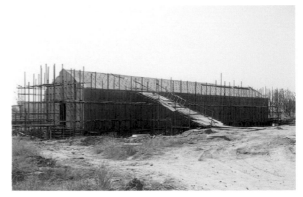

Neolithic Pottery Museum, 2002
Jinhua, Zhejiang Province, PRC

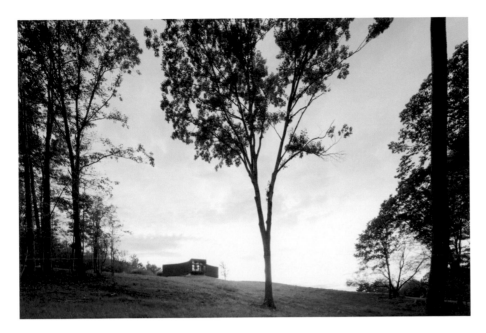

Guesthouse (Tsai
Residence), 2009
with HHF Architects
New York, USA

As the scope and nature of this project suggests, Ai Weiwei is a creator and editor of ideas, a visionary who collaborates with artisans, craftsmen, clients, and architects alike. In contrast to the prevalent image of the architect, Ai seeks control, but is not a control freak. He provides vessels for collaborative endeavours, however without ever fully occupying them himself. 'Instead of putting a personal mark on something, as an artist,' he once claimed, 'you set up a structure, you make room for possibilities.'[14]

Ai Weiwei's rise to international fame reads like a fairytale. While the reception of his work was rather reserved until the mid-1990s, he skyrocketed in the art market over the course of the past ten years. On the one hand, this unparalleled success is certainly based on Ai's provocative ideas, his perpetual output, as well as the previously mentioned open collaborative structure that allows him to engage on all scales; on the other hand it also has to be situated in the context of a world-spanning circuit of partners, collaborators, promoters, collectors, and friends. The notion of Marshall McLuhan's 'global village', based on an increased mobility and improved communication – this development is momentarily culminating in the broad dissemination of social networks such as Facebook, Twitter, or its Chinese equivalent Fanfou – is of course not unique to the art and architecture world, but it has clearly left its traces on the two fields. This increasing presence of networks can be observed in an inflationary production of art and architecture books, which leaves behind an imprint of relationships and flows of information, and in such international venues as the Venice Biennale, *documenta* in Kassel, or Art Basel, as incisive moments, in which collectors and clients, curators and academics, dealers and manufacturers, artists and architects are (voluntarily) exposed to one another in a temporal and spatial compression. In the emergence of Ai Weiwei's wide-reaching network, Switzerland interestingly occupies a prominent spot. In 1995, not long after his return from New York, Ai first met Uli Sigg, at the time Swiss ambassador to China in Beijing. At the same time, Urs Meile, a Lucerne-based gallery owner and good friend of Sigg, set up a branch in town and began officially to represent Ai Weiwei not long after. Sigg, perhaps 'the most important pioneer in exploring the potential of contemporary China', as the architect Jacques Herzog observed, eventually introduced Ai

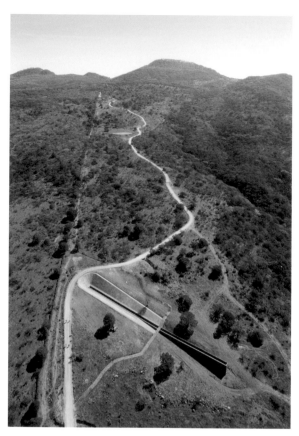

Sanctuary, 2010
Ruta del Peregrino
Estranzuela, Mexico

Ai's architectural projects and large-scale installations alike require a meticulous organization of planning and production processes and are dependent on a smooth interplay between all individuals and entities involved. Ai therefore not only acts as an artist and an architect, but also a manager, a businessman, and the director of a medium-size company that engages with cultural production.

to the late Harald Szeemann who then invited the artist to participate in the 1999 Venice Biennale.[15] What followed reads like a sequence of logical steps: under the directorship of Bernhard Fibicher Ai had his first solo show ever at Kunsthalle Bern in 2004, he took part at *documenta XII* in 2007, and installed a retrospective show entitled *So Sorry* at Haus der Kunst in Munich in 2009 – activities that are naturally all related to actors within Sigg's network.

Ai Weiwei's exchanges with Uli Sigg also had an impact on his architectural career. It was once again the former diplomat who arranged the first contact between the artist and Swiss architects Herzog & de Meuron, who had never travelled to China up to that point. Knowledgeable in Chinese art, architecture, and cultural history, Ai accompanied Jacques Herzog and Pierre de Meuron on a journey, which would also lead them to Beijing in 2002. In a last-minute decision they decided jointly to sign up for the competition for the National Stadium to be inaugurated on the occasion of the 2008 Olympics. Ai took on a consulting role during the competition and design phase of the structure, which was affectionately adopted by the general public as the 'Bird's Nest'. He was also strongly involved in the landscaping, as well as the strategies about how the work could be used and occupied as a 'public sculpture' also after this mega event.[16] About a year's time before the opening ceremony, Ai Weiwei officially disassociated himself from the project to protest against the abuse of art and architecture for purposes of political propaganda – after all, Ai claimed, he was initially hired by a Swiss architectural firm, not by the Chinese government.

Work on the stadium marks a first and formative architectural exchange, but it would not remain the only one. Earlier in 2002 the city of Jinhua commissioned Ai Weiwei to design the Ai Qing Cultural Park in honour of his father, a revered poet and painter, who was born in this town. Three years later, Ai was invited by the local authorities

to design an architecture park not far from the riverbank and the adjacent Jindong New District, a new urban centre proposed by Herzog & de Meuron. While he himself designed the beautifully archaic Neolithic Pottery Museum and the master plan and landscaping for the park, Ai Weiwei proposed to invite a handful of architects from all over the world to design a series of follies, each of which should not exceed a footprint of 100 square metres. Upon the recommendation of Herzog & de Meuron, who were of course asked to design one of the structures, Buchner Bründler, Christ & Gantenbein and HHF architects, three emerging offices from Basel, were also invited to propose a pavilion. Looking at the Jinhua Architecture Park project retrospectively, one could probably argue that it was a formative event bringing together a core group of offices that would also be involved in other projects in China and independently collaborate elsewhere.

ORDOS 100, in its nature a related project, was to be the first commissioned after Ai Weiwei's unexpected decision to abandon the practice of architecture. The way out of this dilemma for him was to operate on a curatorial level and to initiate a master plan that would bring together a bunch of youngsters to design the requested villas for wealthy people in this newly founded city in Inner Mongolia. Tying in with the collaborative effort for the National Stadium, Ai involved Herzog & de Meuron to compile a list of emerging practices from around the world. The group of architects invited consequently reads like a map of the personal, professional, academic, and geographic complexity of the office. From interviews and reported discussions, one has the impression that Ai Weiwei was more intrigued by the gathering of 100 emerging architects rather than the cumbersome act of turning this project into built reality. While it is unclear at this moment whether this luxury village will be ever constructed, there is absolutely no doubt that Ordos had a lasting effect as a social event and act of architectural marketing, and as an opportunity to connect the

world with China – many other independent initiatives involving architects of this particular group emerged in the aftermath of Jinhua and Ordos, most notably Ruta del Peregrino, a project based in Mexico and curated by Tatiana Bilbao and Derek Dellekamp.

Observing such professional gatherings and social occasions, it becomes clear that Ai Weiwei soon transcended his initial position as an individual actor within a larger network. He operates as an architect of networks, actively weaving, nurturing and orchestrating a dense mesh of individuals, offices, and institutions, rather than occupying a knot in it.[17] He understands himself as a mediator, who brings together a series of actors to accomplish a common goal. And finally, such venues as ORDOS 100 or *Fairytale*, Ai's contribution to *documenta XII* in Kassel, for which he brought 1,001 Chinese citizens as a 'socio-political readymade' to Germany, are also important opportunities to create awareness, and to broaden his platform for the dissemination of socio-critical and political concerns.

Considering the conceptual, curatorial, and political character of Ai Weiwei's activities, it seems astonishing that materiality is such a present issue in his work. In the context of widespread contemporary 'China-baroque' developments and the growing presence of an anonymous steel and glass curtain wall architecture in this country, the elegant simplicity and almost archaic appearance of Ai's projects for Caochangdi, built with ordinary materials and based on fundamental construction principles, appears to be surprisingly liberating. The series of buildings erected in the immediate environs of Ai Weiwei's home are proof of a good sense of materiality and proportion and illustrate his request for 'clarity, simplicity, straightforwardness, and accuracy when building'.[18] To realize both his architectural and artistic projects, Ai works with skilled artisans. Key to the success of these undertakings is the concurrence of Ai Weiwei's great trust in the intelligence of

his collaborators and a constant 'push of the boundaries of craftsmanship and artisanship', with the goal to 'see that they are not just mechanical skills but are actually an exploration of the very nature of the materials they employ, a challenging, a questioning of wood or stone materials'.[19]

Such experimentations within the strict confines of Ai Weiwei's highly controlled architectural vocabulary can be well traced in the Three Shadows Photography Art Centre, an institution for the exhibition and production of photography and video art, commissioned by Chinese photographer Rong Rong in 2006. Perambulating through the serpentine sequence of spaces that are all based on the same width, it is interesting to pay close attention to the building's seemingly banal concrete ceiling. Accentuated by the linear light fixtures, it appears that the supporting structure is not running regularly throughout the space. While the direction of the structure originates at the north-western facade of the building, running perpendicular to the brick wall in the northern gallery space, it joins the walls at a forty-five-degree angle in the southern exhibition space. This subtle shift of geometry with its surprising impact on the perception of the otherwise rather minimal space is typical of Ai's architectural sensibility. The previously mentioned challenge of craftsmanship can be traced in the same project, on the brick walls facing the triangular courtyard spaces. What from a distance looks like the rhizomatic structure of ivy, gradually overgrowing the wall, turns out to be a highly controlled relief composed of an impressive number of bricks that are individually positioned slightly off the wall's principle plane.

In various instances, a specific choice and particular display of materials provides Ai Weiwei with the possibility to broach the issue of historical value, to question authenticity, or to engage in interplay between original and replica. The sculpture *China Log*, for instance, is assembled from eight dismantled columns of temples from the Qing Dynasty (1644–1911) to reveal a void in the shape of China's borderlines. This over three-metre long *tieli* wood sculpture juxtaposes the still available craft of traditional wood joinery with a critical reflection of the blind destruction of cultural heritage in a time of sweeping modernization. *Fragments*, an installation assembled from remnants of historic temples and antique Chinese furniture, similarly addresses the radical social and cultural changes of this nation in a state of massive transformation. For his retrospective exhibition at Haus der Kunst in Munich – to introduce an example rooted in the European cultural context – Ai Weiwei created an artefact called *Soft Ground*, which could be regarded both as an artwork and an architectural prosthesis. Made up of almost a thousand tiles, this woollen carpet served as an identical replica of the main exhibition space's limestone floor, which was commissioned by Adolf Hitler and designed by Paul Ludwig Troost. Playing with the surprising material quality, the unexpected softness of a surface that our eye inevitably connotes as hard matter, Ai is creating awareness for an inconvenient past.

Similar to these works based on fragments of buildings or reacting to architectural conditions, a great number of Ai Weiwei's works are occupying the intersection of art and architecture, and thus allow a blurring of the boundaries between the two fields. While some of his artworks seem architectural in their expression or physical presence, some of his buildings suggest the abstraction of a well-proportioned sculpture without the pretension to control every single joint. The installation *Moon Chest*, for example, a series of three-metre tall, free-standing wooden chests, each of which is pierced with four circular holes, is ambiguous in its nature, combining aspects of minimal art and furniture design, and – dependent on the particular setting – demonstrating an impressive spatial and architectural presence. Such precise placements of well-proportioned units into a spatial progression inevitably evoke Donald Judd's

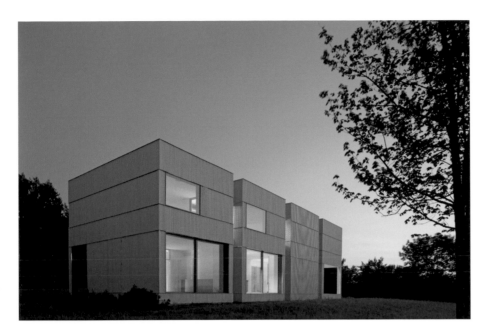

aligned, stacked, or at times cantilevered 'specific objects', three-dimensional artefacts derived from mathematical progressions that tend to eliminate the focus on composition and spotlight the object itself. Comparably, the Tsai Residence, composed of a sequence of four abstract, equally sized boxes sitting on top of a hill and surrounded by pastoral landscape, questions the common sense of scale. Are we looking at a sculpture in the field, or at a building? The abstract character of this first commission in the United States, and designed in collaboration with HHF architects, is additionally emphasized by means of a homogenous cladding made of steel sheets as well as large structural apertures.[20] Three recesses on either side structure the sequence of volumes on the outside and support their independent character. Inside, however – quite in opposition to Louis I. Kahn's famous Esherick House in Pennsylvania, which, though similar in appearance, is organized radically differently in the interior, programmatically separating the functions along the different sections of the house – spaces are organized according to light conditions and views, and (with the exception of the living room) unfold independently of the structure defined by the rigid outer form.

Shifting scales again, the Yiwu River Bank in Jinhua, with a total length of over two kilometres, is probably Ai Weiwei's largest and in its expression also most monumental work. Curiously, it can be perceived on two completely different levels: on the one hand, it is a massive infrastructural measure to protect the inhabited areas from flooding; on the other hand, these triangular, ziggurat-like bodies reaching out to the waterfront remind us of great Egyptian architectures and can be interpreted as a sculptural arrangement independent of scale. This detachedness from the human scale can be well traced in a frequently published photograph depicting two lonely people under a red umbrella sitting at the tip of one stair. Key to the abstract spatial appearance and the scalelessness of this architectural intervention is its realization in homogenous and monochromatic natural stone and without any traces of human occupation (such as handrails, garbage cans, plants, etc.). Over the course of the past decade, the urban scale gradually took on a more prominent role in Ai Weiwei's works. A series of photographs and videos captured along the ring roads of Beijing captures the rapid urban transformation of this megalopolis.

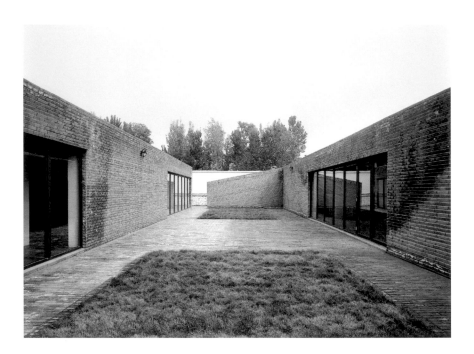

Even though Ai conceived these works with 'no documentary purpose' and without the intention to use them 'as evidence or testimony for anything, but rather to materialize our physical life', they will undoubtedly be important documents to witness the rapid and radical urban and social change in China.[21] The rapid process from existing city fabric to its demolition and the construction of new developments, for example, is recorded in a series of photographs entitled *Provisional Landscapes*, which were taken between 2002 and 2008. *Chang'an Boulevard*, to name another example, is a video project that documents a cross section through Beijing along an urban boulevard that demarcates the Sixth Ring Road in the east-west direction. Over the course of ten hours, this video captures one minute of daily life every fifty metres and in doing so documents the gradual transition from the periphery into the urban core of the city and outward again to the suburbs. Even more expansive in its character and epic in length (150 hours!), *Interval* is an attempt to map the entire city of Beijing, all the hutongs and streets, the entire network of public spaces, using video. It was produced over the course of sixteen days, without interruption, passing through different parts of the city by car, always filming through the windshield. According to Ai, the project shows 'how big, how impossible, how crazy this city is, or how meaningless at the same time, because our proportion, our sense of time, and also our visual contact with the city is really limited by where we are and which direction we go'.[22]

While reminiscent of the documentary character of Ed Ruscha's 7.6 metre long accordion fold-out entitled *Every Building on the Sunset Strip* (1966), which captures every single building along the road, the methodological approach of Ai's investigations could also be situated in the context of contemporary urban research. *Interval* clearly stands in the tradition of such urban analyses as Robert Venturi, Denise Scott Brown and Steven Izenour's *Learning from Las Vegas* (1972), which was the outcome of a research studio conducted at Yale University. Determined to capture the 'car-oriented landscape of "urban sprawl"', the architects drove along the Las Vegas strip, and documented their findings by film and photography.[23]

Tying in with this seminal study, visual media became central tools in more recent attempts to trace urban mutations, including Rem Koolhaas's *Harvard Project on the City*, ETH Studio Basel under the direction of Jacques Herzog, Pierre de Meuron, Roger Diener and Marcel Meili, or Stefano Boeri's network called *Multiplicity*. In opposition to most architectural investigations, however, Ai Weiwei's works are not the initial step toward an architectural proposal. Beyond its documentary character and independent of institutional expectations, commercial needs, and personal intentions, this cycle of works has the potential to carry a critical commentary on democracy, political power and land tenure in a rapidly changing urban environment.

Ai Weiwei's much-debated political engagement is not a recent phenomenon. As is well known, his childhood as a son of poet Ai Qing – probably one of the first politically disavowed intellectuals in China – was highly saturated with politics. From 1981 to 1993 Ai Weiwei lived as an independent artist in the United States, where he was exposed to the works of Marcel Duchamp, Jasper Johns, and Andy Warhol, artists that would strongly affect the direction of his own work. During this stay far away from the shaking events in Tiananmen Square in the early summer of 1989, he expressed his antagonism in an eight-day hunger strike.[24] More recently, Ai demonstrated his concern with civil society in China by means of a series of campaigns on his blog, which was declared to be one of the 'great social sculptures of our time' in the West and considered an inflammatory source in China – a contradiction that underlines how the artist occupies quite diverging roles in the Western and the Chinese cultural spheres.[25] After Ai's investigation of the 2008 Sichuan Province earthquake, an engagement that lead to the campaign *Citizens' Investigation*, for which he initiated a survey of 150 schools in 74 towns to recover the names and birth dates of more than five thousand children who were lost under collapsing, ill-constructed school buildings, his blog was shut down

by Chinese authorities. Continually broaching issues related to democracy, and fundamental human rights – he now used multiple identities to disseminate his messages – Ai Weiwei remained on the radar of the government officials. Following a first house arrest in late 2010, Ai's Shanghai Studio was torn down earlier this year [2011], and he was arrested and detained by the authorities, as part of a crackdown on intellectuals and pro-democracy activists. Not long before this article was finished, Ai Weiwei was been released after more than two months in detainment; however, he may currently not travel nor talk to journalists, he is restricted from using the internet, and has to limit his contact with foreigners.

When Ai Weiwei began to engage with architecture, he must have envisioned the possibility of initiating social change by means of building. He soon had to realize that political activism is currently quite unusual in the field of architecture and that the possibilities have changed since the early postwar years when architects were engaging at the core of societal rifts, advocating the manifestation of democracy, or the uprisings in May of 1968, which brought up issues of participation and also left their traces on architectural education. The Olympic stadium was one of Ai's last official engagements with architecture. He finally returned to his art almost exclusively, and began to engage more intensely with social media such as Fanfou and his blog, which – as the democracy movements in North Africa have shown – are more explosive political vessels than the act of building: '[Twitter or Fanfou] is like a public square. It's like being in Tiananmen Square, talking to everybody.'[26]

Spatiality, as this quote suggests, is not only inherent to Ai Weiwei's architectural projects, but a critical component of all of his endeavours as it allows him to provide his investigations and campaigns with a graspable and easily understandable material presence. By means of his activities on the internet as well as his art, Ai is persistently trying to organize

people into a community. Even if the web offers a forum as effective as a large public square, it lacks its physical existence: while there was much opposition to the demolition of Ai's Shanghai Studio in virtual space, it was the actual gathering of his supporters, which followed an invitation posted on Twitter to join him on site to celebrate the River Crab Feast, that caused a great stir. Similar to the iconic stubborn nail houses, the Shanghai Studio became a symbol of political resistance, which effectively communicated – at least to the Western world. Architecture in the broadest sense of its definition clearly occupies a prominent spot in Ai Weiwei's multifaceted oeuvre. The consideration of both artistic and architectural projects makes unmistakably clear that his way of perceiving the world is not too dissimilar from that of many architects. Nevertheless, he has claimed for years that he will eventually turn his back on architecture, which, as he once observed, 'is so much about the human and I will always love it and I will always be tempted. But dealing with temptations, maybe that is the most difficult part.'[27]

1. 'I have no fascination left for architecture. By doing about sixty projects, large and small, architectural design, urban design, interior design or even furnishing, I have a complete view of it already. I don't have to do yet another project. I have to find something else.' Interview: Mathieu Wellner with Ai Weiwei, *MonoKultur*, no.22, Autumn 2009, p.40.

2. http://www.artzinechina.com/display.php?a=180, accessed 26 May 2011.

3. http://www.economist.com/blogs/prospero/2011/04/qa_1, accessed 27 May 2011.

4. Interview: Lee Ambrozy with Ai Weiwei, *Icon*, no.93, March 2011.

5. Wellner with Ai 2009, p.22.

6. *Sunflower Seeds* was on view at Tate Modern in London from 12 October 2010 to 2 May 2011. It was featured as the eleventh commission in the Unilever Series.

7. Juliet Bingham (ed.), *Ai Weiwei: Sunflower Seeds*, Tate Publishing, 2010, p.101.

8. Caroline A. Jones, *Machine in the Studio*, University of Chicago Press, 1998.

9. See: Germano Celant, 'Art & Project', in Patsy Craig (ed.), *Making Art Work*, Trolley, 2003, p.15.

10. Rem Koolhaas and Brendan McGetrick (eds.), *Content*, Taschen, 2004, p.6.

11. Eduard Kögel, 'Conversation between Ai Weiwei and Eduard Kögel, July 2007', in Eduard Kögel (ed.), *Ai Weiwei: FAKE Design in the Village*, Aedes, 2007, p.8.

12. Kögel 2007, p.4.

13. Mark Wigley, 'Whatever Happened to Total Design?', *Harvard Design Magazine*, no.5, Summer 1998, p.1.

14. Christina Bechtler (ed.), *Art and Cultural Policy in China: A Conversation between Ai Weiwei, Uli Sigg and Yung Ho Chang*, Moderated by Peter Pakesch, Springer, 2009, p.109.

15. Ai Weiwei and Jacques Herzog, 'Concept and Fake,' *Parkett*, no.81, 2007, p.129.

16. Ai and Herzog 2007, p.126.

17. Wellner with Ai 2009, p.22.

18. Ai Weiwei, 'Architecture and Space', blog entry posted on 13 January 2006, published in Lee Ambrozy (ed.), *Ai Weiwei's Blog: Writings, Interviews, and Digital Rants, 2006–2009*, MIT Press, 2011, p.6.

19. Ai Weiwei, as quoted in Mori Art Museum (ed.), *Ai Weiwei: According to What?*, Tankosha, 2010, p.25.

20. Artfarm, Salt Point, NY (2006–2008), Tsai Studio, Ancram, NY (2009–2011), and some of the Five Houses might also be built in the United States. All these projects are collaborations between Ai Weiwei and HHF Architects (Tilo Herlach, Simon Hartmann, Simon Frommenwiler).

20. Adrian Blackwell and Pei Zhao, 'Ai Weiwei. Fragments, Voids, Sections and Rings', *Archinect* (blog), 2006, http://http://archinect.com/features/article/47035/ai-weiwei-fragments-voids-sections-and-rings, accessed 9 October 2013.

21. See also: Mori Art Museum 2010, p.139.

22. Blackwell with Ai 2006.

23. Martino Stierli, 'The Invention of the Urban Research Studio: Robert Venturi, Denise Scott Brown, and Steven Izenour's Learning from Las Vegas (1972)', in: Reto Geiser (ed.), *Explorations: Teaching, Design, Research*, Birkhäuser, 2008, p.48. For a detailed account on *Learning from Las Vegas* see also: Martino Stierli, *Las Vegas im Rückspiegel: Die Stadt in Theorie, Fotografie und Film*, gta Verlag, 2010.

24. Ambrozy 2011, p.xix.

25. Hans-Ulrich Obrist, quoted in Wellner with Ai 2009, p.5.

26. Wellner with Ai 2009, p.5.

27. Wellner with Ai 2009, p.40.

This article originally appeared in Yilmaz Dziewior (ed.), *Ai Weiwei: Art/Architecture*, published by Kunsthaus Bregenz in 2011.

THE NUDGED VERNACULAR

Anthony Pins

The notice that filtered through Caochangdi on 16 April 2010 carried with it news of the village's fate. Printed on a single sheet of government stationery and affixed with a dated stamp – the requisite marker authenticating all official correspondence – its tone and brevity scantly acknowledged its own implications. In a detached, laconic prose, the letter read simply: 'With the fast proceeding of the urbanization process, our village has been listed as an area for demolition and removal. The concrete timing is not yet determined.'

As one of many villages to receive notice of a similar demise, the letter's contents were hardly unexpected. Caochangdi's endangered status had long been rumoured as Beijing's outward growth consumed what was once considered the city's far periphery. Among the 300 or so similarly autonomous settlements scattered about Beijing, Caochangdi was neither the largest, nor did it occupy a particularly strategic locale for real estate speculation. It was, however,

home to the artist Ai Weiwei and to the vibrant microcosm of artist studios and galleries that had emerged over the previous decade.

Since 1999, when Ai Weiwei established his studio in Caochangdi, the village has revealed itself as one of China's more compelling social experiments: a heterotopic menagerie of artists and taxi drivers, migrant workers and cultural tourists, all coexisting in a zone legally independent of the city, yet physically subsumed within its borders.[1] Caochangdi is a *ziran cun* – 'natural village' – a distinction that marks its autonomous status from the top-down planning of administrative villages and socialist public ownership of Chinese urban land.[2] Though officially home to only a handful of locals, the village is chiefly occupied by a fluctuating population of 4,000 to 7,000 illegal residents. This population is comprised mostly of rural migrants living outside their *danwei*, or work unit, who live inexpensively in small single-room apartments while hoping to fulfil the promise of urban upward mobility.

Like many urban villages, Caochangdi has found itself in a perpetual state of tension. Under constant threat of being 'renovated', these longstanding settlements have been described by *Xinhua News* – the veritable mouthpiece of the Communist Party – as 'an unharmonious phenomenon' whose resistance to demolition has 'taken on the form of a malignant cycle: every time rumours of demolition go round it sets off a surge of illegal construction, making demolition even harder and development and transformation even slower'.[3]

Until these villages pose as obstacles to the government's real estate agenda, they remain largely outside of official overview, allowing lightly constricted forms of culture to emerge. It is no coincidence then, that while Ai Weiwei claims over eighty architectural commissions, his most significant projects are located within a few hundred metres of his front gate. These defiant structures, which are built without permits or land title, exist only through informal agreements with the landowners and the permission of village authorities. It is an architecture that is staunchly opposed to the towering monotony of high-rises erected as a result of the state-enabled real estate boom. It also stands firm against the domestic propensity for reductive historicism. Instead, Ai's architecture takes note of its village surrounds, adapting its material palette and modest formal manoeuvres into austere brick volumes. Appropriating vernacular techniques from local tradesmen, he recasts conventional construction methods as a critical architectural language. By the very strength of this language, and its very origins from within the village, the ethos of Ai's architecture has endured beyond the termination of his design practice in the form of copycat architecture: direct reproductions of his own buildings by local villagers.

ARCHITECTURE AND POWER SINCE 1949
Given the intensification of Ai Weiwei's political involvement over the past decade, architecture might appear to be a curious activity for the artist to have dedicated such extended thought and effort to. The profession is frequently deployed as a lubricating agent, enabling ideologies and regimes; it is neither a hospitable environment for the righteous nor a facile medium for insurgency. Architecture has, for the majority of its history, been a disciple in service of those in power, attainable to those able to mobilize the labour, resources, and capital necessary for its realization.[4] As edifices of culture, buildings are communicative enterprises, reflective of the Foucauldian power-knowledge relationship asserting one's power agenda through its inscription into physical and spatial matter.[5] In its visual appearance, a subject frequently derided as trivial or reduced to the mutable realm of taste, architecture presents a sometimes subliminal but often quite overt assertion of values, control and desire – the will of its builder-patron – on to a passive and unsuspecting public.

Ai Weiwei has long recognized these stakes, claiming in one of his oft-repeated quotes, 'architecture is evidence of aesthetics; it shows your attitude'.[6] Well-versed in its political symbolism, he first articulated his disdain for architecture's reinforcement of hegemonic authority in his initial *Study of Perspective* (1995–present), a well-publicized series of photographs depicting the artist raising a choice finger to global icons of power. Yet, buildings themselves cannot give the middle finger so easily as they can receive it. Entering the professional service of architecture requires the acceptance, or at least endurance, of the architect's Faustian bargain: a reciprocal if sometimes uncomfortable relationship to power that constitutes a necessary act of self-preservation. Operating under traditional models of patronage, even the calculating architect may eventually find his or herself cast in the mould of Roberto Unger's 'businessman-artist':

The small percentage of buildings that reach for distinction continue to be built by businessmen-artists who sell promises of contained destandardization and value-enhancing

refinement in exchange for money and fame. These men (for they obviously are men) must, to be successful, find undisturbing ways to surprise. Held in the golden chains of patronage, even the most exacting architect finds himself driven to solutions conforming to established arrangements rather than announcing and enabling alternative ones.[7]

Until recently, the possibility for such alternative arrangements – architectural forms or situational spatial programming intended to invigorate a dormant public – could not be imagined in China, where the state and Chinese architectural practice shared a simultaneous objective. Reflecting Chairman Mao's statements at the 1942 conference in Yan'an, the communist revolutionary spirit was inscribed not only in the planning of Chinese cities, but also in its architectural forms. Shortly after the ascendancy of communism, private architectural practice was absorbed and redirected in service of the state through the formation of official design institutes embedded in the university system. A nationalist style emerged, girded by the belief that a political and ideological confrontation with bourgeois capitalism was a necessity. It was designed to hold at bay the imperialist and colonizing ubiquity of the Western 'International Style'.[8] Outlining nine features of the modern Chinese architectural tradition, the new language focused heavily on principles of 'translatability' and applicability to forms that could transcend the limitation of materials. This new grammar privileged features of Chinese distinction, placing chief importance on an overall silhouette that could be enlarged or contracted to fit a given site without losing its essential iconography. As a result, nationalist architecture tended toward brute Soviet-derived monumentality, ornamented with traditional Chinese forms, none more prominent than the large tiled roof with upturning eaves.[9] Reinforced by colour motifs and other decorative appliqué stemming from ancient temple design, only secondary and tertiary importance were ascribed to the proportion

and order of the building's constitutive parts. Effusive nationalist pride would wear thin as the subsequent realizations of the Great Leap Forward and the Cultural Revolution brought harsh condemnation of intellectuals and crippled the country with famine and poverty. Mao's death in 1976 signalled not only the end to the most ruthless forms of censorship and authoritarian control, but also a shift toward more open exchanges with the West. However, the pro-industrialization policies of the Deng era reforms and the 'get-rich-first' capitalist hybrid only ushered in new forms of suppression. These replaced the heavy hand of authoritarian control with a slightly more delicate touch. Using the promise of wealth to quell the most vocal forms of dissent, Deng and his colleagues saw economic development and the growth of a prosperous class as keys to controlled change, one that would preserve the Party's position of power. Vital to this transition was the reclamation and destruction of existing urban neighbourhoods, feeding the speculative real estate economy and the hunger of its burgeoning construction industry. In theory, newly erected housing was designed to accommodate the influx of rural workers who poured into the city; many ultimately found work as construction labourers, building the very buildings that were supposed to house them. Recasting the Chinese urban landscape in a series of banal towers, repeated across an undifferentiated ground plane, the new high

The profession is frequently deployed as a lubricating agent, enabling ideologies and regimes; it is neither a hospitable environment for the righteous nor a facile medium for insurgency. Architecture has, for the majority of its history, been a disciple in service of those in power.

Courtyard 104, 2005
Caochangdi, Beijing, PRC
Under construction

rises were cheap, privatized, and impersonal. It was a wholly new urban paradigm, emblematic of the socialist market economy, which Chinese architect Chang Yung-Ho defined as the object-building landscape:

> On top of the flat city, the city of objects is built. This is a city that is transformed into an urban field that displays freestanding, figurative, trophy-building-sculptures with a neglected, disorganized or damaged fabric or simply without one. Architecture is collected to assume the role of the trinkets that fill up Chinese treasure shelves.[10]

With the reinstatement of the private architectural practice in the mid-1990s, China has witnessed a third, yet related development in the emergence of formally complex signature buildings designed by native-born architects. Rather than a repetitive series, the new, novel forms of these buildings are one-offs: unique propositions that are nonetheless placeless in their relationship with the surrounding urban context. Given their Chinese clients' predominant concern with icon and image, this architecture is made possible by its very radical nature; it engages in a formal one-upmanship, dedicating little consideration to conceptual or functional concerns. The emphasis of this most recent wave has been one of national pride: global-calibre architectural talent has emerged indigenously. However, with notable exception, the designers now staking claim to China's architectural soul do so only through the lightly concealed imitations of Western architecture, a design ideology simultaneously decried for its architectural imperialism. In doing so, these designers – themselves products of the Western academy and of Western professional pedigree – have staked little new ground to stem the encroaching tide of globalization's cultural conquest.

An initial schematic drawing of the ground floor plan of the Palais Stonborough in Vienna, Austria, by Paul Engelmann

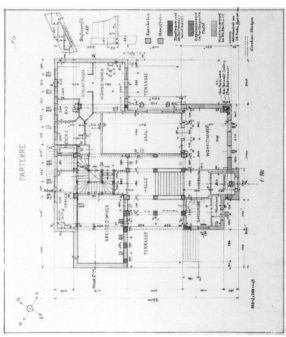

The floor plan for the Palais Stonborough's ground floor as finalized by Ludwig Wittgenstein and completed in 1926

For Ai Weiwei, the physical products of rapid urbanization and the state-controlled cultural sphere pose significant moral and ethical issues.[11] Having lived through both the failed experiment of a Marxist social utopia, and the more recent hybrid of the socialist market economy, his architectural career can be understood in contradistinction to the architectural developments that have accompanied China's political transformations. His modestly constructed, small-scale buildings can appear emphatically neutral, their restrained formal expression supposing no pretensions or adversarial content. Yet in the Chinese context these buildings are highly charged, their simplicity a simultaneous antidote to globalization's marginal cultural output as well as homegrown historicist tropes. In his preference for unadorned, flat-roofed geometries, Ai resists the didacticism of an essential 'Chineseness' in early communist architecture, providing a clear rebuke to, 'those people who still speak of roof tiles, roof brackets, and mortise-and-tenon frameworks'.[12]

The grey brick with which Ai frequently constructs his buildings is strong, tangible and inexpensive. These material qualities that are distinct from the concrete-and-curtain wall construction of high-rise developments that are often characterized as thin and cheap. Even the very notion of spatial refinement, to which Ai ascribes primary importance, can be understood as the expression of an architectural ethos. Resistant to both the malleable architectural silhouette of tradition and reductive efficiencies of tower developments, Ai's understated architecture brims with symbolic content and possibility.

VIENNA, BEIJING: A CENTURY APART
To hear Ai tell it, the twelve years he spent in New York was a period in which he managed to accomplish little of anything. In 1993, following news of his father's failing health, he returned to Beijing no more successful an artist than when he'd left.[13] Moving to the United States had been a necessary escape, providing both physical and psychological

distance from the traumatic events that had shaped his native country and his early life. Recalling this period of time immediately after Mao's death, Ai says, 'I was very disappointed because the nation had just been through a terrible period in its history and no one dared to question what had just happened to us. For me it was unbearable.'[14] In New York, critical reflection was less important than engaging in the city's cultural vibrancy. Amid the bleak milieu of early-1980s New York, Ai thrived, photographing alternative culture and social unrest. He resumed artistic training, first for a semester at the Parsons New School of Design, and briefly at the Art Students League. Later, he directed his studies by attending exhibitions at almost every gallery throughout the city. Ai developed an affinity for Jasper Johns, Marcel Duchamp, and Andy Warhol, attracted to the hybrid of irreverence and critique characteristic of pop and dada. It was a revelation that provided the artist with a means for disengaging from the historical complexity of his native country, arenas in which he would flourish.[15]

In terms of his architecture, however, Ai's time abroad would prove to have a considerably narrower influence, save for an important encounter with an out-of-print book about the Palais Stonborough, the house that the philosopher Ludwig Wittgenstein designed for his sister in 1926. The black-and-white plates displayed Wittgenstein's proportionally refined sensibilities, images which reflected both the Viennese avant-garde's stripped-down anti-ornamentalism along with the philosopher's own concern with precision, austerity, and spatial clarity.[16] In the high contrast images of the house's interior, the dramatic control of light and shadow undoubtedly resonated with Ai, who could now anticipate the strategic use of fenestration to be later employed in his village buildings. Though strained in its efforts at perfection – Wittgenstein is famous for having the completed first-floor ceiling raised by nine centimetres in order to achieve the precise interior proportions he desired – the house's

Studio-House: Site and first-floor plan
Caochangdi, Beijing, PRC

balanced and symmetrical composition evokes a minimalist spatial composition that is likewise a key trait of Ai's buildings. Noting this similarity, Ai nonetheless regards Wittgenstein's obsessiveness as 'very extreme', drawing a distinction between the two: 'On the one hand, my buildings are precise in their proportions. I'm quite picky about my building's spatial qualities. On the other hand, I'm quite loose about monitoring their construction.'[17]

It is hardly coincidental, though, that Ai's Studio-House in Caochangdi shares considerable similarities with Wittgenstein's Palais Stonborough. The likeness of the two houses is most evident in the comparably sized T-shaped footprints, the arrangement of the first-floor plan and the configuration of the

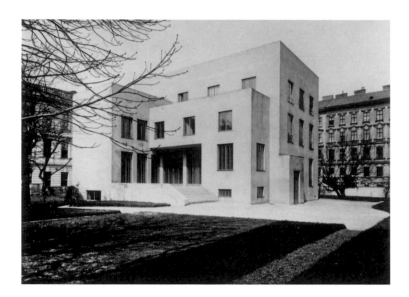

Palais Stonborough, 1926
Designed by Ludwig Wittgenstein

site. Flanked on either side by outdoor terraces, the Stonborough's broadside approach through a naturalized garden is mimicked in Ai's adaptation of the traditional Chinese courtyard. Approached from the south-west, photographs of Wittgenstein's house suggest an intuitive path of entry not to the main entrance, which is diminutively proportioned on the front facade, but to the south-western terrace leading into the main dining space. Ai's Studio-House functions exactly this way, except that the terraces are recast as patios at grade: well-used and communal on the house's front side, and enclosed for privacy at back. The elimination of Wittgenstein's processional entry hall allows Ai to reorganize the Stonborough's salon and living room into a single, large studio occupying the entire east wing of the house. Auxiliary spaces, including the home's bathroom, kitchen, office, and guest bedroom, are shifted against the western wall in much the same fashion as the Stonborough, as is the main staircase, reflecting the plan of an earlier iteration of the house also contained within the Stonborough book.

Interestingly, the similarities between Ai's Studio-House and the Palais Stonborough suggest less of an architectural affiliation with the philosopher than they do with the architect Adolf Loos, a seminal figure in Vienna's cultural sphere in the 1920s. Though it has been suggested that Loos' architectural ideology had only a minimal effect on Wittgenstein's sensibilities, the house nonetheless bears a strong resemblance to the European early-modernist avant-garde to which Loos was a leading contributor as an educator, practitioner and critic.[18] At the Palais Stonborough, Loos' influence is not immediate but instead arrives in the form of another architect, Paul Engelmann, a star pupil of Loos' Bauschule. Engelmann was originally commissioned as the Palais Stonborough's architect and developed the original floor plans that Wittgenstein later adapted.[19] Though he eventually surrendered the commission to Wittgenstein after the philosopher showed an almost maniacal interest in the project, Engelmann's hand is still identifiable and exhibits Loos' noteworthy teachings.

As an indirect but influential forebear, the scope of Loos' career is also interesting in that it anticipates Ai's use of architecture as both a design practice and a disciplinary framework for cultural critique, one frequently espoused in writing. Loos' rhetorical gifts as an author and his penchant for alternating a biting, underhanded wit with forceful eloquence were almost as significant as his architectural

contributions. His attention often roamed far from topics of architectural concern to address political, social, and culturally relevant concerns. The blog that Ai Weiwei maintained from 2006 until 2009 resembled much of Loos' published criticism. In Ai's 'N Town', an entry similar to Loos' 1898 essay, 'The Potemkin City', the two critics are allied in their distaste for the materialism and self-deception attendant on the recent emergence of the bourgeoisie. Where Ai criticizes Chinese cities for 'striving to dress themselves up, as if they are rushing to attend a lavish masquerade ball', Loos accuses the Viennese of 'trying to make someone believe they have been transported to a city inhabited by no one but the nobility'.[20] For each, dialogue represents an important facet of their practice, serving to explicate architectural tendencies and positions to which the buildings

architecture's austere and proprietary relationship to the public realm. In this approach, the architects deal separately with the exterior and interior conditions of the home, segregating intimate and social realms. In his seminal essay, 'Ornament and Crime', Loos argues that 'the evolution of culture is synonymous with the removal of ornament from objects of daily use'.[23] His aversion to architectural appendage stemmed from a belief in the economy and the integrity of practical objects. These practical objects, which included architecture, should subject their form and appearance to the laws governing its most basic purpose, the *Sachlichkeit*, imposed by the principle of utility.[24] Loos' preoccupation with architecture's utility – to provide shelter and an enclosed sense of comfort – is reiterated in Ai's simple forms and implied condemnation of historicist nostalgia. Regarding such flourishes as unnecessary and superficial, Ai positions himself as a staunch essentialist, believing that 'architecture has always been, and will always be, one

This nation, whose architectural output has in recent years surpassed the sum total of all its architectural output in the course of its several thousand years of cultural history is currently, in every domain, displaying all the elegance of a famished beast.

themselves cannot directly speak. In another essay Ai extends his criticism beyond the broad realm of culture to describe architecture's specific role within it. There, he notes that while China's 'architectural output has in recent years surpassed the sum total of all its output in the course of its several thousand years', its architectural appetite has nonetheless displayed, 'all the elegance of a famished beast'.[21] Loos, meanwhile, found Vienna appropriately suited to the architects of his day. He derisively extended an invitation to 'all you champions of imitation, you creators of stenciled inlays, house-ugliful windows and papier-mache tankards'. In Vienna, he claimed, 'the ground has been freshly manured'.[22]

Against these backdrops of materialism and excess, Ai and Loos, separately and in their own way, propose

of humanity's basic activities. This basic activity has moved, and will always move, in tandem with humanity's basic human need for survival.'[25] As a form of dialogue – a theme that has always been central to Ai's production – the unexpressive facades of Ai's architecture are notably mute. This intentional silence, too, is reminiscent of Loos, who implored: 'the house does not have to say anything to the exterior [public]; instead, all its richness must be manifest in the interior.' In the context of Chinese authoritarianism and the not-infrequent censorship of individual expression, Ai's reiteration of Loos' public moralism gives even greater purpose to the plain architectural facade as a form of mask, behind which the individual may retreat in order to preserve a sense of self. Though in primitive societies the mask gave social identity to its bearer,

the French philosopher Hubert Damisch has noted that modern man uses the mask to conceal any difference, to protect his identity.[26] Utilizing a similar concept in his designs for studios and residences in Beijing, Ai's architecture can be interpreted as the creation of spaces in which freedom of personal expression, self-determinism and singular intellectual power are allowed to prosper unhindered.

Contrary to popular criticism, the desire for external modesty and restraint is not suggestive of a lifestyle emptied of personal expression, but rather, the accentuation of individuality within the domestic interior. Although Ai shares Loos' notion that the architect's general task is to provide a warm and livable space, he does not believe, as Loos does, that the role of the designer penetrates the home.[27] Architectural historian Beatriz Colomina notes that in Loos' buildings, 'the interior is pre-Oedipal space, space before the analytical distancing which language entails, space as we feel it, as clothing; that is, as clothing before the existence of readymade clothes, when one had to first choose the fabric.'[28] Customized and idiosyncratic, an architect in the Loosian mode served in the role of a tailor, outfitting the interior with the spatial comfort and utility defined by the particularities of their client. His *Raumplan*, a series of cubic volumes arranged to accommodate these needs, varied in spatial proportions and enclosure, and through the arrangement of built-in furniture always oriented the occupant inward. This inward orientation is not dissimilar to Ai's homes, which remove the possibility of the outward gaze through the sparse fenestration. Lit primarily from above, Ai's interiors are not tailored living spaces, but instead provide an opportunistic platform for living.[29] 'My design has a special characteristic: It has leeway and possibility,' Ai says. 'I believe in this freedom. I don't like to force my will upon other people, the ways you allow space and form to return to its fundamental things thus allow for the greatest amount of freedom.' Placing primary importance on the flexibility of the

space within – a characteristic especially crucial given the frequency of artist residents – the interior is conceived as an inhabitable shell, one in which space can be infinitely configured to the inhabitant's changing needs and desires.

THE NUDGED VERNACULAR
The ideological similarities between Adolf Loos and Ai Weiwei elucidate some pervasive forms of critical architectural response to the social and cultural transformations spurred by modernization. Though both are inherently progressive, intent on developing new architectural potential and forwarding social priorities in favour of a freethinking public, the two architects differ insofar as Loos' architecture was a virtual blank slate and a radical departure from Viennese classicism. In constructing an aesthetic appropriate to modernity, Loos' practice necessitated a critical break from the past as well as from contemporary modes of design.

Ai's architecture, on the other hand, has a clear precedent in the building practices of Caochangdi. Turning inward and developing an architectural language from within native modes of building, Ai's architecture remains rooted in the very society he hopes to effect. For nearly a decade, Ai's architectural production in the village explicitly reflected what he had expounded in both his writings and interviews: that architecture could be essential and humane, contemporary without technological fetish or formal excess, vernacular without nostalgia, and poignantly critical through its very restraint and material selection. Indeed, by adopting techniques native to village construction, Ai demonstrated that he could produce a contemporary architecture that opposed contemporary trends in Chinese architectural production, while remaining firmly within a Chinese cultural tradition. Unified in a consistent formal and material language, his buildings use brick facades, concrete post-and-beam structures, precast concrete floors, and minimal fenestration, all formal decisions

Courtyard 104, 2005
Caochangdi, Beijing, PRC
An interior space lit from a
single window

that echo their village surroundings. Ai's rough but intelligently constructed buildings exhibit an approach that not only resolves architecture's pragmatic necessities, but also demonstrates an authorial modesty which leaves the resolution of construction details to be executed by his craftsmen. With only a general set of instructions, the making of each of his buildings played out in exclusive accordance with the knowledge of on-site builders.

Ai's reliance on local trade expertise reiterates his use of architectural process as a critical medium. It reflects a small but increasingly notable regional focus in Chinese architecture that is inherently sceptical of the homogenizing influence of global culture. Evident in the work of Chang Yung-Ho, Liu Jiakun, Ma Qinyan, Zhang Lei, and Wang Shu – China's first domestically trained recipient of the Pritzker Prize – the basic posture of this architecture is demonstrated to varying degrees, in which the notion of regionalism is applied as 'a concept, strategy, tool, technique, attitude, ideology or

habit of thought'.[30] The work of these designers is distinct from a vernacular architecture insofar as each architect exerts authorship over the forms and techniques considered native to a particular place. Nonetheless, this approach demonstrates a keen awareness of climactic considerations, material availability, and the tradecraft necessary to ply local resources into inhabitable structures that have emerged through repetitive practice over time. Elevating these traditions into a contemporary aesthetic, this emerging brand of architecture reasserts the primacy of cultural and regional difference. Critical value is derived through the utilization and accentuation of techniques, materials, and traditions. Combined, the strategies abet alternative economies and distinct lifestyles, simultaneously opposing the placeless and the banal.

Any number of Ai Weiwei's projects in Caochangdi would provide persuasive evidence of such architectural inclinations, but perhaps none more so than a pair of buildings that Ai constructed

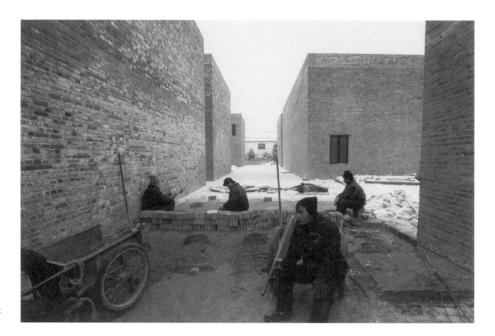

241 Caochangdi, 2007
Beijing, Caochangdi, PRC
Masons install the brickwork
ground surface

on adjacent plots for his friend and local builder
Mao Ran. The first was a renovation of a small
courtyard complex consisting of single-storey
office buildings and a narrow warehouse. The
other was a vacant site to the north, programmed
for artist studios. In these two projects, known
as Courtyard 105 and Courtyard 104 in reference
to their village addresses, Ai demonstrates the
range of methods by which he roots his buildings in
Caochangdi's indigenous, low-resolution culture.

In each, Ai takes up the courtyard building – a type
historically identified with the *siheyuan* houses
of Beijing's central hutong neighbourhoods – as
the primary organizational approach to the
site. Reorganizing the U-shaped Courtyard 105
around a series of stoic volumetric insertions, the
rectilinear geometries of the new studios reinforce
the interiority of the courtyard by shielding the
central spaces from outside view. The primary
addition, taller and more slender than the rest, is
aligned with the entry gate to function as a veil,
recalling the blank privacy walls of misaligned entry
portals in the *siheyuan* gatehouses. In Courtyard
104, this technique is employed to similar effect,

using an entry into a long, vacuous space that
serves little social function. Beckoning without
hinting at what lies at the centre, the complex
slowly lures its guests inward, bringing them to
a central condensed courtyard. Here, the four
studios mediate the conventional Chinese building
form that frames the interior communal space
with the geometric complexities of the site, taking
on a posture that both resembles and affirms the
architectural disposition of the village beyond.

At Courtyard 105, Ai imposes a new material language
atop the weathered concrete of the original walls.
Utilizing common grey brick, the material palette
is ascribed a symbolic value beyond its basic
utilitarianism. The brick is neither structurally
necessary nor required to mediate the existing
walls with Ai's volumetric insertions, yet it is still
present. Imbuing the brick with an elevated material
value, Ai seems to alert the local populace to the
loss of place, community, and identity. For scholars
Tzonis and Lefaivre, such an approach seems to
be intended to 'prick the conscience' into thought
and action. Concealing an existing structure, and
thus performing an act of defamiliarization, the

new building challenges 'not only the established actual world but the legitimacy of the possible world view in the minds of the people'.[31]

Though symbolic, the brick is not a docile material. The inherent variation of each brick is accentuated in Ai's architecture, where its clean, geometric edges are cut and marred with meaningful imperfection. In a conscious effort to enhance his architecture's tactility, Ai positions his work as an opposition to the building as mere imagery. Luring visitors to touch and feel, to experience the architecture in all its physicality, Ai pushes against the fashionable trend of image-making. This is made even more explicit at Courtyard 104, where red bricks are interspersed throughout the grey facade for greater compositional variation. Accentuating the perception of depth and tactile qualities, the scrapes, shallow divots, and rounded deformations resist the flatness of a monochromatic facade.

Ai's embrace of materiality allowed not only greater meaning, but also the possibility of architectural imitation. As Ai Weiwei's architecture increased in scale and prominence, its proliferation throughout the village of Caochangdi soon begat village buildings constructed in its likeness. These shanzhai, or copycat constructions, are built by local farmers hoping to recoup financial losses in agriculture by taking advantage of Ai's valuable cultural cachet. Their buildings, bearing an influence made obvious in their austere geometries, exposed grey brickwork, and minimal fenestration, are sometimes constructed beside the very buildings from which they draw their inspiration. Yet even in their attempt at a clean reproduction, something is lost.[32] Termed 'fake FAKEs', in reference to Ai Weiwei's formerly named FAKE Studio, the double-negating premise of the name is both humorous and value-laden.[33] Further embellishing Ai Weiwei's linguistic cross-pollination of English and Mandarin, the term could either convey admonishing distain, as in 'fake fuck', or mindless gibberish, as in 'fuck-fuck'. In contemporary contexts

the word shanzhai has taken on new meaning in the age of consumer goods and assembly line mass-production, and this is perhaps a more apt descriptor. China's recent culture of manufacturing has eroded the traditional usage for shanzhai – 'imitation' – allowing it a larger set of connotations which include 'counterfeit', 'infringement', 'deviations from standard', 'mischief', and 'caricature'. Each conveys a sense of extra-legal implications that are not altogether frowned upon. As the author Yu Hua notes, 'It would not be going to too far to say that 'copycat' has more of an anarchist spirit than any other word in the contemporary Chinese language.'[34]

It is in the presence of fake FAKEs that Ai Weiwei's architecture realizes its greatest critical efficacy. Constructed by builders with no architectural intention, these copycat buildings extend the lifespan of Ai's architectural contribution outside of the boundaries of cultural production, while coincidentally affirming Ai's aesthetic response to the maladies of China's contemporary physical environment. Seeding the built village with just a handful of designs, fake FAKE builders prove that even at a grassroots level, design can proliferate in a quantity and variety beyond the capacity of any single designer.

In one of his more evocative aphorisms, Adolf Loos adequately summed up the vernacular as follows: 'The peasant builds a roof. Is it a beautiful roof or an ugly roof? He doesn't know – it is the roof. It is the roof as his father, grandfather and great grandfather had built the roof before him.'[35] In line with this analogy, Ai Weiwei can be credited with altering construction of the roof. Advancing the village's vernacular form, the circular process by which native building techniques are re-assumed into the local tradition only after they have been altered by an intentional act of design results in an entirely new and potent phenomenon being born: the nudged vernacular.[36] This phenomenon portends the apotheosis of a regionalist approach, one in which architecture's critical response is no longer reliant on the designer's incremental

contribution from one building to the next. Embedding the architect's critical alterations within trade practice, they proliferate outside of the designer's control in a viral fashion. Such an approach validates Ai's inward turn to convention as a means for architectural resistance and advances the possibility for architecture as a shelter for individualism. In doing so, it also marks the most significant point of difference between Ai Weiwei and Adolf Loos: where Loos' architecture responded to cultural shifts with architectural propositions dramatically different from contemporary practices, Ai draws from within the culture to provide identifiable techniques for the production of new architectural expression.

EPILOGUE
In May 2011, little more than a month after Ai Weiwei's disappearance, the residents of Caochangdi received another letter, informing them that the village would be spared from any immediate plans for demolition. As a battleground site in the nation's cultural warfare, the preservation of Caochangdi would appear a great victory for the arts. However, the village's victory is ultimately unsure; the cultural scene is increasingly commercialized, and the preservation of Caochangdi as an art-village hybrid is uncertain. Ai is even less optimistic about the fate of his own buildings. Chinese property laws allow landholders only the finite protections of a temporary ground lease, and as Ai's relationship with government officials has soured, the inevitable expiration of these protections all but guarantees the eventual destruction of his buildings. For Ai, it would be an appropriate end. He believes that once constructed, his buildings have largely fulfilled their promise. Through their conception, construction and identification with a specific place, they pass along the most crucial facets of an architectural resistance: the promulgation of an alternative. Ephemerality is an inherent and unconditional characteristic of architecture. Few buildings withstand the test of time, and none, no matter the faithful preservation efforts made on their behalf, go unchanged. Such sentiments are best summarized in Peter Zumthor's notion of the architectural act: 'We throw a stone into the water. Sand swirls up and settles again. The stir was necessary. The stone has found its place. But the pond is no longer the same.'[37]

1. Robert Mangurian and Mary-Ann Ray, 'Urban Rural Conundrums: Off-Center People's Space in Caochangdi, Beijing', in *Caochangdi: Inside Out*, Timezone 8, 2009, p.425.

2. Mangurian and Ray 2009.

3. Lau Paquan, 'Rooted in Urban Development and Lack of Co-ordination', *Xinhua News Agency*, 11 August 2004, http://news.xinhuanet.com/focus/2004-08/11/content_1717980.htm, accessed 7 October 2013.

4. Lisa Findley, 'Introduction', in *Building Change: Architecture, Politics and Cultural Agency*, Routledge, 2005, p.xi.

5. 'Knowledge linked to power not only assumes the authority of "the truth" but has the power to make itself true. All knowledge, once applied in the real world, has effects, and in that sense at least, "becomes true". Knowledge, once used to regulate the conduct of others, entails constraint, regulation and the disciplining of practice. Thus, there is no power relation without the correlative constitution of a field of knowledge, nor any knowledge that does not presuppose and constitute at the same time, power relations.' Michel Foucault, *Discipline and Punish: The Birth of the Prison*, Vintage, 1995, p.27.

6. Anthony Pins, 'Interview with Ai Weiwei', 25–27 August 2011.

7. Roberto Mangabeira Unger, 'The Better Futures of Architecture', in Cynthia Davidson (ed.), *Anyone*, Rizzoli, 1991, p.31.

8. Jianfei Zhu, *Architecture of Modern China: a Historical Critique*, Routledge, 2009, p.85.

9. Claudio Greco and Carlo Santoro, *Beijing: The New City*, Skira, 2008, p.5.

10. Chang Yung-Ho, 'City of Objects AKA City of Desire', *A+U*, December 2003, p.2.

11. Pins 2011.

12. Ai Weiwei, 'Ordinary Architecture', in Lee Ambrozy (ed.), *Ai Weiwei's Blog: Writings, Interviews, and Digital Rants, 2006–2009*, MIT Press, 2011, p.65.

13. 'On the way to the airport my mom said things like, "Do you feel sad because you don't speak English?", "You have no money" (I had $30 in my hand), and "What are you going to do there?" I said, "I am going home." My mother was so surprised, and so were my classmates. I said, "Maybe ten years later, when I come back, you'll see another Picasso!" They all laughed. I was so naive'. Ai Weiwei and Hans-Ulrich Obrist, *Ai Weiwei Speaks*, Penguin, 2011, pp.80–81.

14. Charles Merewether, 'Changing Perspective: Ai Weiwei with Charles Merewether', in Ai Weiwei and Charles Merewether, *Ai Weiwei: Works, Beijing 1993–2003*, Timezone 8, 2003, p.21-2.

15. Chin-Chin Yap, 'A Handful of Dust', in Ai and Merewether, 2003, p.10.

16. The book was almost certainly Bernhard Leitner, *The Architecture of Ludwig Wittgenstein*, Press of Novia Scotia College of Art and Design, 1973.

17. Pins 2011.

18. See Lietner 1973.

19. Having visited the Loos' Haus am Michaelerplatz (1899) in his early years at university, Engelmann moved to Vienna in 1912 with the intent to study under Loos at the Bauschule. Working in his office for a time, after graduation Engelmann became a consistent figure in the intellectual circles frequented by Loos and Karl Kraus, the city's most prominent critics of bourgeois aesthetics and its dissociation from the condition of 'modernity'.

20. Ai Weiwei, 'N Town', in Ambrozy 2011, p.29. Judith Bakacsy, 'Paul Engelmann (1891–1965) His Way from Olomouc via Vienna to Israel', in Judith Bakacsy, Anders V. Munch, and Anne-Louise Sommer (eds), *Architecture, Language, Critique: around Paul Engelmann*, Rodopi Bv Editions, 2000, p.26.

21. Ai Weiwei, 'Problems Facing Foreign Architects Working Within a Chinese Architectural Practice', in Ambrozy 2011, p.4.

22. Adolf Loos, 'The Principle of Cladding', in Adolf Opel (ed.), *On Architecture*, Ariadne Press, 2002, p.43.

23. Adolf Loos, 'Ornament and Crime', in Adolf Opel (ed.), *Ornament and Crime: Selected Essays*, Ariadne Press, 1998, p.167.

24. Benedetto Gravagnuolo, *Adolf Loos: Theory and Works*, Rizzoli, 1982, p.19.

25. Ai Weiwei, 'With Regard to Architecture', Ambrozy 2011, p.10.

26. Quoted in Beatriz Colomina, 'Sex, Lies, and Decoration: Adolf Loos and Gustav Klimt', *Thresholds*, no.37, 2006, p.77.

27. 'Carpets are warm and livable. He decides for this reason to spread one carpet on the floor and to hang up four to form the four walls. But you cannot build a house out of carpets. Both the carpet and the floor and the tapestry on the wall required structural frame to hold them in the correct place. To invent this frame is the architect's second task.' Loos 2002, p.66.

28. 'The spaces of Loos' interiors cover the occupants as clothes cover the body (each occasion has its appropriate "fit"). Jose Quetglas has written: "Would the same pressure on the body be acceptable in a raincoat as in a gown, in jodhpurs or in pajama pants? ... All the architecture of Loos can be explained as the envelope of a body." From Lina Loos' bedroom (this "bag of fur and cloth") to Josephine Baker's swimming pool ("this transparent bowl of water"), the interiors always contain a "warm bag in which to wrap oneself". It is an "architecture of pleasure", an "architecture of the womb".' Colomina 2006, p.90.

29. Ai Weiwei, 'Here and Now', in Ambrozy 2011, p.50.

30. Vincent Canizaro, 'Introduction', in Vincent Canizaro (ed.), *Architectural Regionalism: Collected Writings on Place, Identity, Modernity, and Tradition*, Princeton Architectural Press, 2007, p.20.

31. Alexander Tzonis and Liane Lefaivre, 'Critical Regionalism', *Critical Regionalism*, no.3, pp.20–1; and 'Why Critical Regionalism Today?', *A+U*, no.236, May 1990, p.31; quoted in Keith L. Eggener, 'Placing Resistance: A Critique of Critical Regionalism', Vincent Canizaro (ed.), *Architectural Regionalism: Collected Writings on Place, Identity, Modernity, and Tradition*, Princeton Architectural Press, 2007, p.399.

32. Reflecting difficulties in translation, differing site conditions have often resulted in awkwardly proportioned compositions. Frequently, these buildings often contain mechanical appendages that obstruct the visual simplicity of Ai's actual architecture – leaving downspouts and window air conditioning units exposed. In at least one extreme case, a synthetic grey brick veneer stands in for the actual application of masonry walls. Nonetheless, the majority of these reproductions make faithful attempts at the reapplication of Ai's adopted vernacular, evincing an expanded architectural influence within a population that has little literacy within the tropes and conventions of contemporary art and design.

33. Mangurian and Ray 2009, p.153.

34. Yu Hua, 'Copycat', in *China in Ten Words*, Pantheon Books, 2011, p.182.

35. Adolf Loos, 'Architecture', Opel 2002, p.73.

36. The phrase 'the nudged vernacular' was coined and introduced to me by the architect Mary-Ann Ray.

37. Peter Zumthor, *Peter Zumthor: Thinking Architecture*, Lars Müller Publishers, 1998, p.18.

Caochangdi, Beijing, PRC
1999

STUDIO-HOUSE

In the fall of 1999, a house appeared on the dust-swept outskirts of Beijing to little attention. Secluded in a back end lot in an anonymous village – the city's once autonomous settlement subsumed by late-1990s urban growth – the house was an anomalous construction along a road otherwise traversed by farmers and taxi drivers on shift change. It was a modest building, a two-storey grey brick structure set far behind a wall demarcating the street's edge. Simple to the point of abstraction, it bore only a single window on its front, neatly centred within the protruding volume of the facade's western third.

Distinguishable from the street by its turquoise gate, the unassuming T-shaped volume had been designed only 100 days prior. The designer was not an architect, but an artist still of modest acclaim. Six years removed from his return from the United States, he remained virtually unknown in his native country outside the circles of the still nascent avant-garde. The house was constructed from a single sketch made while sitting at his mother's kitchen table. It was an impulse, albeit a subconscious one, that would launch Ai Weiwei's brief career in architecture. Though it would last little over a decade, Ai's foray as an 'accidental architect' would stand in marked distinction to the excesses of the nation's still-awakening culture of contemporary architectural design.

The origin story of his Studio-House reads like an embellished ur-myth. Perhaps an oversimplification of the complex facets of construction, it is the type of story believable only in China where regulatory permits and codes cease to be formal barriers, if present at all. Ai Weiwei's studio is in fact an illegal dwelling, built with only the verbal blessing of the landowner and village authorities. Taking advantage of the village's legal informality, the site was chosen specifically for its remote characteristics.[1] Located between Beijing's central city and the international airport, the village culture is permeated with a type of modest entrepreneurialism where rural migrants,

1. Eduard Kögel, 'Conversation between Ai Weiwei and Eduard Kögel, July 2007', in Eduard Kögel (ed.), *Ai Weiwei: FAKE Design in the Village*, Aedes, 2007, p.4.

Above and previous page:
Studio-House, 1999
Caochangdi, Beijing, PRC

native villagers, and students find employment and opportunity. Ai describes Caochangdi as, 'the gathering place for the poor, but also for those who came from the countryside looking for a new life'.[2] For the artist and many others, it is a location where the economy and immediacy of everyday concerns are unburdened by the bluster of a society in pursuit of materialist ends.

Cognizant of the pervasive threat posed by Beijing's urban development, the village was ideal for Ai's Studio-House because of its very remoteness, but also because it served the artist's more prosaic needs. 'Because I don't drive, the cars coming back from the airport were a good opportunity to go to the centre,' Ai recalls. 'Since the village lies next to a railroad, I thought urban development would not reach it. With those factors in mind, I decided to take the risk.'[3] Indeed, Caochangdi's seclusion beyond Beijing's Fifth Ring Road has allowed it to remain largely unnoticed, and thus evade scrutiny from the city's top-down planning and oversight. Only recently have authorities considered, but ultimately decided against, demolishing the village. Amid the slippages of bureaucratic oversight, Ai Weiwei's architectural experimentation was allowed to flourish. 'Of course there is a lot of planning going on,' he notes, 'but in China, no matter how strict the inspections and the planning are, there will always be creative ways of dealing with them on a lower level. The planning only goes halfway.'[4]

Efforts to situate his architecture within the context of Chinese building inevitably note parallels between Ai's Studio-House and the traditional *siheyuan* houses of central Beijing's hutong neighbourhoods. Ai tends to bristle at these comparisons. 'I think that we are merely using local materials and are putting forth a familiar attitude toward local history, politics, and lifestyles as a means of dealing with something,' he claims.[5] Nonetheless, similarities between the Studio-House and the *siheyuan* exist in both the arrangement of the site and the constitution of its elements. Like

2. Kögel 2007, p.4.

3. Kögel 2007, p.6.

4. Sus Van Elzen, *Dragon & Rose Garden: Art and Power in China*, Modern Chinese Art Foundation, 2009, p.149.

5. Ai Weiwei, 'Ordinary Architecture', in Lee Ambrozy (ed.), *Ai Weiwei's Blog: Writings, Interviews, and Digital Rants, 2006–2009*, MIT Press, p.65.

6. Ambrozy 2011, p.623.

the *siheyuan*, Ai's house is positioned on the northern-most edge of the site opposite a gate located in the south-west corner. Flanked by auxiliary studio buildings, the courtyard forms the pulsating heart of the studio, a locus of activity shuttling between adjacent buildings. The comparisons are partial at best, as the Studio-House's orientation and alignment, as well as its opaque exterior hardly subscribe to traditional standards. Instead, the entry pathway traces the eastern edge of the lawn, extending the full depth of the site. Also absent is the presence of a gatehouse screening views from the street. Instead, the visual terminus of the gate is the Studio-House's blank wall.

The essential refinement of the home lends credence to its conception story as a harbinger of Ai Weiwei's architectural career. Present in its construction are the materials, techniques, and details that formed the basic elements of his village architecture. The use of a concrete structural frame, for instance, recurs throughout all of his locally constructed buildings, and the gridwork economy of reinforced columns and beams is one of the strongest examples of his desire to create 'ordinary architecture'.

It is an architectural ethos that Ai claims is 'simply trying to return to the most basic of possibilities, and to minimize difficulties. I put forth as little as possible – this is the most basic feature of my house. This is also the most basic characteristic of the majority of the architecture that I create.'[6] These essential qualities are present in the forthright subdivision of the Studio-House's interior volumes. The T-shaped plan

Because I don't drive, the cars coming back from the airport were a good opportunity to go to the centre. Since the village lies next to a railroad, I thought urban development would not reach it. With those factors in mind, I decided to take the risk.

Studio-House, 1999
Under construction

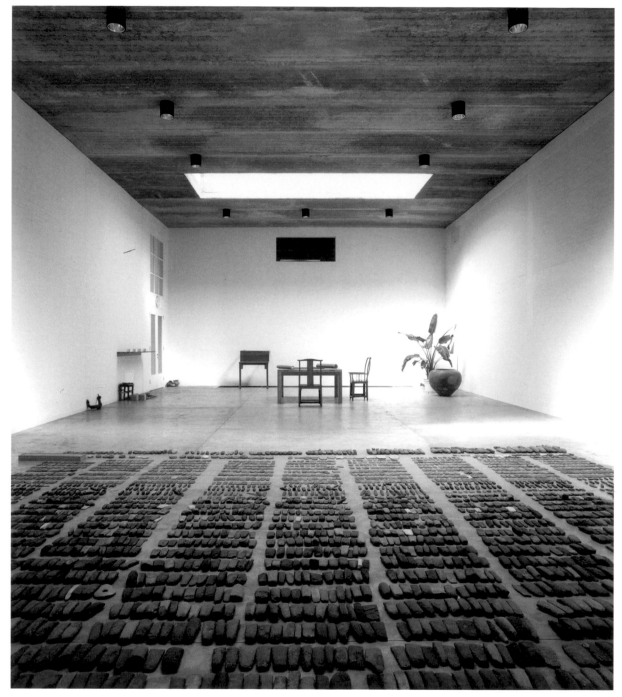

<u>Studio-House</u>, 1999
Ai Weiwei's studio

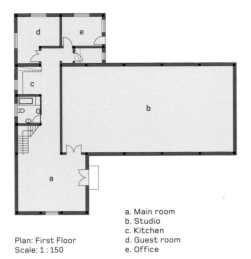

a. Main room
b. Studio
c. Kitchen
d. Guest room
e. Office

Plan: First Floor
Scale: 1 : 150

f. Master bedroom
g. Master bathroom
h. Terrace

Plan: Second Floor
Scale: 1 : 150

is composed of two intersecting bars, one containing the home's domestic functions and the other an open, double-height studio. Stretching east-west across the site, the studio serves as a temporary gallery, an itinerant storage space, and occasionally, as the artist's work area. Often, such an immense spatial enclosure might appear hollow or devoid of life. Under Ai's tactile sensibilities, however, the white brick gives the windowless cube an irregular pattern, alternating stretches of brick with smooth, painted columns. The effect is minimal, almost imperceptible from afar. In close proximity, the walls, sun-starched by the large skylights above, radiate a warmth that undermines the slick austerity of white-box architecture.

The studio is one of three destinations accessible from the main room, which is a tall space with a Camelot-sized dining table. Moving deeper into the home, the living quarters are logically divided by their domestic function. The kitchen, guest room and office remain on the ground floor, while a master bedroom and private terrace occupy the floor above. This strident rationality is not without humour. Allowing the plan to deviate from a purely logical organization of rooms, Ai positions the master bathroom at the top landing of the main staircase: a completely open room with the requisite fixtures positioned in one corner. Serving as the primary hallway to the master bedroom, Ai's attitude towards privacy and the individual can be seen in a brief yet compelling architectural moment. For an artist who occasionally delights in disrobing before the camera, the bathroom is a statement of humanity; like his architecture, it strips away any pretence of social hierarchy or class. This is appropriate for Ai's home, and by extension, his architecture as a whole, which through all its sparseness and restraint seeks to accommodate the occupant as they are, rather than project an image of who they might want to be.

Next page:
The dining room at Ai Weiwei's studio

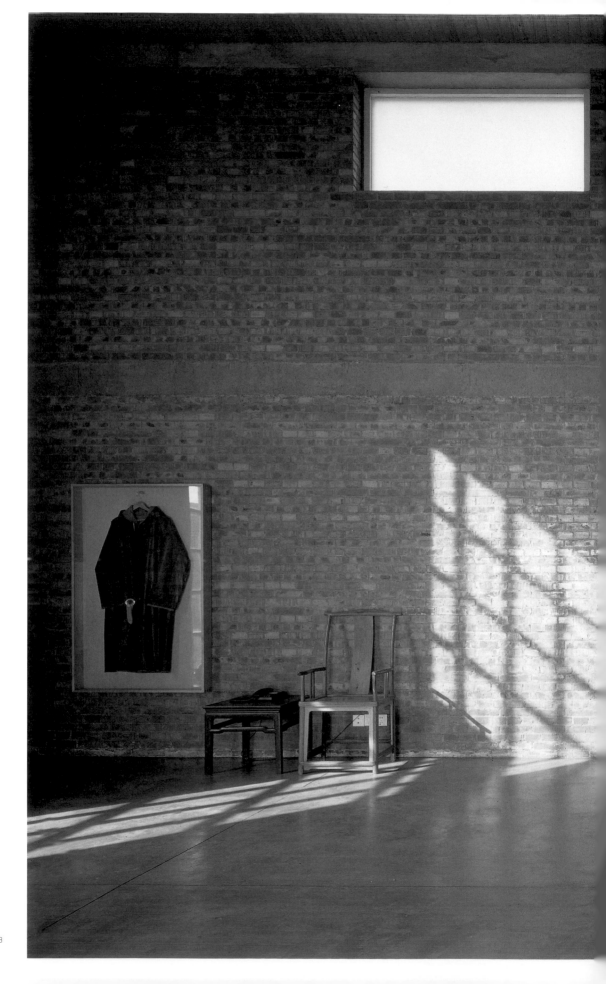

IN BETWEEN AND CONCRETE

In Between, 2000–2001
SOHO New Town, Beijing, PRC

Opposite page:
Concrete, 2000
SOHO New Town, Beijing, PRC

Soon after co-curating the controversial *Fuck Off* exhibition, Ai Weiwei embarked on a pair of public sculptures in Beijing. Commissioned by Pan Shiyi and Zhang Xin, soon-to-be billionaire purveyors of China's first branded real-estate experience, the small office-home office development (SOHO) located on the city's expanding east side was as notable for its tailored lifestyle concept as for its inclusion of open 'public' spaces adorned with sculptural works of art. The first of these works, *In Between*, takes the form of a standard house: it is a blue geometry reduced to four exterior walls, a pitched roof, and a few apertures suggestive of windows and a door. Installed within the condominium's vertical sub-divisions – modules of four floors opening on to semi-private atria – the house exists in a state of tension, literally suspended between two floors. From one vantage the house appears tenuously lodged into the ceiling, uprooted from its foundation and spun askew, imminently threatening to crash back to the lobby floor below; from the other, it is an archaeological curiosity, uncovered through an series of unanticipated tectonic shifts. Taken in the context of his extensive documentation of demolished structures, *In Between*'s sense of impermanence not only describes the house's nebulous predicament, but precedes a dominant lineage in Ai's work that includes *Fragments* (2006), *Through* (2008), and *Provisional Landscapes* (2002–2008) in its thematic preoccupation with the city's diminishing architectural heritage. In this sense, the image of the house emerging from the floor plenum takes on the symbolism of a proverbial telltale heart, a remnant of the dismembered society buried below, or perhaps within, the monomaniacal euphoria of construction and progress.

If *In Between* evoked a sense of architectural impermanence, *Concrete*, an outdoor sculpture, intended the exact opposite. Standing between six condominium towers that each rise more than thirty storeys, the brutish sculpture is explicit in its distrust of both the developer's motives and the very nature of public art. Constructed from its namesake material and

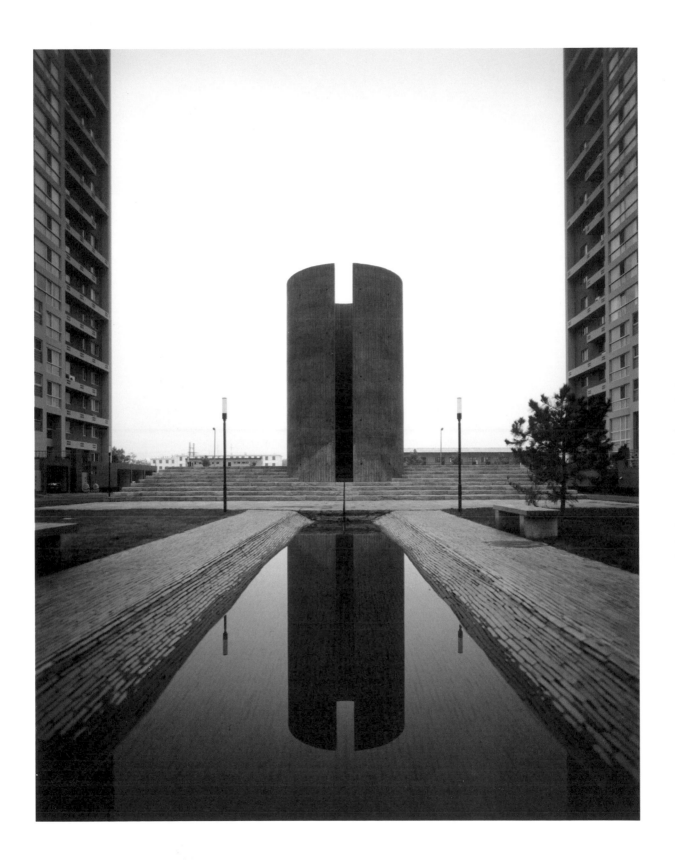

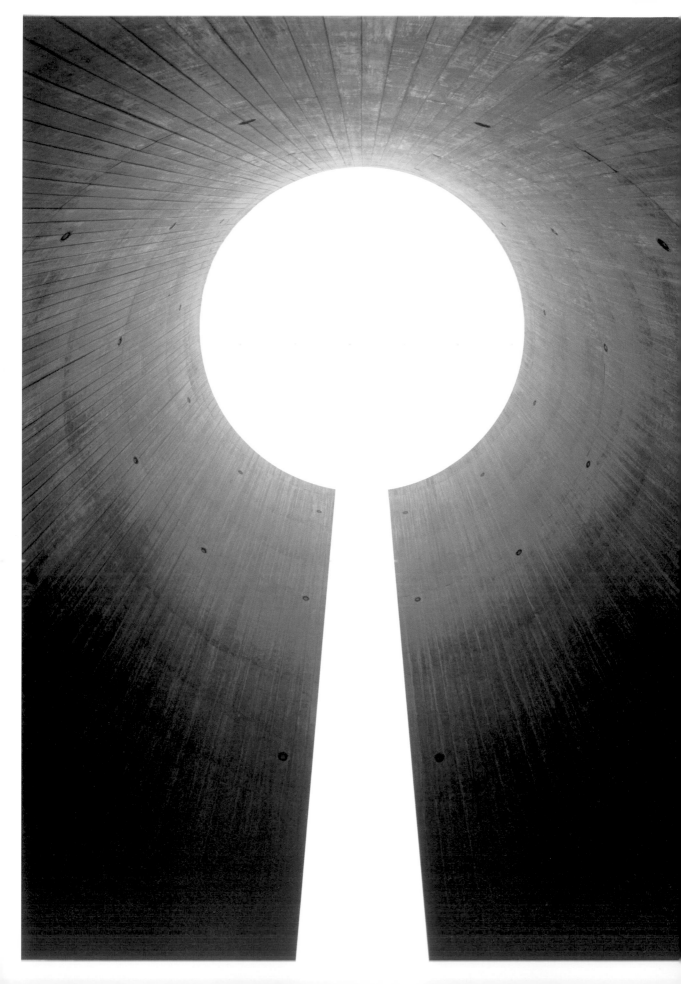

heavily reinforced with steel, the sculpture was conceived as an object that could not be easily removed, an anchor in an otherwise transient urban landscape. Obstinate in its posture toward realms both public and private, the aberrant sculpture attempts to shake the viewer from the complacent lull of predictable urban encounters to engage the piece on its own terms. 'In the northern Chinese cities the water pools are frozen at least one quarter of the year, but people still want to have pools. The developer wanted it,' Ai explains. 'So I had the idea of water hidden underground. You can hear the water passing through, but can't really see it ...'[1]

Obstinate in its posture toward realms both public and private, the aberrant sculpture attempts to shake the viewer from the complacent lull of predictability to engage the sculpture on its own terms.

The artist's intended affront to the palatable kitsch often associated with public taste is evident in the sculpture's raw and unnerving form. Efforts to beautify the environment, Ai contends, usually result in the opposite effect.[2] *Concrete* responds to the blandness of lifestyle-manufacturing masquerading as high design by pulling back its thin veneer, laying bare its essential structure and materiality. In this unadorned state, the immediacy of the subject's milieu returns in to focus. As critic Karen Smith notes: '*Concrete*'s darkest seam of humour lay in its reminder to the developers that having a modern mindset or outlook means little when one is embroiled in the immutable and complex political imbroglio of Chinese bureaucracy, which promotes material growth at the expense of personal freedoms.'[3]

1. Gordana Bezanov, 'Interview with Ai Weiwei on Oct 28th 2006, Caochangdi', *ArtSEEN*, no.4, Winter 2007, p.38.

2. Ai Weiwei, 'Architecture and Space', in Lee Ambrozy (ed.), *Ai Weiwei's Blog: Writings, Interviews, and Digital Rants, 2006–2009*, MIT Press, 2011, p.8.

3. Karen Smith, 'Giant Provocateur', in Karen Smith, Hans-Ulrich Obrist, and Bernhard Fibicher (eds), *Ai Weiwei*, Phaidon, 2009, p.82.

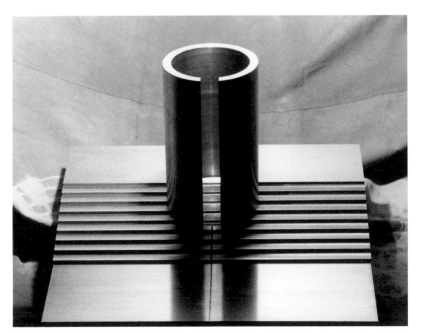

Opposite page:
Detail of <u>Concrete</u>, 2000
SOHO New Town, Beijing, PRC

Left:
Model of <u>Concrete</u>, 2000
SOHO New Town, Beijing, PRC

YIWU RIVER DAM AND AI QING MEMORIAL

Ai Weiwei was originally reticent about designing a memorial for his father, the late poet Ai Qing. Approached by the city of Jinhua to erect a monument in his father's honour, Ai demurred, feeling no particular affinity for his father's birthplace, and unconvinced that he would be appropriately memorialized with a token edifice. Only at the behest of his mother, who warned him of leaving the commission to provincial bureaucrats, did he relent. Rather than subject the memorial to cheerless isolation, Ai's participation was conditioned on the local government allowing him to design the entire riverbank. Embedding the memorial within a kilometre-and-a-half stretch of waterfront parkland, the Yiwu River Dam was built opposite his simultaneously planned Jinhua Architectural Park.

At its widest, the Yiwu River spans about 100 metres, marking the point where it merges with the Jinhua River on its way to spilling into the East China Sea. Upstream, Ai Weiwei's riverbank promenade occupies an unimpressive stretch of land that previously served as a buffer against flooding and erosion. Noting its lack of distinguishing characteristics, Ai reconfigured the landscape by embedding locally-sourced stone in stripes, diagonally, across the embankment. The stone serves as both elegant landscape retention and creates an inviting riverwalk, one that through its materiality and repetition lends the riverfront a suddenly ancient aesthetic.

The River Dam's ziggurat terraces ascend sharply from the water's edge, pausing only for the interruption of a walkway set a short distance from the river. Though the scene recalls period styles of earlier civilizations, the vocabulary is undeniably modern. Cut into quarters, the ziggurat creates a stark, geometric topography, alternating between sheer, vertical faces and cascading steps. In juxtaposing these elements, Ai creates a series of public spaces simultaneously adaptable to large gatherings and individual contemplation. Deprived of any monumental apex, the forms culminate in a plateau with a sharp triangular outline, the point of which extends to overlook the water: a spectacular vantage for the solitary individual.

The <u>Ai Qing Memorial</u> sited
at the <u>Yiwu River Dam</u>,
2002–2003

Previous page:
<u>Ai Qing Memorial</u>,
2002–2003
Jinhua, Zhejiang Province, PRC

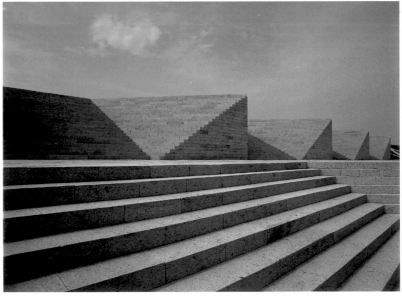

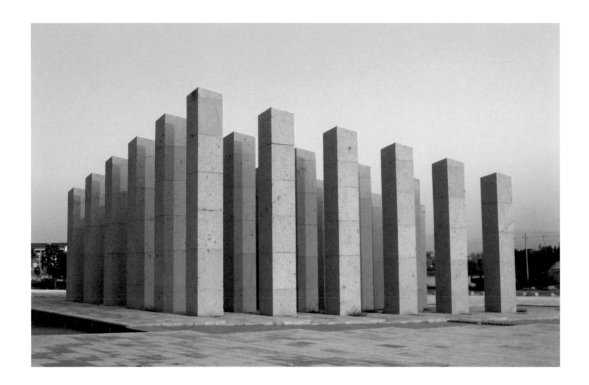

The obelisks of the Ai Qing Memorial stand atop the terraces in contrast to their languid horizontality. Reiterating the monumental form and scale of the ziggurat steps, the phalanx of stone columns cut at a continuous angle is simultaneously imposing and inviting. From either of two flanking pathways, a visitor may advance past the central channel of cascading water. Its sound conditions the transition into a solemn and meditative space, simultaneously separating the memorial from the park while connecting it visually and figuratively with the river beyond. Meanwhile, shifting sunlight reflecting off the water creates a profound sequence of illuminated surfaces and elongated shadows. The cumulative effect is dramatic enough to divide the memorial site from the frenetic cityscape beyond.

The simple expression of the monument has a neutrality that is fitting of its subject. Though Ai Qing was celebrated late in life, Ai Weiwei no doubt saw the contradictions inherent in a monument commissioned by the government that had sentenced his father to years of hard labour. If the grid of phalanxes are without overt signification, they are also consciously without nostalgia. 'They thought I should put my father's poetry on every stone,' Ai said of Jinhua government officials. 'I had to convince them that it's best to read poetry from a book and not from a stone.'[1] The memorial is appropriately solemn, neither reinforcing cultural narratives which gloss over a tumultuous past, nor subjecting the visitors to a historical recounting of Ai Qing's life in exile. Instead, Ai Weiwei creates a quiet space for reflection, contemplation, and the freedom of one's mind.

Above:
Ai Qing Memorial, 2002–2003

Next pages:
Ai Qing Memorial and
Yiwu River Dam, 2002–2003

1. Lee Ambrozy, 'The Defiant One', Icon, no.93, March 2011, p.62.

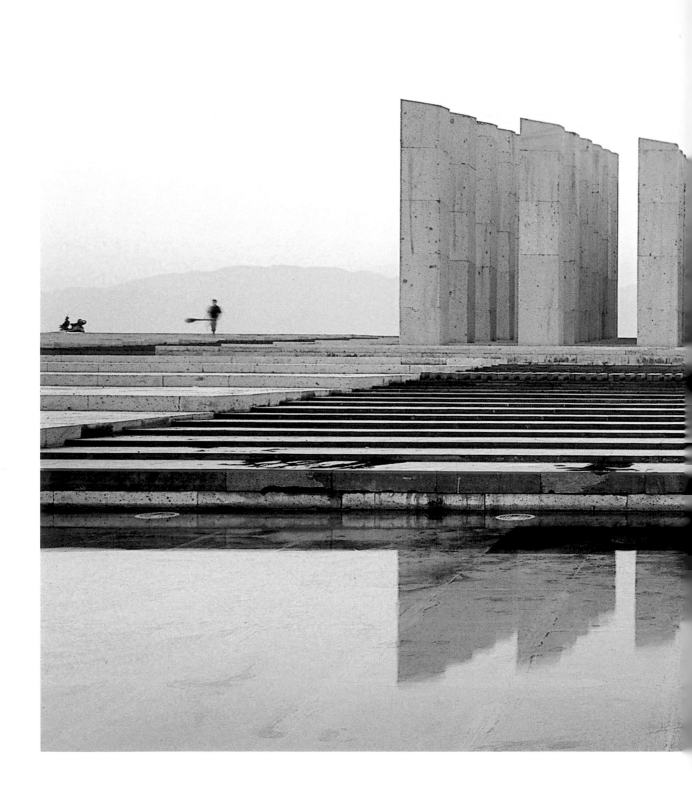

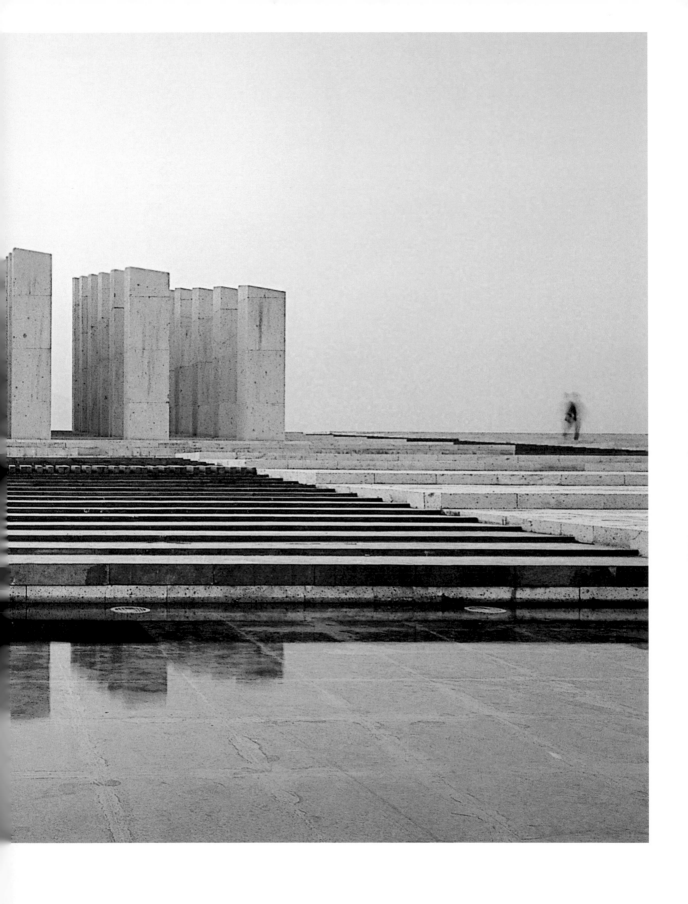

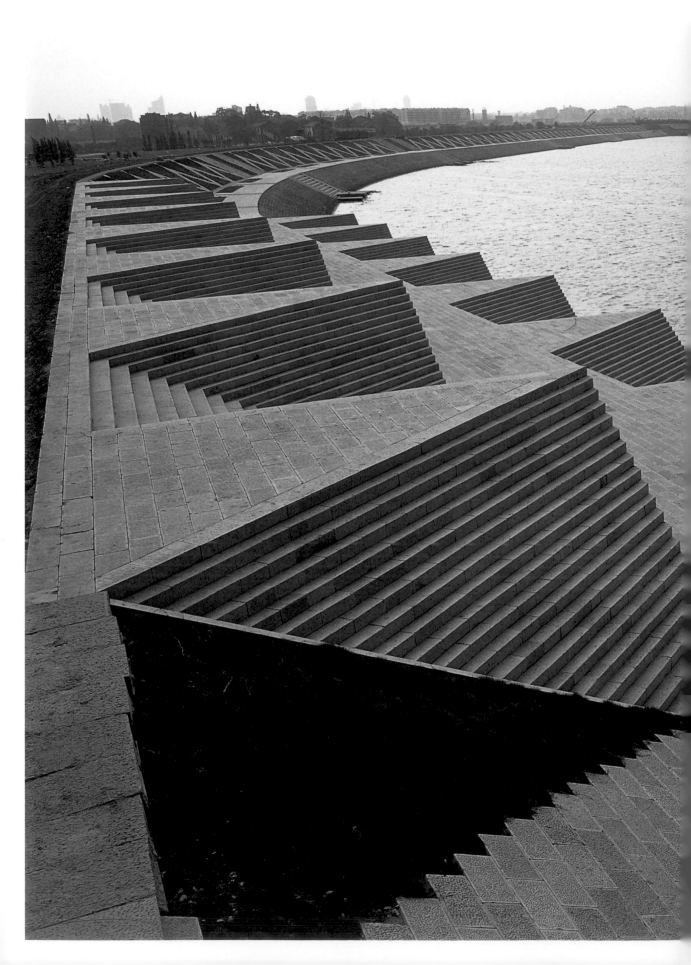

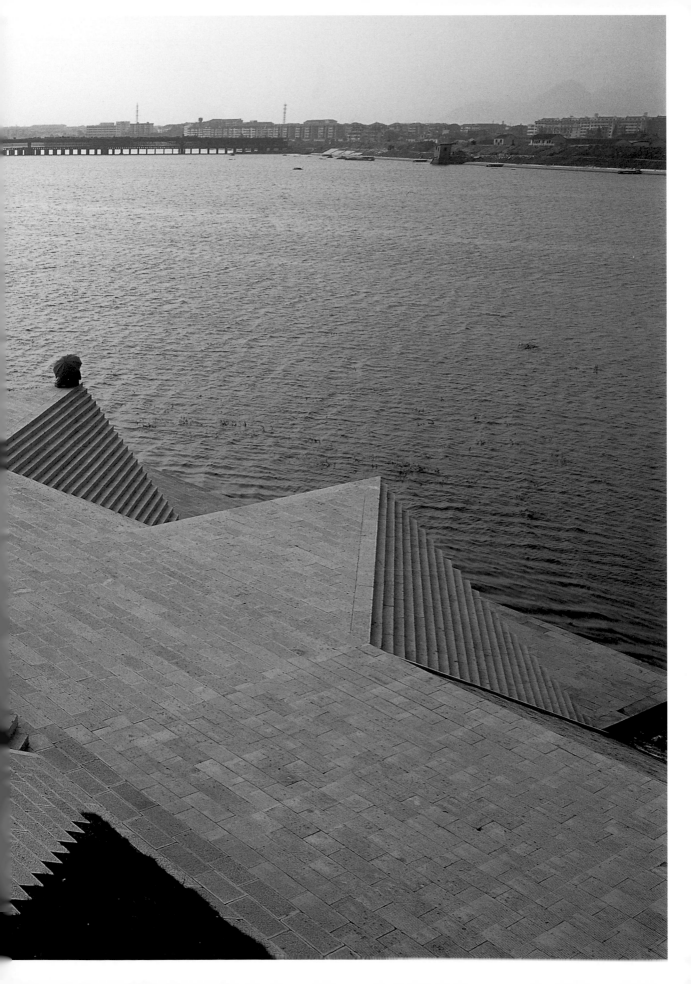

COURTYARD 105

In his famous exchange with a brick, the American architect Louis Kahn supposed that the brick's greatest desire was to be an arch. Owing its elegance and strength to the pure expression of its construction, the arch can span considerable distances, defying gravity while bearing the weight of the wall above. For Kahn, the arch was the apotheosis of structure and aesthetics, and the brick, its principle.

In Ai Weiwei's architecture, it might be suggested that the brick does not desire to be an arch, but rather, to be merely present. For Ai, brick is deployed not for its ability to invoke the sublime, but its humane association with economy, tactility, and operability. Derived from the earth and wrought by hand, the brick is imbued with a material value that acknowledges, yet exceeds, its virtues as a conventional building unit. In this context, the advantages typically associated with brick construction – that it is roughly the size of a human hand, lends itself to quick assembly, and is easily manipulated into a number of configurations – are augmented by a secondary set of associations from recent Chinese history.

The architect Sheila Kennedy has pointed out that, 'building materials are never really anonymous: as manufactured commodities, they are the products of particular social, political and economic contexts'.[1] To understand them fully, one must move beyond the examination of their physical properties, and investigate the 'associations inherent in its cultural history – the ways in which a material is used, perceived and remembered within the contexts of its production.'[2] In Ai Weiwei's architecture, the dichotomy between brick and concrete is subject to such an evaluation. If concrete can be understood as the material characteristic of the Communist process of industrialization and its speculative real estate economy, the brick is associated with structures built under Imperial rule. These modest homes, whose composition was often strongly influenced by the *feng shui* of Confucian philosophy, emphasized humanist values through the brick's connection to the individual.

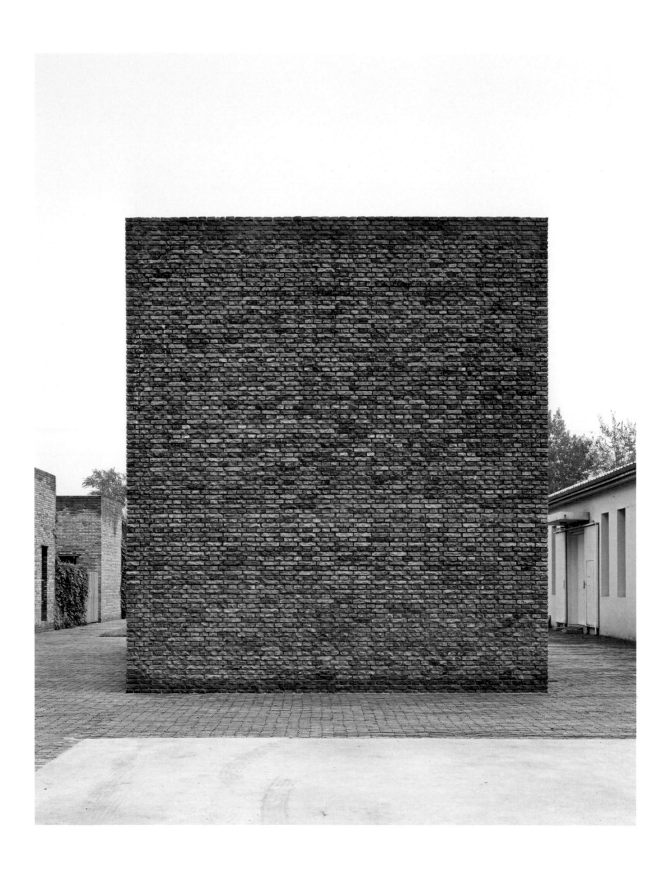

Courtyard 105

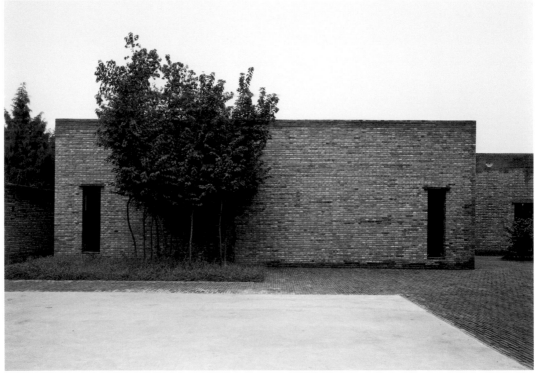

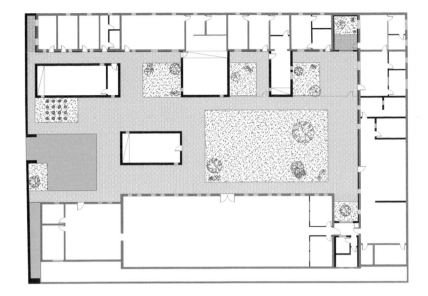

Previous page:
View from the entry gate at
Courtyard 105,
2004–2005
Caochangdi, Beijing, PRC

Left:
Plan: Ground floor
Scale: 1 : 500

Opposite page:
Volumetric additions in grey
brick protrude from the
original complex of buildings

Though a modest renovation, Courtyard 105 is perhaps Ai Weiwei's most explicit expression of an architectural attitude. The project serves as a subtle manifesto on brick's material ethos and a coolly iconoclastic gesture that translates Ai's artistic themes into built form. Taking up a small U-shaped complex that had served a hotchpotch of functions, Ai preserved the negligible yet sound concrete buildings remaining on site and introduced four new cubic volumes: two attached and two independent of the existing structures. Recasting the site's spatial relationships, the enclosure of the complex by a singular, stoic volume axially aligned with the entrance creates a new, privatized courtyard. Punctuating the view into the complex from the beyond the entry gate, this new building recalls the intentional misalignment of the *siheyuan* gatehouses in Beijing's hutong neighborhoods. The tall and windowless street-facing elevation, proportionally slender in comparison to its brethren, terminates any visual connection between the interior and exterior, and establishes a clear sense of arrival. Entering the complex, the spaces are refined to the building's northern edge, where the second independent volume creates a narrow access passage to the private residential units. The imposed volumes are clad in grey brick, as is the exterior of the original building, and the two now appear seamlessly composed.

Ai's use of brick at Courtyard 105 can be understood in light of his interventions on ancient Chinese pottery, an ongoing body of work which indicated the emergence of 'resistance and the question of authenticity as leading, interrelated themes' early in his career.[3] In *Dropping a Han Dynasty Urn* (1995), Ai famously documented the precipitous demise of a historical artefact in an overtly iconoclastic gesture. *Han Dynasty Urn with Coca-Cola Logo* (1994), meanwhile, branded the venerated object with a corporate

1. Sheila Kennedy, 'Material Presence', in Christoph Grunenberg and Sheila Kennedy, *KVA: Material Misuse*, Architectural Association, 2001, p.12.

2. Kennedy 2001.

3. Chin-Chin Yap, 'A Handful of Dust', in Ai Weiwei and Charles Merewether, *Ai Weiwei: Works, Beijing 1993–2003*, Timezone 8, 2003, p.4.

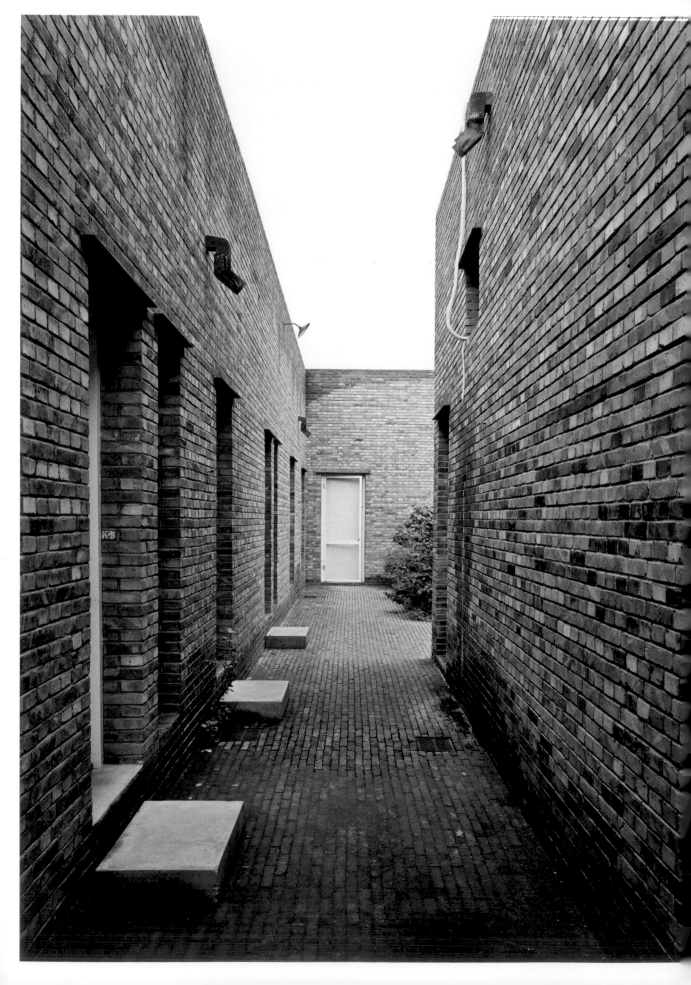

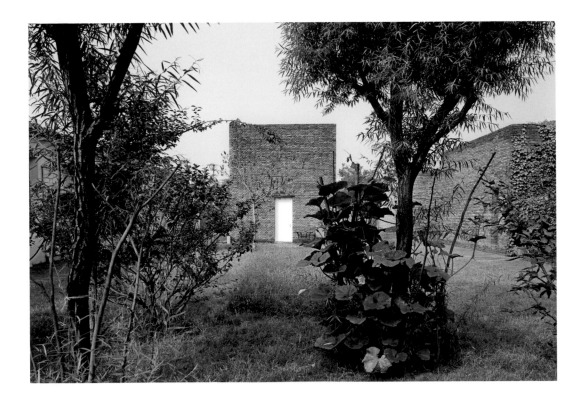

logo drawn from everyday consumerism, suggesting a more nuanced form of symbolic appropriation. As with later endeavours, these works turned 'prized touchstones of Chinese heritage into ironic questions about contemporary power conflicts of authority and cultural worth'.[4] Taking the reverse approach, *Souvenir from Beijing* (2002) places the unadmired, grey Chinese brick into a mahogany box, celebrating its modesty. Alerting the viewer to the endangered status of a society facing demolition, the piece is a critique of cultural priorities that are visibly manifested in the built environment.

At Courtyard 105, Ai's authorship recasts the brick's significance within this distinctly Chinese context. Here, the brick is robbed of its structural properties in order to enunciate its symbolic importance. The new brick wall built on the exterior of the existing building plays no part in supporting the roof, nor does it provide lateral stability within a post-and-lintel framework as it might in Ai's other buildings. There is also little reason why the incision of additional brick-clad volumes into the northern building would necessitate the uniform application of a single material across the building as a whole. Courtyard 105's brick exterior, then, is unmistakably a symbolic veneer, one that conceals the existing concrete facade to negate the material's hegemonic associations. Pitting brick against concrete, the use of brick constitutes not only a subtle but direct form of protest; it also sheds light on Ai's motivations for using brick throughout his architectural projects.

Western courtyard lawn at
Courtyard 105

Opposite page:
A narrow passageway to
the residential units is
situated behind an inserted
rectilinear volume

Next page:
The eastern courtyard at
Courtyard 105

4. Yap 2003, p.5.

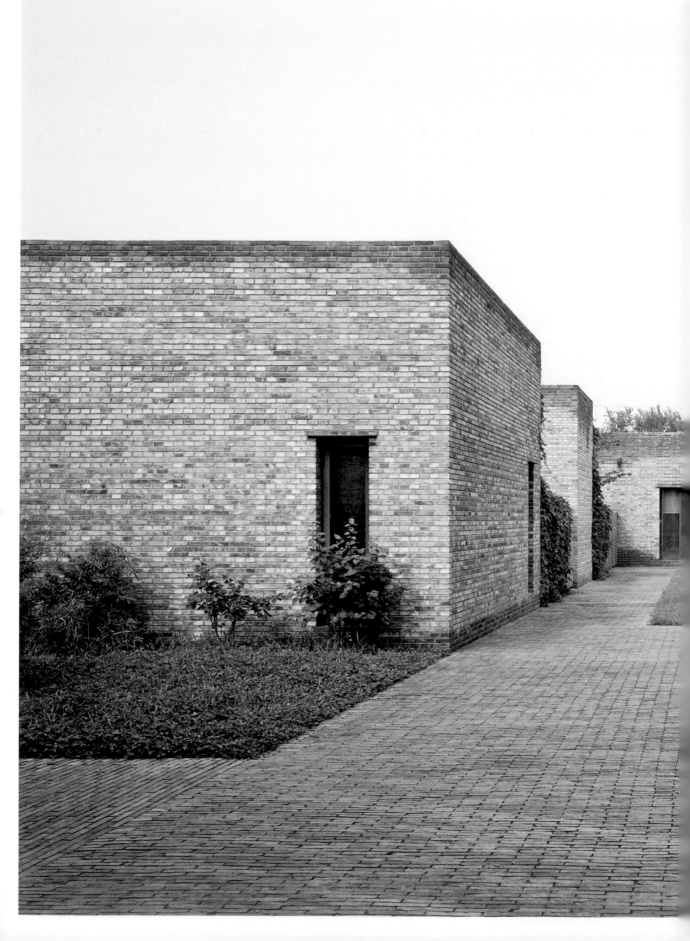

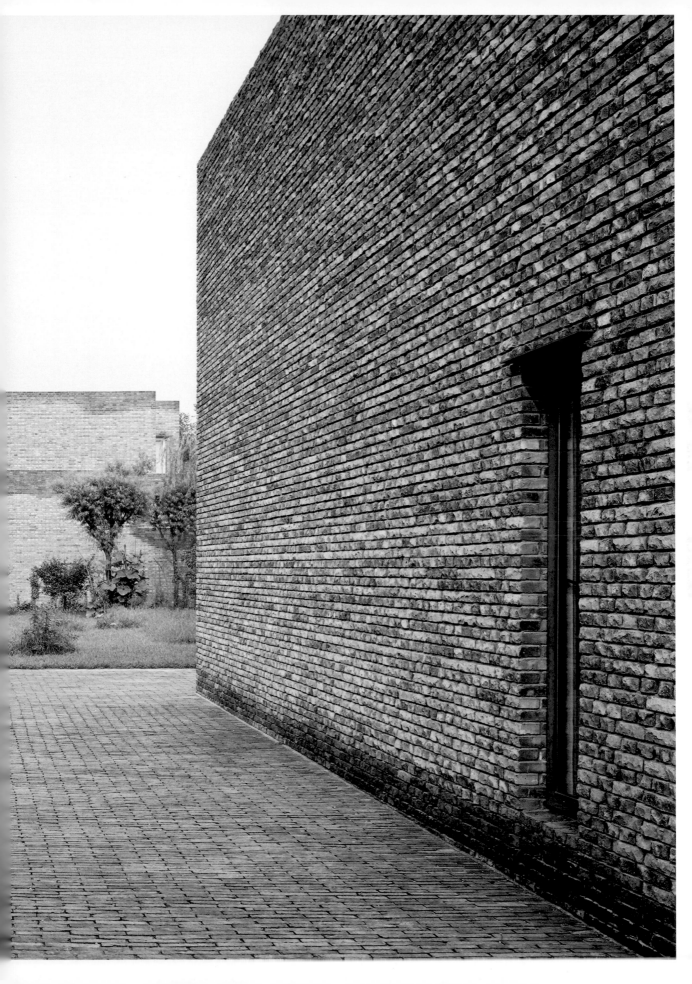

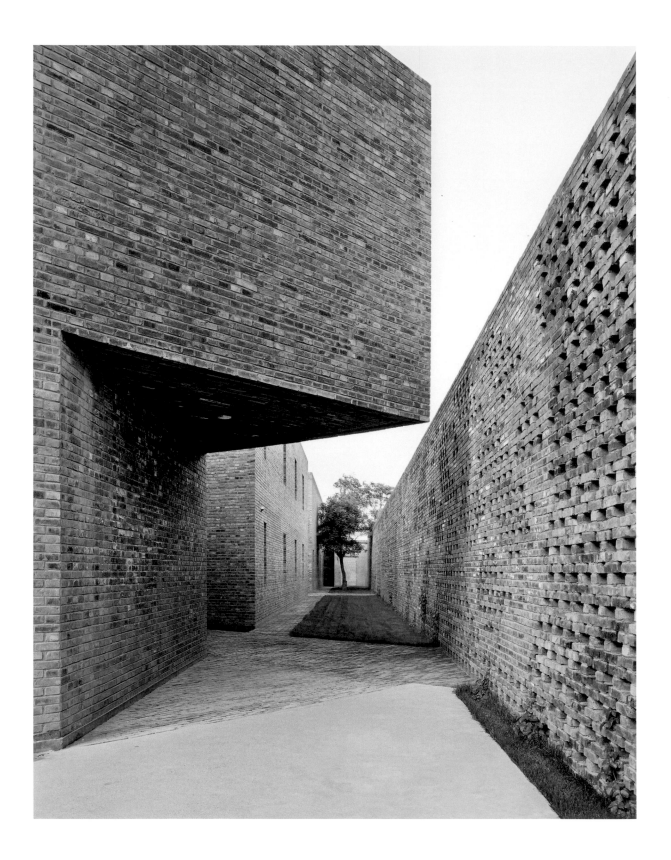

Caochangdi, Beijing, PRC
2005

COURTYARD 104

There is a moment of confusion upon passing through the gates of Court-yard 104. Coming in from the village street, where narrow lanes converge on the corner of a market, the entry gate's angled orientation suggests a path of movement that quickly terminates into a wall. Adjusting to this realization inside the steel doors, focus shifts to an attenuated greenway, a thin strip of lawn culminating in by a few trees. Examining this space, which extends the full depth of the site alongside an ivy-draped wall, one finds few clues hinting at what lies beyond. The entry sequence is a curiosity trap: a tepid liminal zone external to the central courtyard formed by the four units comprising the site's architecture, yet internal to the processional logic which structures the site. Standing in this 'in-between', the visitor is forced to make a decision: to proceed further or retreat to the village behind. As the braver soul presses forward, there is a distinct sense of trespass, an instinct triggered not least by an encounter with a clothesline hung with laundry. The threshold of the gate would seem to imply a delineated boundary, a clear division between the profane arena of the public realm and the sacro-sanct interior. However, the gate at Courtyard 104 is typically left ajar, and the hazy dichotomy of public and private quickly dissolves into a continuum of uncertain spaces.

If the early phase of Ai's career expressed clear reservations over even modest deviations from extruded cubic forms, Courtyard 104 marks a point of formal maturation in his work. Deriving its shape from the ir-regular plot, the volumes containing the four units converge and overlap to create a forceful composition of brute geometry. Moving beneath the cantilevered overhang, a passageway appears in the periphery, revealing yet another courtyard punctuated by a grove of thin trees. The converg-ing walls that frame this view have an alluring pull. Once inside, the cen-tral courtyard opens into a broader triangular space framed by the hefty mass of the surrounding buildings, each sparsely fenestrated. Recalling

Courtyard 104, 2005
Site plan
Scale: 1 : 600

Opposite top:
The entry into the main
courtyard at Courtyard
104 is formed by the
overhanging upper storey
of two connected studios

Opposite bottom:
The central open space at
Courtyard 104 is formed
by stark intersecting
geometries which derive
their form from the
surrounding village

Previous page:
Courtyard 104, 2005
Caochangdi, Beijing, PRC

the unplanned construction of the village in which it is set, this heightened formal complexity results in odd convergences that invite a more direct sensual experience with the brick's texture: an effect amplified by the mixture of red and grey bricks which compose the facade.

This material effect is not solely attributable to Ai Weiwei's own instinctive material command, but also that of his contractors. In Ai's architecture, the notion of flexibility has always extended to the construction itself, a conscious approach that places the architect in collaboration with his craftsmen. At Courtyard 104, the builder was given only a set of plans along with instructions to mix grey and red brick at a proportion of approximately 2-to-1; the concentration and gradient of the brick composition was left entirely to the masons. This collaborative impulse is likewise apparent in the cross-shaped patterns of brick latticework that comprise the complex's southern wall, in which Ai simply instructed builders to reduce the number of bricks by a third. Controlling only the most essential points of the design — the basic proportions of the building mass and its spatial enclosures — Ai's deference to craftsmen enables his architecture to avoid the trappings of appearing timid or self-indulgent.

Despite their increasingly formal character, the buildings retain the flexibility of the interior, a crucial aspect of Ai's design, by linking the slightly irregular geometries through rationally executed floor plans. 'I search for maximum flexibility because I don't know who will end up using the space,' Ai explains. 'Since I know nothing about the interior's final function, I try to control the proportion, the material, and the openings.'[1] Soon after its completion, the Swiss gallerist Urs Meile purchased the buildings at the eastern half of Courtyard 104, renovating them to establish the first international gallery in Caochangdi. In the process of the renovation, doors were removed

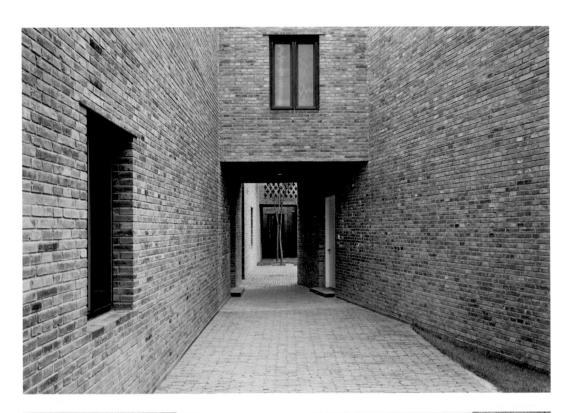

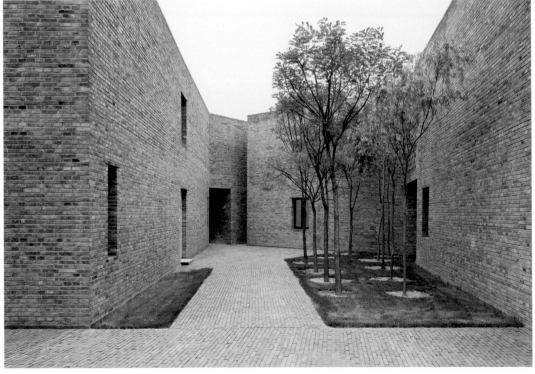

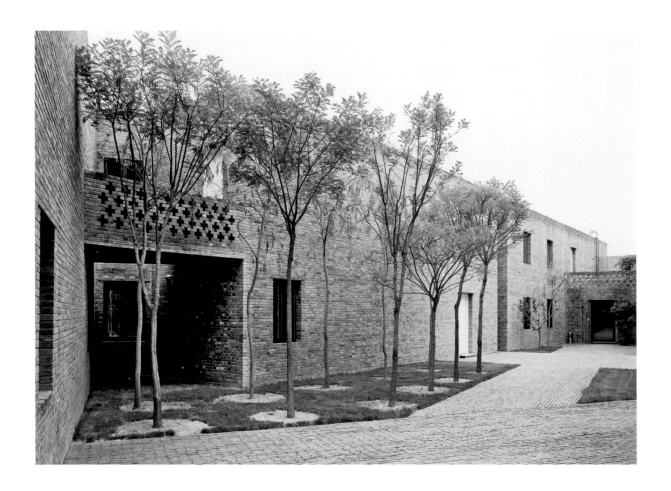

1. Eduard Kögel,
'Conversation between Ai
Weiwei and Eduard Kögel,
July 2007', in Eduard Kögel
(ed.), *Ai Weiwei: FAKE Design
in the Village*, Aedes, 2007,
p.6.

and wall openings widened to accommodate the installation of large works. The spatial arrangements were likewise changed to invoke the appropriate openness of a gallery setting.

Here, the logic of brick construction and Ai Weiwei's notions of the flexible interior take on heightened significance. Though each brick serves a minor structural role, its removal in sections does not compromise the integrity of the building itself. Brick walls, though sometimes associated with a sense of permanence, are nonetheless as malleable and adaptable as the open spatial arrangements of Courtyard 104's interiors. The effect is a logical reversal of sorts. Within the confused and even imposing confines of Ai's stark geometries, occupants find spatial parameters that are most accommodating.

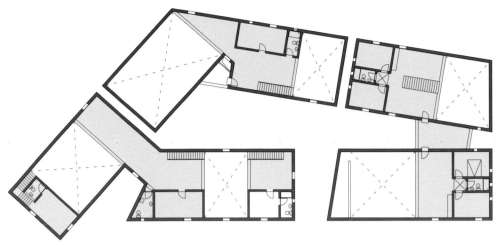

Plan: Second floor
Scale: 1 : 500

Plan: First floor
Scale: 1 : 500

This page and previous page:
Courtyard 104, 2005
Stark volumes of white walls
and concrete floors compose
gallery spaces that are lit
from above

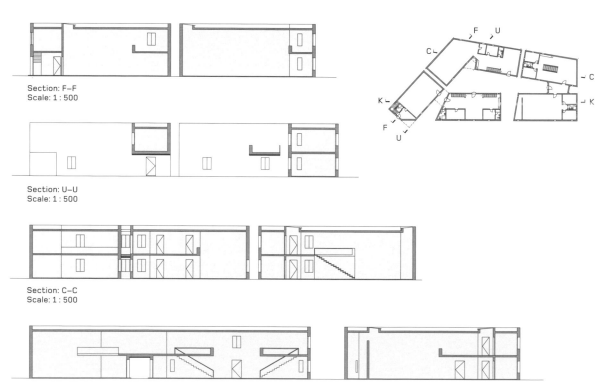

Section: F–F
Scale: 1 : 500

Section: U–U
Scale: 1 : 500

Section: C–C
Scale: 1 : 500

Section: K–K
Scale: 1 : 500

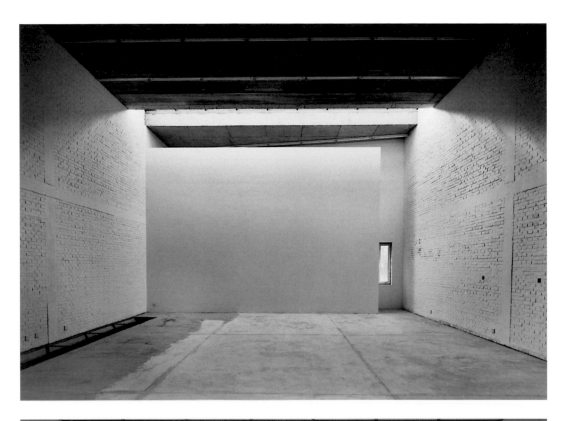

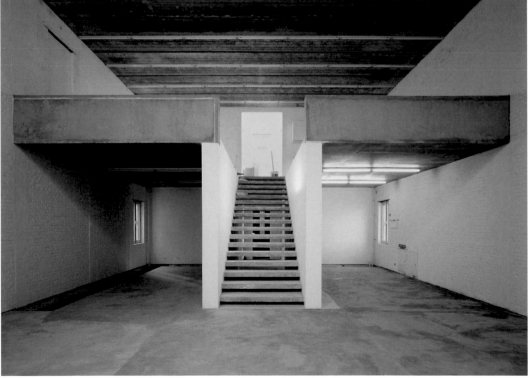

NINE BOXES

So frequently does China's urbanization find itself depicted in the tangled spaghetti of traffic-jammed interchanges and endless dystopian towers – a narrative that aims to convey the very foreignness of China's current milieu – that one assumes an entirely new urban paradigm, fundamentally distinct in scale, organization, and form. Often overlooked in the mediatized imagery of the Chinese metropolis is the prevalence of cultural mimesis originating in the lifestyle products of Western capitalism. Nowhere is this trend more pervasive than in the rapid adoption of the single-family house, made available in all multitudes of mass-produced variation, as the preferred dwelling for the nation's nouveau riche. In China, suburban tract banality accessorized with the typical accoutrements – green lawns, hedgerows, cul-de-sacs – confers an elevated social status rooted in the image of comfortable living. In such a manner, the suburban villa has 'imposed itself as a global vernacular, a paranoid self-replicating architectural trope that bears witness to its inhabitants' naturalization in an imaginary landscape'.[1] Across China developers busily replicate, with varying degrees of fidelity, European and American architectural motifs, on which Joseph Grima writes:

> Malls, neighbourhoods, districts, and cities appear to halfheartedly yearn for a distant reality, each vista a pale, cliché-ridden replica of an English village, a Mediterranean piazza or a Parisian boulevard. Buildings and public spaces fulfill the same purposes as the icons on a computer desktop – colourful, low resolution hyperlinks to the artefacts they stand for, tangible mental shortcuts to the tangible 'real thing'.[2]

In 2004, a developer enlisted Ai Weiwei to reprogramme a community of nine Mediterranean-styled villas as a sequence of art galleries, giving the artist carte blanche to impose a new aesthetic on the generic suburban canvas.

1. Joseph Grima, 'New Village = New Town', in Brendan McGetrick (ed.), *China Urban: Work in Progress*, Timezone 8, 2009, p.34.

2. Grima 2009, p.33.

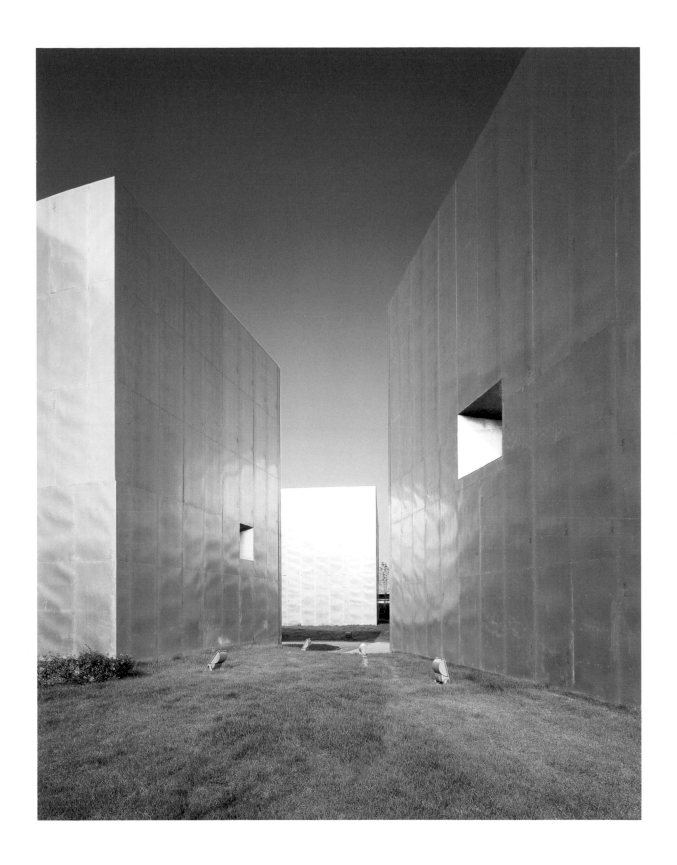

Nine Boxes, 2004
Existing luxury villas are
concealed behind temporary
tin-clad facades

Previous page and overleaf:
Nine Boxes, 2004
Beijing, PRC

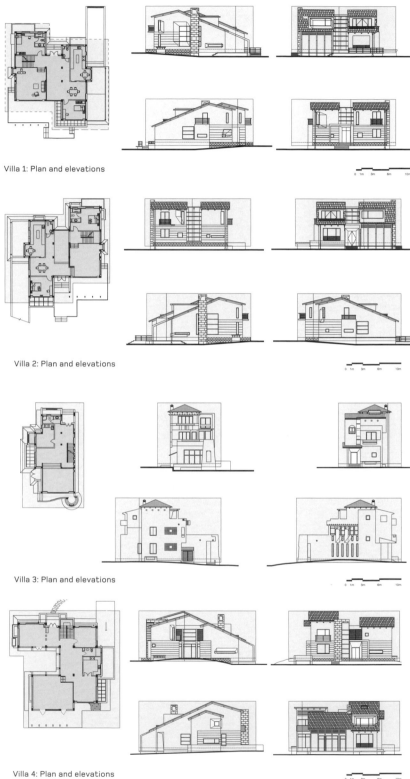

Villa 1: Plan and elevations

Villa 2: Plan and elevations

Villa 3: Plan and elevations

Villa 4: Plan and elevations

Taking the challenge quite literally, Ai covered the houses in a series of nine metallic boxes, encapsulating the original villas to completely conceal them from view. The simple and monolithic boxes permit only a few apertures, connecting select windows to the exterior through elongated passages that convey the depth of the cavity separating the new facade from the existing substrate. As a result, windows and door openings appear as deep subtractions from a dense mass, lending the boxes an illusion of solidity.

The surface of each box is a grid of tin sheets, a material commonplace in urban China and usually incorporated into advertising billboards. In addition to obfuscating the original villas and erasing any register of traditional tectonics, the tin cladding is evocative of a commercial vernacular not dissimilar from Robert Venturi's scenographic translocations of pop imagery. Though ultimately unrealized, early studies indicate that Ai harboured similar intentions. Utilizing the faces of each box as display surfaces for supersized imagery of familiar cultural tropes, these studies fit squarely within a contemporary strategy of using architectural facades as media substrates. In a clear homage to Herzog & de Meuron's Eberswalde Library, one study proposed a building shrouded in enlarged Warhol reproductions, while another displayed suggestively cropped images of a nude woman. Others were more subversive and included media stereotypes of Chinese culture, explosions, tanks, and bomber planes, and a burning World Trade Center. The provocation of such imagery is intentional. 'You want to make an argument in a very dramatic way,' Ai says. 'Of course, the whole thing was temporary. The architect from Singapore was able to do the villas because the developer was very naive, and I was able to do my design for the same reason. I mean, this is crazy.' In their various thematic compositions, the most innocent of these images are impish critiques that cast the commodity fetish for Western suburbanism in an unflattering light. The more militaristic imagery, meanwhile, suggests a staunch, unaccommodating stance toward the deleterious effect of China's ever-expanding consumer culture.

> Of course, the whole thing was temporary. The architect from Singapore was able to do the villas because the developer was very naive, and I was able to do my design for the same reason. I mean, this is crazy.

Nine Boxes, 2004
Facade studies for application of militaristic imagery

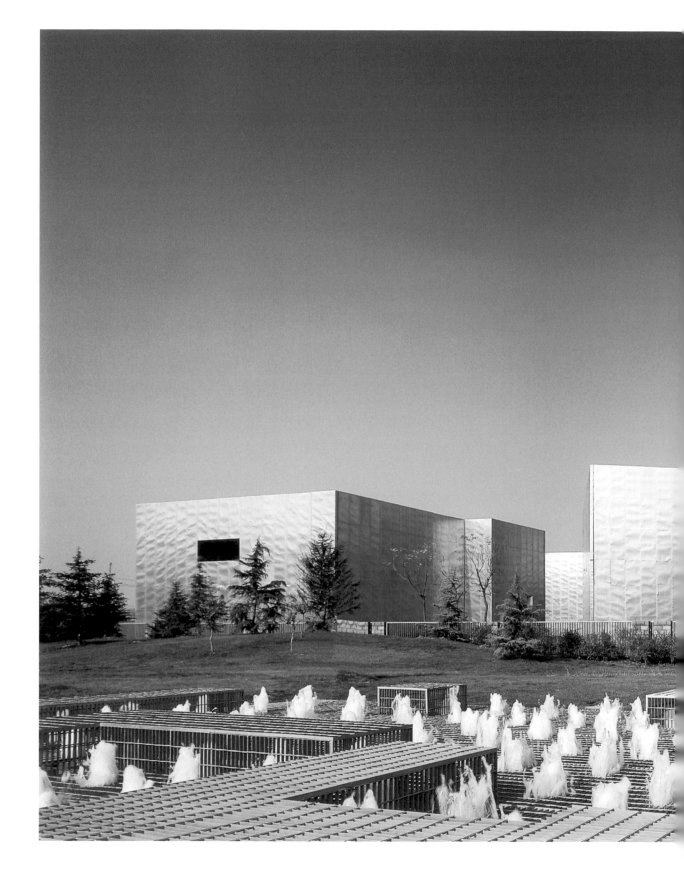

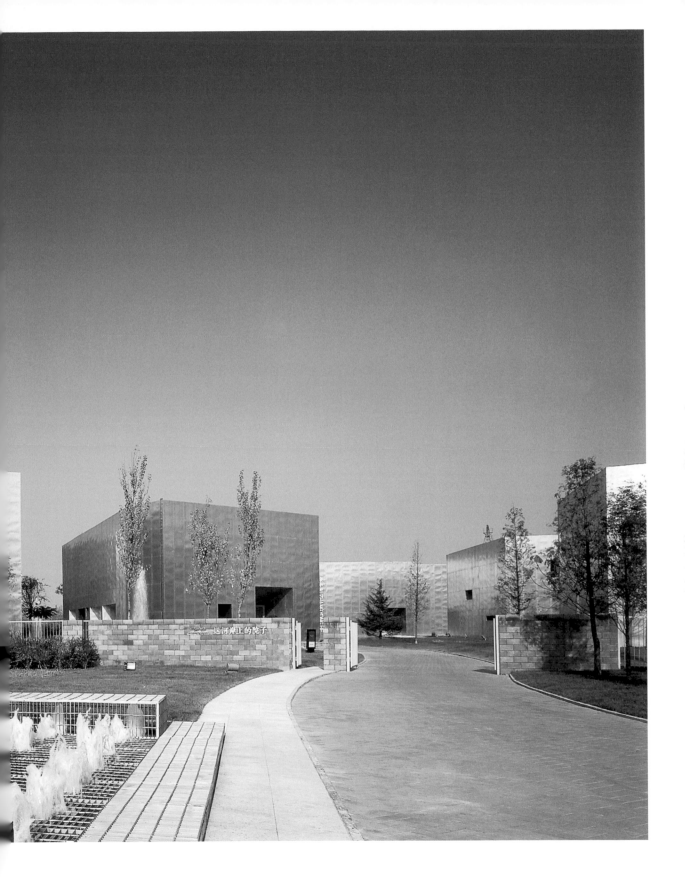

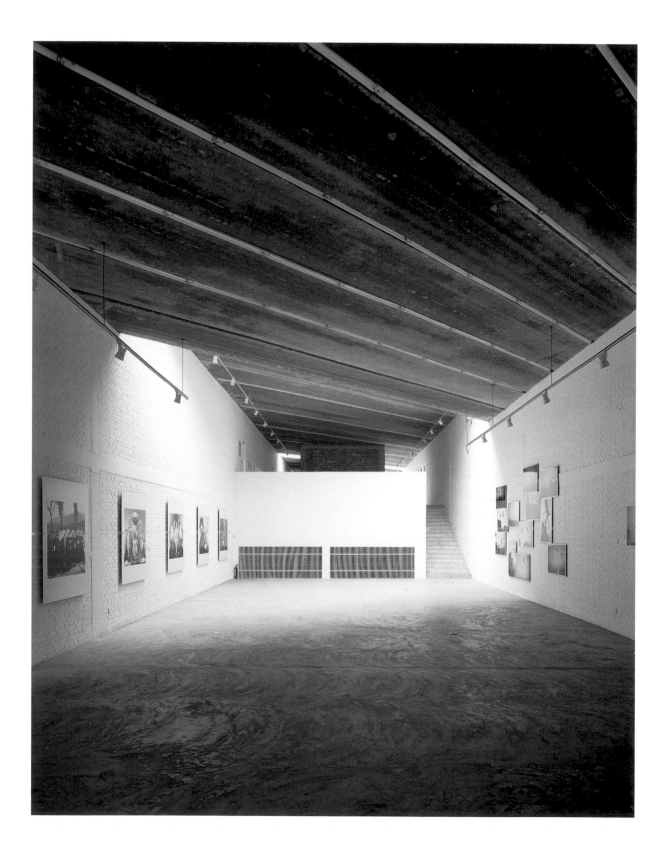

Caochangdi, Beijing, PRC
2005

THREE SHADOWS PHOTOGRAPHY ART CENTRE

By many measures, the Three Shadows Photography Art Centre is an exception to the cluster of buildings that Ai Weiwei designed in Caochangdi over the course of a decade. Sited north of the village's centre, the building rests unpretentiously on a triangular plot amid a spate of negligible warehouses; its rear-of-the-tracks setting can best described as light industrial. Concealed behind a veil of roadside poplars, the gallery eschews the natural prominence of a corner entrance, prompting visitors to follow the distinctly patterned outer wall to a side street gate. Viewing it in a state of distraction, the unsuspecting visitor might easily overlook the undulating brickwork on its eastern facade, its textured, low-definition topography lost among the trees' lower branches. Passing through the main entrance, however, the cascading brickwork pattern climbs and falls across the length of the exterior, projecting in such abrupt, dynamic fashion as to suggest the tunnelling presence of some fantastical creature within its cavities.

Designed for the photographers Rong Rong & inri, Three Shadows is a multifaceted cultural institution. Equal parts gallery, studio, and educational centre, it is, at least by Ai's usually restrained standards, a formally expressive statement of public architecture. Abandoning his typically laissez-faire disposition toward specificity and control over the execution of his work – a deference reflective of his appreciation for vernacular tradecraft and the limitations of his own technical proficiency – Ai concluded that the complex bas-relief along the exterior of the gallery could only be completed if he exerted a more forceful hand in its realization. At Three Shadows, the placement of each brick was anticipated in the design process, an arduous task of precision that required each module be appropriately staggered while preserving the integrity of the wall's intentionally destabilized appearance. The bas-relief on the facade is comprised of three layers, each protruding or receding six centimetres relative to the previous – a pattern Ai communicated to his masons through a single drawing.

Site plan
Scale: 1 : 600

Opposite page:
Courtyard at the
Three Shadows Photography
Art Centre

Previous page:
Interior of the
Three Shadows Photography
Art Centre, 2005
Caochangdi, Beijing, PRC

1. Michael Meredith, 'Never
Enough (Transform, Repeat
Ad Nausea)', in Tomoko
Sakamoto and Albert
Ferré (eds), *From Control
to Design: Parametric/
Algorithmic Architecture*,
Actar-D, 2008, p.6.

2. Meredith 2008, p.6.

At a time when sophisticated computational modelling has become de rigueur in both Western and Chinese architectural practice, one might easily mistake the facade's formal effects for a software-derived manipulation of conventional brickwork. Infatuated with the tautological image of quantity and complexity, a designer using such digital formalization techniques surrenders authorship to a form of technological determinism – an iterative process of design-by-algorithm utilizing a series of operations built upon a methodological binary of subdivision and aggregation.[1] Distancing the architect from operational control over the design, such processes stand in contradiction to the analogue nature of the Three Shadows design and construction, both of which were quite literally conducted by hand. Three Shadows also illuminates a key distinction in the larger oeuvre of Ai Weiwei's architecture, one in which the architect's omnipotent hand is most often intentionally withheld out of clear authorial intent – a clear contrast to the naively positivist position: 'the software did it'.[2] Ai Weiwei's design underscores the degree to which manual, low-skill labour comprises an effective mode of achieving the complexity of a modern digital aesthetic while demystifying the paradigm of technological enhancement as a governing ethos of contemporary design.

The distinctive facade is a result of the Three Shadows' public mandate, a programmatic shift from the private studios and residences Ai had previously designed and one which required a more distinctive architectural identity. Taking its shape from the site's irregular geometry, the zigzag configuration of the floor plan creates a series of semi-enclosed exterior spaces unique in character and purpose. From the north entrance, the

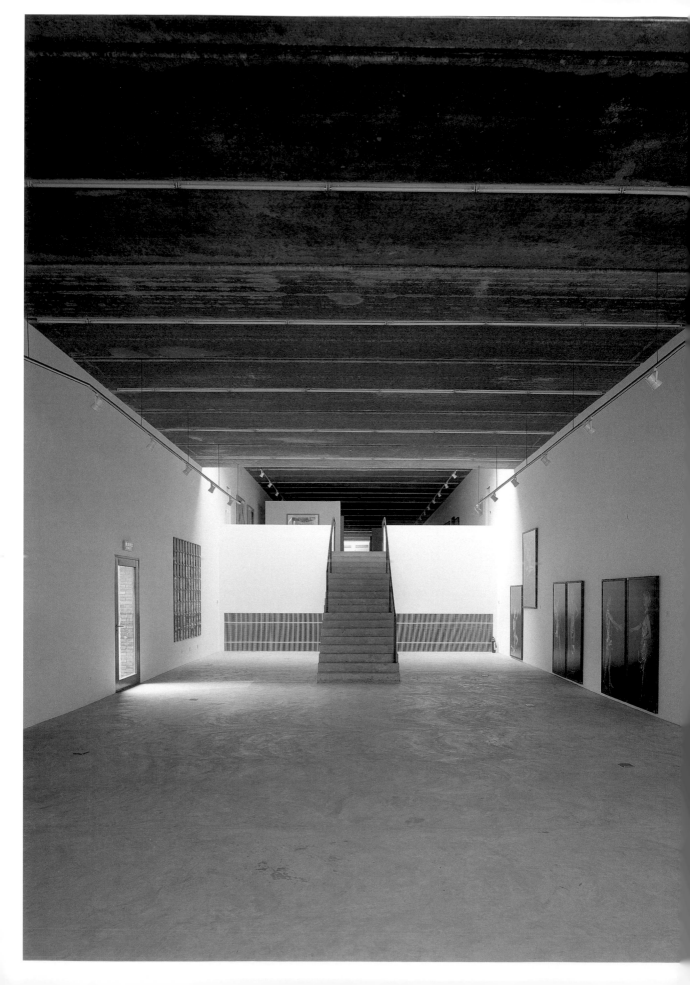

Plan: Second floor
Scale: 1 : 500

Plan: Ground floor
Scale: 1 : 500

visitor initially enters an expansive lawn used for events and film screenings. Framed by the gallery wall to the east and a small outbuilding to the west, the deep inset of the gallery entrance appears against a far exterior wall, the sole aperture in an otherwise solid mass. Without traversing the lawn, the entrance is reachable only by way of a path that forces visitors to confront the building's rough exterior as it runs alongside the northernmost wall. In this tactile encounter, the facade's singular elegance dissolves into its rough individual components, all bricks, mortar, and void, leaving a distinct impression of the building's heft and material's endurance.

It's very complicated to describe. It's really a philosophical and aesthetic question, between dark and light, between restraint and freedom.

As visitors proceed through the choreographed procession that leads up to and through the angled, linear volume of the building enclosure, these engagements provide fodder for intrigue and enjoyment. The building's interiors, however, are most arresting. After the compressed entry vestibule, the subsequent room is a massive double-height cube extending deep into the recesses of the gallery where it is partially enclosed by a second-storey loft. Sliced from wall to wall, a narrow, angled aperture lets in a blade of light. Through this incision Ai renders light as material — calibrated, hot, and alive. For him, these mood-altering plays of light and space are at the core of his understanding of architecture, but they are also enigmatic. 'This is the area of my buildings that is most difficult to talk about,' he notes, 'but it's perhaps the most important factor besides determining the boundaries and proportions of the walls.' Rather than generic lightness, a uniform levity and airiness brushed across the interior, Ai's surgical slices create an environment of extremes. 'It's really a philosophical and aesthetic question,' he says, 'between dark and light, between restraint and freedom.' As one proceeds through the building, the heightened series of alternating emotions does indeed endure, constantly shifting the balance between art and space, solid walls and streaks of illumination, somewhere between terror and delight.

Previous pages, this page and overleaf:
Three Shadows Photography Art Centre, 2005

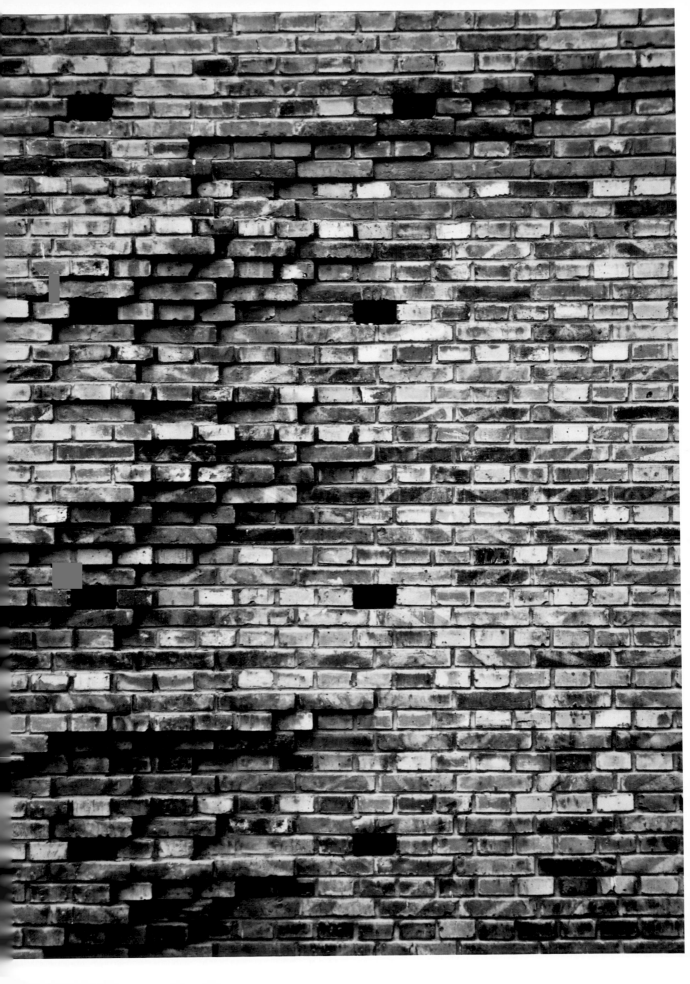

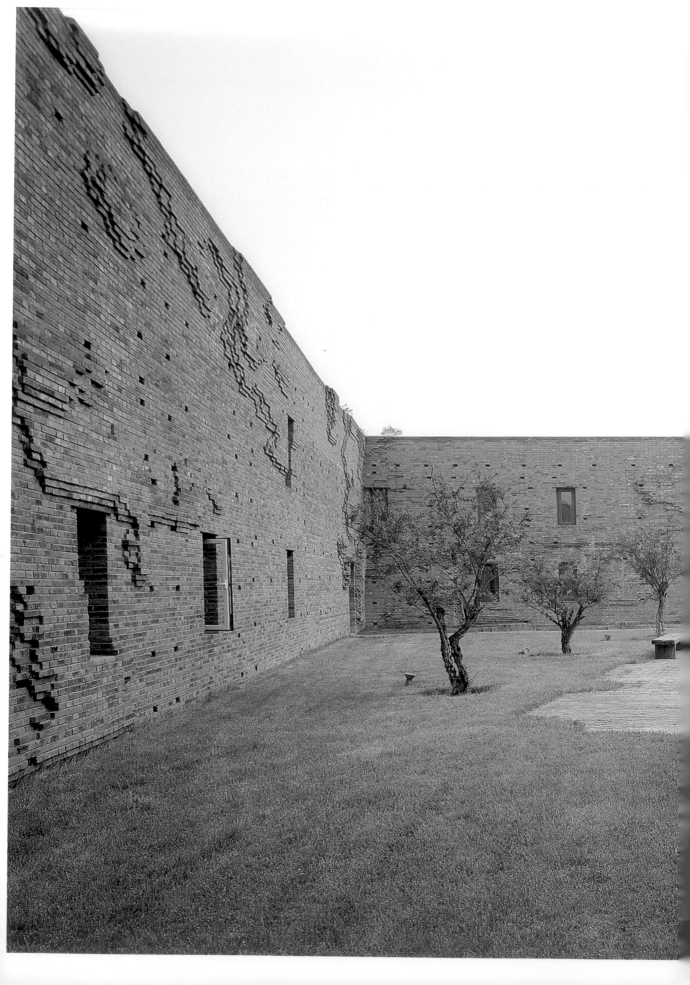

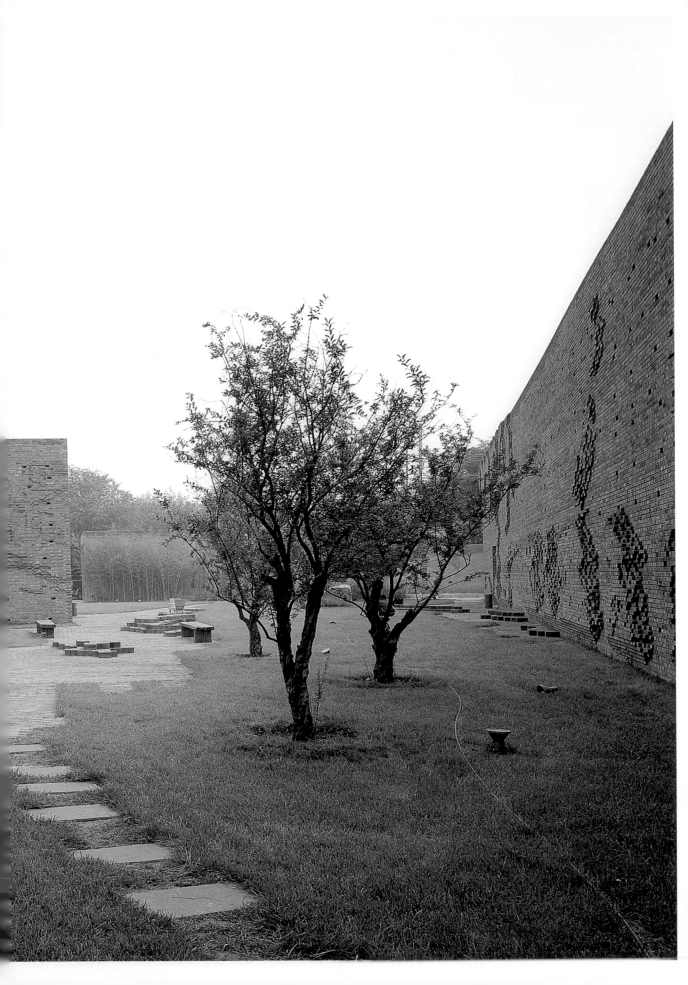

241 CAOCHANGDI

On the eastern edge of Caochangdi, the nineteen galleries at 241 Caochangdi have become a locus for contemporary Chinese art. Built adjacent to mostly single-storey structures, they are home to notable galleries and to the studios of prominent artists with personal connections to Ai Weiwei. These starkly geometric compositions are serial in nature and designed as modestly altered reproductions of one another. They are also the template from which local villagers have created their own replicas of Ai's architecture. In repetition and duplication alike, the galleries have become self-perpetuating manifestations of Ai's pop sensibilities, simultaneously defying authorial control and regenerating the village vernacular.

With very little time to develop an original concept, Ai Weiwei imprinted the formal rigidity of a rectilinear grid on to the elbow-shaped plot. Stamping out nineteen square and rectangular sites, he imposed one of three schemes on to the grid, two L-shaped and the other a long bar, that are each a reformulation of his Studio-House. Simplified and condensed into more efficient arrangements, sixteen of the nineteen buildings feature an L-shaped plan whose flexible configuration permits the elongation and contraction of the interior studio space depending on the constraints of the plot. The studio, the building's only double-height space, is oriented perpendicular to the rest of the building and features a second-floor overlook from the corridor. As in Ai's Studio-House, the auxiliary functions of the home are aligned against the back wall in a linear fashion, a consistent feature of the L-shaped buildings regardless of their size. The hallway, positioned at the crux of the 'L' and accessed by a slightly oversized corridor, dually functions as an inhabitable space by expanding the confines of the open room plans, in addition to serving as circulation. The programmatic space dedicated to the house's domestic functions and service spaces remains consistent regardless of type. In the handful of narrow bar-shaped buildings which line the southern edge of the site, the small living quarters are stripped of their

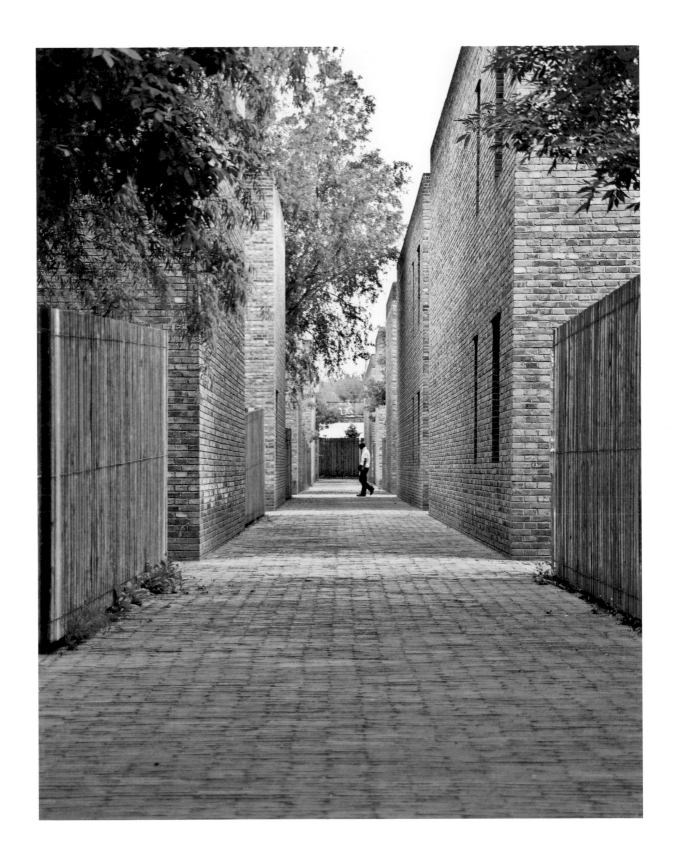

Previous pages and this page:
<u>241 Caochangdi</u>, 2007
Caochangi, Beijing, PRC
Each of the L-shaped homes encloses a small
private courtyard

241 Caochangdi, 2007
The passages at 241
Caochangdi are illuminated
by strips of light embedded
in the courtyard's perimeter
fences

1. Eduard Kögel,
'Architecture Has to Fit to
Life', in Eduard Kögel (ed.),
*Ai Weiwei: FAKE Design in the
Village*, Aedes, 2007, p.25.

large studio. In its place, a double-height living space is generously sized in order to accommodate functions both domestic and productive.

In addition to attracting greater attention to the village's art scene, 241 Caochangdi also focused international attention on Ai Weiwei's architectural endeavours. While Ai's minimal tendencies are derived from expedient construction methods and not from Western minimalist art practice, the project's unintended formal resemblance to the work of Donald Judd is difficult to deny.[1] The buildings are discrete and abstract cubic volumes, arrayed axially and sequenced rhythmically. Their precision and proportions are striking and seemingly mathematical. In the few wider passages meant to allow automobile access, overhanging tree canopies create a gentler spatial disposition. The playful compression and expansion of open space creates a thrilling hierarchy of exterior spaces whose environmental conditions shift progressively in relationship to daily and seasonal weather patterns.

The irony of such Western comparisons is not only that Ai drew from Caochangdi for his architectural inspiration, but that villagers had already begun adapting their own buildings in response to the presence of Ai's architecture. By mid-decade, the nearby construction of *shanzhai*, or copycat buildings, known as 'fake FAKEs', predominated among the buildings adjacent

241 Caochangdi, 2007

Site plan
Scale: 1 : 250

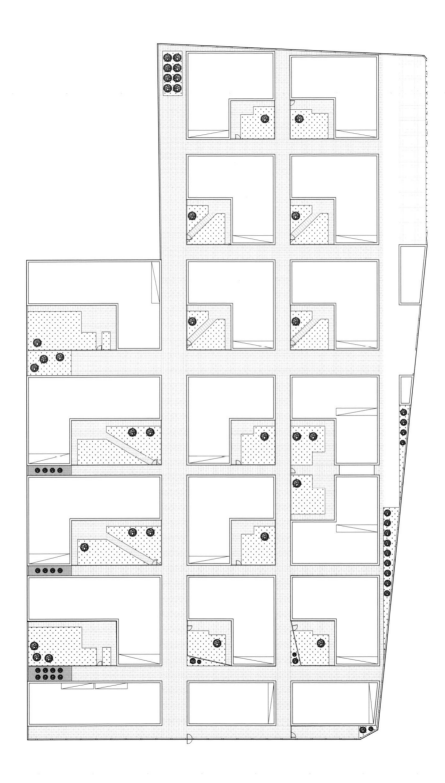

Plan: Second floor
Scale: 1 : 200

Plan: Second floor
Scale: 1 : 200

Plan: Second floor
Scale: 1 : 200

Plan: First floor
Scale: 1 : 200

Plan: First floor
Scale: 1 : 200

Plan: First floor
Scale: 1 : 200

Section
Scale: 1 : 200

Section
Scale: 1 : 200

Section
Scale: 1 : 200

Section
Scale: 1 : 200

Section
Scale: 1 : 200

Section
Scale: 1 : 200

241 Caochangdi, 2007
Neglected agricultural land at
the site prior to construction
of the art complex

to 241 Caochangdi. These modest buildings are identifiable reproductions of Ai's architecture, if lacking its full refinement. They use a similar geometric language and strive for compositional clarity by utilizing basic design principles of symmetry and balance. Importantly, they also express grey brick as the predominant exterior building material, free of the prevalent use of stucco or tile as an exterior cladding. The Fake FAKEs have accentuated the way in which Ai Weiwei's work has become an emblem for the village, even to those with little knowledge of contemporary art and design.

In this phenomenon, there is another tacit connection to Donald Judd: the appropriation of village identity as cultural venue. Caochangdi has become a site of pilgrimage not unlike Judd's compound in Marfa, Texas, now a touchstone for art enthusiasts: a once-sleepy south-western town that is now noted for its galleries and Prada store. In addition to his studio, Ai's co-founding of the China Art Archives and Warehouse in Caochangdi was significant for being one of the first contemporary art spaces in China, albeit one that used the term 'warehouse' to successfully evade the oversight and censorship that typically constrained exhibition venues. A dozen years later, Caochangdi is an important node in the international network of contemporary art practices and galleries. Though Caochangdi and Marfa are dramatically imperfect reflections of one another, the mechanism of their development is indeed strikingly similar. Whether the similarity is coincidence or influence, the evolution of both Marfa and Caochangdi has something to say about the way in which extra-urban spaces can be altered, given the correct alchemy of culture and socio-economic circumstance. 241 Caochangdi has transformed its surroundings in both programme and aesthetic, without an original intent to do so.

241 Caochangdi, 2007
Narrow passageways and strong formal geometries frame views to specific moments within and exterior to the complex

Next page:
The main passageway at 241 Caochangdi leading from the complex's entrance

Build

RED NO.1 ART GALLERIES

To immerse oneself in the village of Caochangdi, it is best to arrive just before dusk. Transported by taxi, a timely arrival is almost certain to be curtailed by traffic where, idling amid the single-file hum, motorbikes whizz by only inches from the passenger door. As the procession slows, the motorized buzz is joined by a car horn's petulant wheeze, first one, then a chorus. Out the window, pedestrians, somehow immune to the grating soundtrack, amble on, overtaken by the occasional cyclist laconically pedalling by. Waiting for the cab to resume, the scene repeats itself. Again. Then again. Soon it becomes clear that it is best to get out and walk.

The village itself has few points of entry. Nestled in the crook of two overlapping freeways, Caochangdi's eastern edge is bounded by an elevated railroad bed. The ramparts of infrastructure hold the city at bay to one side and the hinterland to the other, giving the village's delineated territory a clear sense of arrival. Here, standing beneath an overpass where the Fifth Ring Road launches over a fourteen-lane expressway, the stalemate of converging cars impatiently negotiating a three-way stop marks the village's outer edge. From the outside, Caochangdi presents itself as a solid mass, a dense mid-rise block broken occasionally by narrow passageways. The spatial confines of the village are markedly different from the vast horizontality of modern Beijing. Streets are wide enough for a single car, but only at low speeds. Buildings, meanwhile, consistently top out at five storeys. Following a road which has only recently been paved, the village's oldest quarter is half construction site, half bazaar. Interspersed between the storefronts and apartment entrances, cement mixers and shoulder-high brick stacks hover close to the building walls.

The phrase 'hu da luan jian' roughly translates as 'build an illegal mess in the public street', a description that adequately captures the unfolding activity each evening in Caochangdi.[1] Vendors, intermittently present during the day, multiply, each restaurant pushing out from its frontage to occupy a

Previous page and this page:
Red No.1 Art Galleries, 2008
Caochangdi, Beijing, PRC

1. Robert Mangurian and
Mary-Ann Ray, *Caochangdi:
Beijing Inside-Out*, Timezone
8, 2009, p.214.

2. Sara Blumenstein, cited
in Mangurian and Ray 2009,
p.253.

sliver of street estate. In the crepuscular haze, Sara Blumenstein observes, 'everyone becomes more vivid, more concentrated, more curious, gregarious, irritable. Suddenly the lit interiors of rooms become visible from the dark street and visions of domestic routines play like shadows across the glowing projection screens of windows and doorways, rendering the building surfaces a cinema for the passerby.'[2] Further down the road, scents from coal-heated deep fryers and grilled meat skewers lift into the air. At the intersection of two major streets, the village's resilient street wall peels back, creating a confined but vibrant public square where the scents of various cuisines flow from every open door, vendor, and food stand.

The architecture of the village is hardly benign. Through framing, bounding, shifting and altering its spatial parameters, the village gives conceptual and material structure to these experiences. In much the same manner, Ai Weiwei's Red No.1 Art Galleries complex, situated at the edge of the village's old quarter, serves as a backdrop against which village life unfolds. Each evening, nearby restaurants serve food at plastic tables pushed up against its exterior fence. Extending two village blocks, its long, heavy mass frames the street life against the procession of narrow structures across from it. The complex is understood at once as an extension of the village, but

Red No.1 Art Galleries, 2008

also a series of buildings distinct from it. Its red-brick facades are solemn, more composed, and less chaotic. A perimeter fence separates the complex from direct access. It marks the point at which the residential village fabric gives way to an area formerly occupied by agricultural fields, and is now home to a vibrant, if markedly different, set of art-related industries.

The complex, which is colloquially known as the Red Brick Galleries, is organized along a bent central spine that feeds a dendritic network of narrow paths. Punctuated by five courtyards, the system of alleyways echoes the spatial fluctuations of the village and conditions different experiences as occupants navigate its interior passages. Interstitial spaces between buildings condense to less than two metres, intensifying personal exchanges. Blind corners build suspense and reveal surprises. The alleyways extend to the edge of the site and amplify visual connections to the village through open crevices that reveal glimpses of the activity beyond. The juxtaposition of the village's frenetic motion with the Red Brick's austerity and stillness is significant, but not alarming. From a large courtyard at the centre of the complex, the main entry lane frames a view of the village's smokestack. The connection to the village is one that Ai Weiwei readily acknowledges:

> Personally, I take my inspiration from common places like villages or from the local, mostly poor people, or people who do not think about architecture. They might not think about it, but they know how to build their house. They have no money for an architect, so they have to find their own way. I think their solutions are often as good as those of so-called architects … because it's cheap, because it's necessary, because it's done with limited means.[3]

Though borrowing its spatial characteristics, it is clear that Ai Weiwei is not merely replicating the village, but regenerating it. The twenty-five galleries and studios which occupy the complex, as well as twelve residential apartments, are considerably more spacious than the typical village building. The interiors are attuned to the needs of their artist inhabitants. In the exterior common spaces, cars are banned and the building facades are cleared of mechanical appendages such as air conditioners and satellite dishes.

The Red Brick Galleries also mark a significant departure for Ai Weiwei, in which the artist abandoned the grey-brick aesthetic for which his work had become identified. Stripped of their facade, the Red Brick Galleries bear only their naked skeleton: a rectilinear structural grid that encompasses the building's spatial mass. The transparent display of structure produces a legible registration of the building's construction. Repeating concrete post-and-beam structural members, with brick infill for lateral stability, reaffirm Ai's notions of 'essentiality' by reducing the building's materiality to the minimum required for its enclosure. Whatever modest pretentions may have been latent in the use of grey brick are now removed as the architecture exists in its most immediate form.

The tectonic immediacy of the Red Brick Galleries provides a resolution to a question of aesthetic integrity that has frequently confounded architects operating under the modernist idiom. Valuing literal transparency enabled by technological advancements in glass and steel, modernists attempted to reveal the relationship between structure and architectural space in order to demystify, and secularize, architectural meaning. This tension has played out between two predominant tendencies. The first has manifested itself in an aestheticization of structure, often achieved through the expression of mechanical and structural systems on the building's exterior. These expressions, though evocative, invoke measures of complexity far surpassing the building's actual mechanical and structural requirements and shroud architecture in the image of a technological performance that it is not equipped to achieve. Alternatively, architects have fetishized pure geometric forms, particularly through affective qualities of surface and skin. These objects often mask the engineering prowess that produced their clean aesthetic. Going to great efforts to conceal wires, substructure, and their messy internal workings, this architecture is reticent about revealing itself as a building.

Ai's architecture, with its pure forms and honest structural expression, finds strength in architectural modesty. It demonstrates the historian Kenneth Frampton's belief that 'architecture is founded in the apposition of a compressive mass (as exemplified in brick construction) and a tectonic frame'.[4] Like the manufacturing buildings of Albert Kahn which Frampton admired, the integrity of the Red Brick Galleries derives from its aesthetic purity and functional economy. Located in the village and placed in service of the arts, however, this straightforward appeal is given new meaning and new form outside of its previous association with capitalist production.

This page and next page:
Red No.1 Art Galleries under construction and completed in Caochangdi

3. Eduard Kögel, 'Architecture Has to Fit to Life', in Eduard Kögel (ed.), Ai Weiwei: FAKE Design in the Village, Aedes, 2007, p.6.

4. Hal Foster, Art-Architecture Complex, Verso, 2009, p.150.

Collaborate

**Experimentation, Exchange,
and Cultural Dialogue**

Entries from Ai Weiwei's Blog

Problems Facing Foreign Architects Working
in a Chinese Architecture Practice
Posted: 22 January 2006
Written: 16 December 2004
Translated by Philip Tinari

China has rapidly become the fastest developing and largest-scale economic entity in the world. This phenomenon has, in turn, transformed the Chinese architecture market into a force that the whole world attentively watches. The major reason for the Chinese architecture market's becoming such a powerful force originates in the fact that this nation, which has a fifth of the world's population, has, after lying comatose in the domains of economics and politics for the past 100 years, accumulated great hopes and demands in the course of its nearly thirty-year conversion to capitalism. Thousands upon thousands of villages are becoming like cities. More than 100 million peasants are currently becoming urban dwellers and industrial producers. One hundred million households are moving. People thirst to become rich overnight. They are ready at any time to become new people living in a new home, a new neighbourhood, a new city. The power of these desires has caused this ancient culture to rise from the dead to live again; this suggests, moreover, the revolutionary potential of a completely new attitude toward human existence.

In nearly 100 years of Chinese social practice, those varieties of social ethics and aesthetics that take traditional cultural forms as their foundation have been scarred and battered; nothing remains. What has replaced them is the Marxist conception of a socialist utopia, the cruel ideology of 'class struggle', and an inhuman societal reality. The 'economic reforms' of nearly thirty years ago were the unavoidable choice for this calamity-ridden people to make at the end of history. After several decades this choice has already pushed this land of 1.4 billion people gradually to become a part of the global systems of economics and politics. China and the world discovered each other with great amazement. This has forced both parties to come to know themselves anew, as well as to recompose the spatial order and structural system of the globe.

This nation, whose architectural output has, in recent years, surpassed the sum total of all its architectural output in the course of its several thousand years of cultural history, is currently, in every domain, displaying all the elegance of a famished beast. China is consuming one half of the world's concrete and one third of the world's steel; and it is producing nearly half of the world's textiles ... These contemporary realities are causing the world to stare and to gasp, eyes wide open, mouth agape.

In the midst of this suffering, Chinese people are studying these loathsome realities, one after another. After the struggles of the past 100 years, they have returned to those inescapable foreign systems of thought – 'democracy and science'. At the same time as China is prostituting its labour force, is painfully accumulating wealth, and is sharing in the fruits of human culture, it is discovering that it must also choke down these harsh realities.

Within the domains of contemporary urban development and architecture, be it with regard to ideas, to concepts, or to technological means, China still lags behind the rest of the world. This is causing China to be unable to face problems and to put forth effective solutions. In the course of the past 100 years, Chinese architectural practice has just barely managed to resolve the basic demands for shelter of one billion people; otherwise, it has not managed to leave behind any other spiritual meaning or cultural legacy. In facing the speed and scale of today's development, the avant-garde culture and the mature technological resources gained from abroad represent the necessary path to fulfil the demands of China's development. This is a question of life and death. This is not a question of emotional preference. Although the situation is like this, clear reasoning is still, in different times and practices, suffering from crazed obstacles posed by the influence of outdated traditions, as well as by the special interest groups representing such beliefs. Such forces have persistently advanced under the mottoes '[for] the benefit of the nation' and 'for the national spirit' to cover up the hypocrisy of such cultural standpoints and the incompetence of academia.

'The rise of China' has attracted global interest. In the course of the past several years, a great number of foreign

architects and structural engineers have taken on projects large and small around China. These offices include both the 'elite' of the pinnacle of global architectural culture and large-scale, functionally perfect, commercial enterprises. They include youthful practitioners and hordes of college students who, filled with idealism, attempt to discover and to realize in this new world. To this unknown land and unknown culture, they bring all of their past knowledge and experience.

These practitioners who possess this astounding courage must take the greatest risk that a risk-taker can: they must face the infinite confusions created in these many situations in which they encounter different languages, different life conventions, different systems and structures of social power, different cultural views of values; and they must deal with projects of enormous scale, unimaginable speed, low fees, lack of clarity, illogical ordinances, simple tasks, complicated goals, absurd operational routines – these fickle, unclear, ambiguous projects lack verifiable bases and laws to follow.

The same single entity that gave birth to the several thousand-year history of the mysterious cultures of Confucianism, Daoism, and Buddhism, also embraced the system for realizing the ideals of communism. This same entity possesses a cultural tradition of history's most complete system of ethical thought, as well as a most materialist, desire-driven reality. It has a dogmatic theory of government, and also a society flooded with liberalism. These many types of confusions have caused this bit of land to be filled with energy and injury; with possibility and impossibility; with opportunity and danger, surprise, excitement, frustration, and despair.

People still come to China and still pay attention to China, because she is a part of humanity. Be it in terms of its significance for philosophy or in terms of its real life, China is becoming a real, irrefutable part of world culture. As the West faces China, it is also coming to recognize another face of the world, another condition of civilization and humanity. In doing so, perhaps it is also recognizing the limits and weaknesses of reason and order, and feeling the happiness that comes from doing so.

<u>Olympic Virus</u>
Posted: 26 July 2008
Translated by Lee Ambrozy

I've been into the city twice over the past few days. My ears are full of the endless complaints of taxi drivers, and everything out the car window is indeed a scene of desolation.

There is a slew of new safety regulations; we need a travel permit even to enter our village. As for global 'anti-terrorist' measures, we've already matched those of the American imperialists, or even surpassed them. A police state built in the name of fighting terrorism has become the greatest threat to a harmonious civil society. Aside from the injury to life and other related costs that any terrorist victory in the world might cause, an even greater price is paid in the consequent threat to society's collective psychology and the disruption to the peaceful nature of the common people's lives. This is the real cruelty and backwardness.

How many citizens will have their rights further encroached upon in the name of safeguarding the state? The people are paying such a high price for the 'national benefit'; is this the mark of a democratic country, or the foundation of totalitarian dictatorship?

We've been arguing about culture and creativity for so many years, finally pouring all our national reserves into Olympic design. It would have been a rare opportunity to gain face for the nation, and who doesn't want face? *Haha*! This time we lost big face! Bring out the results for assessment, because this is precisely why transparency and public disclosure are so great. Every bit of the Olympic design, from Beijing's masquerade, to the taxis, the 'Friendlies', medals, torch, flag, posters, costumes, logos, fonts, colours, and symbols for each Olympic event. A few years ago, when the professionals convened, they spent an unlimited amount of money, and the final result is a compromise in quality that has plummeted far below any of its precedents, and exceeded even the lowest known standards. There are throngs of designers in this magnificent and vast nation, and not a single project or object could be called worthy of display.

Cultural creativity is going nowhere, and if we gave millions of party members all the money in the world, they still

couldn't boost creativity. They are incorrigible. This society was never meant to meet with the true, good, or beautiful; it is filthy, denies individual creativity, scorns culture, and is controlled by a corrupt system, all of whose efforts will ultimately end up as a blaspheming of cultural ideals and truth. Today, Olympic design has embarrassed itself in front of the entire world – doesn't anyone feel their faces getting flushed?

Anything like this society's exuberant joy necessarily derives from lies and deception, and a society with no integrity necessarily has shameless lackeys. Chinese nationalists are attempting to fob off the Swiss-designed National Stadium of Herzog & de Meuron as 'China's own'. Although a few people know who its real designers are, bird's nests popping up across the city are beginning to look guilty.[1] I've seen immorality, but I've never seen this brand of stupidity. Imagine spending three generations' worth of your family's savings to buy a BMW, and then stubbornly insisting you had bought a knockoff – could there be anyone as foolish as you? This time I understand why shameless people fear reality and alter the truth; it is the hopeless incompetence and sense of inferiority that runs deep in their bones.

You've called me the 'consultant representing the Chinese side' countless times. Let me admonish you one more time: I have nothing to do with 'the Chinese side'. I've never worked on your side.

In all the joint-venture projects, those cooperating with the so-called 'Chinese side', to put it mildly, are nothing more than job-seeking migrant amateurs. They flock into the city, and then return home to their villages telling people that all the buildings in the city belong to them.

As for those striking poses after being crowned the 'chief Chinese designers', perhaps the public isn't quite yet aware of the weight of your crucial significance. Why don't you get up on the scale now? We'll throw you a ladder and you can climb right up; anyway, both the masses and history are fools. Overworked to the point of 'fainting' and 'sleep loss'?[2] That's nothing, but acting naive and ignorant in front of the entire world, pretending to throw a tantrum like a child, daring to plagiarize and then still swagger around town – yours is not merely a 'broken spirit', it's more likely

a problem of character. As they say in Hebei, you ought to 'inspect your reflection in a puddle of your own piss', or, they might ask, 'What kind of weeds are growing on your ancestral grave?' Your miserable face has already become the very cornerstone supporting them; are you pleased with yourself? You really love your motherland too much, to the extent that you can't wait to smear mud on her face.

A phony military commander hollering commands, setting fires, pinching the ladies of the house, and grabbing a few chickens as he trails behind the Japanese invaders is already profiting enough at other people's expense. If you started bragging that you were Yamamoto Isoroku wouldn't you be looking for trouble?[3] And what day was it that the Japanese imperial army surrendered? Your days are likewise numbered. Soliciting in the national whorehouse, eating on their tab and feeding the enemy under the table, you stand to profit no matter what wins. Judging from your skills, you should have started burning incense a long time ago.

Turning black into white and confusing right with wrong are at the very core of socialism with special characteristics, the very foundation and spirit of a despotic state and a cowardly people.

The Olympic Committee
Posted: 18 August 2008
Translated by Lee Ambrozy

There is no love or hate in this world without reason. If you don't know even this, then there are many things you won't understand; someone has sold you out, and you're helping him or her count the money. About the sacred Olympic committee; why do they look and sound more like military arms dealers, or the mafia? And why is it they increasingly prevent other people from saying this is so, shield themselves so enthusiastically and seek justification, while violating the truth with bigger, more ludicrous lies? This is not a brainteaser, the answer is simple, one word: profit.

The world has truly changed, and it would be a mistake to say it's become smaller. It's become dirtier. In this world, the real battlefield is no longer teeming with battles over beliefs and ideological wars. The real war is over profit, naked

profit. Profit is multiregional, straddles different groups, and is transnational. The dream of modern globalization is, time and again, the redistribution of profit by capitalists and global powers. In this sense, you discover that you and your enemy could possibly be fighting on the same side of profit, because you all face the possibility of being divided up.

This isn't hard to understand, because there will always be some international bad guys kicking up a fuss, holding you down while others beat you, or lying to you with their eyes wide open. That international committee is full of beasts in gentlemen's clothing; however much they stand to gain is how able they are to solemnly vow, 'This is the best Olympics we've ever seen, the most effective management, the cleanest air.'

We're all living together, so there's bound to be horseplay, and the inevitable conflicts and injuries. But the cries that come rolling in about an Olympic spirit from Olympic-mongers in faraway lands, they are just peddling fake medicine. Their every word, every action, and every glance are to seek out and protect their greatest personal profits.

Don't trust the internationalist hypocrites, who are even more frightening than the bare-toothed nationalists, and who would never truly concern themselves with the lives or the equity of their friends in neighbouring countries. They could speculate on the universe for profit. This is a more accurate diagram of the world.

And this makes for a more extraordinary reality: the world is no longer just you and your neighbours – your home, streets, cities, and country are in the process of being, or have been, traded. When you finally wake up and open your eyes, you'll have no idea, but you might be a hundred times worth your original cost.

Joy and pain will no longer arise from right and wrong. Whether a person is good or evil, and distinguishing black from white, are merely the brutal competition of interests. It is above religion, stronger than beliefs, and triumphs over nation and state. Are the Chinese prepared, or could they just be jumping from the tiger's cave into the wolf's den?

This is precisely why we should forget thousands of years of ideological struggle, why we should sober up, and learn how to do business with this filthy world. Anything else

would be destroying your kitchen pans to sell them for iron, and after you've sold everything, other people will point and laugh at you, saying: 'Look at that true socialist SB with special characteristics'.[4]

For a moment, forget the struggle between tyranny and civil rights; forget the extravagant dreams of referendums or citizen votes. We should struggle for and protect those most basic, miniscule bits of power that we truly cannot cast aside: freedom of speech and rule of law. Return basic rights to the people, endow society with basic dignity, and only then can we have confidence and take responsibility, and thus face our collective difficulties. Only rule of law can make the game equal, and only when it is equal can people's participation possibly be extraordinary.

As for our friends from faraway lands, we ought to look more deeply into their eyes, and much more often.

1. Designs inspired by the Bird's Nest – or, more specifically, the appropriation of the characteristically irregular pattern of its steel supports – had already begun to appear all over Beijing in 2008. Similar weblike patterns have been spotted in discos, restaurants, and police stations, as soap containers, in plastic shoes, and elsewhere. Ai Weiwei served as a consultant to Herzog & de Meuron in the design of the National Stadium.

2. This is a specific reference to a quote in the media from a Chinese engineer working on the National Stadium, who (presumably in an effort to show his patriotism) said that he was working so hard that he was losing sleep, and was exhausted to the point of fainting.

3. Naval Marshal General Yamamoto Isoroku (1884–1943) was the commander-in-chief of the Japanese combined fleet during World War II, responsible for major battles such as Pearl Harbor and Midway.

4. SB is Internet usage for *shabi*, a vulgar insult.

All posts from Ai Weiwei's blog were edited by Lee Ambrozy and published in *Ai Weiwei's Blog: Writings, Interviews, and Digital Rants, 2006–2009* by MIT Press in 2011.

A CONVERSATION WITH AI WEIWEI

Jo-Anne Birnie Danzker

JBD: Ai Weiwei, I was wondering if we could talk about the Beijing National Stadium and your collaboration with the Swiss architects Herzog & de Meuron. [Ai Weiwei groans.] If you'd rather not we can discuss other topics!

AWW: But I have to, during my entire lifetime I will have to repeat this. Because it is so big! [Both laugh.]

JBD: You recently described the National Stadium as 'a very bold design for a nation that wants to prove itself part of the international family, to show we share the same values … As an architectural work, it stands for this moment in history.'[1] What are these values that the Chinese nation shares with the international family?

AWW: What values they share, or what values should they share? That's a different question. They should be much more open; the culture and the politics of society should become much more open and fair. This, I think, is most important. And they are related. If you are not open, this creates even more unfairness. Chinese society has a very old structure. The government tries to fix up everything, to change everything, except this structure. We have come to a moment where everyone can tell that this is not possible. You can see all the problems that have occurred which the old ideology and philosophy are not capable of dealing with.

The Open Door Policy of the past thirty years allowed good practical opportunism to take up the chances being offered by globalization. There is profit, and the nation is much stronger. But it still has the old political structure. For such a large nation just being opportunist is not going to be enough.

JBD: The openness in the West has not necessarily brought about the kind of society you want to see.

AWW: No, it is not about copying the West, it is a very different question. I am not talking about using the West as a model or following in its footsteps, we

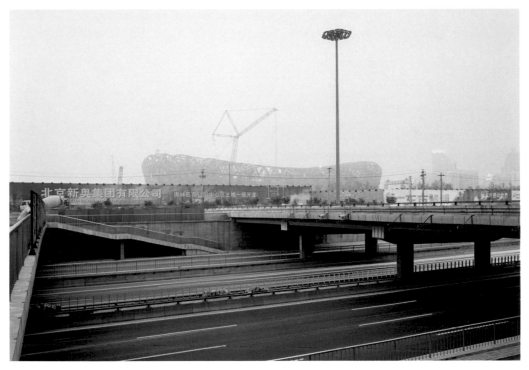

<u>Beijing National Stadium</u>, 2002–2008, C-print, with Herzog & de Meuron, Beijing

can tell that would not work. We are a very different society and have a very different history. But a nation has to have the courage and bravery to find its own way, and to offer new values and new solutions to the world. Maybe China can be an example for the West. But not today, it is not offering something meaningful. Every society has to fight for fairness, justice, and human rights. Every society needs these basic values, in the East and in the West.

JBD: You described the Olympic stadium as a symbol of a new China and as a 'freedom structure'.[2] It seems to me that it is, above all, the structural characteristics of the stadium that symbolize the political and social structures you wish to see in a new China, and in other societies, whether they are in the East or in the West.

AWW: Yes, we wanted to express openness, freedom, and a more civil society – not centralized power. These structural characteristics represent different thinking and different values.

JBD: Although there has been a great deal written about the stadium, I haven't come across information on your working process, on how you designed it, or even how you came to work on the project. Did Herzog & de Meuron approach you?

AWW: Yes, they did approach me, I didn't know them. When they were invited to the competition they asked the collector Uli Sigg for information about China, and about the possibilities. Uli called me because he knows I am an artist, but I am also interested in architecture. In fact I spend almost all my time in architecture. So I gave them some information. Later they asked me if I wanted to join the design team. I said yes because I was very interested in this project, and I flew to Basel where we had a very special, intensive working meeting. We made clear decisions about how the stadium would look, how it could function, what kind of ideology, and what concept we should present. Then I flew back and they continued to work on it. We emailed back and forth talking about details and adjustments.

adjustments. And more than one month later, they presented the final product which turned out to be the winner of the competition. We continued to work together. I worked on the concept of landscape design; we worked together on other details including signage and colour.

JBD: The stadium is much more than fabulous architecture. Jacques Herzog described it as a venue under open skies.[3] Among the structural values it reflects are interdependence, mutual support, and transparency. One of the complications with the notion of transparency is that it has recently taken on another more negative level of meaning. In the name of public security, safety, and protection, Western democracies are rapidly transforming themselves into states of total, around-the-clock surveillance. Citizens are being routinely fingerprinted in countries around the world; tourists, as well, if they want to travel to the United States. I was wondering if you discussed or considered this a form of double-edged, invasive transparency?

AWW: We didn't go into those types of issues but we definitely did talk about transparency and about the need to create a feeling of welcoming people from any culture or any background. You can enter from any direction and when you are sitting in the stadium, you don't sense the beams and pillars. Normally pillars determine directions.

We also discussed the use of the stadium before, and after, the Olympic Games. That is much more important than the Olympics which are only twenty days of activity. We talked about how to make the stadium a perfect fit for the city to make it a place where people can bring their children, enjoy games and sports, hang around, do *tai chi*, or listen to music. We want it to be part of an active city. This is what we imagined the stadium to be.

JBD: A stadium is a gathering place; it is also a place of spectacle. You have pointed out on several occasions that the spectacle of the Olympic Games is inherently political in nature. Your comments just now, however, are about a use of the stadium that is very gentle, low key, about family and activities that people want to share with one another.

AWW: We are interested in creating a non-hierarchical experience so that the participants feel it has been made just for them. It is evenly spread out, so regardless of where you sit you have the feeling that you are in the centre of the audience. This strategy is an obvious choice but one that is most easily forgotten by architects because such a construction is difficult due to the size of a stadium and because of structural needs.

JBD: In other words the focus in your stadium is not only on what is taking place on the playing field but also on what surrounds it. The viewer in the stadium can also feel like a 'star', and is an equal among many.

AWW: This is the most important aspect, and the most difficult to achieve. This is why the stadium has this web, this net, because it was the only way to create these structural conditions.

JBD: I wanted to ask another question about the Olympics but I suspect you are tired of speaking about politics.

AWW: No, it is okay.

JBD: You were very critical of Steven Spielberg who withdrew from the Olympic Games.

AWW: Not really, that was how the newspaper put it. The *Guardian* asked me if I would participate in the opening ceremony because I was a member of the design team. I said no, the design is finished, and I am not very interested in this kind of celebration; it doesn't reflect the values I want to share. I told them that I have no high expectations for the kind

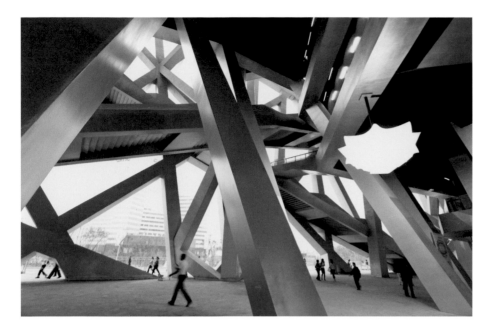

Beijing National Stadium,
2002–2008
Ground floor concourse

of ceremony they are going to perform. These kinds of parties never really stimulate or respect true creativity. They only use directors and teams who reflect their way to understand the world.

It will be a big celebration with no meaning, spectacular with very little content, staged by directors who are not independent, who have never offered intellectual values or cared about human and political conditions.[4] They only want to align themselves with the larger political powers in order to exercise their own ego. I said that, it's a very personal thing, but the newspapers then wrote that I was boycotting the Games. I would never use the word 'boycott', but as a person you can always take a stand. This is how I then became the first person to 'boycott' the Games. I respect what Steven Spielberg did, what kind of person he is, and his work as a director. He is someone who fights for his own moral standards and beliefs, which to me is to be respected.

JBD: I'm going to ask a question which you can refuse to answer.

AWW: I never refuse to answer questions.

JBD. Living in Germany, one is constantly having to deal with history, with the actions of the past, and with their consequences. People often find themselves in very difficult situations, regardless of where they live. The question is how to navigate one's way through these conflicts, how to know when to take a stand (such as you have done), or to try to find another way.

There was a recent article in the New York Times about the artist Cai Guo-Qiang, director of visual and special effects for the opening and closing ceremonies of the Beijing Olympics. In this article, one of his assistants raised the issue as to whether he has been zhao an'ed, or co-opted, by this process. Cai himself said: 'For an artist, a good place to be is you have some kind of influence and power to get things done, but in your essence you remain a nomad or a soldier facing difficulty to be overcome. You can do things for your country, but you cannot be imprisoned by it.'[5] Is there a 'good place to be' for Chinese artists participating in the Beijing Olympics? Are there ways to participate and at the same time to keep that distance?

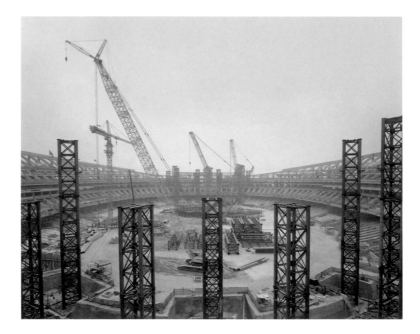

Beijing National Stadium,
2002–2008
C-print

AWW: Of course! Participating has different forms; even keeping away is another form of participating! Spielberg participated by resigning. I am not saying people should just give up or resign; I am saying let's see what the result is. We will see what's there, and what is not there. It is not enough just to give nice speeches.

JBD: In other words, you took a strong position …

AWW: Everyone is calculating! There are all kinds of interests, and everyone always makes excuses for themselves. That is very human. For every good or bad action, for every right and wrongdoing, there is always a reason behind it. Some are even quite convincing reasons.

JBD: You have said that one needs to talk about the past. The German way of dealing with the burden of its past during World War II and during the communist regime in East Germany (*Vergangenheitsbewältigung*) has meant making millions of files accessible to victims; the removal of former officials from office; and decades of educational programmes and public debate. Even

sixty years after the end of World War II, the process is still not over. The concern has been to locate the truth in whatever detail one can make available and to constantly research it.

The South African model following the demise of apartheid was very different. It was based on the notion of truth and, above all, reconciliation. In other words, the belief that one must begin on the basis of forgiveness. For many East European countries as well, after the collapse of the Wall, the question was how can we move forward from here? Nowadays it is Northern Ireland that is addressing this question.

There is often concern that if in fact one delves too deeply into the past society could be torn apart. How do you imagine this process of talking about the past could take place in China, given the kind of society here, given the conditions here?

AWW: There are two questions – one is a matter of tactics and the other is a moral one: how human society can function, and what its moral standards are. But each of them is about very different

conditions. When I talk about the past or truth, it is rather practical, it is not about accusing people of wrongdoings in the past because no one is more intelligent than those people who struggled at that time. But there is always right and wrong.

By looking at the past we can find out how we should act today. It is about giving us lessons in order to avoid the same kinds of problems happening repeatedly. So many people died, so many people were living in such darkness and shadow. It is not even about justice for them; hopefully those people are now living in peace. It is not even for that generation, it is for later generations, not even to remember them, but to understand that the fact that what happened was a tragedy.

JBD: And to give them the tools ...

AWW: Yes, this is the minimum we can do. If we don't do that, I would ask, what is the reason you don't do that? What are you hiding? This drives me crazy, I think about it every day! What are you hiding? Are you ashamed of your past? Or you don't think the future can be better? Or that we can make it better than before? Or do you want to keep the same kind of wrongdoings?

JBD: You say that everybody has their justification. Perhaps it is simply a desire for social harmony and a concern that if one opened the floodgates ...

AWW: I think, yes, we can say let's forgive everything but still we need to know what happened, to know what we should forgive. To not tell the truth means that we don't even give people the chance to forgive.

JBD: I was personally deeply moved by the lives and fates of the first China modernists when I was doing research on their time in Europe in the 1920s and 1950s ...

AWW: I am so touched you did this. There is this tendency to erase everything. My father was with the group of early artists who went to Paris. All these materials are lost. These people's lives are not considered valuable. If their life is not valued, then how can we value our own life? How can you have citizens' responsibility? What will become of our nation? One talks about creativity, about how one is going to reach society with colour, with expressions. This is impossible!

JBD: One of the most interesting projects of that period was an exhibition organized by Xu Beihong for the *Jeu de Paume* in Paris in 1933. The French writer Paul Valéry wrote a text for the catalogue in which he suggested that Chinese modernists in the 1930s possessed two pasts – 'theirs and ours' – and that their work was about the resolution of 'profound dissonance' rather than the result of difference.[6] As someone who has lived in China and in the West, do you feel that the intellectual and artistic community in China shares two pasts?

AWW: Do you mean contemporary artists today?

JBD: Essentially the question is about those Chinese artists who went to Europe in the 1920s and 1930s, and the old debate as to whether they simply

Beijing National Stadium, 2002–2008, C-print

appropriated what they saw and brought it back to China unchanged. In other words, was their work derivative? The artists themselves were adamant that this was not the case. They believed that they had the right as individuals and as citizens of the world to take what they wanted from the past (and the present) of the West and to transform it into something new.

AWW: This is a very complicated discussion. We are not only talking about Chinese artists but about early modernists from New York to Paris and back to New York. Western artists in Paris appropriated African art, and were influenced by Oriental art. Each case is individual: it all depends on how strong the cultural influence was. Somebody's mindless act can be meaningful in the context of history. And the source of somebody's creative effort or consciousness may never be recognized.

JBD: I want to come back to your own situation. Do you feel that you are drawing on the past of China and the West? Are you drawing on both traditions equally? Or is this a totally irrelevant question for you?

AWW: No, it is not irrelevant. I used to say that I had no influences from China because I totally wanted to break away from these traditions because of my early conditions. But by doing that I was giving power to these traditions. I stayed twelve years in New York (from 1981 to 1993). I wanted to have as much influence as possible from the West. When I moved back to China with the true imprints of the West I started to look at my own past to make comparisons and to analyse it. Then you start to be more free to pick up on what is really useful for you.

JBD: In 1912 Liu Haisu …

AWW: Liu Haisu was a very close friend of my father. Lin Fengmian, Liu Haisu, they were all very close.

JBD: Liu Haisu published a manifesto in 1912 in which he described the society of the day as 'callous,

apathetic, desiccated and decaying'. He said, 'We believe art can save …'

AWW: You have all this material! I really must learn more. We are totally cut off from this history. We don't know what happened.

JBD: Liu Haisu said, he phrased it so beautifully: 'We believe art can save present-day Chinese society from confusion and arouse the general public from their dreams.'[7] Do you believe that art – your art – can accomplish that?

AWW: I once said that only contemporary thinking can save China, only modernism can save China. Modernism is not a style. It is more a way of how we can justify ourselves, how we can examine and criticize our acts, how we can be critical, break all boundaries and give ourselves a new position, and new possibilities. That is most important. We have such a long history and all kinds of historical arguments. We are also facing such complicated issues. There is the need to apply the attitudes of modernism towards today's conditions. That is what I think.

JBD: There is an interesting article by Xu Jiang[8] on modeng, the Chinese translation or transliteration of modern, in which he discusses what the Chinese characters for modeng mean. I have come to believe that there is possibly a quite different form of modernity, modeng, in China. Or that 'modern' has a different meaning in China than in the West.

AWW: I will have to think about that. Modern to me means contemporary, 'at the moment', and collective thinking of the present stage of the possible intellectual and social concerns. For me it is an ongoing concept.

JBD: Another early Chinese modernist, the artist Gao Qifeng, argued that the artist was required to 'consider his fellow's miseries and affliction as his own' and that art should lead to 'a betterment

of man's nature' and 'an improvement of society in general'. Is this insistence on the social or moral purpose of art in the service of the common man one of the most important legacies of twentieth-century art in China?

AWW: In name only, but not in reality! Limiting the rights of a person's free will, or individual rights, or freedom of expression, and forcing somebody to do the 'right thing', has been proven to be a disaster for this nation. There is no so-called perfect justice or right. It has to come out through individual struggle. To dismiss these human rights, and the individual struggle, can be a most cruel and brutal crime.

JBD: In the West many artists have been concerned with the social welfare of others and with the moral purpose of art, but, especially, in the second half of the twentieth century there has been a much greater emphasis on the individual, on subjectivity, and individual vision.

AWW: Because Western society became more democratic, you don't have unified interests. But in China artists never had a common goal – maybe only for a very short moment, in my father's generation, when they were fighting for the nation – but on the whole artists were only seen as a tool for social change. So who is going to use this? This is the ideology of the Communist Party and how they are going to use it is to sacrifice individuals' feelings. That which is related to the private individual is dismissed and cancelled. This is the condition here in China and in Russia. The result is only one type of propaganda. This is, then, not coming from the heart, but from policy.

JBD: You have great faith in the wisdom of the individual, in the individual as the bearer of moral responsibility for the betterment of society.

AWW: The problem is who is going to bear the responsibility? Either it should be someone who is willing to make the mistake, or someone who is tyrannous enough to make the mistake for everyone! I think that it is more fair if everybody bears the responsibility, if you can trust everybody. You know, they may not offer great intelligence, and it may not become a perfect society but that is human, that is closer to reality.

1. 'No one in the state here would ever hire me for a project like this. Even if they tried, I would not do it.' Interview with Ai Weiwei by Jonathan Watts, *The Guardian*, 9 August 2007.

2. Ai Weiwei and Jacques Herzog, 'Concept and Fake', *Parkett* no.81, 2007, pp.126–7.

3. 'Transparenz, Durchlässigkeit, und Öffnung', in 'Baukunst. Wenn ich das schon höre', interview with Jacques Herzog by Mirjam Hauck, *Suddeutsche Zeitung*, no.156, 10 July 2007, p 13.

4. 'The Games are a propaganda show, a giant masked ball. The outcome will be endless nonsense and boredom', in 'The Olympic Games Are a Propaganda Show', interview with Ai Weiwei by Andreas Lorenz, *Spiegel Online International*, 29 January 2008.

5. Cai Guo-Qiang, quoted by Arthur Lubow in 'The Pyrotechnic Imagination', *New York Times*, 17 February 2008.

6. Jo-Anne Birnie Danzker, 'Shanghai Modern', Jo-Anne Birnie Danzker, Ken Lum, and Zheng Shengtian (eds.), *Shanghai Modern*, Museum Villa Stuck, 2004, p.32.

7. Danzker 2004, p.25.

8. Xu Jiang, 'The "Misreading' of Life"', Danzker, Lum, and Zheng, Shengtian 2004, pp.72–5.

This article originally appeared in the Autumn edition of *Yishu* in 2009.

ARCHITECTURE ON THE MOVE

Bert de Muynck

Ordos, also known as Erdos, is located eighty minutes' flying time west of Beijing. With Baotou (100 kilometres directly north) and Hohhot (200 kilometres north-east), it completes a metropolitan region referred to as the Inner Mongolian Golden Triangle. The city sits at the top of the Ordos Basin, an area known as 'China's twenty-first century energy bank'. Today the city of Ordos has entered a stage of large-scale development. In the slipstream of a large number of energy projects, Ordos is building a city from scratch in the Kangbashi New Area. In 2008, as part of that development, 100 international architects were each invited to design a 1,000-square-metre villa, including a swimming pool, in an area designated as the 'Ordos Cultural Creative Industry Park'. Flying 100 architects from twenty-seven different countries to Ordos twice in less than three months was already a unique undertaking. The word 'unprecedented' is too frequently used to characterize China's urban development, a blind and uncritical epithet for a country in the throes of change. But in Ordos, the

ORDOS 100 project was beginning to suggest that this word was meaningless. In January 2008, a first group of twenty-eight architects was invited for a project introduction and site visit. They came back in April to present their proposals. Another sixty-nine architects joined them during the April meeting, and were invited for a site visit and to see the first proposals. In June, seventy-two practices – three more having arrived in May – came to Ordos to present their proposals. In less than half a year, 100 villas by many of the world's young and promising architects had been designed and presented in a city in China few had ever heard of.

ORDOS 100 is the brainchild of the Chinese tycoon Cai Jiang, who made his fortune in milk and coal and who is a passionate patron of architecture and the arts. He acts as the client in this project, which happens through the investment of two companies that he runs, namely Jiang Yuan Cultural & Creative Industrial Development Ltd and Jiang Yuan Water Engineering Ltd. During the January meeting, he

explained the commission he gave to the architects as follows: 'We give the architects the freedom to design whatever they want, so they can put all their ideas into their work. If there happens to be a difference between the designs and the Chinese regulations, we will do something to make the balance and try our best to make it better.' The second player in ORDOS 100 is the iconoclastic Chinese artist and architect Ai Weiwei, who acts as the curator of the project. In January he expressed his hope that ORDOS 100 would contribute to the development of Chinese architecture through an exchange of knowledge. He told me that 'this project focuses both on China and the world. For me the important question is how to bring worldwide contemporary architectural knowledge in touch with Chinese practice. This is an important part of this project. To me it is really about action and the understanding of today's culture.' And last but not least, there is the context. Ordos is located in the Inner Mongolian desert, making it very cold (as low as -24°C) in winter and hot (up to 40°C) in summer. For the majority of the architects, working in China means adapting to a different building process while acknowledging that their involvement ends with the design phase, as the construction drawings and the execution are the responsibility of their Chinese partners.

CONTEXT
About one hour's drive from the construction site of the ORDOS 100 project is the Genghis Khan Mausoleum, a tourist spot that serves to remind us that this is the territory from where Genghis Khan sprang to conquer a large part of the known world. Today, the roles are reversed. Through the conquering of its own territory, the local government marks its ambition to claim a position in the world. The exploitation of copious resources – the area sits on top of the world's seventh largest coalfield (and China's largest) as well as on an enormous gas field – is the driving force behind the quantum leap in urban development that China's Inner Mongolia Autonomous Region will make over the next decade. Today, China is investing heavily in its energy development and the central government has listed optimizing the structure of China's energy resources as 'the priority among priorities'. The China.org website explains the situation as follows:

> Currently coal and oil products from the Ordos Basin have played an important role in China's economic development. The basin is now providing 4.75 billion cubic metres of natural gas to 15 large and medium-sized cities including Beijing and Tianjin. Natural gas will also be pumped to cities along the eastern coast such as Shanghai and Nanjing starting this October.[1]

Today, the first results of this economic development can be seen. The rise of per capita GDP last year surpassed that of Beijing. Having the second highest per capita income in China and an annual economic growth rate of forty per cent, Ordos is capitalizing on its resources, investing in real estate construction, and creating a new middle class that needs better living conditions and a new generation of billionaires that wants outstanding buildings. One sign of this development is making the area accessible. The opening of Ordos Airport towards the end of 2007 was a first step to attract business and tourism. Although modest in size, Ordos Airport is China's first privately run airport with a total investment of RMB200 million featuring a 2,400 metre runway and terminals covering 3,500–5,000 square metres.

The 100 architects were selected by Swiss architects Herzog & de Meuron. The invitees were not only asked to design in total freedom, but have clearly been identified as the creative messengers who will draw worldwide attention to this place. At least that's what the local government, the client and the curator want them to do. And given the media attention so far, they appear to be succeeding.[2] But in this case, it's not only marketing. The strategy of inviting internationally recognized architects to lend lustre to high-profile developments is common

ORDOS 100, 2008
Ordos, Inner Mongolia
Architects search the
desert for their specific plot

practice all over the world today. One of the many recent examples is Next Gene 20, a collection of twenty villas in Taiwan, designed by MVRDV, Kengo Kuma and Julien De Smedt, and the like.

But ORDOS 100 differs from similar projects in more than one respect. First, ORDOS 100 is part of a whole new urban development of which a Creative District was part of the programme to construct a new city from the start. Second, it's actually going to be built, and very quickly at that. According to planning, construction of the 100 villas will start after the Mongolian winter of 2008 and will be finished by the end of 2009. And third, Herzog & de Meuron's selection of the participating architects, following their design of the National Stadium (also known as the Bird's Nest), represents a new collaboration between Herzog & de Meuron and Ai Weiwei. In an interview some years ago, the Swiss architects explained their reason for working with the prominent Chinese artist-architect as follows:

Weiwei is someone who tests our ideas. [Jacques Herzog] We have lengthy talks with him about how things work in China today. You cannot just walk into China and do what you have always done. We like to learn from other places, and China is the oldest civilization on the planet. With Ai Weiwei, we find contemporary lines of energy from that tradition.[3]

For ORDOS 100, Herzog & de Meuron have avoided inviting starchitects and opted for young, up-and-coming architects instead. For the majority of these architects, working in China means adapting to a different building process from that to which they are accustomed.

The bulk of China's urban development happens through stitching urban development plans to existing cities. Ordos represents a rather unique case. In 2001, it became a Prefecture Level City (PLC), making it possible to have its own People's Congress, and granting the local government more

power and ability to oversee city development. In March 2005, the *Erdos Urban Region Development Strategy – A Report to the Municipal People's Government of Erdos* was published. This report for 'The World Bank (EASUR) and The Cities Alliance' was prepared by Chreod Ltd, a company advertising itself on its website as 'an independent consulting firm providing market research, investment risk analysis, development planning, public policy, and information management services to corporations, governments, and international financial institutions active in China'. The report had the following objective:

> The scope of the Erdos Urban Region Development Strategy was defined during consultations with the Erdos CDS Leading Group and with stakeholders. Central to the strategy are the recommendations that will support the preparatory work for the Eleventh Five Year Plan (2006–2010). The City Development Strategy (CDS) is viewed as an important input to the long-term development plans for Erdos, with a timeframe to 2020.[4]

Moreover, the report clearly states the ambition for the Erdos Urban Area to be enlarged to 42 square kilometres to support a population of 355,000 by 2020. It also states that the urban economic constellation will be 5:50:45 among the three sectors (primary, secondary and tertiary) and that the newly built district should promote Mongolian-style eco-tourism. The report even hints at the type of architecture this new city should develop: 'In fact, new buildings are to reflect elements of the Mongolian nationality.'

GROWTH OF A REGION

On a half-hour drive from the new airport, through largely empty desert territory, one starts noticing construction cranes filling the horizon. Here, on a land area of 155 square kilometres, the local government is building a city from scratch with a planned population of 200,000 by the year 2020.[5]

At the same time, national highways are being constructed and a railway is planned to run through the south of this area. Ambitions run high. Yang Hongyan, the vice-mayor of Ordos, explained to me during the inauguration ceremony of the ORDOS 100 project that 'with this new development we aim for excellence and exception'. I interviewed her in the Holiday Inn, where in 2008, in January (over three days), April (five days) and June (five days), 100 international architects came to attend conferences, engage in eco-tourism, present their projects, visit the Genghis Khan Mausoleum and criticize, along with colleagues, their own and others' design proposals. For many of them it was their first time in China, and for all except one the first time in Ordos. The vice-mayor continued:

> Three years ago (2005) few people would have been able to identify Ordos on the map. We built up a team, and the mayor proposed the concept that Ordos should reach out to both China and the world. Due to the economic development of this region we have an advantage and are aiming to attract companies in the top world 500. For planning the new urban district, we invited international architects to come in first, not just domestic. The development of Ordos is happening through leaps and bounds; we have ambitions to become one of the most vibrant cities in the west of China.

This ambition to develop a new model of a city has an advantage. As Ordos is a latecomer in its urban development, it can benefit from the mistakes and lessons learned by the Chinese cities that have developed, expanded and reinvented themselves during the past two decades. In that development, Ordos doesn't want to go unnoticed, but envisages that it will be both a test case and a role model, as the vice-mayor explained:

> In the 1980s we looked at Shenzhen as a model for urban development, in the 1990s we looked

at Shanghai and Pudong and it is my hope that in the coming twenty years when people look for a new model they will look at the development of Ordos.

In the first half of 2008 I visited Ordos three times and took several tours through this city under construction. From the aforementioned report it is clear that the local government is serious about implementing the second of 'two important government plans for the Erdos Urban Area':

Second, the new Erdos Municipal Government (of the entire PLC) proposes to develop the Qing Chun Development Zone or New Area (QNA), also known as the Kangbashi New Area. The QNA is to be located 27 kilometres away from the current city and will have a targeted future population of approximately 150,000. This new town idea rests on a number of presumptions: relocation for water access, escalating population densities in the Erdos Urban Area, and the cost-effectiveness of developing new land in Qing Chun, as well as recognizing that the municipal government needs a new administrative centre due to existing ambiguities surrounding revenue streams and government restructuring when Erdos attained PLC status. This development proposal has been approved by the State Council. The total area of the new development is to be 200 square kilometres, with a core urban area covering 31 square kilometres.[6]

That the invited architects are brought together at the Holiday Inn during their stay in Ordos is no coincidence if we read the first of 'two important government plans for the Erdos Urban Area':

The first, an initiative of the Dongshen District Government, is to develop the Tend Xi Re Area (TA). The TA is located west of the railroad which acts as a border to the existing urban area. The total planned area is 15 square kilometres. Currently, 7 square kilometres are serviced with roads and electricity. A five-star hotel has been built and is now operating as a Holiday Inn. The government has financed the construction of this facility.[7]

CONSTRUCTING CREATIVITY
One important feature of the Ordos urban development is the integration into its urban programme of the cultural and creative industries. In 2005, the State Council (China) released its '11th Five-year Plan' and put the creative industries on the formal agenda. A couple of months later, in his address to the 17th National Congress, President Hu Jintao stressed developing the cultural industries as a means to enhance culture as part of the soft power of China. These – sometimes referred to as 'cultural', at other times as 'creative' – programmes fill both a void in the existing programmes of Chinese cities and attract further real-estate investment like shopping malls, retail and mixed-use developments, targeted to a growing mass of Chinese consumers.

The Chinese city is a space of conflict, confusion, crowds, culture and construction sites. Despite its exceptional development and growth, the Chinese city has the same programmatic characteristics as the usual city: housing, offices, parks and roads. Scale and the pace of construction distinguish the Chinese city from the usual city. In Beijing, a group of artists accidentally discovered a new urban programme, a way of living between art and economy. A couple of years ago, they transformed an old industrial factory into an experimental laboratory. Eager to capitalize on their creativity, they failed to foresee how their act of innovation would destroy the source of this creativity: the place itself. The art factory soon turned into an art market. Art was produced in another part of town, but still consumed in the factory. In the end, it was all about place-making, branding and imposing international policies upon a local context. Today, it doesn't matter what is on display, as it is about a brand – in the Beijing case

Ordos, Inner Mongolia
Visiting architects gather
at the city centre during a
meeting in 2008

798 – and the creative industries. Once that formula was understood, tested and controlled, it served as a model radiating from Beijing outwards. This led to a formulation of the future of the Chinese city, a city where creative business districts (CBDs) and special creative zones (SCZs) are an indispensable part of urban planning. These areas offer everything between creativity and consumption, folk cultures and foreign intrigue, coffee and cultural critique.

The Ordos Cultural Creative Industry Park has a total planned area of 197 hectares, and a total construction area of 1.46 million square metres. Next to the focus on creativity, there is also a plan for SOHO1 and SOHO2. With a total investment of RMB4.5 billion, the construction plan will happen in three phases. The first construction on the site started in July 2006 with the Ordos Art Museum, which opened in August 2007. ORDOS 100 is part of the first phase of this urban development. Phase two is expected to be completed in 2011, and phase three in 2012. The idea of bringing in 100 architects is to create diversity in quality and creativity. However, this seems to be at odds with the general image of the work of foreign architects in China. Mostly

they receive commissions and requests to design larger projects than they would ever be able to build in their home countries. Designing a villa at an almost record pace in conditions with which they are unfamiliar will undoubtedly make the area distinct in character. The outcome of this project is a high-end residential setting, which some see as akin to a World Expo, while to others it looks more like Beverly Hills or an architectural zoo where international ideas on housing can be tested under Chinese conditions of speed, quality of construction, labour skills, a creative industries context and return on investment, as each of the 100 villas is expected to sell for $1.5 million. At the same time, this development is in tune with the demand of the market for the wealthy who look for culture, second, third or fourth residences and uniqueness in their lifestyle.

FIRST IMPRESSIONS
In January, 2008 a site visit with the participating architects was arranged. At the time there was a largely empty site where one could notice the unique desert topography and climate characteristics. It was stressed to the architects that they needed to incorporate these severe climate conditions

into their designs. The architects knew nothing about the future inhabitants of their villas, except that they were billionaires. Two buildings bordered the site: the Ordos Art Museum designed by the Chinese architecture firm DnA and the Artist Studios by Ai Weiwei/FAKE Design, the last one being an exact replica of the artist studios that Ai Weiwei built in the upcoming Caochangdi art district several minutes drive from Beijing's notorious 798 art district. The Ordos Art Museum features a 2,700 square metre space for an exhibition and research programme. For some architects, it is hard to imagine the transformation of this barren site. 'I need all the imagination in the world,' Dutch architect Kamiel Klaasse from NL Architects tells me. 'Is this going to be a rough place or a sophisticated paradise? It's hard to imagine what our client sees beyond the horizon.' The high density of the master plan confuses some architects as well. Mexican architect Derek Dellekamp said:

> Considering the fact that there is no lack of space here, I expected the villas to be more freestanding. The openness here is a treasure. Why not use it? According to the master plan, this area will be very urban. I have to make a mental switch for that.

The fact that there are 100 architects involved raises some concerns as well. 'I can't deny that our client has a fantastic vision,' says Indian architect Gurjit Singh Matharoo. 'But there could be big chaos in the end. There are so many minds on such a small plot of land. It might not generate a beautiful place, but maybe this project is about something else, about the exchange of architectural ideas, for instance.'

Three months later, when we meet again in the Holiday Inn hotel lobby, Matharoo proves to be right. The atmosphere is both relaxed and tense. Some architects (those who made a design for the first phase) are here for the second time; others (those who worked on the second phase) are here for the first time and curious to understand what is happening. In the corridors, the proposals of phase one are displayed for discussion. During the arguments, one hears English, French, Spanish, German, Dutch, Hebrew, Swedish, Chinese and some other languages. It becomes clear that ORDOS 100 is an attempt to build a Babel for billionaires and Ai Weiwei is its curator. After the dinner on the first night in April, the architects from phase one fill a large mock-up of the building site with their models. A whole caboodle of architecture arises and different styles compete with each other: a villa with 100 rooms, a dwelling without distinction

ORDOS 100, 2008
Architects examine models of the villas at a
conference in Ordos

Villa 092
Single Speed Design

Villa 042
Bottega + Ehrhardt Architekten GmbH,
Giorgio Bottega, Henning Ehrhardt, Christopher Seebald

between inside and outside, a house with a green heart, a monolith, different boxes colliding together into one form, a house based on the idea of 'holistic materiality', a villa without a claim on its territory, a dwelling dug into a dune, a green mountain rising out of the desert. In June, a stack house, a knot house, a twice house, a house house, a mirror garden house, a big brother house, and a hutong on top of a union are some of the villa concepts added to the site.

The Parisian office Encore Heureux, along with G-Studio, designed a Gourbi Palace. The architects call their retro-futurist design a 'survival-utopia': a 1.4 metre brick wall protects the inside from the outside, shielding it from warmth, cold and wind. Their justification:

> The notion of context is absent as we didn't know what other architects would propose. For us the context is the sky, as we were sure nobody would touch that. So we made this central void, around which the house is organized.

Israeli-Palestinian architect Senan Abdelqader proposes a reinterpretation of the traditional Chinese villa. 'Globalization is all pervasive,' he tells me. 'I think that the Chinese dwelling, like the Arab

house, should be translated into a modern idiom. I don't believe in the vernacular anymore.' A series of voids and solids vaguely resembles a traditional house and creates a compact plan that maintains a low profile. The Mexican office Productora opts for a narcissistic house that brings the facade to the interior. The explanation: 'By slicing up the volume, we created an introverted house as each room looks at the back of the next segment, a closed brick wall. When you enter a house you normally lose sight of the facade, but here one is constantly confronted with it.' And these are only the architects of phase one. As soon as the architects from phase two arrive at the meeting in April, the Babel-like confusion is complete. Some want to critically review the assignment and the master plan; others just want to give an answer to the brief. Turkish architect Han Tumertekin (Mimarlar) is an exponent of the latter. 'When I am confronted with such a big organization I presume the assignment is well considered,' he says. 'Architects have become much more interested in issues outside architecture over the past few years, but some of them have forgotten how to carry out a brief well.' Chilean architect Alejandro Aravena (Elemental) is also supportive of the master plan. 'Luxury houses in such a dense context are unusual for wealthy people. I hope this could shift the tendency of rich people to try and isolate themselves

from each other.' Korean architect Minsuk Cho (Mass Studies) sees another challenge: 'Normally a city is composed of layers of accumulated history. Here we have to come up with instant identity, character and all of that. How do you do that? I don't know yet.' But whatever the results, ORDOS 100 is, from all perspectives, a unique project. It gives the architects involved a lot of freedom and asks them to push the limits of their creativity, while at the same time it forces them to come up with a strategy for the lack of control during the building process.

Some of the architects involved in phase one have taken a close look at Ai Weiwei's own work and his philosophy of keeping architecture simple. One of them is Senan Abdelqader. 'My plan is clear and uncomplicated,' he says, 'so it should be very

He quit architecture and is now working on the 'railroad', because he wants architects to meet, discuss and create without constraints. 'We provide possibilities,' he tells me with conviction. 'That's what I am interested in. We need possibilities instead of conclusions and results.'

easy for Chinese workers to realize. That's my way of making sure that the result resembles my intentions.' What is to come out of it remains to be seen, but according to Ai Weiwei this uncertainty is exactly the point of the whole project. When I interviewed him in October 2007, he told me he would quit architecture. When I confront him with this statement in April 2008, he laughs: 'I am not on the train any more, I am working on the railroad now,' he replies. Meaning he now shapes the conditions for architects to do their work. He quit architecture and is now working on the 'railroad', because he wants architects to meet, discuss and create without constraints. 'We provide possibilities,' he tells me with conviction. 'That's what I am interested in. We need possibilities instead of conclusions and results.'

A CITY FROM SCRATCH

How do you build a city from scratch? During the past year criticism has been voiced on the way China has been developing its cities, most notably the notorious critique by Qiu Baoxing, China's vice-minister of construction, that 'many cities have a similar construction style. It is like a thousand cities having the same appearance.'[8] Ordos is hoping to make a difference, creating a unique urban setting by focusing both on the rich cultural legacy of the area as well as connecting it with the best of the West. Singaporean firm AGV is carrying out the planning of the new district. Its master plan is to organize along a concentric pattern and based on the idea that the new city centre is like a sun rising from a meadow and radiating from the centre to all sides. In the heart of the project lies a central axis, connecting the governmental administration area with the entertainment area and a financial district. The central square – Genghis Kahn Square – is 1.6 kilometres long and 400 metres wide. Around this square are currently four buildings under construction called the four cultural relics buildings: a library, museum, culture and art centre, and ethnic theatre. They have been designed by Beijing- and Shanghai-based firms. Here again the architecture holds references, albeit maybe a bit too explicitly, but certainly in line with the idea that 'new buildings are to reflect elements of the Mongolian nationality'; the design of the library evokes the image of the three most cherished ancient bibles for Mongolian people: the *Mongolian Mystery*, the *Mongolian History of Gold*, and the *Mongolian History of Origin*. Two of the texts were written by ancient residents of Ordos. The design of the ethnic theatre has the shape of the hat that traditional Mongolian people wear. Construction started in 2006 and this new administrative and entertainment centre of the

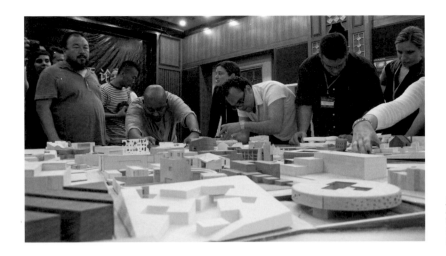

ORDOS 100, 2008
Architects place models of
the proposed villas into a site
model at the conference of
participants in Ordos

city was expected to be finished in 2008. The new
city is divided into two sections by large avenues
and two green belts, one 100 metres and the other
400 metres wide. Further from the centre, new
high-tech areas are being planned, along with an
area for the emerging automobile industry.

THE ARCHITECTURE OF ADAPTATION
The invited architects all operate in vastly
different conditions; most work exclusively in their
country of origin. Unsurprisingly, these architects
travel with a set of ideas and design skills that
now have to be incorporated within the Chinese
city. To some, this import—export aspect of
architecture doesn't pose a problem, as Mexican
architect Julio Amezcua (AT103) explains to me:

> We find a lot of similarities here to Mexico:
> the way we interact, build and communicate
> in terms of 'Yes, yes we are going to do it like
> that.' When you check the final result it always
> looks different, but at least they put the risk
> to do it, they didn't stop it. Also, in our culture
> a lot of the people start building based on the
> rendering, which can really be a problem.

Chilean architect Alejandro Aravena talks about
the same loss of control when he explains
the way his villa should be constructed:

A key issue in this project is how to manage
distance. In my project, brick is the common
language that shortens the distance and
guarantees a quality of the design. I found a
brick on the site and it is fantastic to see how
easily it breaks, showing red on the outside,
black on the inside. The breaking is very rough;
construction workers can do it and place it
on the outside. So it has this rough quality,
independent if mistakes are made or not.

When asked to respond to a possible critique of
ORDOS 100, which questions the creativity invested
in building luxury houses for billionaires in a country
that is still largely developing, Serbian architect
Milica Topalovic gives me the following response:

> Obviously this was the first question I asked
> myself when accepting the invitation. From
> a European and American perspective this
> type of work would be extremely debatable,
> heavily criticized and probably not possible
> at all. Imagine to develop such a project in
> the Netherlands or Switzerland where any
> development is constrained by a much more
> intense public debate. There each project is
> the result of a kind of negotiation of public
> values of which nobody knows anymore what
> they are. Somehow in Europe the post-socialist

democratic situation has led to a form of nostalgia featuring a conscious presence which keeps things more moderate. Here, I was curious to see how much these parameters are shifted and what direction they take.

On the level of architectural creativity implemented in the design, it is clear that for every participating architect there is another type of architecture, not only by way of giving names to the projects but also in the way the architects explain their concept, analysis and proposal during the presentations. Spanish architect Toni Montes Boada (F541, with offices both in Barcelona and Boston) sees the following distinction:

> What I find interesting is that although we all have the same commission and constraints, all projects look radically different. Besides these basic constraints, the notion of the local context is not so obviously visible in the proposals. I find it curious to be able to easily recognize the place where the teams come from, where they have been studying. For example, the projects from architects studying in the Ivy League architecture schools, the Swiss or Japanese projects. For me the cultural context relates to the place where the teams come from.

Increasingly, architecture is becoming a profession of managing, creating and controlling reality from a distance. Whatever creativity the architect gains, he or she soon has to relinquish in terms of control. ORDOS 100 and its Cultural Creative Industry Park provide an interesting test case in the field of architecture to understand the impact of China's creative industries ambitions, as an urban and cultural model, as a real estate investment (Mr Cai Jiang), a curatorial practice (Ai Weiwei) and policy implementation (the local government of Ordos). ORDOS 100 is branded and legitimated by the involvement of '100 International Architects' (note that they aren't called 'Foreign Architects'), positioning this project as an import–export experiment at the centre of the debate on the creative industries. It is a project that imports, exports, adapts and experiments with our understanding of exchange and development in the field of architecture, labour, culture, media and urbanism. There is certainly an element of creative roughness, if not brutality, in inviting 100 architects for this project. As it currently stands, this project is clearly an experiment in the production of a new architectural culture, irrespective of its shortcomings. As always, it is only through mistakes that we learn to make better cities and update urban models.

The House House, by American practice Johnston Marklee, deals with a doubling of the iconic house with the pitched roof, leading to a result Sharon Johnston describes as a 'primitive form that through a process of multiplying has the ability to absorb a big range of complexity and resolve this at the same time on different levels. And, it has an imaginary quality.' The proposal of the Portuguese practice SAMI Arquitectos is a house built up out of a single line, determining facades, floor plans and programme distribution: 'We designed in a pure architectural way and saw it as an exercise with our imagination, background and ideas on how to do a house in China. What could be an interesting way to work with this? There is a thin border between architecture, art, and sculpture, as Ai Weiwei said in the first meeting.' For the Japanese practice Bow-Wow, there is another aspect to the commission besides, but influencing, the design. Faced with the intensity of human exchange in both gatherings, they refer to ORDOS 100 as a 'social sculpture': 'We are interested in this aspect of the project. Participation is the most important, to become the material itself. Competition here is not so important. When we realized this we decided to create something calm and follow the restrictions of the master plan.'

CONCLUSION

ORDOS 100 will take up a unique position within international and Chinese architectural history. It will be a theme park of a particular kind, but also home to many. At the same time, it is too early to draw conclusions based on the three meetings, as for every architect there is a story attached to their villa in China – some realistic, others overly formalistic and some unrealistic. Some have raised concerns about the notion of sustainability or the fact that this is a gated community for billionaires. It seems that the first needs to be dealt with at the level of each individual villa, while the second is unavoidable given the Chinese context. The careful selection of internationally upcoming and locally established young architectural practices has created an exciting setting for experiment of all kinds: in cultural exchange, architectural discussions on sustainability, gated communities, architectural construction, the master plan mixed with the designers' desire to rethink the concept of the villa in a Chinese context which is characterized by a desire for innovation, alternatives, distance, local culture and context. For many of the participating architects, it is a great way to have almost carte blanche to express their desires and test them in the unique conditions of contemporary China. More than an 'architectural zoo', one gets the feeling of an 'architectural jewel box' – a series of precious villas placed in close proximity to each other in the wide open desert. Once all of them are built, our understanding of the impact, legacy and reality of ORDOS 100 might change again.

The tremendous speed at which China has been urbanizing in recent decades has put to the test the idea of the city and has led to diverse visions of real estate investment. The unique opportunity to build a city from nothing in the desert of Inner Mongolia is the beginning of a new chapter of urban development in China. The introduction of international architects in a small part of this urban planning, which is an officially designated area for culture and creativity, is both a sign of intelligent city branding and will serve as a lever for further real estate investment in the area. With inhabitants who can afford a 1,000 square metre villa, there is no doubt that other real estate investors will jump on to this train of establishing creative business districts, understanding that quality of design can make a quantitative financial difference.

1. '"Ordos Basin" Undergoes Large-scale Development', *Xinhua News Agency*, 14 April 2003, http://www.china.org.cn/archive/2003-04/14/content_1062131.htm, accessed 8 October 2013.

2. A few examples of the worldwide media attention generated through ORDOS 100 include 'Xanadu 2.0', *Urbane China*, January 2008; 'Herzog Picks 100 Architects for Inner Mongolia Housing Project', *Building Design*, February 2008; 'DRDH to Design Mongolian Villa', *Architects' Journal*, March 2008; 'Young Residential Architects Invade Mongolia', *Architectural Record*, March 2008; 'Dawn of New Century: ORDOS 100', *Urbane China*, April 2008; 'In Inner Mongolia, Pushing Architecture's Outer Limits', *New York Times*, May 2008; and 'ORDOS 100', *Icon*, June 2008.

3. Hugh Pearman, 'Iconoclasm Rules: How Herzog and De Meuron Work with Conceptual Artist Ai Weiwei on Beijing's New Olympic Stadium,' *Gabion: Retained Writings on Architecture*, January 2004, http://www.hughpearman.com/articles5/weiwei.html, accessed 22 March 2009.

4. *Erdos Urban Region Development Strategy – A Report to the Municipal People's Government of Erdos*, 30 March 2005, http://www.citiesalliance.org/cdsdb.nsf/Attachments/China+-+City-Regional+Development+Strategies+-+Report+Vol+2:+CDS+Erdos/$File?Vol+2_ED_Erdos_30Mar5.pdf, no longer accessible.

5. Depending on the source of the targets, figures regarding the size of the development and number of inhabitants for the new district vary. A general tendency is that the new district will have a size between 150 and 200 square kilometres and is intended for a population of between 150,000 and 200,000 inhabitants.

6. *Erdos Urban Region Development Strategy*, 2005.

7. *Erdos Urban Region Development Strategy*, 2005.

8. Jonathan Watts, 'Rush to Modernity "Devastating China's Cultural Heritage"', *The Guardian*, 11 June 2007.

This essay originally appeared in Yilmaz Dziewior (ed.), *Ai Weiwei: Art/Architecture*, published by Kunsthaus Bregenz in 2011.

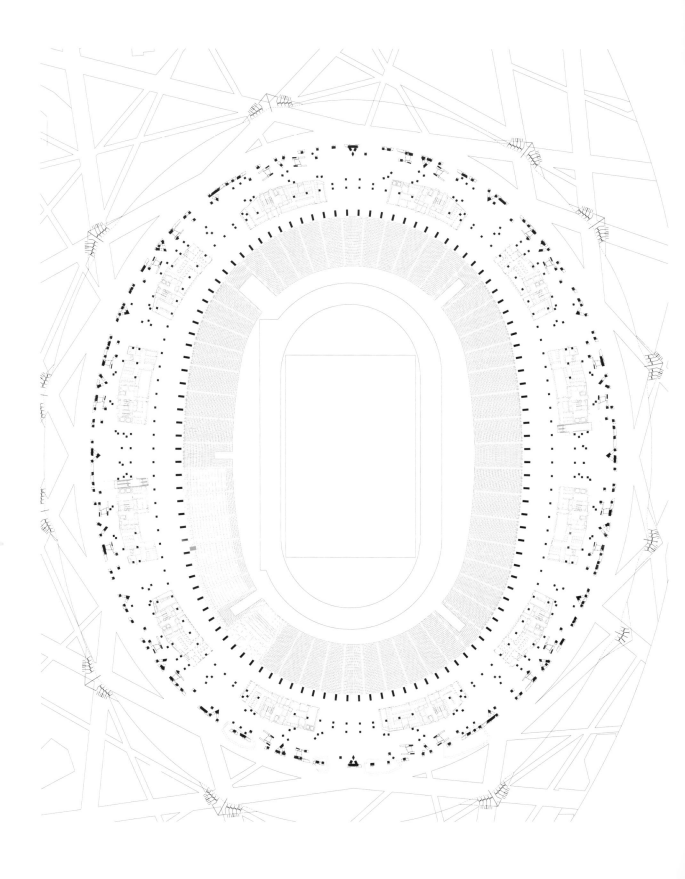

Collaborate

Beijing, PRC
Collaboration with Herzog & de Meuron
2002–2008

BEIJING NATIONAL STADIUM

Even before its completion, the Bird's Nest, Beijing's affectionately nick-named stadium and monumental centrepiece to the 2008 Olympic Games, was a globally recognizable icon. Muscularly refined and undeniably alluring, the stadium is settled atop a gentle mound along the Olympic Green. From its prominent location, the graceful interlacing of diagonal steel encasing the arena's elliptical red drum induces fragments of shadows and light that are simultaneously dynamic and sublime. As colour and light spill forth from the stadium's centre, its glistening exterior attracts attention, even from afar. It is a public seduction that is even more promiscuous at night.

Owing its unquestioned beauty to its iconic shell, the stadium's seam-less composition belies any structural load that it carries. The twenty-four cross-hatched steel columns, alternately described as 'Piranesian' and a 'chaotic thicket', each weigh more than 1,000 tons. Bearing the weight of the roof's voluptuous curve, they are neither purely structural, nor solely orna-mental. Nor are their visual effects reducible to a surficial veneer. Instead, the columns take on spatial characteristics, delineating and structuring the stadium's interior concourses and subtly facilitating the human activity with-in. The 'nest' is an encompassing metaphor that permeates every facet of the design. Enhancing the spectator's connection to the events on the field, the bowl rises higher to the north and south ends. The steepness of the angle creates an even greater sense of drama, and accentuates the triumphalism of the stadium's sleek and curvaceous profile. On the interior, the monu-mental scale becomes even more palpable. Wrapping overtop the stadium's seating, the massive steel members hang overhead, enveloping the specta-tor within the stadium's confines and connecting to a steel ring that out-lines the large oculus that opens to the sky.

Amid the proliferation of the stadium's image and the increased at-tention placed on its architects, the somewhat surprising nature of Herzog & de Meuron's collaboration with Ai Weiwei is often overlooked. Their initial

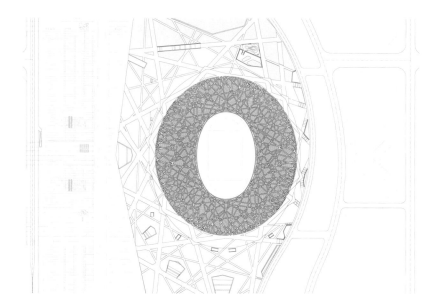

Previous page:
Beijing National Stadium,
2002–2008
First-floor plan

Right:
Beijing National Stadium,
2002–2008
Site plan

encounter was decidedly tepid. Following a chance introduction by Uli Sigg, a former Swiss ambassador to China and a prominent art collector, Ai first attempted to dissuade the architects from participating in Chinese design competitions, perceiving the process to be neither fair nor transparent.[1] Only when they returned to China, this time to participate in the National Stadium competition, did Ai agree to join as a collaborator and cultural liaison. By his own admission, he accepted the offer with little knowledge of Herzog & de Meuron's work and even less hope of winning the commission.[2] Perhaps liberated by such diminished expectations, it was only then that the architects could commence work to conceive the stadium anew.

Despite their dissimilar backgrounds, the team's productive collaboration formed around a fundamental architectural attitude and common aesthetic sensibility. Emerging from the Swiss Federal Institute of Technology (ETH) in Zürich where they were pupils of the distinguished Italian architect Aldo Rossi, Herzog & de Meuron's earliest works were compositions of disarming simplicity. In the Stone House (1982–1988), for example, the structure's post-and-lintel construction is expressed on the surface of the modest two-storey home – an aesthetic trope Ai would notably employ in Caochangdi. Later, the Swiss pair gained recognition for their distinctive facades, frequently integrating pop images into the panelized assemblies that clad stoic geometric volumes. Progressively, this work charted new territory within the modernist idiom, extending the building's materiality and structure beyond both early modernism's ascetic whiteness, and its sleek mid-century banality. The prominent Spanish architect Rafael Moneo has noted how this early work, 'appears, or is "deposited", in austere prismatic volumes, minimal units to be acted upon by the architect'. The work, be it of stone or concrete, is 'architecture offer[ing] the best it has by giving material the capacity to

1. 'When Sigg called Ai to ask if the CCTV competition would be fair, Ai replied, "Never, from my experience in China, will you have a fair competition"', Arthur Lubow, 'The China Syndrome', *The New York Times Magazine*, 21 May 2006.

2. Ai Weiwei and Jacques Herzog, 'Concept and Fake: Ai Weiwei and Jacques Herzog', *Parkett* no.81, 2007, p.127.

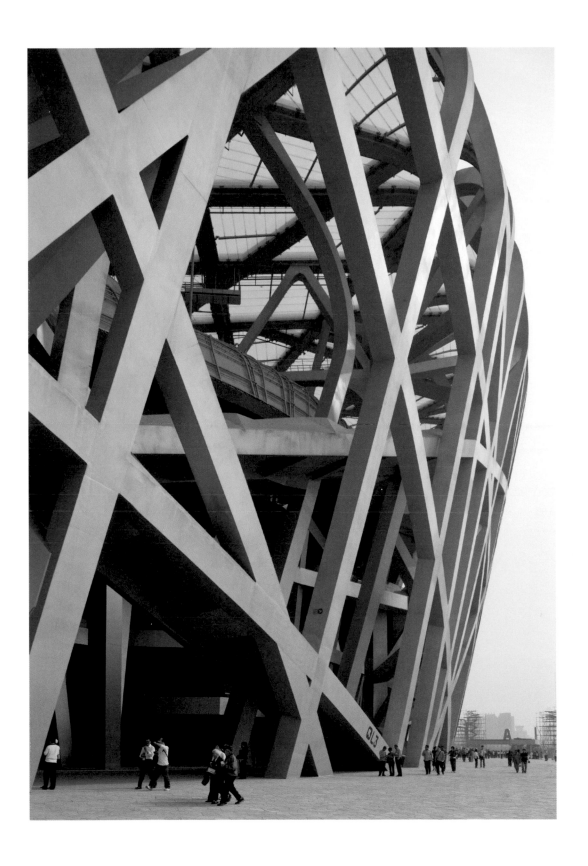

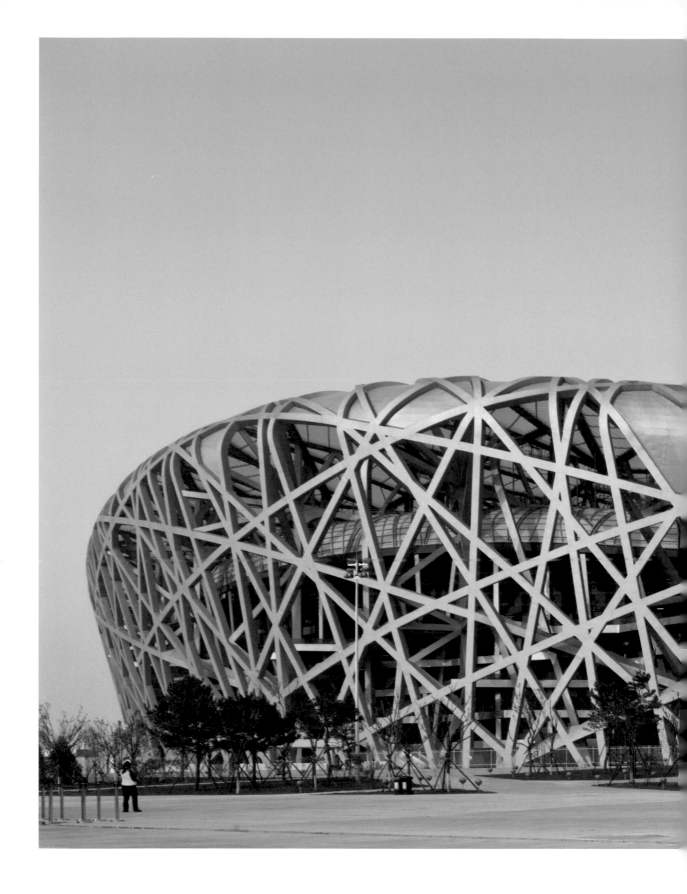

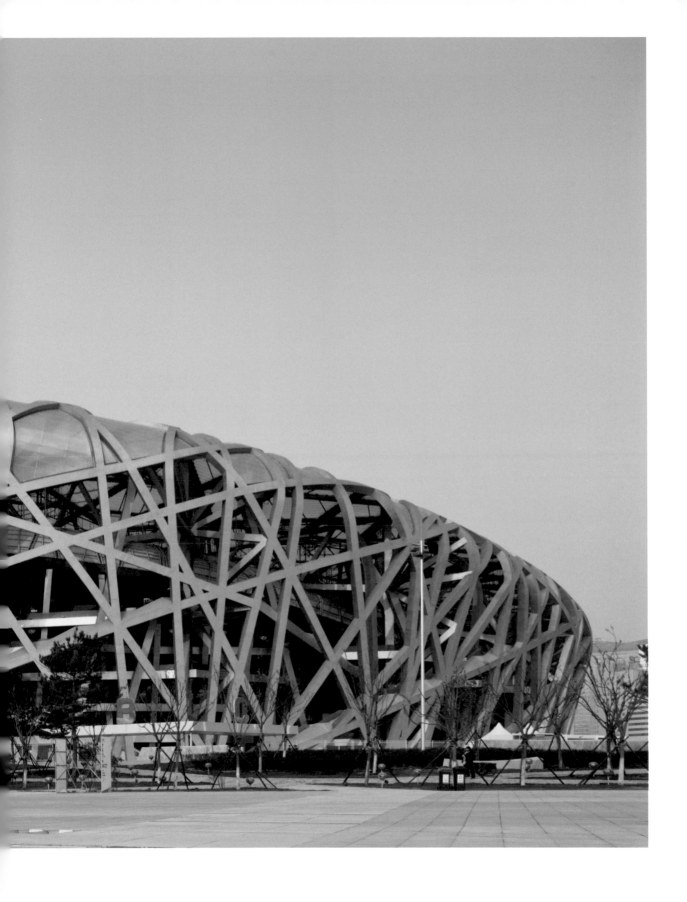

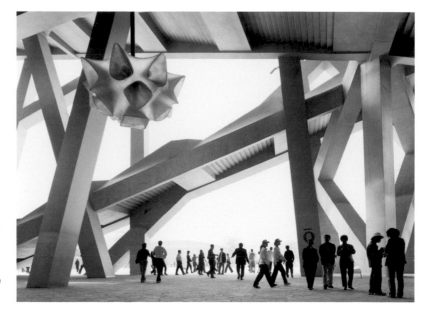

Previous pages and this page:
<u>Beijing National Stadium</u>,
2002–2008
The ground floor concourse
is an open latticework that
configures space to facilitate
unexpected activities and
social gatherings

show all they are capable of.'[3] Though often more extroverted than any of Ai's architectural works, the seeds of collaborative production stemmed not only from a mutual fascination with architecture's potential as a medium for transmitting pop imagery, but also the steadfast desire to produce architecture wrought from 'particular, precise, well-defined situations', contingent not just upon site, but a deep reading of cultural context.[4]

With its unmistakable ambitions towards iconicity and expressionism, the formal restraint and modest materiality of the collaborator's independent works are not immediately evident in the Bird's Nest. Galvanized by the ubiquity of the stadium's image in popular culture, critics of the stadium have accused the architects of participating in a communist propaganda routine, claiming that in capitulating to the state's desire for an icon, the architects disengaged from architecture's social and political mission so that they could pursue their own formal aspirations. Others charged that the architects had not done enough to promote improvements for the conditions of the migrant workers that built the stadium. These interpretations were only accentuated by the location of the stadium's site; the Olympic Green is in direct alignment with the city's historically charged north-south axis. Given its importance as an index of the nation's evolving polity, many insinuated that the stadium was intended to counterbalance Tiananmen Square's Maoist-era monument as 'a testament to the global ambitions of the world's fastest growing major economy'.[5]

To comprehend the Bird's Nest as anything but an emblem of state supremacy, it is necessary to understand the extent to which Herzog & de Meuron, along with other Western architects, saw their participation in the Olympics as a 'small stone' in China's political transformation. Imbued with

3. Rafael Moneo, *Theoretical Anxiety and Design Strategies: In the Work of Eight Contemporary Architects*, MIT Press, 2004, p.363.

4. Moneo 2004, p.367.

5. Paul Goldberger, 'Out of the Blocks', in *Building Up and Tearing Down: Reflections on the Age of Architecture*, Monacelli Press, 2009, p.42.

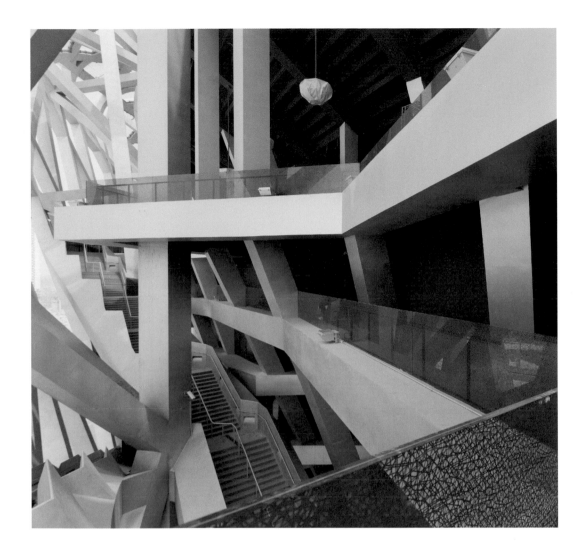

Beijing National Stadium,
2002–2008
A view from the stadium's
upper concourse reveals
the Piranesian web of
interwining columns

fresh optimism, these architects viewed the Beijing Games and its inter-
national congregation as a significant democratic influence. Participating
in the design of the stadium, they rationalized, was part of a gradual ef-
fort in which the core agency of architecture could play not only a symbolic
role, but a functional one as well. The stadium exhibits a common line of
contemporary architectural thought, namely that irregular geometries and
unconventional spatial conditions are inherently anti-totalitarian and able
to foster new and unexpected activities. Indeed, Jacques Herzog describes
the Bird's Nest as 'a stadium for so many people', and 'more democratic'
than previous Olympic venues. 'It's a freedom structure that people can ap-
proach from all directions, and when you are inside, there is no sense of a
good or bad direction.'[6] In its Olympic afterlife, the architects envisioned
the perimeter of the ground-floor concourse remaining open to the public,
enabling a new public space that would establish the stadium as the locus of

6. Ulrike Knöfel and
Susanne Beyer, 'Herzog on
Building Beijing's Olympic
Stadium: "Only An Idiot
Would Have Said No"',
trans. Christopher Sultan,
Spiegel Online, 30 July
2008, http://www.spiegel.
de/international/world/
herzog-on-building-beijing-
s-olympic-stadium-only-
an-idiot-would-have-said-
no-a-569011.html, accessed
8 October 2013.

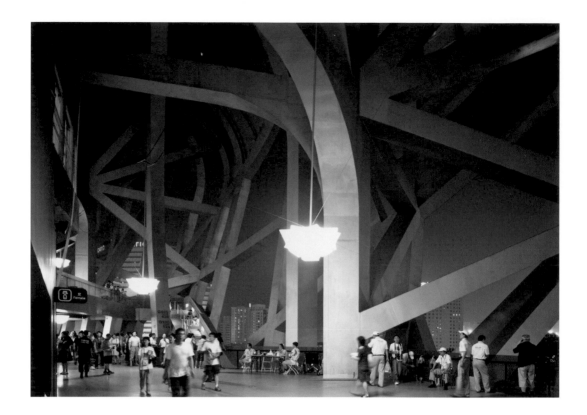

Evening activity takes place on a mid-level concourse of the Beijing National Stadium with fragmented views of the city behind

Following pages:
Beijing National Stadium, 2002–2008

7. Knöfel and Beyer 2008.

urban activity amid the redevelopment of the surrounding neighbourhood. The act of designing a state object was then not one of complicity, but deceit, and the stadium built for the Olympics would become an architecture for the people. At the time, Herzog described the stadium as 'a type of Trojan horse', in which the architects satisfied the venue's spatial requirements while facilitating the potential for more diverse uses later. 'We made everyday meeting places possible in locations that are not easily monitored, places with all kinds of niches and smaller segments,' Herzog noted. 'In other words, no public parade grounds.'[7]

Reiterating this political agenda through more symbolic modes, the stadium resists direct alignment with the historically charged axis. Sidestepping this line ever so slightly, it frames the public space of the Olympic Green against the Olympic Aquatic Center to the west. That this area was indeed used for ceremonial processions is perhaps indicative of the difficulties in enacting effective architectural forms of resistance. Like the stadium's rounded shape which provides no clear front and thus lacks a clear line of approach, these techniques are often confined to forms of messaging which are deeply subliminal.

While Ai Weiwei may have been more demure about his partner's optimism for imminent political transformation, his participation in the stadium's design was hardly devoid of political and cultural critique. Recognizing

the Olympics as a platform for dissent and a foothold to advance architectural dialogue, his partnership with Western architects was seen as a clear dismissal of Chinese architecture practice. Such was the affront taken by the profession's domestic establishment that they protested the invasive presence of non-Chinese designers in a letter to Premier Wen Jiabao. The letter accused Herzog & de Meuron, among others, of 'using the Chinese as their new-weapons test field'.[8] More than happy to promote the Chinese symbolism of the Bird's Nest – a bird's nest is a Chinese culinary delicacy – Party officials were less eager to acknowledge the significant presence of Western contributors to the design of their Chinese games. So protective of the Olympics' domestic image were Chinese officials that Pierre de Meuron, having travelled to Beijing at Christmas to participate in a groundbreaking ceremony, was not permitted to hold a shovel and was unceremoniously ushered out of the photo.

Perhaps Ai's most important gesture was his willingness to participate in the commission in the first place. Accepting a stake in the development of China's cultural dialogue, Ai understands that protest without proactive undertaking is easily reduced to a mutable form of discontentment. While debates about the political efficacy of contemporary architectural form continue unabated, Ai's role in the production of the Bird's Nest, and his continued support of the project, suggests a more nuanced reading of architecture and politics. Ai has famously derided the stadium's co-opted symbolism as an icon for Chinese progress. Nevertheless, he considers the stadium, in its conception and execution, an architectural achievement:

> I see the Beijing National Stadium as an architectural project ... From beginning to end, I stayed with the project. I am committed to fostering relationships between a city and its architecture. I am also keen on encouraging participation and exchange during mass events that are meaningful for humankind ... I have no regrets about the role I played; the stadium is a work of great quality and design.[9]

Framing an evaluation of the Bird's Nest within the limited terms of formal expression and functional performance may at first appear to abdicate architecture's broader social responsibility within society. Ai Weiwei recognizes that without edifices of culture – particularly those that strive for the highest forms of artistic expression – on to which meaning can be projected, cultural dialogue stagnates and progress wanes. The Bird's Nest remains a polarizing work of architecture precisely because its beauty conjures conflicting emotional responses that elicit both discomfort and internal reflection. These effects, perhaps more than the spatial ambiguity of the lower concourses, renew cultural and political discourse that has the potential for change. In doing so, the stadium, like Ai's denunciation of the Olympic opening ceremonies, can be understood as an instigator of dialogue, and a form of architectural activism.

8. Lubow 2006.

9. Ai Weiwei, quoted in 'Ai Weiwei: China Excluded Its People from the Olympics. London Is Different,' *The Guardian,* 25 July 2012, http://www.theguardian.com/artanddesign/2012/jul/25/china-olympics-london-ai-weiwei, accessed 8 October 2013.

Elevation: A—A
Scale: 1 : 1000

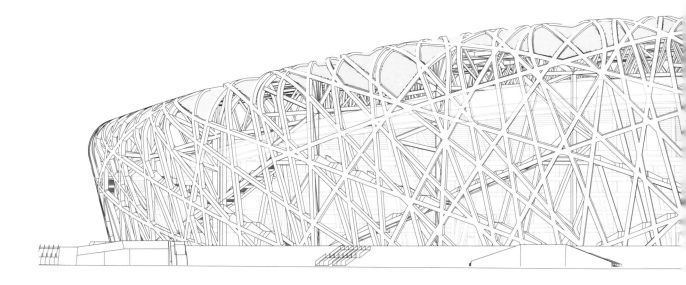

Section A-A
Scale: 1 : 1000

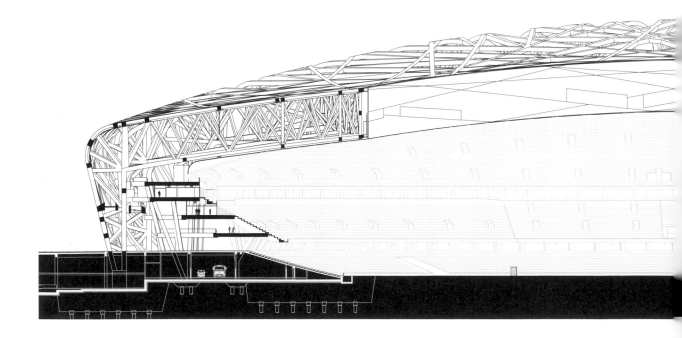

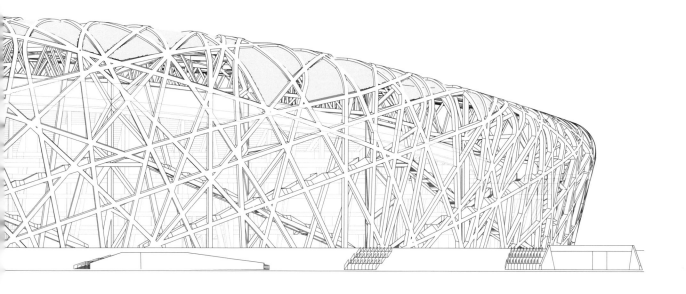

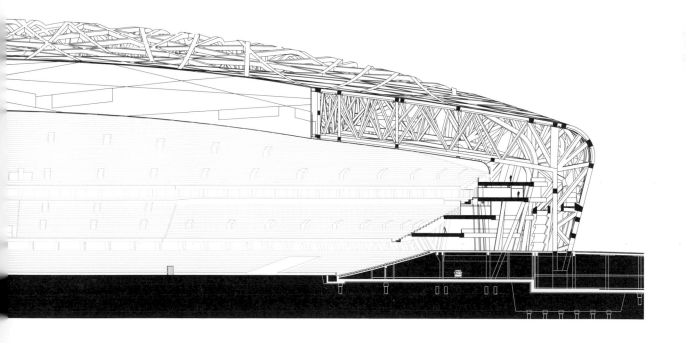

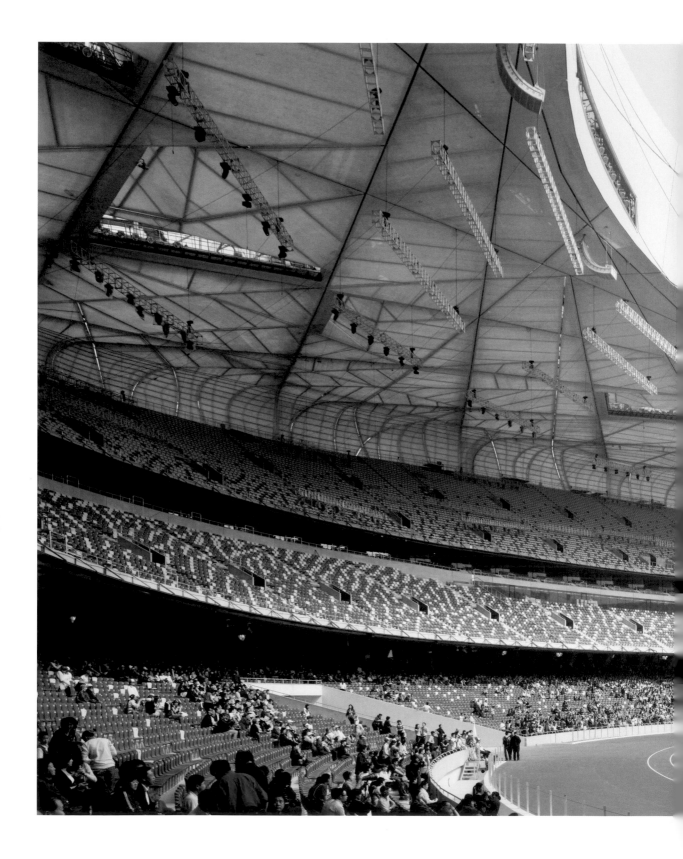

Collaborate

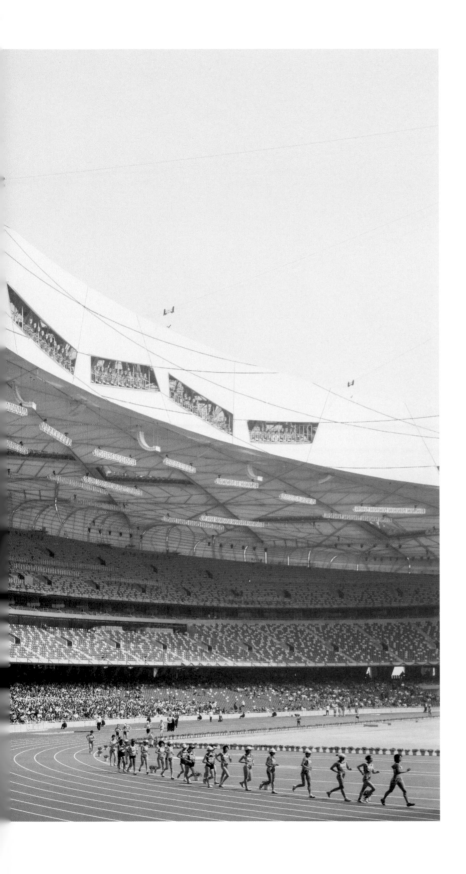

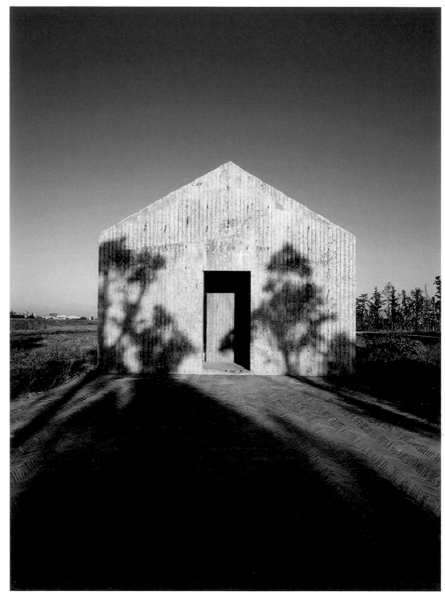

<u>Neolithic Pottery Museum</u>, 2004—2007
Jinhua Architectural Art Park
Jinhua, Zhejiang, PRC

Jinhua, Zhejiang Province, PRC
Collaboration with multiple architecture firms
2004-2007

JINHUA ARCHITECTURAL ART PARK

During the Maoist era, the state-driven insistence on a uniform national culture suppressed attempts to cultivate difference, pertaining to both individual human expression and collective identification with distinct regional and urban characteristics. The messages of homogenous culture emanating from Beijing, along with the state's predominant anti-urban position, mitigated the formation of strong civic identities that might have threatened to undermine the larger national goals of production and unity. In many locales, urban cultural distinctions formed around benign characteristics, while permanent forms of expression, including architecture, remained in the firm grasp of the state.

The generic Chinese city is thus an appropriate and contradictory backdrop for Ai Weiwei's first effort at architectural curatorship, a project known as the Jinhua Architectural Art Park. At Jinhua, Ai invited seventeen architects to design a small 'mini-structure': a pavilion-like structure tied to a general, oftentimes malleable programmatic stipulation. Situated on a prominent bend along the northern bank of the Yiwu River, the Jinhua Architectural Art Park takes on the characteristics of a traditional Chinese garden. Ai Weiwei adapts the principles of the garden to the park's attenuated site, linking each pavilion, like sentinel towers, in communicative relay. Spaced more or less evenly, distance, rather than a measure of physical proximity, enhances the temporal experience of the procession between pavilions as they unfold across the extended grounds. There is rarely a path from one pavilion to another, frustrating expedient movement through the park. Instead, its east-west orientation configures the park such that experiential relationships between adjacent pavilions are complicated by topography and the screening effect of tree groves. Moving through the site, the pavilions emerge and retreat from view, each concealed to varying degrees up until the specific moment when they are presented, at last, in full. This distancing not only intensifies the dramatic sequencing of architectural

Neolithic Pottery Museum
2004–2007
Site plan
Scale: 1 : 400

objects, but also frees them of the encumbrance of contextual adjacencies. Only from within the pavilions themselves, where basic formal manoeuvres reveal a tacit acknowledgement of neighbouring sites, does the garden's structure become more apparent. Rather than subverting the objects to the logic of the landscape plan, the spacing of the pavilions allows an unabated exploration of the architect's conceptual and formal desires. Each pavilion, through legible expression, is revealed as the prototype of an ideal.[1]

The concept of the pavilion takes on an important role at Jinhua, a fusion of its typical situation within the Chinese garden and the historical trajectory of Western modernist pavilions. In China, the pavilion has an extended and complex history dating to the initial appearance of the pagoda during the Song Dynasty (960–1279). Arriving in the form of the Indian *stupa*, it quickly assimilated the characteristics of military watchtowers and fortified gatehouses, eventually adopting a stable form as Buddhist monasteries became naturalized within Chinese culture. The pagoda later gained significance within the Chinese garden, becoming a place of contemplation and worship that often served manifold possibilities in spite of its prescribed use. Western notions of the pavilion, meanwhile, are wrapped up in the idealism of a fleeting prototype. Invoking the French term *papillon*, the imagery of the modern pavilion is associated with the peripatetic flutter of a butterfly wing, a sensation arriving from an unknown place, 'a pure image in flight, hovering for a moment'.[2] Such pavilions are usually short-lived, often constructed for temporary exhibitions to mark the brief enthusiasm of a particular historical moment. It can be claimed, however, that throughout the twentieth century no two architectural structures were more integral to the continual advancement of contemporary architecture than the pavilion, and its counterpoint, the folly.

1. Evan Chakroff, 'Ruins of an Alternate Future (Jinhua Architecture Park)', *Tenuous Resilience* (blog), 30 January 2012, http://evanchakroff.com/?p=800, accessed 8 October 2013.

2. Beatriz Colomina, 'Beyond Pavilions: Architecture as a Machine to See', in Bennett Simpson and Chrissie Iles (eds), *Dan Graham: Beyond*, Museum of Contemporary Art, 2009, p.206.

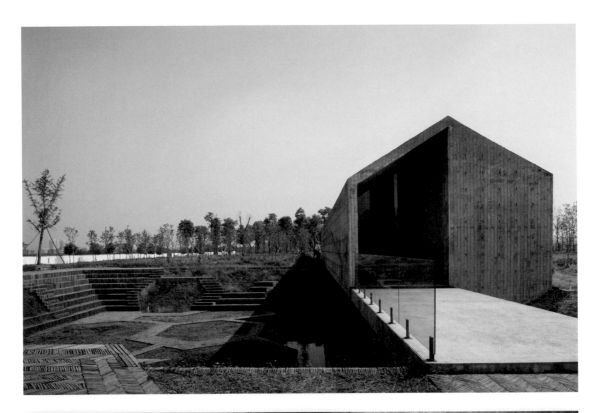

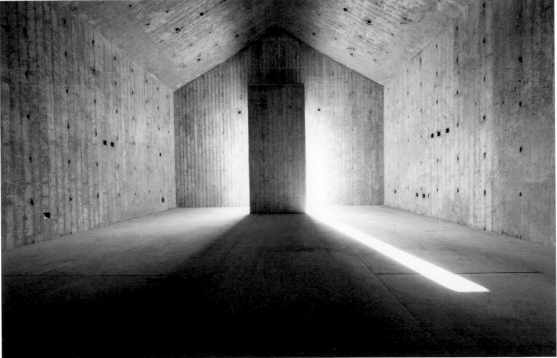

<u>Neolithic Pottery Museum</u>, 2004–2007
Entry and interior gallery space

Collaborate

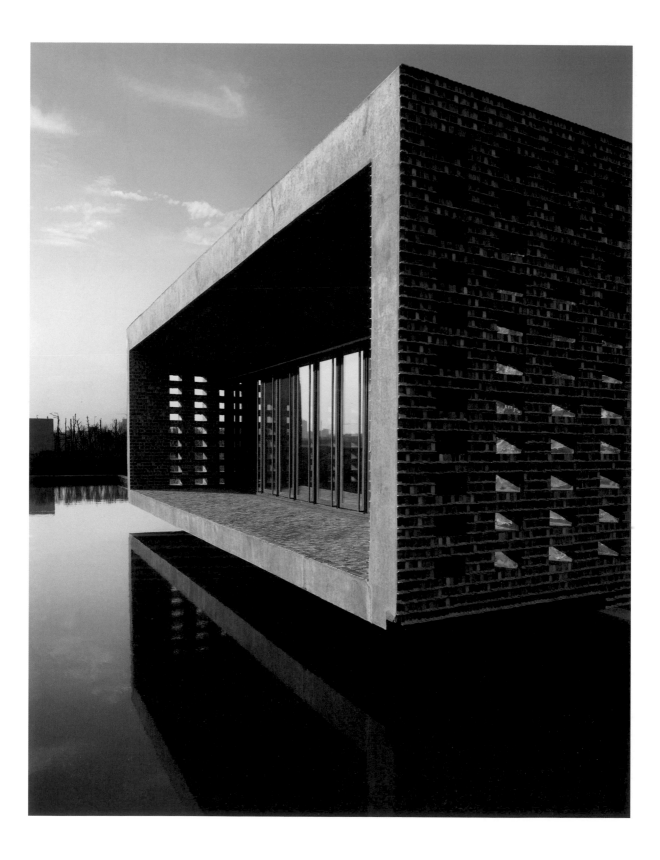

Collaborate

 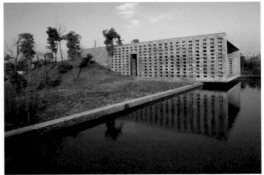

The pavilion was the preferred experimental building type of the modern avant-garde, encompassing many of the seminal figures from architecture's twentieth-century canon including Bruno Taut's Glashaus (1914) and Konstantin Melnikov's USSR Pavilion (1925), as well as Mies van der Rohe's Barcelona Pavilion (1928) and Le Corbusier's Pavilion de L'Esprit Nouveau (1925). In the modernist tradition, the pavilion vacated contingencies of programme and site in order to provide the freedom to explore new possibilities, particularly the tectonic expression of material and technology. Functionless and temporary, it constituted a partially rendered image of architectural potential, closely associated with the possibilities of architecture in the main. The folly, by contrast, is far more antagonistic. Rather than a utopian projection, it occupies 'the essential nature of opposite pole, of extreme undesirability, of absolute contradiction'.[3] Almost by necessity, follies are conceptual fragments that do not aim to reach the pavilion's full resolution, but rather follow the principles of good building in order to allow the imagination to elaborate on the simplest forms.[4] Closely allied with studies of architecture's ability to incite new social conditions through the manipulation of form, follies are more concerned with the architecture's social ramifications than with projecting a future potential for an architecture's mainstream adoption.

As the term 'mini-structure' tellingly implies, the conventional description of a 'pavilion' does not quite apply to the buildings at Jinhua. Conscientiously given a programme, and thus a stronger relationship to their social potential, these structures seek to imagine new visions for architecture in China through the lens of a pluralistic society which values difference and cultural advancement through exploration.

At Jinhua, Ai Weiwei's own structure most closely resembles a straightforward work of architecture rather than a speculative pavilion. Adopting site and programme, Ai engages the viewer in a tactful conceit, presenting the visitor with the pentagonal frontage of a typical house punctured only by a single, symmetrically placed entryway. The structure, alternatively programmed as a Neolithic Pottery Museum or an Archeological Archive, exhibits all of the competencies and complexities of programmatic

Opposite and above:
Cafe, 2004–2007
Designed by Wang Shu

Previous pages:
Neolithic Pottery Museum,
2004–2007

3. 'As the emblem of foolish luxury, it offered a warning to spendthrifts and unproductive investors; as totally without function, it provided a specter of emptiness and uselessness without which function itself was meaningless; as close to madness, it described a realm and embodied a visual metaphor that decorated and domesticated an otherwise awesome concept, one that was readily incarcerated behind nonsignifying walls.' Anthony Vidler, 'History of the Folly,' in Archer, p.10.

4. B.J. Archer (ed.), 'Introduction', in Follies: Architecture for the Late-Twentieth-Century Landscape, Rizzoli, 1983, p.8.

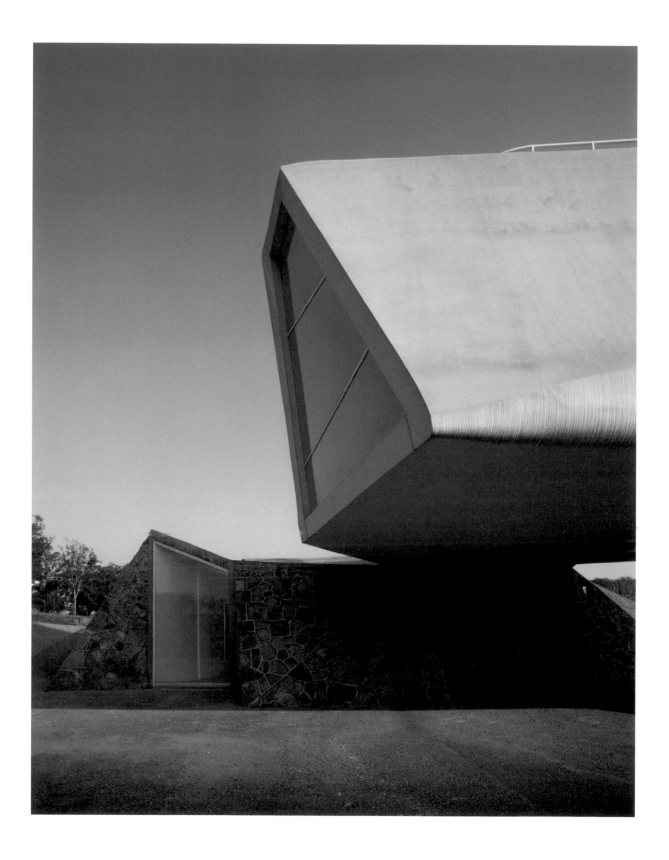

Collaborate

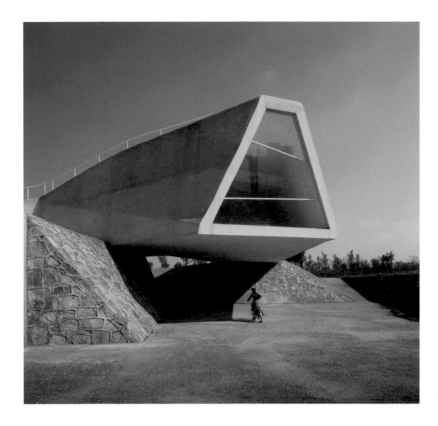

Exhibition Space, 2004–2007
Designed by Tatianna Bilbao

use – electrical, mechanical and plumbing services, as well as a form tailored to its site. Approached from the east, the long, low structure appears barn-like. Its five-sided profile stretches across the verdant prairie setting, suggestive of an unarticulated agricultural past. The museum's concrete form is a remnant, a monolithic trace of the repetitive board walls used to give the concrete walls their form. As one circulates the perimeter of the site, the museum's shifting formal complexion elicits multiple, if contradictory, associations.[5] South, toward the river, the eastern approach to agrarian forms gives way to pure geometry, as the ground is excavated away to reveal an octagonal volume.

Neighbouring Ai's Neolithic Pottery Museum, Wang Shu's pavilion-like structure is equally rooted in its context. Approaching the rectangular form from its broad side, the ceramic-clad volume emerges from a mounded hill to cantilever over a narrow reflecting pool. The building extends across the footpath, obstructing the pedestrian's progress through the site. The visitor is forced to enter the structure where the pool's shallow water mirrors the river beyond, through the framed view of the glazed facade stretching from ceiling to floor. Once inside, the visitor is treated to a surprise, as Wang has carved out the pavilion's back end, allowing the hill to slope directly to meet the pavilion's floor at grade. From within, a set of interior stairs provides access to the rooftop, itself entirely clad in ceramic, to allow

5. Chakroff 2012.

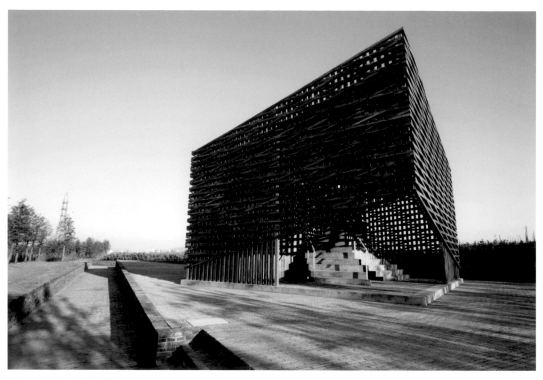

Welcome Center, 2004–2007
Designed by Til Schweizer

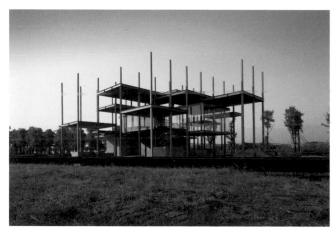

Restaurant, 2004–2007
Designed by Fun Design Consultancy
and Johan De Wachter Architects

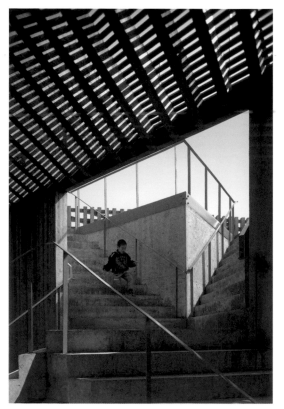

The staircase of the Welcome
Center, designed by Till Schweizer

panoramic views of the river and park. Unlike Ai, for whom the use of concrete is nothing new, Wang's use of ceramic tile constitutes a far more experimental material expression. Anticipating the randomized use of recovered building materials at the Ningbo Historic Museum, Wang himself spent a number of years as an apprenticing craftsman, a fact that is evident in his firm's frequent transformation of common materials by contemporary means. Imbued with a critical self-consciousness, these explorations of materiality, technique, and culturally rooted practice recall Kenneth Frampton's notion of a critical regionalism, one that can at least partially 'find its governing inspiration in such things as the range and quality of the local light, or in a tectonic derived from a peculiar structural mode, or in the topography of a given site'.[6] Wang's pavilion, however, remains firmly within the realm of non-architecture, still awaiting its adoption into the mainstream.

Many of the structures in the park straddle the distinction between pavilion and folly, maintaining attributes simultaneously projective and antagonistic. At the park's far-eastern edge, the dense wooden latticework of Till Schweizer's Welcome Center poses a 'curiosity challenge', a deft flirtation cautious in revealing only a hint of its interior through a low-slung canopy. Not entirely antagonistic, the pavilion was envisioned as both a meeting place and location of repose, utilizing the split stair's irregular configuration for both congregation and access to the rooftop overlook. Meanwhile, Fun Design Consultancy and Johan De Wachter's atomized, multi-level restaurant recalls the Chinese dining experience of spaces made private by screens and walls. Here, the solid partitions are dematerialized through the extensive use of glass, emphasizing an open, voyeuristic culture of 'watching and being watched'. Liu Jiakun's tea houses are elevated to satisfy 'the foremost yearning for relaxation during tea time to get to a higher place to enjoy the view and the wind', while the geologic formation of Tatiana Bilbao's Exhibition Space mediates the relationship between landscape and building. Within the latter's tectonic bulge, the interior is surprisingly fragmented, necessitating a process of discovery; multiple tunnels, pathways

6. Kenneth Frampton, 'Towards a Critical Regionalism: Six Points on an Architecture of Resistance', in Hal Foster (ed.), *The Anti-Aesthetic: Essays on Post-Modern Culture,* Bay Press, 1983, p.21.

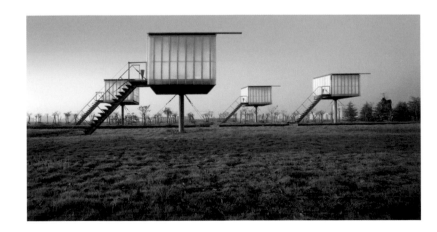

Tea Houses, 2004–2007
Designed by Liu Jiakun

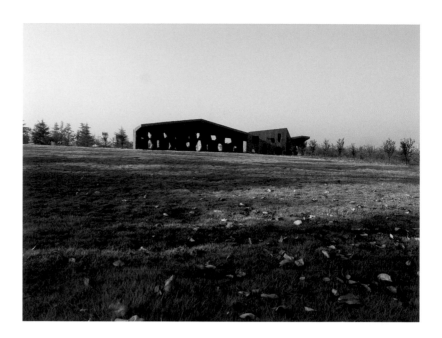

and terraces guide the user though its plaza and into the building. Each work mixes a social programme with architectural possibility, mediating the performative intentions of the pavilion with the social agency of the folly.

It is the work of two Swiss firms, HHF Architects and Herzog & de Meuron, that most closely exemplifies the folly. Taking advantage of the opportunity to build in China, both firms arrive at similar proposals that bluntly eschew fine details for raw and material mass. Both HHF's Baby Dragon and Herzog & de Meuron's Urban Mini-Structure are constructed of pigmented concrete tinged red to match the Jinhua soil, and in each the intentionally untreated concrete is left to weatherize. In the process of bleaching, eroding, and staining, the structures become more firmly embedded in the conditions of the site. The sited-ness of these structures is affirmed in their perpetual inhabitability throughout the day. With no defined enclosure, both Baby Dragon and Urban Mini-Structure are open and completely exposed. They create a sense of interiority only through formal implication – an effect achieved through various manipulations of cantilevered overhangs, slanted wall slabs, and the perceptible relationship of their compositional elements.

HHF's Baby Dragon is a monolith subsequently punctured and carved away. Displaced voids derived from the randomized application of eleven unique volumes perforate the concrete mass in a manner that makes the wall simultaneously porous and inhabitable. At times, the volumes are combined to enhance the complexity of the apertures, intersecting midway through the half-metre-thick wall. Primarily intended for children, the apertures in the Baby Dragon create an open system for play and appropriation. Sited at a corner of the walkway system and articulated in three parts,

Jinhua Architectural Art Park

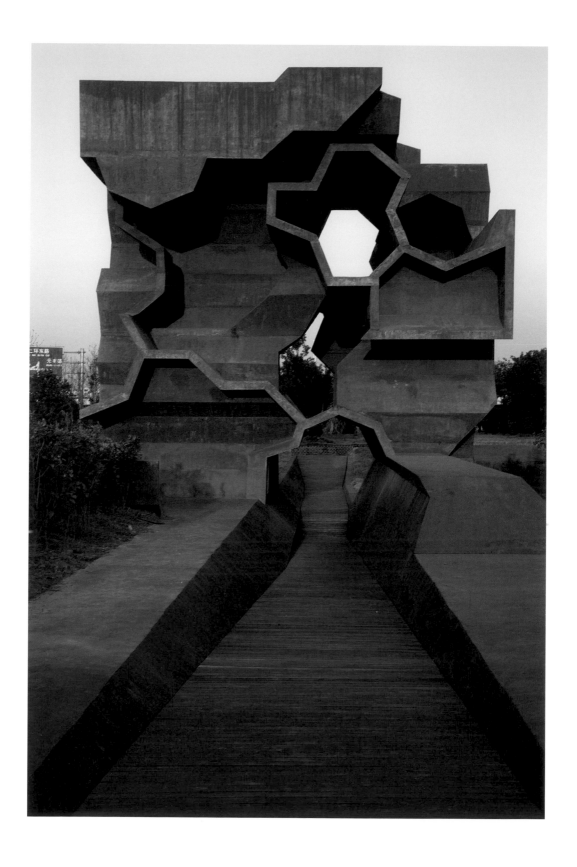

Collaborate

the structure inhabits the border between an open lawn and a space under evergreen trees. The three variations of enclosure create different conditions of intimacy, control and usage. The construction's most public area is a protected meeting place for parents and the children's attendants, while its most private and least-controlled end becomes, almost, a part of the woods – a conceptual extension meant for play.

Herzog & de Meuron's Urban Mini-Structure, however, is the park's *pièce de résistance*, a folly in the truest sense. In Urban Mini-Structure, the cubic volume from which their proposal took shape served as a conceptual mechanism that allowed the architects to arrive at a concrete form. Herzog & de Meuron were already working on an unrealized master plan for a nearby section of the city. Taking the randomized patterning scheme they had developed to provide variation within the urban fabric, the concept of variation became a model for the park structure's design. Projected on to each side of a cube, the pattern's lines were extended through the interior, creating a web of intersecting and conflicting lines, planes and volumes that the architects were then challenged to resolve. As depth was given to the pattern, the selective inclusion of the resulting geometries was driven by the potential for human-scale activities. The outcome is what the architects describe as 'a virtually constructed sculpture of slabs, voids and solids, eroded and shaped by the needs and scale of the human being, creating many different spatial conditions and outlooks'.

Urban Mini-Structure, 2003
Designed by Herzog & de Meuron

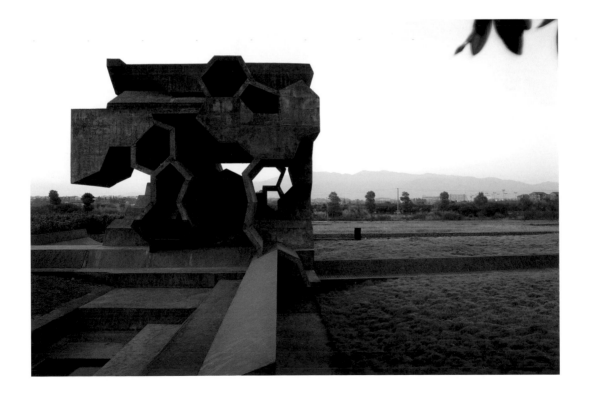

Collaborate

Ordos, Inner Mongolia, PRC
Collaboration with Herzog & de Meuron
2008

ORDOS 100

1. Charles Merewether, 'At the Time', in Urs Meile (ed.), *Ai Weiwei: Works 2004-2007*, Galerie Urs Meile, 2007, p.179.

2. Philip Tinari, 'Chairs and Visitors', in Meile 2007, p.12.

3. Merewether 2007, p.179.

4. Alexander von Vegesack and Matthias Kries, *Mies van der Rohe: Architecture and Design in Stuttgart, Barcelona, Brno*, Skira, 1998, p.136.

In the summer of 2007, Ai Weiwei dispatched 1,001 Chinese citizens to the German city of Kassel. These volunteers, many of whom had not previously owned a passport, were the integral members of Ai's conceptual performance *Fairytale*, in which, among other motivations, the artist sought to probe the meaning of being Chinese outside the limitations of the nation's borders.[1] As part of the work, visitors were provided with matching luggage, lodging, a few utilitarian items and a modest stipend. Then, they were set free. The performance was, as the art critic Philip Tinari has noted, 'an experiment in controlled chaos … [participants] decided how to spend their time, form their social networks, and allocate their leisure money. In this way, the project provided a general microcosm of [Chinese] public life, in which certain parameters are set from above, but what unfolds inside them defies regulation.'[2] Pressing against culturally formed notions of Chinese nationality, *Fairytale* encouraged re-evaluation through the interaction with the unfamiliar, a tactic whose effect was reciprocal across all parties. As Ai was keenly aware, the Chinese citizens would be fundamentally changed after they had travelled abroad, but so too would the people they interacted with.[3]

In 2008, Ai brought 100 international architects to China for a project equal to *Fairytale* in its scale and ambition. Participants, rather than being chosen at random, were selected based on relative merit by Ai's Swiss collaborators Jacques Herzog and Pierre de Meuron. Assembling a list of designers from twenty-nine countries, the field of architects represented a contingent of reputable, but relatively inexperienced designers whose potential as critical theorists and disciplinary practitioners might conceivably reach fruition within the project's open parameters. The brief for the ORDOS 100 project was straightforward, if laden with complexity. Each team was to design a luxury villa in the middle of a non-existent desert community located thirty kilometres from the next city in the heart of China's coal-rich region.

ORDOS 100, 2008
Participating architects visit the Ordos site for the first time
Ordos, Inner Mongolia, PRC

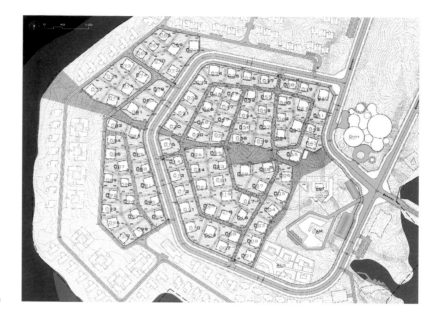

ORDOS 100, 2008
Site plan indicating the
location and parameters
for each villa

Opposite page:
Architects search for their
site in the Mongolian desert

Next page:
The assembled teams of
ORDOS 100 in Inner Mongolia

Conceived by Cai Jiang, a billionaire energy tycoon turned Chinese art hobbyist, the ORDOS 100 was not originally a project of visionary architectural scope. Part of a government-led attempt to attract a population of 200,000 to an area ignominiously labelled Jiangyuan Culture Creative Industrial Park, both the project's optimistic aspirations and its institutional epithet hinted at the disconnect between the interests of the invested parties. Initially, seeking a prominent name to attach to the project, Cai had requested that Ai Weiwei design each of the 100 villas. Having just ceased his office's architectural engagements, Ai refrained, offering instead to lead the project in a curatorial role. He also designed the project's site plan.

The remote location of ORDOS 100 posed atypical challenges to architects accustomed to working in the well-defined urban conditions of existing cities. With little to react to in the way of the site's physical parameters, the architects were confronted with only impending unknowns – the form of future villas on neighbouring sites. By virtue of ORDOS 100's experimental programme, even a general sense of the surrounding buildings could not be predicted. Variations in form, material, and orientation might challenge the legibility of the designer's intent or they might enhance the perception of its architectural effects. The designers could not be certain.

Given the project's heterogeneous authorship, ORDOS 100's speculative disposition found itself in easy association with many utopian proposals from early- and mid-twentieth century modernism, none more commonly cited than the 1927 Weissenhof exhibition in Stuttgart. Under the creative directorship of Mies van der Rohe, the *Weissenhofsiedlung* assembled a contemporary roster of European talent under the banner of progressive housing that exhibited enlightened social values and novel forms of residential

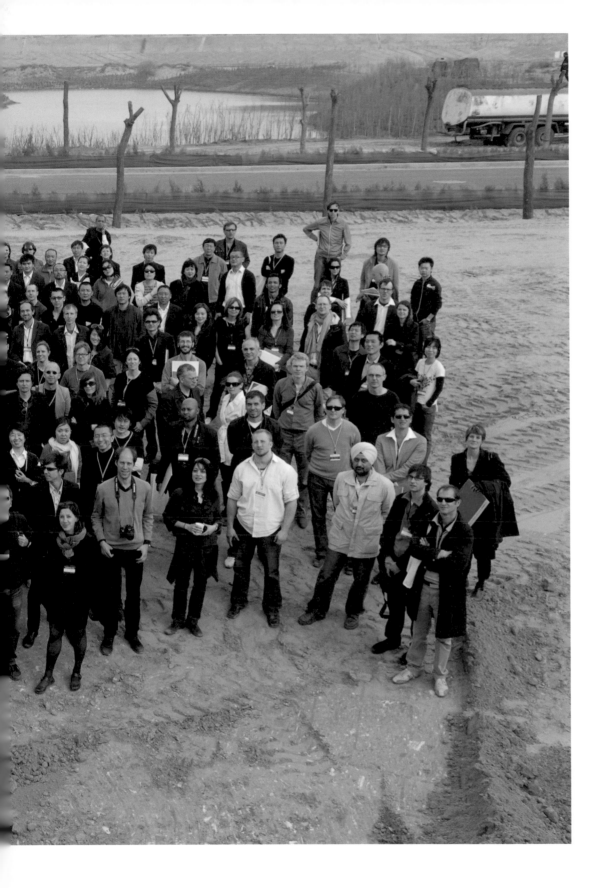

collectivity. Developed through a variety of housing prototypes, Mies was purported to have held imperative an atmosphere 'free of one-sided and doctrinaire viewpoints'.[4] This was proved to be little more than a token gesture. Mies would eventually insist that all buildings comply with his prescriptions for flat roofs and monochromatic exteriors. Architects, including the Viennese architect Adolf Loos, who were critical of these plans were eventually removed from the project.

The distinctions between Ordos and Weissenhof elucidate ORDOS 100's role as a conceptual model for Chinese urbanism, if not a formal one. Absent an ideological commitment to one particular mode of architectural thought, especially European modernism's advancement of technological optimization and spatial efficiency, Ai Weiwei's promotion of architectural plurality as an inherent quality of progressive society takes on activist tones. Like the Jinhua Architectural Art Park (2004–2007), stylistic diversity serves as a critique of uniform nationalist tropes. Both Ordos and Jinhua operate in a similar manner to Ai's *Black*, *White*, and *Grey Cover Books*, broadening cultural knowledge through exposure to precedents outside of the established domestic practice. In architecture, it's a simple approach that is latent with subversive potential. It supposes that by developing techniques to accommodate new architectural forms, native practitioners will also be induced to press against the discipline's limitations.

At a meeting in 2008, Ai gathered all of the participating architects to experience the Ordos site firsthand and receive their individual plots. The heavily documented affair was a celebration of the architects' diverse origins as well as their collaborative unity. Despite the project's grandiose vision, or perhaps because of it, it is difficult to resist the impression that the whole event was an elaborate hoax orchestrated by Ai. Photographs depict scenes that appear satirical in the context of China's reputation as the Western architect's gold mine. The architects play perfectly into Ai's conceit. Descending upon the Mongolian frontier in search of a golden commission, the swarms of black-clad designers find only sand. Unwittingly, or perhaps to conceal their late-dawning suspicions, the architects carried out the performance for the cameras by surveying the sand-swept landscape, noting the contextual features of a site defined by its very placelessness. If it seemed far-fetched that such a radical proposal could take place in the heart of the desert, Ai remained a sincere host. Though the conspicuous presence of videographers did little to downplay the event's theatricality, Ai's actions were prosaic. He presided over meetings, reviewed models and offered modest alterations. Elsewhere, groups of architects conferred privately while others pressed Cai Jiang about the project's environmental impact.

Ultimately, for Ai, these exchanges form the project's lasting effect – to foster intellectual dialogue across cultural and national affinities. 'For me, the question is how to bring worldwide contemporary architectural knowledge in touch with Chinese practice,' he says.[5] Like *Fairytale*, however, the effect goes both ways.

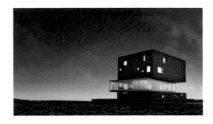

Villa 066
PAD Inc./Samer Hoot

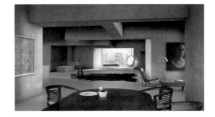

Villa 021
Pedrocchi Meier

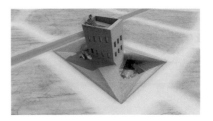

Villa 047
Preston Scott Cohen

Opposite page:
ORDOS 100, 2008
Renderings of the proposed development with architects' schemes assembled

5. Bert de Muynck, 'Ordos 100', *Perspective Plus 2009*, Perspective, 2009, p.113.

New York, USA
Collaboration with HHF Architects
2005–2008

TSAI RESIDENCE

Described as a weekend home for two young art collectors, the Tsai Residence is the type of tastefully appointed domestic retreat where art, nature and cosmopolitan society intertwine. Set in the pastoral hills of upstate New York, the house rests atop a manicured slope and is nestled at the edge of a wooded expanse. Approached from the end of a rural road, the winding drive takes part in a cinematic unveiling in which the house emerges from behind a grove of pine trees. It appears like a landscape sculpture, metallic and orthogonal, composed of four equally proportioned cubic volumes aligned axially from east to west. The solid masses are reduced by large voids removed at the ground floor. Long, linear spans of reflective glass sit within deep window recesses. The depth is accentuated by the reddish tint of cedar cladding lining the perimeter of these exterior spaces, at once assimilating with the natural surroundings and the material palette of the nearby guest house. Sited only a few metres away, the guest house that Ai Weiwei designed with HHF Architects is an equally artful building that is notable for the slow, convex curvature of its weathered steel facade.

Under the conventional top-down logic of modernist hierarchy, the four primary volumes suggest a series of linked yet discrete programmes, each isolated into its own self-similar unit and subdivided by necessity and function. The plan, however, resists such diagrammatic reductivism, allowing the interior to vacillate freely between open and intimate spaces. The volumetric expansion and contraction extends both horizontally and vertically, creating light-filled spaces with mezzanine overlooks and attenuated views stretching nearly the length of the house.

Unlike many buildings developed under Ai's singular authorship, the Tsai Residence exhibits none of the hermetic interiority favoured in his modest village architecture. Through swathes of glass installed along the major living spaces, the house offers expansive views in each direction. These dematerialized surfaces contradict both the formal integrity of the cubic

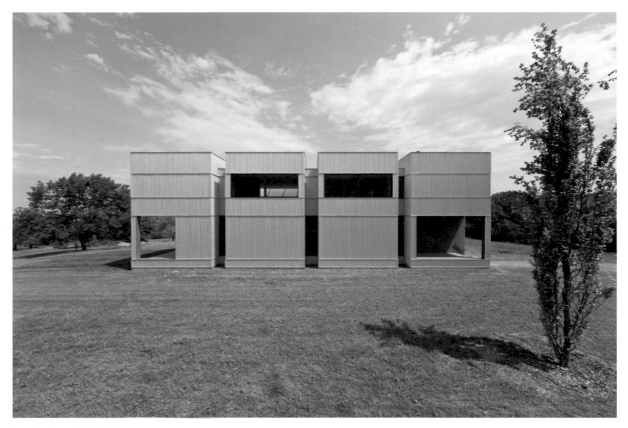

Tsai Residence, 2005–2008
New York, USA
Southern elevation

Elevation: North

Elevation: South

Plan: Second floor

Plan: First floor

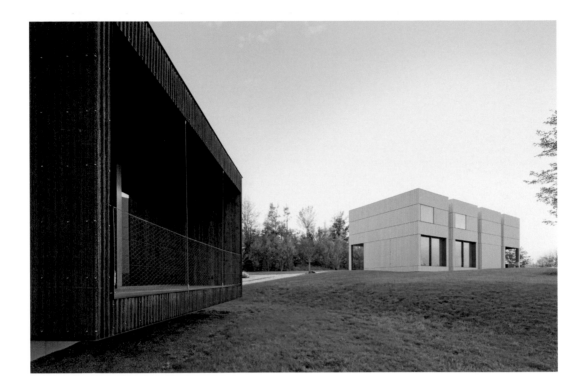

volumes as well as the clear delineation of the building's interior and exterior environments. Spaces dedicated to the display of artwork, meanwhile, suggest a clearer articulation of Ai's deft control of light. In the living room, for example, diffuse interior light is cultivated through indirect solar exposure. Accommodating the need for gallery-quality conditions to display the resident's collection, the house provides conditions that are simultaneously airy and intimate. Fenestration is consciously planned to accommodate the pieces without subjecting them to the dominance of the countryside view. In these spaces, wall-mounted compositions and the room-height picture windows alternate as framed works of art.

The overlap between Ai Weiwei's architectural sensibilities and those of his Swiss collaborators is revealed in the modest persuasion of the house's materiality. In contrast to many of their Swiss peers, HHF's early efforts conspicuously avoided the fussy technical detailing of contemporary minimalism. This approach is mirrored in Ai's architecture, resulting in the tough, tactile volumes of brick and concrete, which the artist describes as 'rough architecture'. In collaboration with HHF, however, the exterior is notably less imposing. Clad in corrugated iron, the reflection of sunlight off the facade's shallow waves induces subtle changes to the house's appearance throughout the day. This experience is extracted through the expediency of a material palette and construction method derived largely from the American housing industry: lightweight wood structural framing with a thin veneer.

Top:
Tsai Guest House, 2009, and
Tsai Residence, 2005–2008
viewed from the south-west

Above:
Tsai Residence, 2005–2008
A second-floor mezzanine
overlooking gallery space

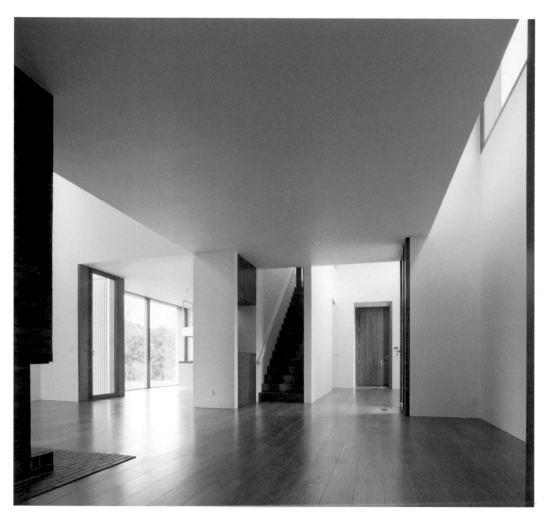

Above:
Continuous living and dining
spaces on the ground floor
of Tsai Residence

Right:
A bedroom on the second
floor

Above:
The library mezzanine open to the living room below

Right:
The main entrance to the house from the west, seen through the primary living and dining spaces

Art Farm, 2006
New York, USA
North facade

New York, USA
Collaboration with HHF Architects
2006

ART FARM

The rolling hills of upstate New York are a pastoral quilt, alternating patches of verdant forest, manicured farmland, and lush estate grounds. Ai Weiwei's Art Farm, which he designed collaboratively with the Swiss firm HHF Architects, would appear at home in any of these settings. Built to serve as an exhibition and storage space for a professional art collection, the steel exterior of the gallery's tripartite configuration masquerades as a barn in the agrarian countryside, stepping gently down the sloped terrain with simple elegance. Its major volumes, easily identifiable from the outside, delineate the building's interior functions and are bisected by a cascading ramp traversing the building's central axis. In the uppermost volume, a large rolling gate door provides access to the primary storage room. The shorter mid-section houses office and gallery space. On the lower landing, an open exhibition room allows for the display of large works of art. The passageway, though intended primarily for circulation, is also appropriately proportioned to show wall-mounted media.

Reaffirming its place among the agrarian landscape, the Art Farm's crenulated exterior is a result of the building's pre-engineered steel assembly system. It is a system frequently used for agricultural purposes, utilizing a set of profiled sheet-metal components that are fastened together to create a stiff, structural shell. Given the collection's susceptibility to fluctuations in temperature and moisture levels, the interior had to be heavily protected to maintain consistent internal conditions. Enhancing the shed's thin enclosure, the roof is insulated with pillowy tufts covered in a soft, reflective vinyl sheeting. In contrast to the tough exterior, this cover gives the ceiling the luxurious appeal of a Chesterfield sofa.

Right:
The hallway leading to the
main showroom also serves
as auxiliary display space

Below:
The exterior of <u>Art Farm</u>
seen from the north

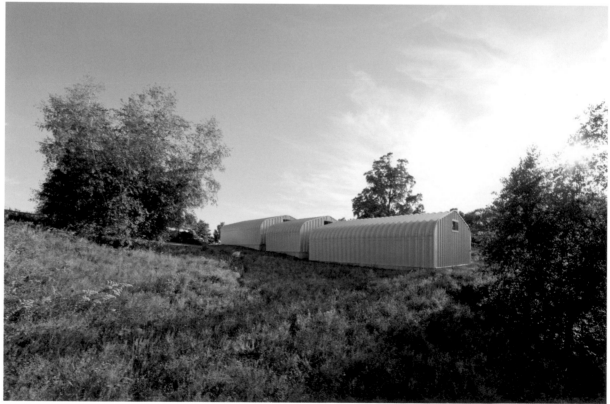

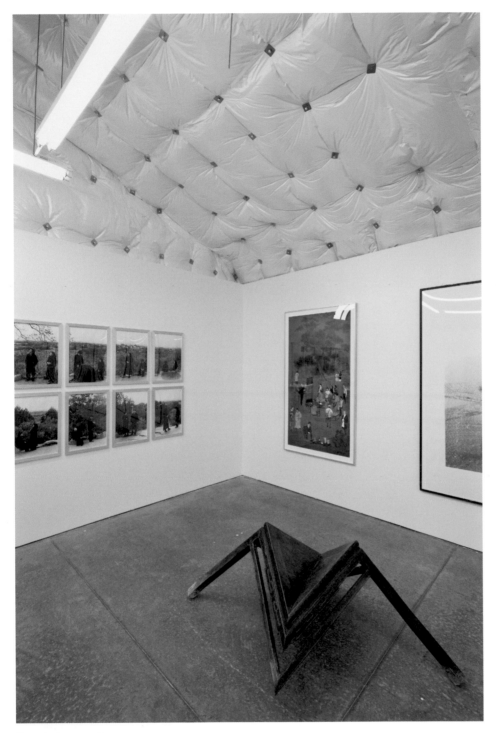

The main showroom at
<u>Art Farm</u>, designed by Ai
Weiwei in collaboration with
HHF Architects

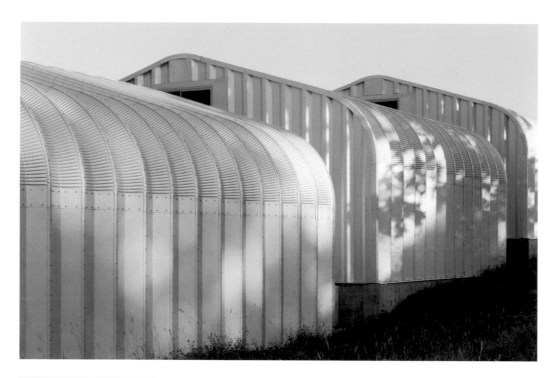

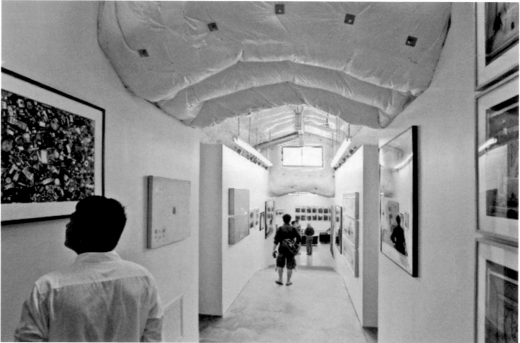

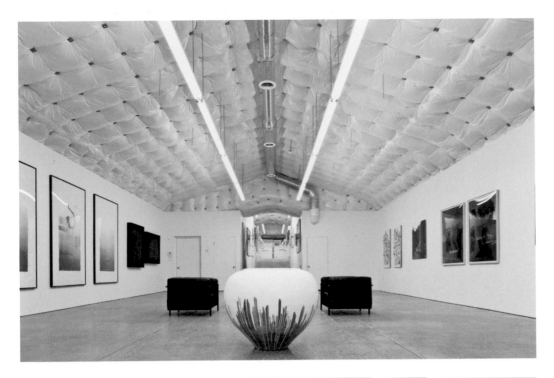

This page:
The main showroom and the art storage room

Opposite page:
A detail of the pre-engineered steel exterior
and the central hallway display gallery

Investigate

Transitions in the Contemporary Chinese Metropolis

Entries from Ai Weiwei's Blog

N Town
Posted: 19 March 2006
Translated by Lee Ambrozy

In N Town, in the nation of C, the first Qin emperor established a city where three rivers converged.[1] I found myself in N Town on some rather absurd business – I was helping to jury an architecture award. Standing at the side of the road, I could see that N Town was no different from other southern cities.

All cities in C Nation inherently maintain a faithful record of the scars left by authoritarianism. Unlike actual ruins, which are caused by rational, ordered destruction, these cities are elegies on frenzied architectural activity. Their creators and their landlords are victims of their own idiocy and base behaviour, and as a result of their nonexistent conscience and lack of common decency, cities are thus humiliated. The elderly are too ashamed to tell the newest generations about the past, and the young are left with more despair than hope. People's hearts are fast becoming mediocre, shrewd, and old. Year after year, people have become so accustomed to finding their diversions amid darkness and suffering that they are able to take pride in their shame.

Even though it is utterly unaware of this fact, C Nation has become this way as the result of its self-punishment. Cruelty does not arise from savage competition or a bloody reality, but from contempt for life, homogeneous standards, and a numbing of the senses. Life is no longer flourishing, souls become muddled, and the vitality of dreams pale.

Years of abuse, crudeness, and wantonness have caused the people in these cities to walk with a quickened pace, and to see with lifeless eyes. They have nowhere to go, and nowhere to hide. At last, the people lose their sense of belonging. They aren't attached to their homes, villages, or cities, and they become strangers in permanent exile.

News of N Town emanates without pause from a central city plaza designed by Mr M. Surrounded by sumptuous commercial centres, his enormous new plaza is the favoured destination for urban residents enjoying relaxing strolls. Beneath the gently flapping flags, an ingeniously crafted

musical fountain graces a marble-lined pool, where films are projected on to a screen of falling water. Mr M's design is unlike the rest of N Town; it appears to be at the cutting edge of style, is novel and unique, and has a festive lavishness that adds a light touch to this otherwise outmoded, degenerate place. Like other economically developed zones, the city is besotted with music halls, opera houses, and art museums.

N Town's art museum is also brand new, and I arranged with a friend to pay it a visit. The enormous establishment had not a single piece of art to display, and was showing instead mounted skeletons of enormous animals from the Jurassic period. A clumsy ignorance was evident in every aspect of the exhibition's garish displays – the lighting, special effects, explanations, and wall labels. All of this sat in powerful contrast to the inconceivable wonder exuded by the skeletons of these giant beasts. That was an age of true glory – the earth once boasted such landscapes, skies of such colour, such winds and rains! What destiny shaped these giant beasts that ruled that world, and what disaster finally exterminated them, and turned them into fossils to be displayed here in this museum?

The aeons rolled on, at last begetting the weak, fragile-bodied, and calculating race of humankind. The fossils were small, yet hugely presumptuous, both greedy and faithless. I lingered before these fossils, filled with a sensation difficult to describe.

One of the halls in the museum had attracted a crowd of locals. It featured a display of human organs and corpses. In the midst of the crowded hall were displays containing conjoined twins, and mummies dried in a standing position, amid assorted organs and brains. In the centre of the hall was a woman's body floating in formaldehyde like a giant fish. Her skin was pale white tinged with yellow and she was wearing black silk gloves and long silk stockings. Even more fascinating were the two objects placed in adjacent bottles besides her, labelled: 'broken hymen' and 'unbroken hymen'.

There are places one should not go and there are things one should not see. The principles are very simple: knowledge and experience come at the cost of innocence and decency. Such ugliness isn't frightening, but such corruption of social morals will make you hopeless.

This exhibition was N Town's most popular in years, attracting thousands of visitors daily, from the silver-haired elderly to young girls and boys. The country in which N Town is located is the world's largest producer of and dealer in cadavers.

Mr M's buildings are stylized and pretentious, and shiny new, but when you look closely, there's just something not quite right about any of it. The problem is, no matter how artfully this new skin is arranged, you can never forget the decrepit body that hides beneath it.

China's cities are striving to dress themselves up, as if they are rushing to attend a lavish masquerade ball. The onlookers are accustomed to jeering and catcalling at spectacle, and just so long as there's spectacle at hand, everyone is energetic. Every participant hopes he or she won't be recognized, but even if they can only hide themselves for just a moment, it will be such great fun. The people are unwilling to spend another moment in pain and humiliation, they would much rather strive for a feverish happiness that might help them overcome their self-loathing and fear of death.

Take leave of N Town, forget that musical fountain, and those films projected on water.

S Village in Beijing
Posted: 30 March 2006
Written: December 2005
Translated by Lee Ambrozy

Outside the city of Beijing lies Suojia Village, a community where many artists reside. They will live there until the day that their dwellings are forcibly demolished, because they were 'not built in conformance to building codes'.[2] Beijing is the capital of C Nation, a place where demolishing row upon row of inferior housing is no big deal at all.

Many other villages surround Beijing, each with countless structures that do not conform to code, and there are more than 10,000 cities in C Nation, each with countless illegal and temporary buildings violating various laws and regulations. But it's possible laws or regulations will never arrive at their doorstep, unless they are in the path of an engineering project that is to be the highlight in someone's political career, or perhaps someone's relative takes a fancy to their land, some

Hong Kong businessman or Taiwanese compatriot wants to invest and develop it, or perhaps they are just unlucky bastards who could get even cold water stuck between their teeth.

For so many years, the primary affairs of state in C Nation have been focused around demolition. The sounds of roofs caving in and walls crumbling are everywhere. Another of its national characteristics is sales, because aside from your house and your land, you can sell resources, mineral rights, factories, banks, enterprises, and equipment. They will sell everything until the floor falls right out from under you. Nothing left to sell? Sell your official post, a professional job title, diplomas ... sell everything that can be sold and even anything that can't.[3]

Looking closely at all of this business, each transaction could be in violation of some law or fail to conform to some regulation. This is because, no matter how poor or how ruined C Nation may become, it will never be empty handed.

Oftentimes the people living in those houses waiting to be demolished are breaking the rules: they have no papers, they wander in groups, and they are unemployed. They surge into the city from the countryside to do those jobs that no one else dares: demolish homes, repair roads, transport goods, sell vegetables, sweep the streets, collect the trash ... We can't say they aren't courageous: they've witnessed coalmine explosions and still send their husbands and children down the shafts, they've seen the dead fish in the river and they still drink the water. One day, as you walk down the street, the oncoming pedestrian traffic will be entirely composed of migrant workers hailing from strange, faraway lands. Their expressions speak of panic, their behaviour is strange, and their manner is coarse. You'll want to avoid them, because no one is willing to face poverty and hopelessness square on; both poverty and hopelessness come from the uncivilized 'other', and are products of injustice and hypocrisy. But we are this 'other'. Of those country kids, all the boys who can stand up straight and can walk properly become gatekeepers or security guards; all the girls with symmetric facial features turn into beauticians or masseuses; and the city dwellers are filled with a sense of gratefulness. But to thank them would be to break the show of unity, and yet observe how the urbanites

are forever beseeching the Buddha, offering incense, seeking divine guidance by drawing lots, and kowtowing. Those country people were born into the cult of fake medicine, charlatan doctors, and fake goods; venomous neighbours and the trafficking of children are common sights for them.

The vast majorities of domiciles in the outlying urban areas of C Nation are either temporary dwellings or were built in violation of regulations. These substandard structures are sustaining the development of C Nation, and they fill in the cracks left by society's development. Hundreds of millions of peasants pour into cities, where they plant themselves and rest their heads in these temporary and nonstandard structures. Where else could they live except in these substandard buildings? These are the places that so many people call home, and the economy of C Nation is resuscitating itself under these circumstances. But with a nod of the head they become illegal, and this is an issue of the legitimacy of the law.

Of these people from poor and remote regions who are surging into cities like moths to the flame, how many have the guarantee of basic labour laws or living standards? Who should take responsibility for this? They are creating value brick by brick; with every doorframe and every rooftop, they simultaneously struggle to maintain their own life necessities and sustain the stable development of the entire society.

If law merely prohibits but does not protect the weak, it loses its impartial significance. Law protects civilian property, and temporary and substandard buildings are also civilian property; civilian property is not classified into the distinguished and the humble. If property is old or decrepit, squalid or miserable, that is because these people only have so much. Who doesn't see the inevitable relationship between the dirt, the chaos and their inferiority to the superwide highways and the luxury shopping plazas? Laws should not only be created to demolish; they should likewise respect personal rights, civilian rights.

There are many misunderstandings in Beijing; for example, art districts should not be filled with circus troupes, and protecting ancient architecture isn't just to improve the scenery, and nor is it to give the city a competitive edge – it is because people need to remember. When we

confront an old city and ancient architecture, we cannot simply discuss the value of cultural merchandising while refusing to face authentic cultural issues. The livability of the city is not a question of its physical appearance; if a city is irrational, inhumane, unsympathetic, and cannot treat others with benevolence, what good is a pretty face? A city is for its inhabitants, multifaceted people with fragmented, petty emotions, and who by right should have the potential to enjoy the use of the city, the potential to communicate and to make demands.

Ideal Cities and Architecture Do Not Exist
Posted: 24 May 2006
Translated by Lee Ambrozy

When we call any building a piece of architecture, it is merely a product, just bearing the weight of certain information. Architecture is not just an issue of architecture; it is also a social issue, and a statement on an era's identity. The shape of a city's architecture shares an important relationship with its cultural status.

In my experience, it seems that over the past decade everyone is moving house. No matter if you live in the countryside or the city, finding a person who hasn't moved house over the past ten years is an oddity. This is similar to postwar situations. Currently, China alone is building at a rate equal to the sum of the entire world's construction, and is consuming one-third of its steel and glass. What brought about such great architectural activity? It's common to see buildings being erected amid the ruins of demolished ones, and even though China currently appears to be one enormous construction zone, no one is contemplating the plight of man or his relationship to architecture, and there are no architects in the real sense of the word. That includes our current state of blindness with regard to urban planning and traffic issues: there is a lack of cultural, aesthetic, and ethical cultivation, and even when logic is employed, it is fragile and weak.

The concept of city that we are discussing now is a place where many people are biding their time together, not a space that could be called a 'city' in any meaningful sense. For instance, we could say that the space in which we hold

a lecture is meaningful because there are seats, people have come of their own free will, and a projector sits in the rear. A city should be a prolific space that cannot be controlled, is free, multilayered, and endowed with various potential; it is a space where we are able to interact, make demands, and develop. Currently, Beijing's residents can be simply divided into those who have a Beijing *hukou* and those who do not, and this reveals its crude and backward state. This city is lacking functional parts, and humankind's essential rights have yet to emerge. Society is in the midst of transition, and the entire city has been thrust into a state of simply frenetic confusion. I don't want to get involved in this madness.

As for those people who hope to seek out the feeling of the countryside in the city, or achieve an urban feel in the countryside, they should be sent directly to the madhouse.

I do not believe that ideal cities or ideal architecture exist; I can only say that meaningful, significant cities do. Put simply, my earliest experience with architecture was when I was eight years old, and we were 'sent down' to Xinjiang; as punishment we were forced to live in an earthen pit. I think that in political circumstances like those, living underground can provide an incredible feeling of security – it was a pit dug right in the ground, in the winter it was warm, and in the summer it was cool. Its walls were linked with America, and its roof and floor were flush, and often enough, when pigs would run overhead, their bottoms would fall through our roof, making us all too familiar with the sight of swine nether regions.

I remember some details: on one occasion, because there was no light in our earthen pit, my father was descending into our home and smashed his head on a roof beam. He fell immediately to the earth on his knees with a bleeding forehead. Because of this, we dug out one shovel's depth of dirt, an equivalent to raising our roof twenty centimetres. Architecture requires common sense, a ton of common sense. Because we were a family of readers, we needed a bookshelf in our home, and my father dug out a hole; in my opinion that was the best bookshelf. These are reasons why I don't believe in ideal architecture.

Cities are also like this, and the most appealing thing about New York is that it was built from mistakes. In its early

stages, Greenwich Village was a hamlet, but after some simple planning the lifestyle was preserved. New York's ruined factories were taken up by artists and have become fashionable districts, and the nearby immigrant communities chose their locations because they had to. Thus the city has become a most interesting place. The most fascinating thing about the city is the different interest groups and people of varying status, all of whom form their respective spheres of influence. This conforms to human nature: it is both rich and mysterious. When we want to see and be seen, we leave our houses, but with the turn of a corner we can disappear, and throw off our pursuers. These needs are similar to the habits of animals. We need to find more freedom than we need in cities.

I have a small firm that began accepting architectural commissions five years ago, and we have designed more than forty buildings to date, roughly equivalent to one finished product each month. Foreign architects can't believe this. However, after I've finished all my remaining architecture work, I don't intend to continue with it. Erecting a few more shoddy buildings doesn't really achieve much. Originally, I had hoped to seek new possibilities through architecture, I had hoped I'd be inspired, but in practice it is actually extremely tiring. Architecture is not a one-man show, it involves the whole of society, touches on various different realms, and leads one into endless frustration. In addition to that, I'm the kind of person who will create endless obstacles with every detail. I'm already forty-nine years old, and even though I really don't want to do 'ordinary' things, I can't be so frenetic everyday. Obviously, this is some kind of sickness.

There's a saying going around that 'China has become an experimental playground for foreign architects.' This couldn't be farther from the truth. Chinese people like to hear a certain saying and then base all their opinions on it. Every year China breaks ground on many new projects, and non-native architects participate in only the extreme few. In most cases non-natives who win a competitive bid watch as the Chinese complete the project to their standards and then hang a foreign name on the finished building. Outsiders bring in a different system, but because we are so comfortable in the preexisting system, the 'other' system will never truly exist

here. Koolhaas and Herzog & de Meuron have multiple pro-
posals in China, but none of them are realizable. The China
Central Television tower and the 'Bird's Nest' are outliers –
thanks to the new planning offices of Beijing, and a young
generation that has been properly trained. These two pro-
posals were rare engineering projects for China, the oppor-
tunity for non-native architects to compete before a panel of
judges. But in reality, aside from commercial architects who
meet the most common technical requirements, there are
only a handful of projects that reflect non-Chinese design or
ambitions. To say 'China has become the experimental play-
ground for foreign architects' is bullshit; the experimental
architecture in most Western cities exceeds that of the whole
of China over these years, including many years to come.

Before Herzog & de Meuron (the firm responsible
for the 'Bird's Nest') sent their bid in to the competition,
I recommended that they take on a Chinese partner, and
they asked if I was willing to participate in the project
design. I'm willing to engage in anything unfamiliar
to me, and of course I didn't consider in what way it
was related to the Olympics. When I agreed to join, the
preparatory work was already completed, and the time had
come to make a decision. I simply asked, 'What do you
need me for?' They told me they needed my opinion.

Owing to my participation, the results of their
previous discussions were altered dramatically, including
the basic concept, shape, construction, issues of structure,
and function of the stadium, including the exterior form and
cultural characteristics. We connected on many aspects,
and because we thought the possibility that the proposal
would be accepted was rather small, bravely absorbed
unfamiliar methods. In the end, the project was successful.
Before I came home, they told me that they had originally
hoped to take a step forward, but ended up taking two.

Herzog & de Meuron like to create things that have
uniform characteristics when viewed from different loca-
tions but that are also irregular. However, they are incred-
ibly self-aware architects, and they know that formalist meth-
ods are something to be avoided. The 'Bird's Nest' is an inte-
gral structure from inside out; its exterior form is a structural

support. This form is actually the result of a rational analysis; only later was it misinterpreted as the shape of a bird's nest.

There is increasing discussion on urban issues, but the concept of 'city' increasingly resembles a cosmic mystery. Neither pure urban science nor architectural sciences exist, and effective discussions on these matters must include other materials and scientific realms, touching on politics and sociology. Concrete analysis can achieve positive results, and could be as minute as individual case analysis, but Chinese research organizations and academic institutions are unique the world over in that they do not conduct such research. Of course, research is admittedly important, but the prerequisite to any scientific method is that we are able to confront reality, and humanity has yet to discover a path nobler than the pursuit of truth. We must bear the burden of the simple truth, for it is the foundation in shaping new viewpoints.

An uproar is raging over the issue of preserving ancient architecture. On one hand, this is a reaction to the ruthless development, and on the other, it is the need to create an urban identity that any competitive city must put forward, least of all to attract economic growth. When most people bring up the issue of tradition, they have not declared exactly what culture we are protecting – what is tradition? China's understanding of culture has stalled at what is currently a very superficial level. It's a question of simple benefits, which cannot have any benefits for the protection of Chinese culture, and thus the 'altering' of ancient architecture is not much better than its 'destruction'.

On the notion of architecture, I believe the first thing to consider is that everyone should confront the reality of the here and now: Why are you here, what surrounds you, what happened in the past, and what will happen in the future? If these questions are not clarified, no judgement can be clear. For instance, if you want to buy a car, you should have a basic reason: Will you use it to take your child to school, or to travel somewhere for pleasure? But if everyone's motivation were merely to conform to the logic of others, what kind of society would this be?

Different Worlds, Different Dreams
Posted: 5 September 2006
Translated by Eric Abrahamsen

Once a month I return to my home in central Beijing. It is a small courtyard inside the Second Ring Road, that kind built of grey brick, having three rooms in the north and a few side rooms. All together the buildings and yard occupy about one *mu*.[4] The Chinese pagoda tree in the yard is already as thick as my calf, and there is a magnolia tree which flowers every year. Before his death my father's vision had begun to fail, and I would often see him counting its buds, over and over. Even in the most tumultuous times, flocks of pigeons still fly overhead. No matter how chaotic the outside world becomes, a return to this yard always finds it quiet and ablaze with light.

Today I went home, the taxi turned into our alley, and our gate is on the north side of the alley only a hundred metres from its west entrance. The courtyard is in one of Beijing's few remaining cultural protection zones, in the city's eastern district, so there are no tall office buildings in the vicinity. Even though a half-century of property rights disputes have left Beijing's buildings and neighbourhoods poorly preserved and ill-maintained, even decrepit like weak old men, they still retain a sense of composed calm. However, the scene unfolding before me today was unimaginable. The unthinkable had happened – I couldn't even distinguish my own front door. The entire alley had been covered in a coat of paint that shone with an artificial, cold grey-blue light; every dilapidated old door had been painted bright red; and no repairs had been made whatsoever. It was as if every resident on the street had been issued an identical hat and identical clothes, regardless of whether they were male or female, old or young, fat or thin.

Our courtyard home was rebuilt in the early 1990s, with grey bricks and a red door. The craftsmanship was coarse but solid, and inexpensive. In the space of one night, ours and every home on every alley here met with the same fate: a giant hand had come down and had plastered everything with concrete, eliminating all traces of history and memory at the same time.

Atop a layer of concrete was a coat of dark grey paint, and bogus brick outlines were cut into it. Private property has been altered beyond all recognition by this single crude and

absurd decree. The place we call home suddenly lost all the personal characteristics of 'home', and was stripped of its sense of security, privacy, and identity. They say that along with the rest of Beijing, all the alleyways in the city's eastern district will get this treatment, but the day that happens, this ancient city will vanish completely. Using taxpayers' money to erase the entire city, with no regard to green or red, black or white, they've tried to accomplish several goals in one blow. Their intentions are laughable, their methods crude, their attitude despicable; it's almost impossible to believe.

This is Beijing in 2006, only two years before the Olympics. This capital, becoming more international by the day, is revealing the true meaning of the Olympic slogan to the world: 'New Beijing, New Olympics'. Or 'One World, One Dream'. Not long ago, a newspaper reported that, based on the results of research by a group of experts, grey has been designated as Beijing's basic colour, and the entire city is to be renovated accordingly. Who would have guessed that, after the renovation, people would be unable to recognize their own homes? The whole city is like a poorly assembled and cheap stage where all the people passing through it – men, women, the young, and the old – were nothing more than props, all part of an unsightly performance on culture, history, and political achievements. Once again, the rights of the common people, humanity, their emotions and sense of self-determination have been taken from them, after a thousand such brutalities. Truly perplexing is why this society, lacking in both honour and integrity, is so fond of painting and powdering its own face.

Various remodelling projects continue in the city's alleyways. In the alleyway opposite us, more than ten families live in courtyards crammed to bursting point, but such conditions have gone unchecked and unimproved for years: plumbing and running water is a mess; pipes are cracked, electric wires are in a tangle; right at the very spot where their doorway opens on to the street, someone is building the kind of moon gate you might see in an imperial garden. Everyone has become accustomed to this kind of absurd reasoning; no one inquires, no one questions, and hardly anyone even pays attention to what's happening.

There have been three major makeovers to Beijing's alleyways that I can remember. The first was for Nixon's China visit, when residents discovered that in the space of one night, their walls had all been painted. At that time they used a grey whitewash with a colour similar to the bricks. The second time was for President Clinton's visit, when workers used paint rollers to transform the entire city into a sort of medium grey colour. Clinton probably never even noticed. All they can do in this 'land of etiquette and ceremony' is paint the walls, again and again.[5]

Times change, and we should already be living in a rational era. I so rarely return to my central Beijing home, and then, one day, the elderly in my home wake up to find that their homes have taken on a completely new look, a thick layer of cement has flattened the brick walls.

The alleged 'preservation of Beijing's old city' actually means plastering over the walls with cement and then redrawing the outlines of bricks, irrespective of the buildings' age, history, or ownership, whether they are of private or public ownership, ancient or modern. A brand-new fake city – a fake world – has been created. In a city like this, how can we even begin to talk about culture? What 'spirit of civilization' is there to speak of? This is a brutal, incompetent, and coarse society, heartless to the point of lunacy, and, according to the workers, it's not over yet: doors and windows have yet to be renovated.

The plans are already in place. Over the past few decades, which of these 'renovations' haven't been destructive?

Prior to the 2008 Olympics, as Beijing is undergoing a total urban-planning upheaval, how many more opportunities will remain to protect this ancient city? How many more opportunities will the people of the world have to come to Beijing and see a fake, unnatural city?

Spare the homes of the common people; if you can't help them, then leave them some peace. Keep your distance from them, and please do not try to speak for them; let them quietly, silently pass away. Continue the corruption of large-scale projects, of the banks and the state-owned industries, but don't paint the faces of the common people. This nation,

our home, has been whitewashed so many times, we can't even recognize our own faces, or perhaps we simply never had a face at all.

Documenting the Unfamiliar Self and the Non-self: Rong Rong & inri
Posted: 15 November 2006
Translated partly by Philip Tinari

There are many cats here. All of them are Dami's offspring.

You can find many cats on the outskirts of Beijing; this city is like Rome, it is sprinkled with ruins. Cats don't abandon ruins – or we could put it another way and say that ruins were designed for cats. This is also a reason for cats and humans to be together, for any place with humans will have ruins. The disposition and home of anyone who keeps cats will always have a ruined quality to it. Cats may suddenly disappear, but humans cannot simply abandon cats, who just move from one pile of remains to another. Cats are self-aware and proud, and being lost and then found is instinctual to them. This is a cat's world, but they don't mind sharing it with us. Each time a cat changes its location, this adds to its melancholy. Cats have been melancholy throughout the ages.

The photography in this volume represents a portion of Rong Rong & inri's works spanning the eight years between 1994 and 2002. These works document their life, activities, gatherings, cats, love, and lastly, the destruction of their small courtyard in Beijing's Chaoyang district, the location where all these activities transpired.

Rong Rong took most of the black-and-white photos. He's never had much affinity for colour. In Rong Rong's two-dimensional world, black-and-white is a manifestation of the outside world, the only possible relation with the world. Monochrome is one of the basic characteristics of his works, whereas inri's world is full of colours.

Throughout the short duration of the Beijing East Village, Rong Rong recorded life and death in this artist's colony. That was a distorted and transformational era when artists struggled and expressed themselves here. Most of their perspectives were very different from those of the majority of people. Such was the case with Rong Rong, who was an inseparable part of the East Village's reality.

Those photographs became rare documentation of Chinese contemporary art; they became a segment of the physical reality that was the East Village.

At that time, Rong Rong's works were not considered art; instead, they were part of the hazy everyday life in the East Village, a lifestyle outside of life, another kind of action. They were a record of the ceremonial works of friends and of the artists that gathered there; they were a part of that gloomy period. Popular ideology looked on modern art as a scourge, a conspiracy that would allow the Western world to destabilize China. In such a confined era, the activities of artists seemed even more like underground exploits – they were hunted and dispersed, and they faced a reality that included arrest and jail. Among all the Chinese artworks from this period, the East Village was the sole place preserving relatively integral visual forms, and these were inseparable from Rong Rong's activities.

Activities in the East Village represented the first juncture where Chinese contemporary art became self-consciously and soberly concerned with the indigenous state of affairs, addressed the actual relationship between art and reality, focused on the character of artists themselves, and engendered experimentation with the artists' own bodies. In regard to the declarative, enlightening activities of performance or action art, it was entirely native, the beginning of a new here-and-now awareness and thought. It produced a group of enlightened beings, Ma Liuming, Zhu Ming, Zhang Huan, Zuzhou, Zhu Fadong, Cang Xin, and Rong Rong among them. It's just as hard to believe that the underground publications of this now world-renowned East Village – the *Black, White, and Grey Cover Books* – would rise to such a prominent position.[6] In truth, the actual life of this village lasted only a little over a year. I remember artists discussing their works and the possibilities for their implementation in the 13th courtyard; these conversations included how to hide out, to conceal oneself, or prepare to flee.

If photography can be considered art, then it must necessarily be a scattering of art's inherent qualities, an innocent pressing of the shutter, a lie in the face of reality. In that moment of recording, the world that it faces dissolves like smoke. Anything realistic that remains becomes a reliable lie.

Photography appears to be the most unreliable media of all; it's so intimate with life, yet the furthest manifestation of it. It forces us to believe, tempts us to re-envision and create a world that can never exist. It seems to be the most authentic, with what we call a vision and reasonable logic of its own; it tells us what the world is like now and what it was like in the past. We all willingly believe that our memories require evidence, and such a piece of evidence is the path to our next actions; or perhaps it is a trap, or an obstacle.

In their works from this period, Rong Rong and inri were most concerned with their personal lives, each tiny detail, even if nothing was happening. Life was just so, and the days just passed one by one. In this period, their photography entered a unique stage as they began to pay more attention to the shooting process itself. A brand-new world evolved, as if it were springing from an inexhaustible pool of the introspective, the inner self. Such was the state of gratuitous aimlessness, simultaneity, disorder, and chaos that gave rise to those endless stories and indescribable emotions, all those things we can't make sense of in life – a personal world, behind a closed wooden door, in a place that no one knows.

It is always possible for a person to enter himself or herself, to look deeply inside where the soul is like a barren wasteland. Desolate places and self-exile are among the most common of life's territories; they are the most familiar path to violence, and the most direct result of violence.

Ruins are proof of systems and civilizations that once flourished. Eternal ruins are lifeless pieces of deserted land, places with no potential, bereft of all confidence and goodwill, hopes or expectations. They are places that seek to be forgotten and provide evidence of the violence that once transpired upon them. We live in a similar age of deserted ruins; by celebrating the ruins, we point our fingers at them and declare ourselves a part of them. These ruins existed long before we even became ourselves; our existence only proves the power of their eternity.

Ruins, uncultivated ground, and the savage power that runs contrary to civilization prove the undeniable truth of death; they prove the enormous dark shadows and the unlimited possibility of large-scale destruction.

Caught in the undercurrents of a painful era, we must die a hundred times, a thousand times, ten thousand times. With our deaths we take with us a sinful era, an era of atrocity and with no humanity. Each time we behold these ruins, a feeling of joy burns through us, through our world, the entire world.

Powerful art is like a powerful government, but facing personal choices, they are equally weak and will both fall at the first blow. We live in a time where black and white are reversed, in the utter absence of right and wrong, a time with neither history nor a future, where one is ashamed of one's own shadow and embarrassed by one's own face, and an era where our greatest efforts are poured into concealing reality and truth. It is an age where our greatest, most diligent efforts go into camouflaging reality, an age that gradually fades from our personal files, from the details of our existence, from our most vague emotions. Like snow melting in the sunlight, these details can only be dim and shadowy memories, and they will be replaced by the daily joys and irritations of fresh lives.

Rong Rong was born in a village outside Quanzhou, in Fujian province, in 1968. His real name is Lu Zhirong. In 1992, he came to Beijing to study photography, and we met shortly after that. Rong Rong and other artists lived in the East Village for more than a year before they were forced to move; the police then were endlessly hassling and purging Beijing's artist communities; there was a period when the plight of Beijing's artists was something akin to distressed mice scurrying across a street.

inri's full name is Inri Suzuki, and she and Rong Rong got together in 2000. She has a calm, elegant, naive energy, and eyes with a clear and tough glitter. This is a contrast to Rong Rong's effeminate, bashful introversion. The aura of a Japanese female like her is rarely seen in China.

Dami, which means 'Big Kitty', is their cat. I recall that after she gave birth to nearly eighty kittens, after she was spayed, she mysteriously gave birth to another litter. In some way, cats prove the stupidity and impotence of humans. Everyone worships Dami and talks about her; she has witnessed everything that has happened to Rong Rong over the years, she remembers the courtyard where Rong Rong

lived for eight years, its demolition, and she is just as familiar with Rong Rong's new home. But how she sees all of this will always remain a mystery.

1. 'N Town' is the city of Ningbo in Zhejiang Province, which houses multiple projects by the architect Ma Qingyun (b. 1965), including the Tianyi City Plaza, Zhejiang University Library, Ningbo Urban Museum, and the retail complex, Ningbo CCD.

2. Suojia Village, or *Suojiacun*, is an artists' compound on the north-east corner of Beijing's brick loft-style studios over roughly nine acres of land. In late 2005, bulldozers appeared and proceeded to demolish the first row of studios. The artists protested, and although *Suojiacun* was still standing at the time of writing, its fate is unclear.

3. The sale of official posts, university diplomas, etc., is a widespread phenomenon in China, and is not necessarily new. The classical Chinese term *juanguan* refers specifically to government positions that were obtained through large 'tax donations', a practice recorded as early as the Qin Dynasty, and which flourished in the Qing Dynasty.

4. One Chinese *mu* is roughly equivalent to a sixth of an acre.

5. The classical saying, 'land of etiquette and ceremony' (*liyi zhi bang*), refers to China, a country that traditionally pays special attention to ceremonies and etiquette.

6. The *Black*, *White*, and *Grey Cover Books* (*Heipi shu, Baipi shu, Huipi shu*) are a series of underground publications edited by Ai Weiwei and curator/critic Feng Boyi (b. 1960) in the mid-1990s that documented artists' activities in China and introduced overseas international art to the mainland. Highly influential in their time, the books have been called manifestos of the Chinese avant-garde and have acquired something of a cult following. The English translation, 'Cover Book', renders the Chinese title in its most literal form, though a more accurate translation would reflect the intended political pun. The 'White Papers' (*bai pishu*) of the Chinese government are official documents that have represented the 'official point of view' on matters from development to foreign policy since 1949.

All posts from Ai Weiwei's blog were edited by Lee Ambrozy and published in *Ai Weiwei's Blog: Writings, Interviews, and Digital Rants, 2006–2009* by MIT Press in 2011.

FRAGMENTS, VOIDS, SECTIONS, AND RINGS

Adrian Blackwell and Pei Zhao

AB: There are two things we are interested in with your urban work. The first concerns your thoughts about the contemporary city: what's happening right now with Chinese urbanization? The second is the approach you take in your own urban interventions. I thought we could begin by talking about some of your recent projects. You started making art in the late 1970s, architecture in the late 1990s, and then quite recently, just a few years ago, you began to making works that are about urban space, documents of your city. I know of four of them: the Beijing video map, the void photographs, the Chang'an Boulevard project and the Ring Road project. They are each fascinating ways of reading Beijing. What made you start making work like that, what made you start documenting the city?

AWW: It's not exactly documenting. It has that function, but it has no documentary purpose. It's not being used as evidence or testimony for anything, but rather to materialize our physical life, its condition in the moment. If you are in place A or on line A or line B,

then that present there or that movement is simply as it is. We're living in a constantly changing world and everybody sees it and knows it, but as an artist who is also involved in issues of design and urban planning, I always try to find a way to most efficiently capture what I call fragments, or very small pieces which carry the flavour or carry the essential meaning of the city. So it's a very small effort that I have made, even if it looks quite massive in terms of the length of the videos, it's just one section of a fact – the concrete world.

AB: So maybe we could talk briefly about each of those pieces. Let's start with the first piece, the video which follows every street in Beijing within the Fourth Ring Road. It's about the street network and it makes me think of Zhu Jianfei's book *Chinese Spatial Strategies*. He talks about the public space of the city of Beijing, arguing that in a Western city you have squares, public space is organized around openings in the fabric, while in the Chinese city (his example is Ming and Qing Dynasty Beijing) public

space is in the street, so the public space is not a void, but a network of space, and the active spaces are simply nodes, or widenings in that network. One of the things that I like about this project is that it is an attempt to map this entire network using video, but it also conflates the map and its opposite, which is the experience of simply being lost in the city. What were you thinking about with this network of every street in Beijing?

AWW: I think that a city is a three-dimensional or multi-dimensional thing, but the work itself is not even two-dimensional, it's just one point to another, to another, to another. So of course in time this weaves a net if you are thinking of the road you have been travelling along or if you join the individual points. It covers the whole city, all the hutongs and streets, but actually it is made at one time, at a moment. Still it follows a line, a line made by a vehicle which has more than a dozen people on it, and from day one to day sixteen it passes through different parts of the city. So it appears to be a complete view of Beijing, but if you look at any point, it's just dots, because there is no camera movement except the movement of the car. Very little changes, but the attitude or position that drives it is not passive – it's fixed through a very concrete concept.

So I think it's quite ironic in that sense: after 150 hours it documents the city, but nobody would watch 150 hours and at any moment you see, you are confined to a single point, or proportionally stretched points form a very short time within this big work. It only works when it is so long, more than six days and nights. It shows how big, how impossible, how crazy this city is, or how meaningless at the same time, because our proportion, our sense of time, and also our visual contact with the city is really limited by where we are and which direction we go. The moment is about a certain period of time, so when you just look at one moment you don't really know what is before or what is next, even if you can pretty much guess.

AB: With the void photographs you are documenting a moment where there is nothing. If you think about Chinese cities as constantly being torn down and rebuilt, then this is a moment of quiet in between. It seems that this is a moment of potential, but I don't know if you are that optimistic about this possibility all the time. What made you take those photographs?

AWW: I think that's a special landscape in today's China, you are the largest construction site in the world and each year Beijing has 100 million square metres of construction which exactly equals the area of the whole city in 1949. Every year you have this total amount of construction, but you only

Provisional Landscapes, 2002–2008
C-prints, various dimensions

Chang'an Boulevard, 2004
Video
1 hour 50 min

finish a third of it, thirty million square metres. You know these are just numbers, but they really tell you something about the urban condition, especially when you see that China builds twenty times the area built in Beijing. The whole country is building crazily. So you have a kind of landscape that destroys the old, because the old is really garbage I think. It's really shelter in its worst condition, like Harlem. We used to say that Harlem was 100 times better than most ordinary people's houses. Then after you destroy, you make it flat – we call this *san tong yi ping* [three infrastructural connections and one levelling].

PZ: By now it's *jiu tong yi ping* [nine connections and one levelling].

AWW: Then all this land will be rebuilt by powerful people, developers. Most of them are connected to the government. They make big profits from land, which is not constitutional. After 1949, land was taken from the landlords. They killed the landlords,

and the land was given to the people, under the control of the state. Now all the land is being auctioned to people in favour or associated with the state, who are profiting from their privileged background. So you have a landscape that is just waiting for this future. Even if it's totally empty, it will soon be built. Soon it will change the whole landscape of Beijing and of China.

It's a very sad condition: you see a nation or a city rip up the past, not to benefit the people, or the situation, but for profit – it's really the idea of all those new rich. It's like a country girl has to be a prostitute, because there is no other way to get out of the village. China's development is so much based in this idea: to let somebody ruthlessly become rich, but they can't become rich unless the party and government also profits, otherwise it's impossible. So who has become rich? Who has become more powerful? Who benefits and who is losing their rights, or their property? This property belongs to

everybody, it belongs to somebody who never sees this property, because you know we are a communist country and this, of course, for the past ten to twenty years has been a hidden secret (I mean nobody talks about it). It's stealing. I am not criticizing, these are only the facts. I record the condition after things are torn down and before they are built up; you know, it's a very short moment, but in that moment nobody wants to look. There's a question mark there, a big, big void. The old is so sad, but the new is also sad. It is a very sad condition, so I think it's interesting to record it. It's a unique situation, a void with many questions, yet people don't want to look, or raise these questions.

AB: If the void project looks at empty moments inside the city, the *Chang'an Boulevard* project moves in a straight line from outside through the city. It's a section. You were interested in the movement from rural space through urban space and back to the rural. How do you see that piece describing the contemporary city?

AWW: I think that surprisingly enough when I started to make it, I did not know what it would be. It's not based on very sophisticated thinking, more

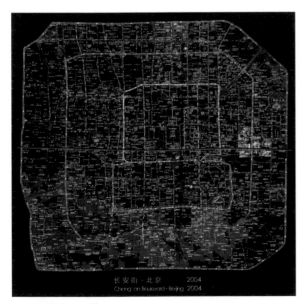

Chang'an Boulevard, 2004
Map of travel route

on an attitude than on careful planning. It started when one of our friends said they had a son who wanted to come to Beijing, but had nothing to do. After he arrived I asked him if he could do this for a while. Then after days of planning what he should do, I found that Chang'an from the Sixth Ring Road to the Sixth Ring Road is 45 kilometres. So I made a very simple decision: just take one video shot for one minute every fifty metres. No technical requirements: push down, count one minute, turn it off, move another fifty metres, push down … Whatever happens in front of the lens is fine. It took months, the whole winter, because in the winter there is no better or worse view. I think in Beijing the winter really reflects northern landscape very well. You know there is a kind of sadness there. So after months he had taken thousands of shots: from a very rural, primitive village, to the business district, to the political centre, to an old town and later on ended up in the Capital Iron Company, which has just been destroyed and moved to another city township. This video was the last possible time to take these shots of the Capital Iron Company, a symbol of socialist industry. They made all the iron for the nation.

AB: When you look at maps of the growth of Beijing from 1949 to the present it is amazing to watch *Chang'an Boulevard*, it draws the city out, away from the old city. So much of the growth of the city is along that line that it is much longer than the rest of the city. The last work that I know about that deals with the city is your Ring Road project.

AWW: I made two pieces, one about the Second Ring and the other about the Third Ring. The video of the Second Ring is structured through the thirty-three bridges, taking one-minute shots on each side of the bridge. So standing there you see the car traffic moving from overhead. Then I did the Third Ring, fifty-some bridges and the same thing, the only difference is that Second Ring is taken on cloudy days (in Beijing most days are like that), while the Third Ring is taken on sunny days. If you look at it,

Provisional Landscapes, 2002–2008
C-print

immediately you know that one's Second Ring and one is Third Ring. One is just grey colour, and sometimes snowing. It's very boring and not an exciting thing to do, but nevertheless it records the condition at the time, it's very much like a witness passing through: what he would see, his eye, anybody's eye. There is no artistic or aesthetic value, not much judgement there. It's a very, very simple situation; it's very much like a monitor, actually.

AB: We have talked a little bit about these works you have done about the city. But the other thing I am interested in is the way you live in the city. You live in a village; you don't really live in the city.

AWW: Well this city, Beijing, surprisingly enough is not a real city. I cannot call it a city, it's still very flat, not dense enough, not strong enough, it doesn't have enough variation and mixed conditions, it's still very even.

Today I live in Beijing. I was also born in Beijing, but soon after we moved to Xinjiang and I grew up there. My father owned a courtyard in Beijing, but for years other people lived in it, because our family was considered an enemy of the people, an enemy of the state, and an enemy of the party. Three enemies. Being just one of them was enough to be exiled.

Then after twenty years away we returned and lived in different parts of the city. We borrowed places, because our home was inhabited by other people. We lived in different places: west, north, east or south, so I have a very clear image of what the city looked like. At the time the city was occupied by bureaucratic compounds: universities (of course, at that time they were not open), government, military and so-called scientific research institutes. All these different departments were all under the same conditions, communist, without private property, everyone belonging to the work unit. So there was only one condition: you were either one of the people or an 'enemy of the people'. So simple. I guess there weren't so many 'enemies of the people', but from time to time that vein was very consciously mined. They were trying to find out who was an enemy of the people for years while I was growing up. It was one political movement after another after another. It was crazy every day. Today you talk about it and it sounds more like a joke: 'What a joke, why are you still talking about things like this?' But this was true: many people lost their lives. I think that that ghost is still haunting China today. Not the communist ideology, the ideology may be good, but the way that this power is maintained within society and how brutal the state can be towards a human's basic condition, not to talk about human rights, but essential needs.

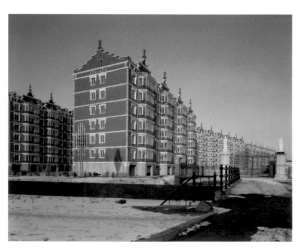

Provisional Landscapes, 2002–2008
C-print

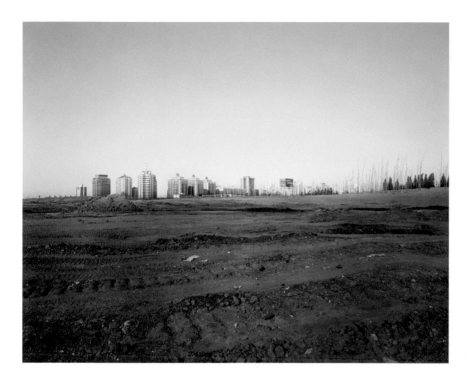

Provisional Landscapes, 2002–2008
C-print</superscript>

So that is basically what this city was and half of the city is still based in this and the other half is the so-called new rich, after Deng Xiaoping's getting rich first policy. Of course, who is going to get rich? It's not the ordinary person. But this is not a complaint, it's simply the truth. You know in China, you still talk about people who have the right to live in the city or not to live in the city. It's called *hukou*, dividing people into locals, non-locals.

PZ: You need a licence, or special registration to live in the city. Throughout the entire world only North Korea and China have a policy like this one.

AWW: Locals don't have many rights, besides the privilege of enrolling in school, but in the newspaper they often talk about the crimes caused by non-locals. There is a crazy amount of discrimination against people who are not local. A small example of this is that the city has laws against illegal structures like this one (Ai Weiwei's Studio-House). Think about it this way: the city is built solely by migrants from the outside, but none of them are

locals except the boss and where are they going to live? Nobody provides any space for them. Of course, they gather at the outskirts of the city …

PZ: And in the village in the city …

AWW: Just to build a place that they can stay, whether it's legal or not.

AB: But this village, Caochangdi, is it a village that pre-dates the city, or is it a village like you are talking about now, a village that is built illegally? Most people that live here appear to be migrants, but did they build this village, or did they inhabit an existing one?

AWW: In the 1960s this was a so-called 'China Albania Friendship Farmer's Village'. These were very privileged farmers, who were supposed to provide an example for the country, growing vegetables for the city. So when university or high-school students graduated, and Chairman Mao sent them to be re-educated on a farm, they would send some

people here. At that time people working here found much better conditions than you would find in more distant areas. At least on the weekend they could ride their bicycle home. These were example farmers, so it was a good farm.

Recently I heard that it is no longer a village and the former farmers are buying out their *hukou* to become citizens, instead of farmers. The real reason this is happening is so that the land can be returned to the government, because if you are a farmer no one can take your land. Of course, there is real benefit for these new citizens, they have some new citizens' rights, but at the same time the land is returned to the state, so that it can sell the land to anybody it wants to. There are a lot of tricks and games, but it is really so simple: the state is the only beneficiary. But in a state, like China, which is not a democratic society, far from it, nobody argues about this, the press won't talk about it, intellectuals never discuss it. Probably I am the only crazy guy who always talks about it. But they think: 'This shit guy, why is he always talking about this?'

So what kind of city is this? I can't see a city without citizens. It's like you don't see a religion without followers. Nobody can decide how the city is going to be; everything is done through governmental decisions: today we need a road here, tomorrow ... It's by very simple decisions from the top. If Sanlitun [a Beijing bar street] becomes nice they say: 'Oh, let's change it, we'll plan big buildings so that someone can profit from it, not all you street vendors.' It's crazy: whenever they see people benefit, they will grab the profit. It's so simple, they change here or there not, as they say, to make the city better. The city is already better when they do nothing, take 798 [a contemporary arts district, in a former model industrial work unit] as an example, but once they see this they always take action.

So that's my understanding of this city. I really have no relationship with it, except when journalists come

to visit me. Otherwise I just go to one restaurant, which I designed (called Where to Go?). A lot of friends go as well, so we have a place to meet and eat dinner, and then I come back here.

AB: This is a courtyard house, and it seems to me that the kind of city you are talking about when you say you live here and in your restaurant has very few elements; it's not so much about the city space in between. I am interested in that because a lot of people, for instance New Urbanists in North America, might say you make a good city by making lively streets, by concentrating energy on the public space of the city. I don't know if it is the way you would like to make a city, but the way you live is different from that, it's much more about autonomy, creating a separate space through the compound, but still finding forms of community. The restaurant, for instance, is a kind of public space, which can't be here in Caochangdi; it's better that it's in the city, because people can get to it more easily. I am wondering if you are interested in making a city that starts from the way you live in it, which I think is quite different from the way many others think a city should work.

AWW: Of course, most European cities are based in convenience and efficiency. But it's not necessary to me that these functional requirements are supported, what is more important is the use. You need a real variety of intention and purpose: people who are doing things that you would never think about. So you know that's important. I think a city can be very brutal and lacking in qualities of life, because these are not desired, but without many different purposes, the city loses its initial reason for becoming a city.

Many places, like this city, have vast areas without use. It is so strange, these spaces are not for individuals; they're for a special group that has no meaning. This group gives the city no meaning; it's a negative force, working against other people.

AB: Maybe we could finish with a question about the different processes you use in making art. I'll list some of the different techniques, or tactics, that you use. I am interested in how you might see them applying to your design thinking and its relationship to processes of urbanization.

The first is the notion of *detournement*, this situationist idea of diverting the meaning of existing artefacts, taking found things and altering them slightly to change their purpose. You've used this technique in architecture, in the projects you did at Beijing's SOHO housing development, the silo and the upside-down house, and in the project we're sitting in – your own studio. Even though it's not a found object, it looks like one. You use ordinary typologies and vernacular forms and slightly modify them.

The second involves letting things go, you just drop a Han Dynasty vase on the ground. You let it go to see what happens. I think this works like the video pieces as well: you set up a process to see what ensues. But then there is another tactic you use: an overt 'fuck you!' working very strongly against authority, centrality ...

AWW: ... order and the state, establishment ...

AB: And I guess the final one, which is in some ways the opposite of the last one, is that you use the power of developed knowledge, a general intellect, vernacular techniques, you have a deep respect for the way people do and make things. So I am wondering how you see these tactics in relation to the city. Can you see your practice of making urban space in relation to these same techniques?

AWW: I think we are in a very special moment, as Chinese people, but also internationally. We have gone from the cold war, an unjust society, towards so-called globalization, or a stronger capitalist society, or an information age. Everything happened with a purpose leaving us with unknown conditions. I don't think humans can ever really control this, and it has become even less controllable. Circumstances are now much more complicated than we can predict. For example until quite recently there was no China or India and now suddenly they are the factories of the world. But people are still trying to figure out what this means in relation to ideology, social and political structure, and all kinds of other problems, like education and the environment. I don't think there is a single reaction, at least for myself, that can answer these questions, or put me at peace. So I constantly think about the condition of being lost. Once you're lost, you try to figure out where to go. Imagine you're in the middle of a train station and you try to understand the much larger, much more complicated, space around you, or the travel you are embarking on.

The whole thing is crazy. I am not very clear about what I am doing. If I have a character, I don't have much purpose in my life, but more of a natural flow. The only fact is that I am still alive. I'm here. This is solid now, but even this might change. I can't figure out what is going on. Really, that's true. Honestly, I don't have a clear answer for this. The clearest answers look ridiculous to me.

This interview originally appeared on the blog *Archinect* in 2006.

BEIJING 2003
CHANG'AN BOULEVARD
BEIJING: SECOND RING
BEIJING: THIRD RING

DURATION WITHIN TIME (EXCERPT)
Charles Merewether

In October 2003, Ai Weiwei mounted a video camera in the front seat of a van with a driver, Wu, and two assistants, Liang Ye and Yang Zhichao. For sixteen days they drove along every road within the Fourth Ring Road of Beijing. Beginning at the Dabeiyao Highway interchange, they travelled 2,400 kilometres, ending where they began. The result was some 150 hours of video (*Beijing 2003*), and 1,719 images or video-stills, taken every five minutes, which were printed together as a book entitled *Beijing 10/2003*, in the dimensions of a single brick (11.1 x 24.3 x 5.9 cm). Accompanied by a text in English and Chinese, it concludes with sixteen maps, each of which corresponds to one of the sixteen days' timing, and a brief matter-of-fact account of the process and the following description:

> Beijing: Capital of The People's Republic of China. Political and cultural centre. Located at latitude 39.56°N and longitude 116.20°E. Total area of 16,808 square kilometres. Population approximately 11 million people.

In describing the subsequently produced video, *Beijing 2003*, Ai Weiwei makes clear that its conception and structure was not to document the city but rather to 'materialize our physical life, its condition in the moment ... I always try to find a way to most efficiently capture what I call fragments, or very small pieces which carry the flavour or carry the essential meaning of the city ... it's just one section of a fact – the concrete world'.[1] So often in earlier work, Ai Weiwei's deadpan approach diminishes the idea of authorial intent in order to suggest a lack of subjectivity, emphasizing rather the sheer, brute, factualness of the subject. As he writes in the book: 'The sum of the entire process became the meaning of the work.'

 This project follows the beginning of an extensive series of photographs entitled *Provisional Landscapes* (2002–2008), showing locations

1. Adrian Blackwell and Pei Zhao, 'Ai Weiwei: Fragments, Voids, Sections and Rings', *Archinect* (blog), 2006, http://http://archinect.com/features/article/47035/ai-weiwei-fragments-voids-sections-and-rings, accessed 9 October 2013.

Stills from <u>Beijing 2003</u>,
2003
Video

Still from <u>Chang'an Boulevard</u>
2004
Video
10 hour 13 min

within the city that have been razed to the ground: a levelling of whatever was there, prior to what will be there. Nothing is left except the industrial machinery and barren landscape. In one instance, a photograph shows a building from a certain perspective within the landscape; in the next, without moving the point of view from where the photograph was taken, all will have changed. Whatever material history there was disappears between the two photographic instants; whatever memory one had is erased. What was it that was there, one asks? The landscape becomes a site, a provisional space in-between. Existing between past and future, this space is a void both physically and as the motionless time of the present, as Ai Weiwei observes:

> A void because no one speaks, no one asks the question of who is behind it, how is it that in a communist country when the people supposedly own the land they have no rights over it: it's a very short moment, but in that moment nobody wants to look. There's a question mark there, a big, big void. The old is so sad, but the new is also sad. It's a unique situation, a void with many questions, yet people don't want to look, or raise these questions.[2]

While Ai Weiwei has always had a camera close by, it is not until recently that photography and video have assumed a significant role in his oeuvre. What unites this work with other earlier work is the concept of duration: from that of a material object in which historical time is embedded to the possibility of opening up and distending the moment through duration. In such terms, the *Provisional Landscapes* series continues what had

2. Blackwell and Pei 2006.

become the generative point and defining axis of his work: the contingency of value by means of exploring the transformative potential latent or inherent in the instability of form. This is symbolized by the artwork *Souvenir from Beijing* (2003), a series of small, oblong, wooden boxes made from destroyed Qing Dynasty temples, into which Ai Weiwei placed a brick from the demolished courtyard houses of a traditional hutong. Located within Beijing's Second Ring Road, these houses had made way for commercial property and massive housing development and, later, a further series of ring roads connecting the city around the central axis of the Forbidden City. At first glance, Ai Weiwei's work appears to function as a simple fragment that evokes a nostalgic relation to the past, a memento and relic symbolizing the body laid to rest. However, the ambiguity of the title in English suggests an alternative reading. For, unless taken ironically, how can this violation be a gift? To whom is it being given but to one who benefits from the tearing down of these people's houses? Rather playing upon the temporal meaning of the present, the work is a gift that belongs to the present because the bricks being offered are not simply the remains of the past but, more so, the building blocks for a new work; a new work of art.[3]

As in other artwork by Ai Weiwei, we return not to the idea of nostalgia for things past but rather that of its meaningless destruction for reasons of profit by those in favour with the state, or by the state itself. The bitter historical irony, as the artist points out, is that after 1949 the land was taken from the landowners and given to the people under the control of the state. Now developers are auctioning the land with the authorization, if not the complicity, of the state.[4] Reminiscent of Robert Smithson's concept of 'ruins in reverse', this 'zero panorama … contain[s] all the new construction that would eventually be built … The buildings don't fall into ruin after they are built but rather rise before they are built.'[5]

The video work that followed, *Chang'an Boulevard* (2004), was structured by a similar procedure. Learning of a friend's son coming to Beijing with little to do, Ai Weiwei suggested making a video along the major arterial road Chang'an Boulevard (The Boulevard of Eternal Peace), which is the axis between the East Sixth Ring Road and West Sixth Ring Road, a distance of 45 kilometres. The plan devised was to record a single frame of one minute's duration at measured increments of fifty metres. Taking a whole winter to shoot, the resulting video was a document of the life of the boulevard ranging from a rural village to the business district, the political centre and what proved to be the last days of the Capital Iron Company, once a symbol of socialist industry. As a snapshot of the heterogeneous character of a China composed of different temporalities, communities and aspirations, Ai Weiwei's traversal of a single road results in a diachronic portrait of the country in which one can view the aspirations and ruins of post-socialism jostling alongside one another.

3. Blackwell and Pei 2006.

4. Cited by David Spalding in his review of Ai Weiwei's exhibition at Galerie Urs Meile. David Spalding. 'Ai Weiwei', *Artforum*, September 2006, p.395.

5. Blackwell and Pei 2006.

Stills from <u>Chang'an Boulevard</u>
2004
Video
10 hour 13 min

Stills from <u>Beijing: Second Ring</u>, 2005
Video
1 hour 6 min

Stills from <u>Beijing: Third Ring</u>, 2005
Video
1 hour 50 min

6. Blackwell and Pei 2006.

Chang'an Boulevard was followed by two more highly formalized videos, *Beijing: Second Ring* and *Beijing: Third Ring*, both in 2005. Each was structured around the bridges over the ring roads (the first having thirty-three bridges and the second, fifty-five). The videos record each side of the bridge for the duration of one minute while, as Ai Weiwei notes, there was no other intervention except in planning that the first video was to be filmed on cloudy days and the second on sunny days. But what is it that appears by virtue of this process? Ai Weiwei remarks it is simply recording: 'the condition at the time, it's very much like a witness passing through: what he would see, his eye, anybody's eye. There is no artistic or aesthetic value, not much judgement there. It's a very, very simple situation.'[6] However, he then adds that the process of filming and editing was predetermined according to a disciplined and 'strict, rational – even illogical – behaviour' which 'works in tandem with the randomness of the subjects.' Hence while the method may be claimed to be scientific or rational, it is shaped by behaviour that has little or no relation to its subject, a form of mapping or a grid that fails to impose any order other than its own imprint. Rather, what is revealed is the caesura or disjunctive relation created by the imposition of an order on an otherwise random subject.

In essence, both this series of video works and *Beijing 2003* constitute forms of mapping Beijing. Each had been structured according to existing maps whereby the videos or photographs correspond to particular locations. However, locations themselves are unstable, changing, transitory – a form of 'non-site', as Smithson would phrase it. The maps themselves, therefore, are little more than a construct following the course of destruction and construction that is taking place and, at best, provisional in their apparent unity and status as documents. The irony, of course, may also be that Beijing, like other major cities in China, is being rebuilt by migrant labour, non-locals who have neither relations in the city nor rights to live there.

This excerpt from the chapter 'Duration Within Time' first appeared in *Ai Weiwei: Under Construction* by Charles Merewether, published in 2008 by University of New South Wales Press.

2002–2008
C-prints
Various dimensions

PROVISIONAL LANDSCAPES

It has been estimated in the first eight years of the twenty-first century more than one-million households were removed in the efforts to prepare Beijing for the Olympic Games.[1] By mid-decade, the cyclic process of demolition and construction reached a fever pitch, marking a historic shift in the city's spatial planning that left large swathes of the city in a barren state of in-between. As a harbinger for the nation, the changes occurring in Beijing were emblematic of metropolitan transformations taking place in hundreds of Chinese cities. From 2002 until 2008, Ai Weiwei periodically captured these scenes in his photographic series, *Provisional Landscapes*.

In *Provisional Landscapes*, the artist eschews the studied objectivity of his earlier film projects, intentionally framing conditions of transient vacancy from across China. Settled in a brief holding pattern, these photographs depict a momentary ellipsis in the mechanical hum of progress as the sites await a destiny that looms in the hazy outline of towers beyond the foregrounded rubble. In scenes which frequently resemble battlefields, images of halfway executed demolitions stalled in progress endure resiliently. In one such scene, detritus spills out of the remnants of a half-demolished building, its interior left exposed, while the contents of its walls dangle from the wound like an amputated appendage. In another, flattened and dust-swept ground extends endlessly, met only in the distance by a skyline of construction cranes hovering above a row of buildings nearing expiration. In a third, tumbleweeds and leafless trees foreground a handful of withering homes that resemble a twenty-first-century ghost town.

For residents, the levelled fabric of former neighbourhoods is less a spectacle of destruction than a vestige of the final sites of resistance. *Chaiqianhu*, the displaced residents of demolished households, did not always relocate willingly. The most obstinate of these holdouts, referred to as *dingzihu*, or nail households, were rarely received with kindness. Portrayed

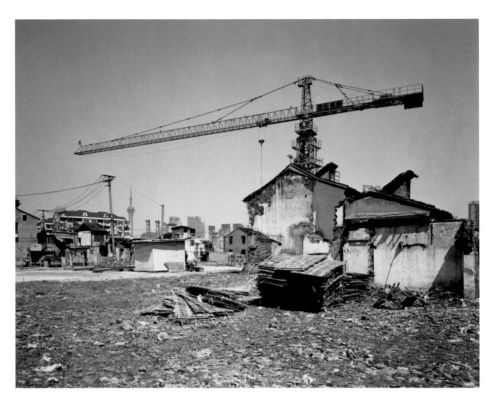

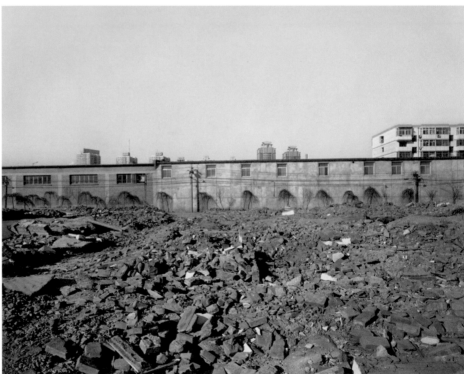

Provisional Landscapes,
2002–2008
C-prints, various dimensions

Provisional Landscapes, 2002–2008
C-prints, various dimensions

as 'tigers that block the road', they were painted in the official press as opportunistic negotiators siphoning finances from the state. Such accounts glossed over the forms of intimidation, sanctioned and outsourced by official departments in charge of relocation, that were implemented in opposition to the lingering occupants. It was hardly exceptional for residents to find their utilities cut by teams of mercenary thugs – a form of municipal deprivation intended to force residents from their homes. When intimidation failed, violence was not uncommon.

In Ai's photographs, there is uneasiness in the void, a tension derived from the future unknown and an implicit recognition of violence. In another artist's hands, they might border on cliché. The repetitive tropes of destruction and loss captured through overt signifiers could easily be deployed to suggest the disastrous erasure of a centuries-old society or the exuberance of progress. In *Provisional Landscapes*, however, neither conclusion is fully supported. Instead, Ai lets the images stand for themselves, noting, 'I think the whole process is a period that we can learn from. The result will of course be adjusted by other intentions in the future. Because the project was large and long, the image of the city might appear as the final result of something, but actually everything is moving and continuously trying to find a new definition.'[2] Interspersed among the images, Ai captures the eccentric and absurd facets of China's modern urbanity. Countering the more common scenes, their presence instils a measure of cognitive dissonance against a unilateral reading of the series as a whole: the mammoth concrete span of a reservoir dam, the concave facade of a luxury hotel styled in Swiss fashion, freight ships unloading cargo, dirt and nothing else.

Taken in the context of Ai's architectural career, these efforts can be situated in contemporary urban research undertaken by avant-garde architects throughout the past half-decade. Descending from Edward Ruscha's *Every Building on the Sunset Strip* (1966), this documentary tendency is embedded in a lineage of work that extends from Robert Venturi to Rem Koolhaas, who deploy film and photography as objective media for the comparative study of urban imagery.[3] For Venturi, along with his partners Denise Scott-Brown and Scott Izenour, 'learning from the existing landscape is a way of being revolutionary for an architect ... [a] more tolerant way; that is, to question how we look at things.'[4] Citing pop art as a predominant influence, the supposed pastiche of Venturi and Co.'s postmodern vernacular only constituted a partial rendering of populist culture. Scrubbed of the darker facets rooted in late-capitalism's consumer culture – a theme explored explicitly in Warhol's 1963 screenprints of deaths by car wreck and botulism victims – *Learning from Las Vegas* was an optimistic endorsement of the contemporary autoscape that not even Ruscha shared.[5]

In denying *Provisional Landscapes* any generative purpose towards an architectural or artistic proposition – a decision which preserves the very inconclusiveness that he holds central to the work – Ai shares more in spirit with Ruscha than any of his architectural descendents. In *Every Building on*

the Sunset Strip, Ruscha claimed that 'the character, function, and reputation of the Sunset Strip make it a discrete thing, one that carries, for good or ill, considerable cultural distinction. It functions, in short, as a horizontal monument.'[6] The description is suitable to another of Ai's projects, *Chang'an Boulevard*, which in its exhaustive cinematic sequencing of a single road closely recalls Ruscha's original piece. Widened shortly after 1949 to serve as the de facto parade route passing before the Forbidden City and Tiananmen Square, Chang'an Boulevard carries with it complex associative baggage. Its east-west orientation is the communist counterpoint to the city's historically prominent north-south alignment, and its condition at any given moment can be understood as a both a projection and a barometer of the Communist Party's constructive ambitions. In capturing fragments of imagery from its length, Ai Weiwei collected the material to allow each viewer to evaluate its monumental significance for themselves.

What ties Ai's work to Ruscha and other predecessors is not only a common medium, but the exhaustiveness of the projects themselves. Though Ai's labours began without purpose, and, the artist claims, were not consciously conceived as a singular project, the collective body of work encompassing his videos and photographs stands as a vivid, yet open-ended narrative on the nation's urban transformation leading up to the Olympics. In doing so, it captures the city in three distinct stages. The first, seen most prominently in *Beijing 2003*, displays fragments of a civilization on the cusp of a transformation, albeit one that is already underway. The second stage, captured in *Provisional Landscapes*, is a city of voids, evincing a nation in the process of redefining itself through destruction and vacancy.[7] The final stage, shown in Ai's later photographs of the construction of Olympic monuments, hints at a growing suspicion for the enthusiasm equating material growth with social improvement. The narrative bears witness to a prevailing attitude that believes, according to art critic John McDonald, that 'the demise of a few old buildings and a pollution problem are the inevitable price of progress' after years of ideologically driven isolation.[8] To that conclusion, however, Ai Weiwei's photographs remain defiantly mum.

1. Deanna Fowler, *One World, Whose Dream? Housing Rights Violations and the Olympic Games*, Centre on Housing Rights and Evictions (COHRE), 2008, p.6.

2. Anthony Pins, 'Interview with Ai Weiwei', 23–25 August 2011.

3. Reto Geiser, 'In the Realm of Architecture: Some Notes on Ai Weiwei's Spatial Temptations', in Yilmaz Dziewior (ed.), *Ai Weiwei: Art/Architecture*, Kunsthaus Bregenz, 2011, p.49.

4. Robert Venturi, Denise Scott-Brown, and Steven Izenour, *Learning from Las Vegas*, MIT Press, 1972, p.12.

5. Hal Foster, *The Art-Architecture Complex*, Verso, 2011, p.7.

6. Quoted in Peter Plagens, *The Works of Edward Ruscha*, San Francisco Museum of Modern Art, 1982.

7. Charles Merewether, 'At The Time', in Urs Meile (ed.), *Ai Weiwei: Works 2004–2007*, Galerie Urs Meile, 2007, p.180.

8. John McDonald, 'Destruction and Creation', *Sydney Morning Herald*, 17 May 2008, http://www.smh.com.au/news/arts/destruction-and-creation/2008/05/16/1210765144217.html, accessed March 18 2012.

<u>Provisional Landscapes</u>, 2002–2008
C-prints, various dimensions

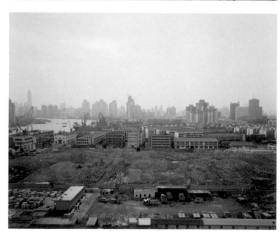

<u>Provisional Landscapes</u>, 2002–2008
C-prints, various dimensions

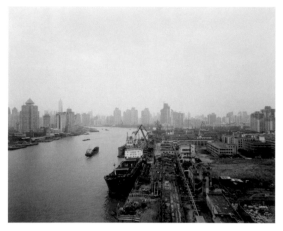
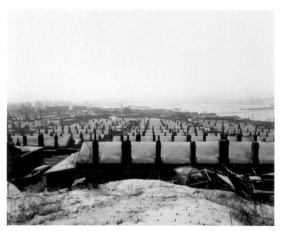
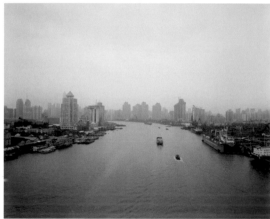
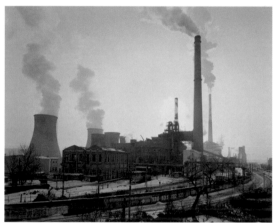

<u>Provisional Landscapes</u>, 2002–2008
C-prints, various dimensions

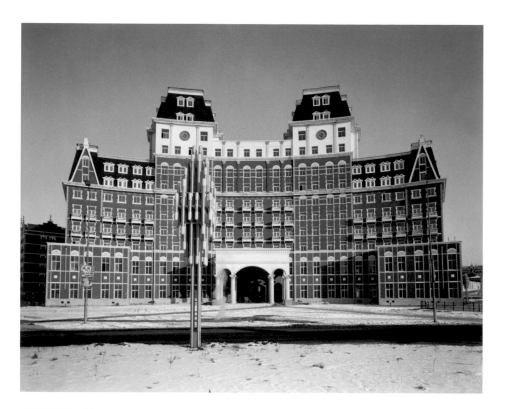

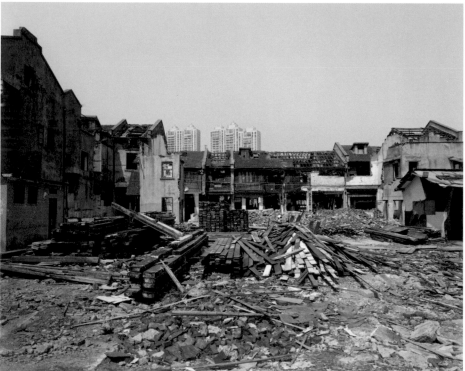

<u>Provisional Landscapes</u>, 2002–2008
C-prints, various dimensions

Investigate

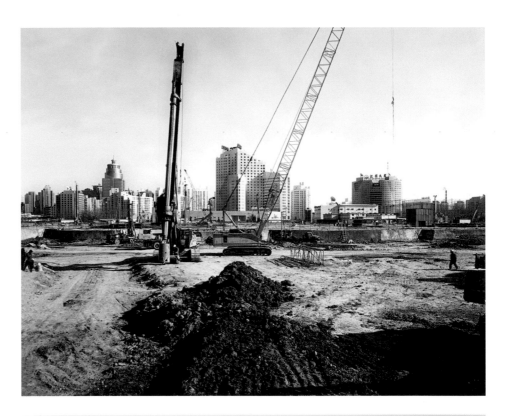

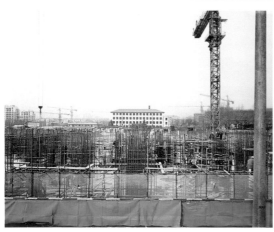

Provisional Landscapes, 2002–2008
C-prints, various dimensions

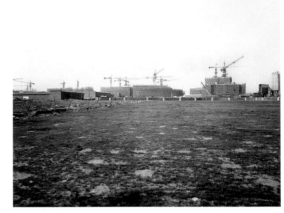

2002–2008
C-prints
Various dimensions

BEIJING NATIONAL STADIUM CONSTRUCTION

In one of the more compelling compositions from Ai Weiwei's photographic series depicting the construction of the Beijing National Stadium, the artist shows the massive edifice from afar, three-quarters assembled, at each hour over the course of a day. In the image's lower third, a few sprouts of grass pierce through a sea-green ground covering. In the upper third, the shifting atmospheric conditions of a hazy Beijing day cast a moody pall over the Olympic grounds. As for the stadium itself, little seems to change. The set of twenty-four photographs is a surprising contradiction to the dominant narrative of speed and frenzy with which Chinese construction sites are portrayed. Seen in the background, neither the subtle rotation of construction cranes nor the illuminated site, alive with night-shift workers, reveal the vigorous efforts taking place within. If the nest's embryonic referentiality is suggestive of the vitality of sport cultivated within, in this series it is the stadium itself that is being slowly nurtured.

The twenty-four-hour series is a rare instance in which Ai Weiwei abets any notion of the Bird's Nest's gestalt formalism. Taken over the course of twenty-six months, the photographs reveal the incomplete stadium in various states of undress. The incompletion is ideal for Ai, who, in seeking to undermine the icon's compositional totality, depicts the stadium in its moments of greatest vulnerability. Frequently, he captures individual units of the stadium's latticed trusswork in isolation, an image of structural impotence that stands in sharp contrast to the facade's apparent strength and stability. In one such instance, a truss lays prostrate across mud-covered ground, an immobile witness to the Lilliputian-sized workers that pass it by. In another, a crane hoists a final roof member into place, the lifeless latticework dangling in mid-air. The imagery situates the stadium's construction within a conventional part-to-whole compositional regime that resists the facade's seamless appearance – the potent architectural quality by which it acts as both ornament and structure.

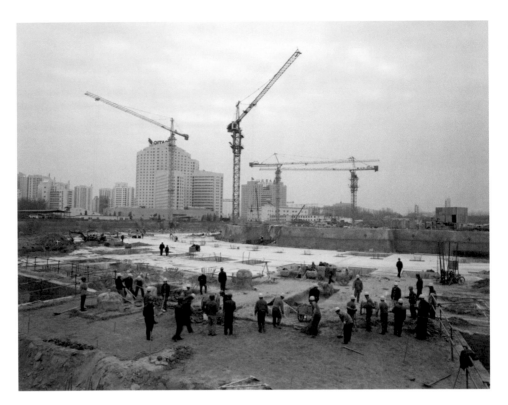

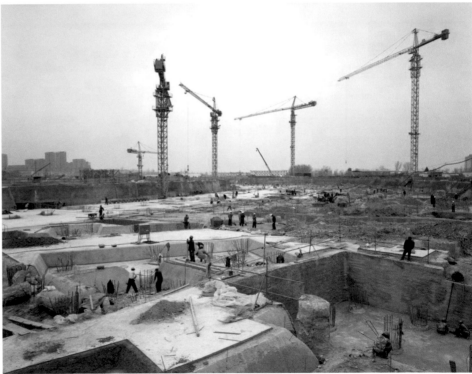

Beijing National Stadium,
2002–2008
Top–bottom:
19 October 2005
20 December 2005

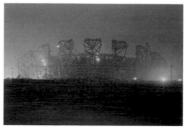

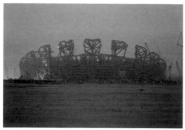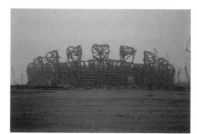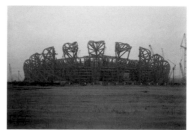

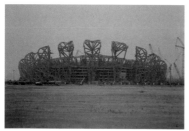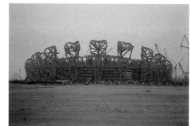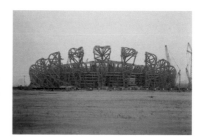

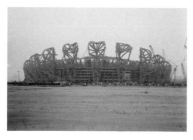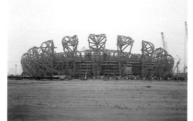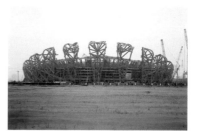

Beijing National Stadium,
2002–2008
3–4 June 2006

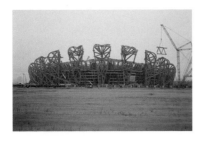
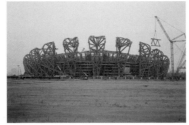
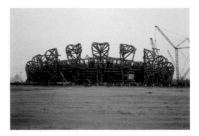
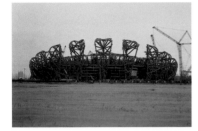
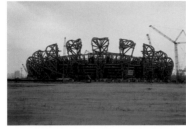
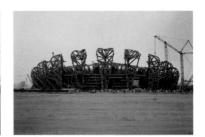
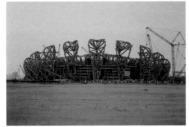
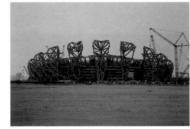
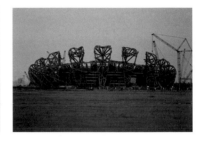
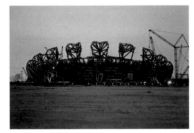
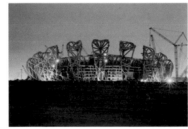
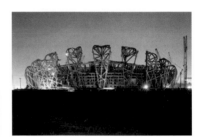

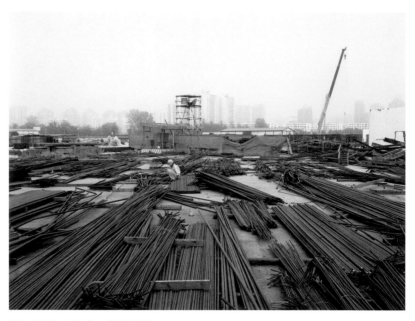

Beijing National Stadium, 2002–2008
14 May 2005

Rarely foregrounded, the images are populated with the workers who numbered as many as 7,000 at the height of construction. Represented as mere pixels within the photographer's field of vision, the workers are dwarfed by the stadium and recede into the creases of its tangled lattices. These workers remain mostly invisible except for the bright colour of their construction helmets, a simple but effective visual metaphor reinforcing the state's prioritization of its own iconography over the well-being of its citizenry. Where the workers are not directly seen they are represented by proxy – small visual clues hint at a temporary pause in the day's work. Left implied is their inevitable return. In one image, a backhoe is caught in a momentary repose, its hydraulic arm resting in front of a partially demolished building. Elsewhere, racks of steel pipe sit in an eerily empty unfinished concourse. Diminished or completely invisible, the neglected presence of humans in these photographs evinces the marginalized state of China's migrant construction workers. The low-wage exploitation of the rural citizenry, enticed to leave home by the mirage of economic advancement, is emblematic of the false-promise of China's modernization. This sentiment becomes palpable as the stadium draws closer to the opening ceremony, created though images of absence, incompletion, and muck that place a psychological dint on the Bird's Nest's stainless surface.

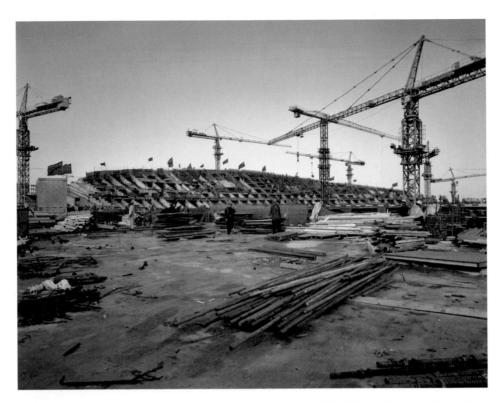

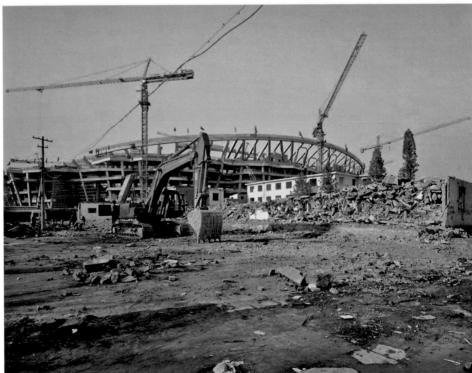

Beijing National Stadium,
2002–2008
Top–bottom:
19 October 2005
20 December 2005

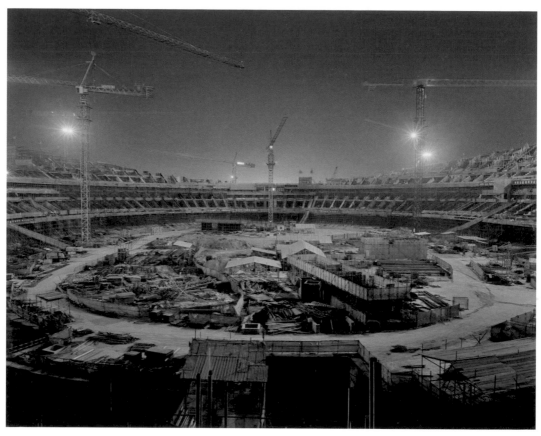

Beijing National Stadium, 2002–2008
22 October 2005

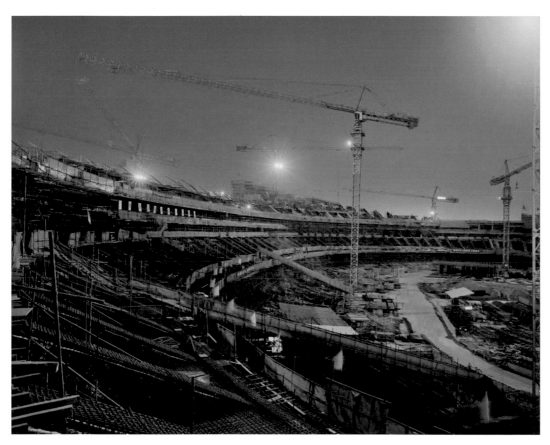

Beijing National Stadium, 2002–2008
22 October 2005

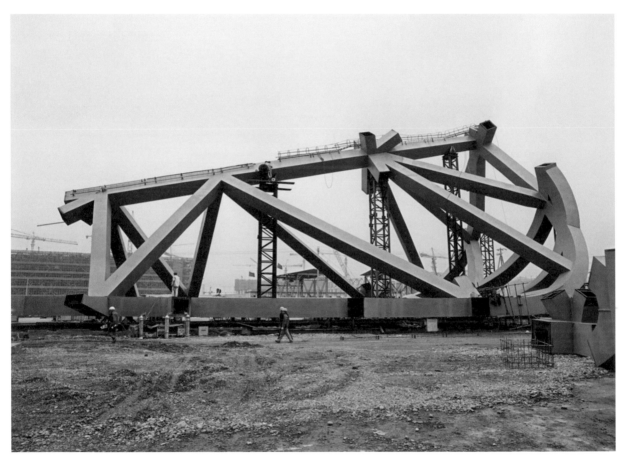

Beijing National Stadium, 2002–2008
3 May 2006

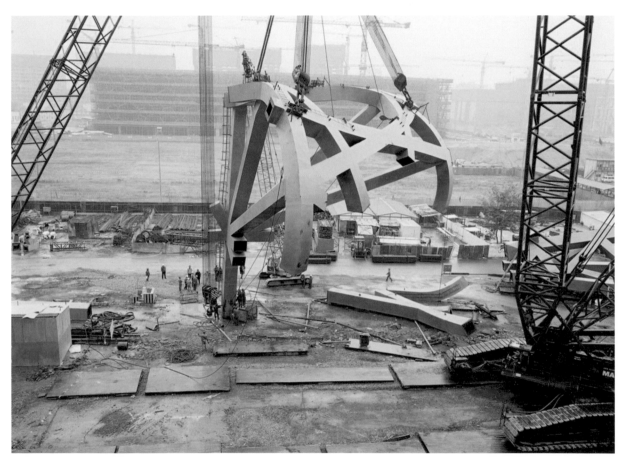

Beijing National Stadium, 2002–2008
6 May 2006

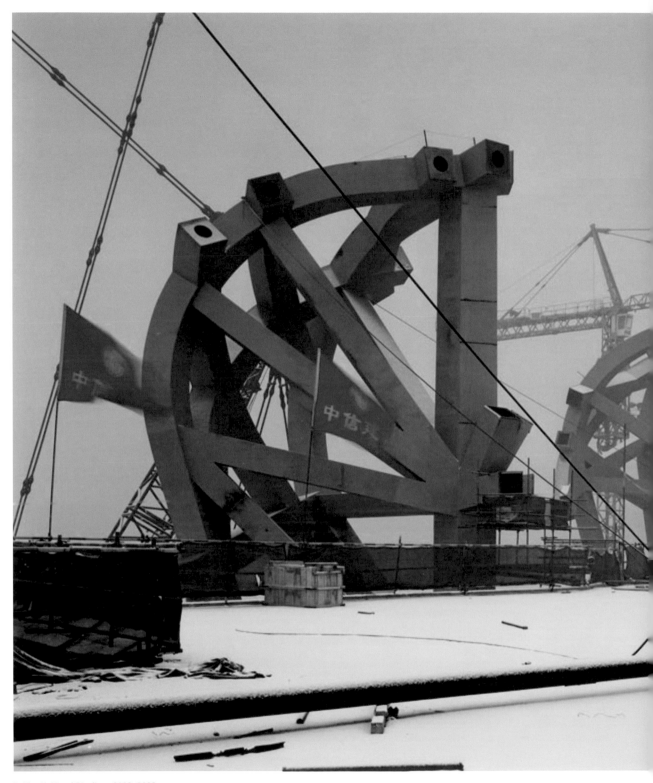

Beijing National Stadium, 2002–2008
1 January 2006

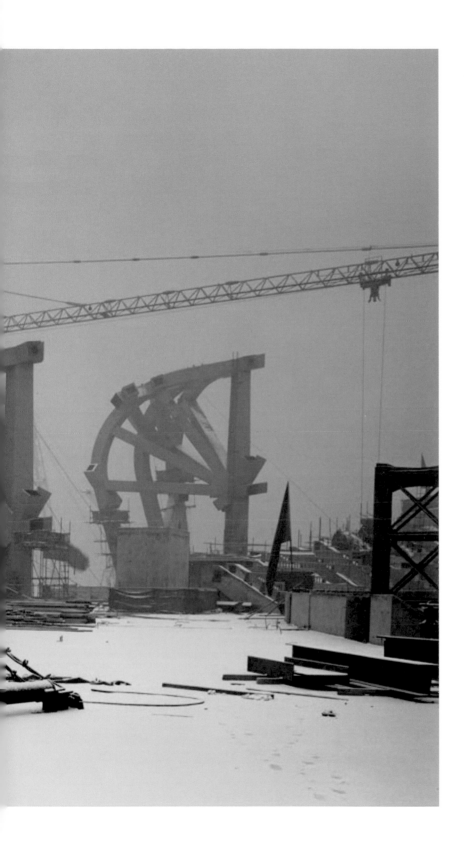

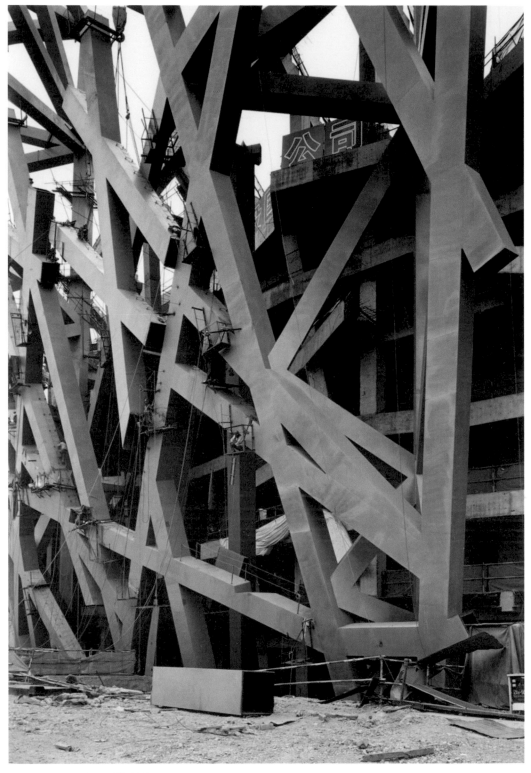

Beijing National Stadium, 2002–2008
7 May 2006

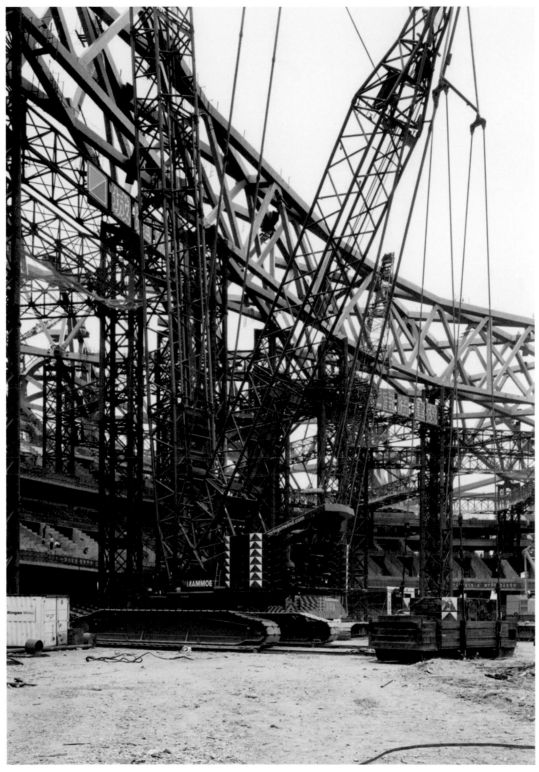

<u>Beijing National Stadium</u>, 2002–2008
12 July 2006

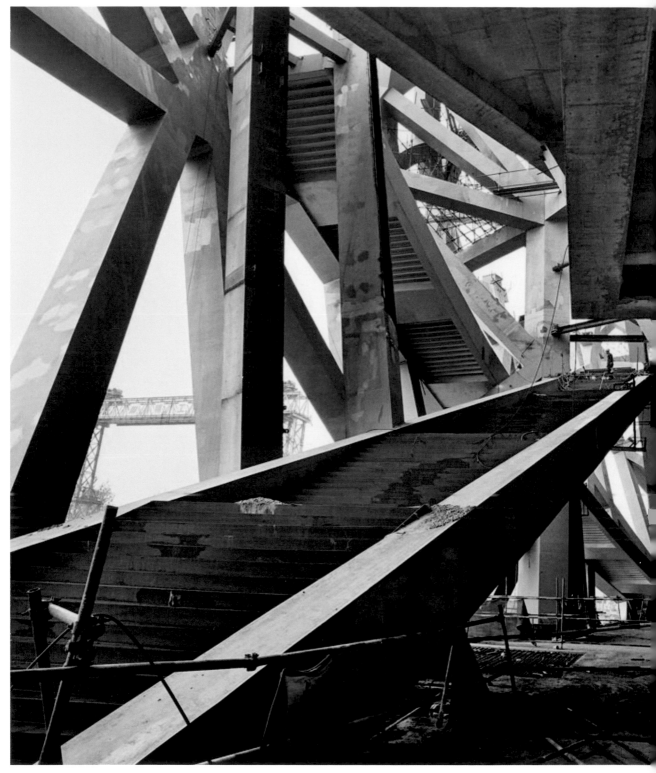

Beijing National Stadium, 2002–2008
15 August 2006

Investigate

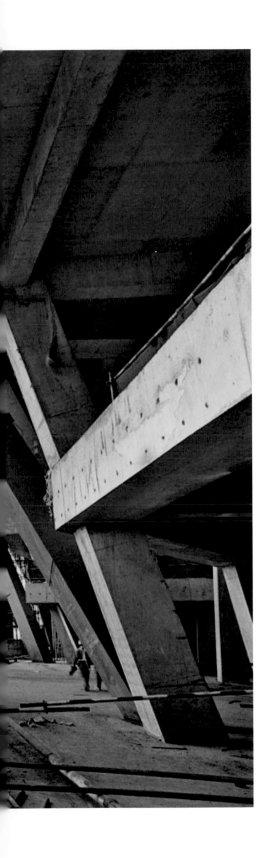

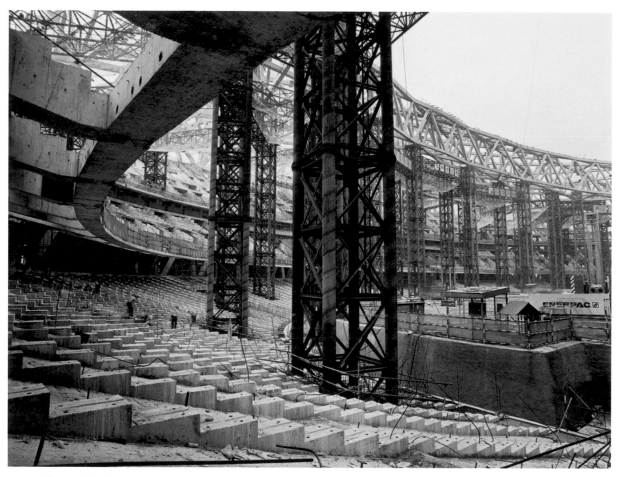

Beijing National Stadium, 2002–2008
15 August 2006

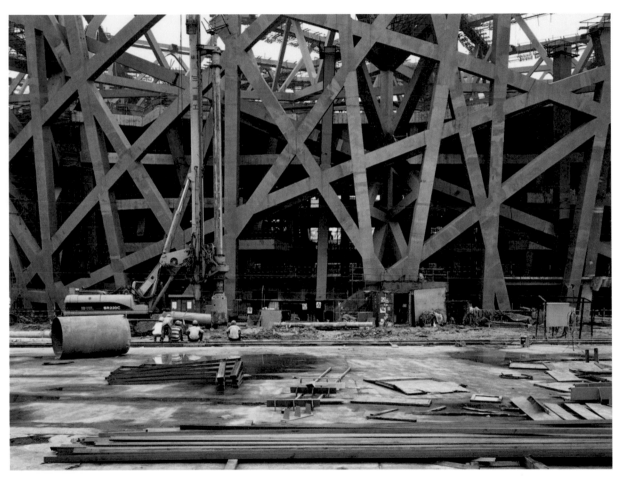

Beijing National Stadium, 2002–2008
15 August 2006

2005–2007
C-prints
Various dimensions

TERMINAL 3

BECOMING
Brendan McGetrick

It is tempting to portray Ai Weiwei and Norman Foster as a pair of polar opposites.

Foster's public persona is that of a sober, sinewy modernist – a master of the machine age who thought his way out of Manchester's working class to conquer the globe, leaving a trail of revolutionary function-following forms in his wake. Over the course of almost forty years of practice, he has blended the insights of a few forebears – the material restraint of Mies, for example, the structural adventurousness of Buckminster Fuller – with personal fascinations (airplanes, bicycles, etc.) into a kind of architectural protein shake, and the world has drunk deeply. He has received every significant architectural prize, and flies his own jet between his three offices in London, Tokyo, and Hong Kong. As the *Guardian* newspaper proclaimed in a 2005 article, 'Norman Foster stands on the shoulders of... well, Norman Foster, really. He is the world's most famous and most productive architect. A giant.'

Ai, on first inspection at least, couldn't be more different. From his Studio-House, which he built illegally on government-owned ground, based on a plan he'd drawn on a napkin, Ai Weiwei produces art, film, books, and buildings that inspire, amuse, and occasionally insult. His first show, exhibited in New York in 1983, consisted of a violin with a shovel handle for a neck, a pair of conjoined shoes, and a wire hanger bent into the profile of Marcel Duchamp, the artist who, along with Andy Warhol, provides Ai's most explicit influences. While Foster has maintained a forward gaze for most of his career, exploring the possibilities of technology to deliver a better, more functional future, Ai is infamous for his deformation, duplication, and wanton destruction of technologies of the past. Both men have confronted Berlin's Reichstag in their work, but where Foster gave the building a new identity, transforming a symbol of the city's traumas into a manifesto on openness and sustainability, Ai, in his *Study of Perspective*, gives the Reichstag the finger.

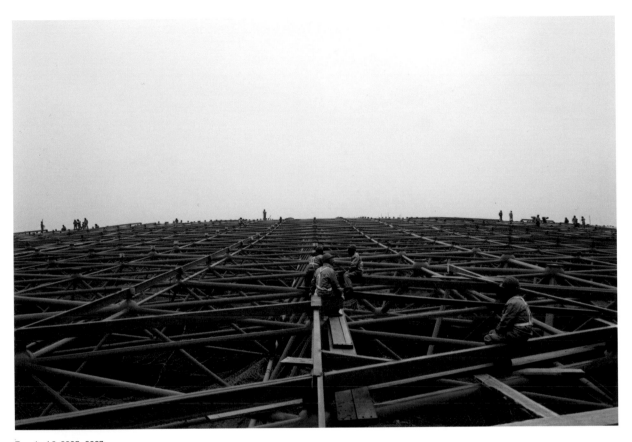

Terminal 3, 2005–2007
Beijing Capital International Airport
15 November 2005

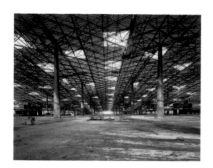

Terminal 3, 2005–2007
3 January 2006

All of the above is true, but at the same time untrue. It is, to borrow one of Warhol's phrases, 'deeply superficial'.

Despite their obvious differences, there are large areas of overlap between the approaches of Norman Foster and Ai Weiwei. For one, both men exhibit a fascination with large-scale, high-complexity projects. In the architect Foster's case, this is seen in works like Chek Lap Kok, Hong Kong's airport, a six-year venture that, in the words of critic Deyan Sudjic, 'involved the building of two major suspension bridges, 34 kilometres of motorway, a mass transit rail system, the removal of a mountain, and the creation of an artificial island, even the assembly of a fleet of ships to take the workforce to and from the site'. In his capacity as an artist, Ai has produced work of similar ambition and organizational rigour. For *documenta XII*, for instance, he created a living exhibit that involved transporting 1,001 Chinese people to Kassel, outfitting them with matching clothes and luggage, housing them on bamboo bunks in Ai-designed temporary quarters inside an old textile factory, then setting them off to roam the streets of the host city for the three-month duration of the show.

Not surprisingly, efforts like these have given Ai and Foster reputations as men inclined toward attention-grabbing gestures. Showy, Hollywood-ready landmarks like Foster's Swiss Re building in London and controversy plays like Ai's *Dropping a Han Dynasty Urn* dominate the public's perception, blocking out their creators' subtler, more fundamental qualities. *Becoming* is an opportunity to change the focus. The images presented here offer a view to what is, for me, the essential commonality among these two seeming opposites, their passionate commitment to craftsmanship and detail. It is a quality that imbues even their most blatant works with layers of hidden depth, and which, perhaps, explains how a book like this came about.

Throughout their careers, Ai Weiwei and Norman Foster have applied a working method based on careful study and commitment to craft. Even in works like *Slanted Table* and *Table with Three Legs,* where he deforms Qing Dynasty furniture, rendering it absurd and useless, Ai is resolute in his faithfulness to historical construction techniques. The architecture of Foster is often described as high tech, but also shows strong affinities with the English Arts and Crafts tradition, particularly its emphasis on connecting design and fabrication. It is a commitment that extends to the most seemingly trivial aspects of Foster's designs, as seen in the architect's well-documented quest to design the perfect doorknob.

The photos presented in *Becoming* showcase this shared fascination. They do not strive for completeness; they don't explain or adulate. Instead they examine, taking a curious, educated eye to the inner workings of a building that hundreds of millions will use, but few will ever understand. In the process they subtly show the relation between artists with different eyes, but similar hands.

What is most striking about Ai's photos of Foster's new terminal for Beijing Capital International Airport is the sense of order and calm that they

evoke. For the work of a supposed prankster, the images are surprisingly straightforward. Though they apply techniques associated with art photography – large format, short exposure, high depth of field – many have the simple qualities of a snapshot. Often, the photos impress with what they do not show – namely, people.

Terminal 3, as the new airport is more formally known, is the largest covered structure ever built, a monument to China's greatest free-market virtues – scale, speed, and cost. As is widely reported in the British press, it is about twice the size, half the cost, and planned and built in almost a third of the time of Heathrow's Terminal 5. There are dozens of other startling statistics that can be rattled off in regards to the airport, but for the purpose of this book, the most pressing is this: it's estimated that at its peak the airport's construction required a workforce of 50,000.

Strange then that Ai Weiwei's photos, taken at various points during the construction, are virtually worker-free. One might expect a hive of activity, workers clambering over each other, or perhaps the construction equivalent of the coordinated human pixels at a North Korean sporting event. But Ai's photos appear serene, almost melancholic. Flipping through page after page of empty, majestic spaces, one gets the sense of being in the eye of a hurricane, witnessing the last moments of tranquility for a patch of earth soon to be turned upside down.

It is an approach well suited to the architecture of Norman Foster. Foster's buildings are often visually intense, but that's generally due to their structural complexity and technical refinement. In terms of their architectural language – the range of materials and finishes applied – his work is radically stripped down. This commitment to minimizing visual noise is what gives the best Foster + Partners buildings the sense of order and coherency for which the firm is so widely admired. 'The best sign,' Foster once told a journalist inquiring about the wayfinding system in his first airport at Stansted, 'is no sign.'

In his photos, Ai Weiwei has eliminated the human noise, avoiding the predictable appeal to pathos in order to provide a more coherent visualization of the building itself. Instead of depicting the workers, he captures their traces, revealing an unstable but tranquil environment in which perfection and chaos occupy the same space. Solid structural elements like concrete columns and steel roofing are juxtaposed with fuzzy, scattered materials, such as slabs of wood, tangled cables, and discarded cement sacks. In other images, the constructions themselves fascinate; we see steel rods bent like rubber bands, iron supports spread in columns like the oars on a Viking warship, piping organized in hollow, interlocking pyramids ...

For most of the photos, the terminal is skeletal. Its most dramatic qualities – the light and airy glass walls, the high ceiling, the descending walkways and russet roof – are obscured. It is an impressive form without a recognizable personality. In this gestating state, it seems the building could develop to become almost anything: a space ship, a giant turtle, a

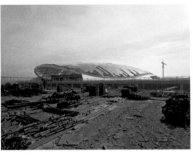

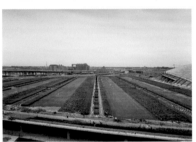

Terminal 3, 2005–2007
Top–bottom:
3 January 2006
22 September 2006

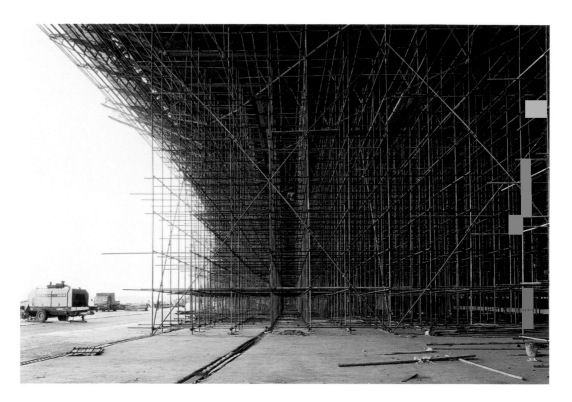

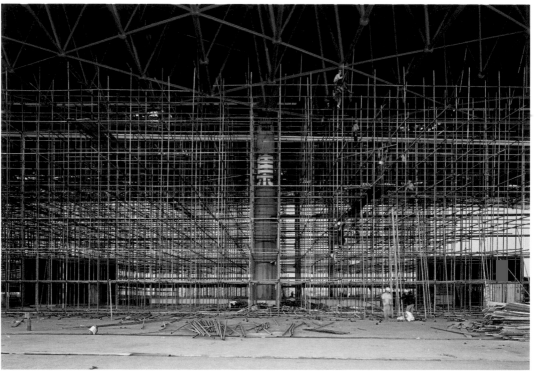

Terminal 3, 2005–2007
11 August 2006

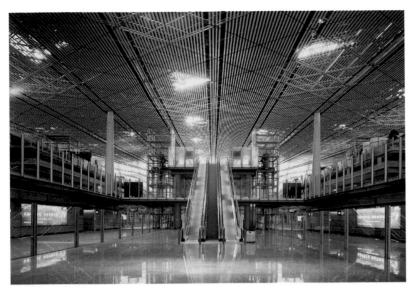

Terminal 3, 2005–2007
25 December 2007

ski ramp, a music video set, a greenhouse, a jungle gym ... As the construc-
tion progresses, it becomes interesting to guess which potentialities will be
highlighted, and which will disappear – what views will be lost, what spaces
dissected, how the infinite possibilities of wide openness will eventually give
way to the rigidity that guarantees an airport's efficient operation. The
authors removed, we are left with no choice but to consider the conse-
quences of their work.

Then, suddenly, the undeniable airport interior: the reflective floor,
the grey spatial dividers, the silver travellators and hanging atmosphere of
short-term urgency. What once appeared desolate now delivers touches of
the sublime: sun rays beam through vast, unobstructed windows and are ex-
tended via metallic ribbons along the ceiling. Sunlight generally soothes build-
ings, but in Foster's terminal its presence is triumphant, almost euphoric.

With completion, the tension between new and used disappears.
There is no more sagging canvas or frayed rope to be seen, only gleam-
ing tiles, immaculate, interwoven steel, smudge-free glass, and occasional
bursts of PRC red. In the absence of old, a new tension emerges, precisely
the kind that has been avoided until now: the building now contains specks of
humanity, and Ai's large-format images capture the startling juxtaposition
between the building's epic scale and the smallness of its users. As their
movements come to dominate more and more of the frame, it becomes clear
that we have arrived at the end, and the terminal at its beginning.

This essay first appeared in *Becoming: Images of Beijing's Air Terminal 3*, published in 2009 by
Timezone 8.

Terminal 3, 2005–2007
11 October 2005

Investigate

Terminal 3, 2005–2007
11 October 2005

Terminal 3, 2005–2007
2 November 2005

Investigate

Terminal 3

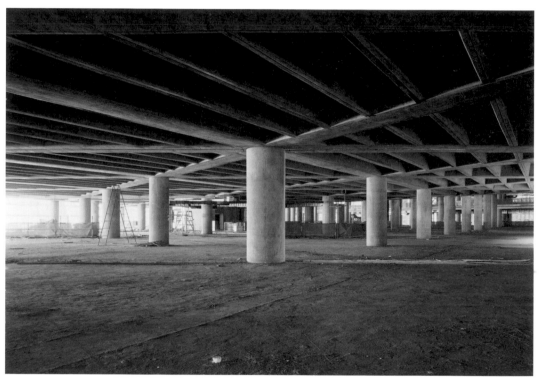

Terminal 3, 2005–2007
15 November 2005

Investigate

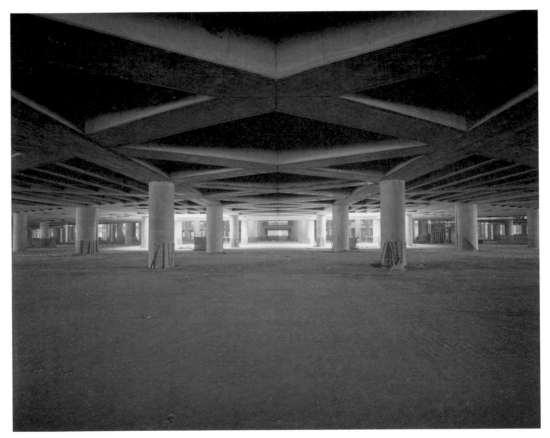

Terminal 3, 2005–2007
23 November 2005

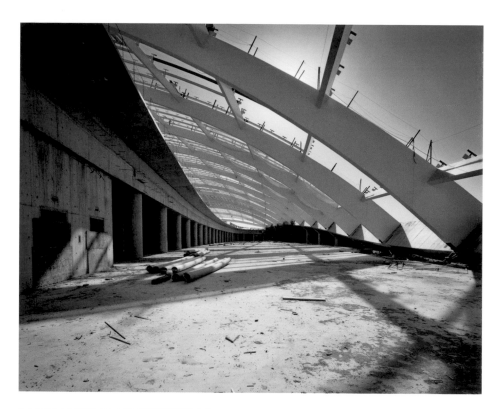

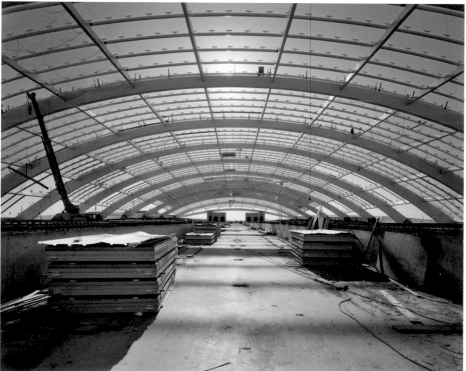

Terminal 3, 2005–2007
5 December 2005

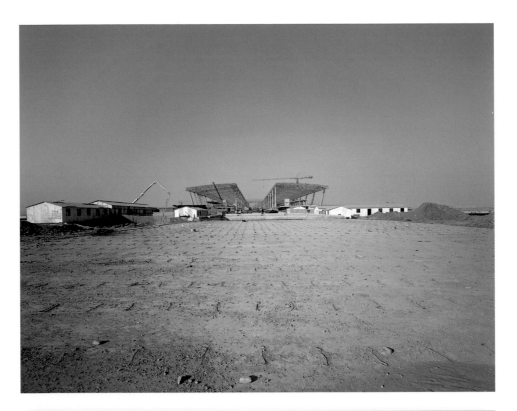

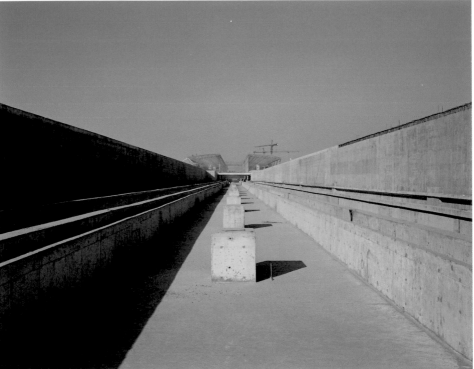

Terminal 3, 2005–2007
23 March 2006

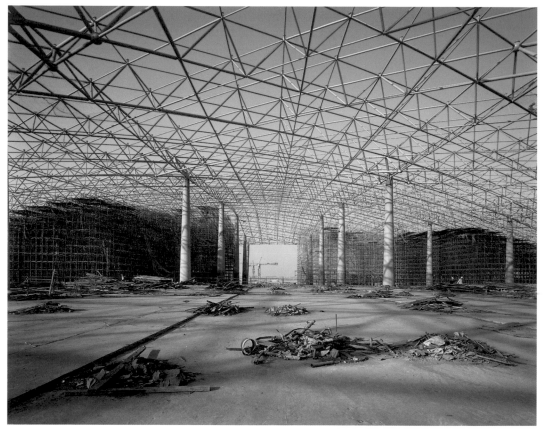

Terminal 3, 2005–2007
10 April 2006

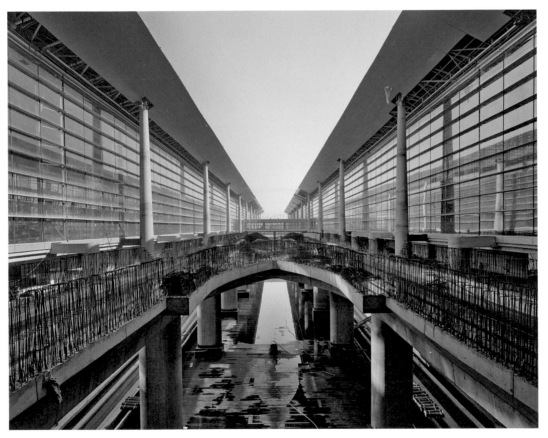

Terminal 3, 2005–2007
11 August 2006

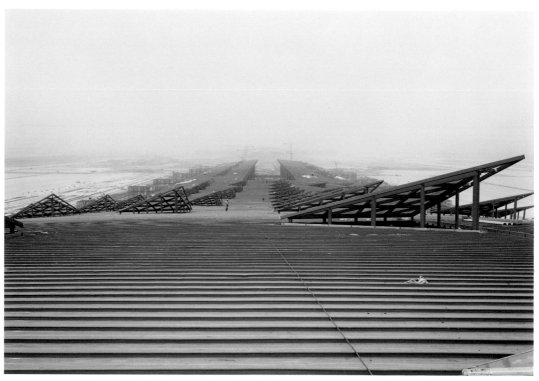

Terminal 3, 2005–2007
20 May 2006

Investigate

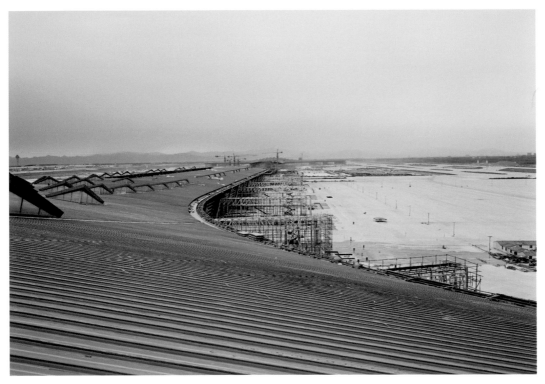

<u>Terminal 3</u>, 2005–2007
22 September 2006

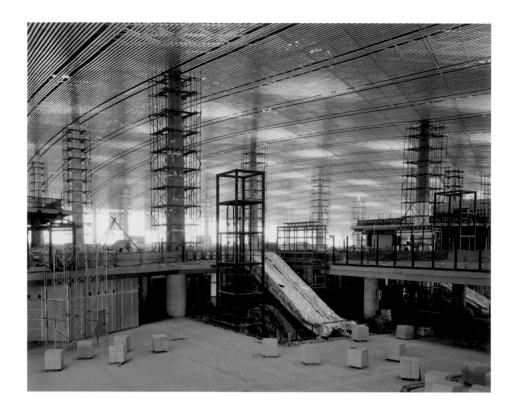

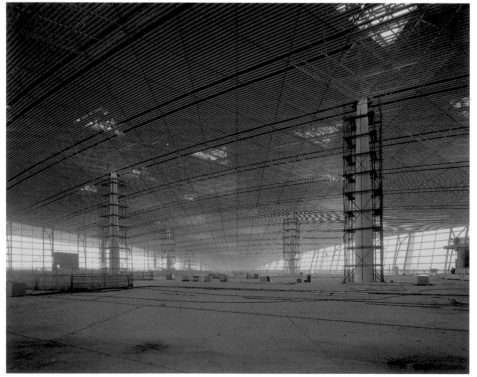

Terminal 3, 2005–2007
17 November 2006

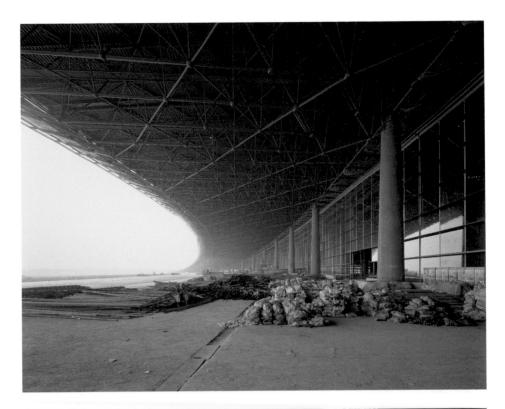

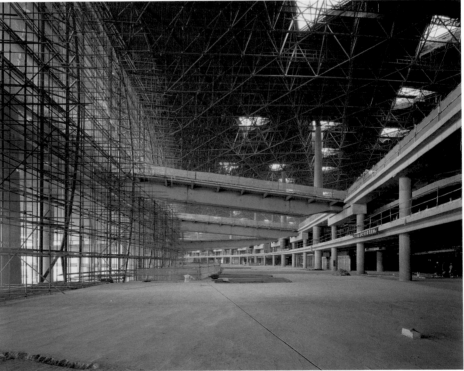

<u>Terminal 3</u>, 2005–2007
13 March 2007

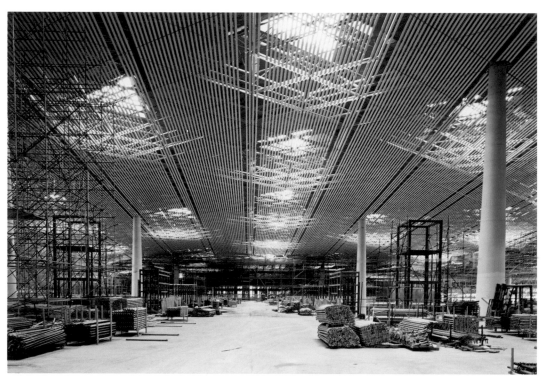

Terminal 3, 2005–2007
11 September 2007

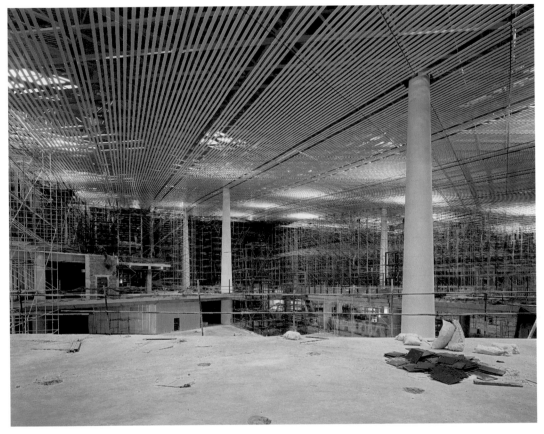

Terminal 3, 2005–2007
11 September 2007

Engage

Activism, Online Media, and
New Forms of Social Collectivity

Entries from Ai Weiwei's Blog

<u>Quietly Settling Dust</u>
Posted: 26 April 2006
Translated by Lee Ambrozy

This dusty weather persists in China's north, and, just as usual, every time a situation reaches its most implausible extent, silence reigns over everything, just as if nothing has happened at all. People are all too familiar with such circumstances – don't make a sound, lest great catastrophes befall.

Yes, you can be silent. And just the same, you don't have to smile, or put on your pretty dress in the morning, or promenade the streets with your friends, ride your bicycle to the suburbs on a spring outing, play by the riverside, go shopping, or chat about fashion. You don't have to discuss anything related to beauty or makeup, and you don't need plastic surgery. You don't need to talk about luxury anymore, or rising costs, the internet purge, a creative society, and you don't need to talk any more about advanced culture, because it's very simple: we are all living amid this dust. This is a singular reality, open your eyes and you will see it – a truth that no one can deny, a truth that won't go away. But how is this kind of truth identified? Here, this becomes an eternally perplexing puzzle.

No matter how many newspapers or television stations, journalists, or writers there are, no matter how many experts or scholars, it has been proven possible that these all are irrelevant to the truth. Truth is the one thing people are least interested in.

You can overlook everything else, but it is impossible not to breathe. Breathing is one task you are compelled to undertake, even when you are utterly disheartened, you breathe because you must live.

There are still so many children who want to live fairytales, young men and women who want to be in love, young people dreaming of their life to come, successful people who want to drive BMWs, buy luxurious apartments and take a second wife, participate in important meetings, discuss academic issues, develop real estate, put their company on the market, open a joint venture, expand their investment portfolio, sell medicine, produce, sell tickets, promote, improve ... so many 'wants', but no

desire to breathe. No desire to open our eyes. It seems people can exist in the suffocation and darkness.

The dust quietly settles, silently covering people in grey. It reminds us of the tragedy a few years ago, the air became equally still, and the world was similarly serene. It was the same time of year, and in the same place. No one knew what had happened, they only knew their neighbour was in the hospital, or their workplace had transferred documents. More people were kept in isolation, and the death toll was secret. It was the conscience and courage of one old doctor that rescued an entire city.[1]

Every time something big happens, newspapers, print media, and television no longer act affronted at the injustice, they are no longer filled with righteous indignation; they become one part of these tragedies. When the truth is not staring them directly in the face, could any one of them stand up? There is no investigation, no judgement, no suspicion, and no point of view – there is only the increasing technical prowess of our flashing fluorescent screens. Reality is transformed into a tedious comedy. Our waterways are polluted and dry, banks are hoarding dead accounts, greedy officials live free and unfettered in the suburbs, coal mines are collapsing, and state-owned enterprises are sold off. Imagine if you were born into this moment in time, what kind of life would be waiting for you? If all of this is in retribution, what could it possibly be for? Who shall pay the price? Who will bear the responsibility?

We live in a nontransparent world, and only in an opaque world could such tragedies occur and be sustained. But let's believe that all the misfortunes that occur here are natural disasters, that they are all because God, Allah, or Sakyamuni hasn't yet made time for the hardworking, brave, honest, and kind people of this land.

As Soon As You're Not Careful ...
An Encounter with Idiocy on a Sunny Day
Posted: 14 May 2006
Translated by Lee Ambrozy

At a friend's urging, I set off for the rather poor *feng shui* of Beijing's western district for a gathering of schol-

ars who were discussing the current 'cultural crisis'.[2] I'd heard there would be some cultural critique involved, and my suspicions were doubling the entire ride there.

I was already late. First we listened to some guy with a Shanghai accent expound on music. His tone was very similar to the flatulent voice of a teacher I once had from the 'precious island' of Taiwan. He began talking about prehistoric music, and carried on until contemporary music, neatly working Shanghai's new shopping centre Xintiandi into his discussion.[3] At first I was confused, and then I became bored to the point of madness, but near the end, when he brought up the names of certain Chinese musicians, I almost threw up.

Later on, and even worse, the great fool of a man named Zhu spoke.[4] I had overheard he's a cultural critic – that kind of person who makes a living by criticizing other people's books and then eats for free at cultural events. As soon as he opened his mouth, he started in about how Yu Hua's new novel was a failure, his reasons being more or less that the novel was self-indulgent and lacked any literary relevance.[5] This guy was so pretentious and criticized Yu Hua so harshly that he nearly made me believe that 'Yu Hua' was some inanimate object, or a kind of bird that could write. Zhu concluded that although Yu Hua was good at selling himself, he would never be a literary master. I don't understand why 'egocentric' people can't become masters. Does that really even matter? Isn't everyone self-indulgent?

I don't follow literature, so I didn't pay much attention. Finally, this Shanghainese guy seemed to have forgotten who he was, forgotten that he was on the West Third Ring Road of Beijing, and forgotten that there are no innocents or adolescent undergraduates here, and he began blabbering about the evils of internet literature. I'm not into literature, and I'm new to the internet – new to the degree that I love it too much to part with it – and I did not want to hear that kind of talk.

This guy even said that the teenage star novelist Han Han's level of literary cultivation was inferior to that of his middle-school students, and that Han Han held no promise for the future. Next he said that, even though the actress

Xu Jinglei's blog and website for culture and fashion have among the highest number of hits in China, their content was still garbage.[6] Based on his tone of voice, he was trying to say that Chinese culture was in the process of ruination at the hands of these internet mongrels. His basic theory was: because the moral character of netizens is so low (all they can do is *click, click*), their reasoning is tantamount to mob mentality. They have no idea of what literature is, not to mention an appreciation of high literature.

While I lack the means of investigating the moral quality of netizens, I do believe that Chinese literature can't really be that much better than internet literature. Furthermore, I'm positive that the transcendent, timeless form of literature that he was referring to simply doesn't exist. But he was still blathering on: 'Time can be the only measure of quality for this branch of literature', which, in my opinion, sounds like nothing but the kind of cliché claptrap rampant in those academic and literature circles, those kinds that I haven't been treated to for a long, long time. I would have the bad luck to run into these cultural critics and university researchers and their boastful audacity and unique brand of ignorance. They are shameless people with one foot in the system and the other out the door. China is so unfortunate, it's almost impossible to find a decent person rubbing elbows in these types of circles; phonies are everywhere, with wannabe phonies hovering around them.

Before leaving, I very clearly told all the people at the forum my opinion of this stupid ass. He screamed out that I didn't understand literature; I replied: 'I don't understand literature, but how could I not understand that you're a tool?' It was the first time I used the term 'SB'. Mysteriously, at that precise moment, I just couldn't find a more suitable word.[7]

Perhaps it's because I've been surfing the web too much lately, it must be rubbing off on me. But with this I swear, from this moment on, that term will become a specialized bit of my vocabulary. I'll never use it on another person. In addition, I need to remember: never again appear at any horseshit culture forums. Cherish your mind, stay away from ignorance.[8]

Grief
Posted: 22 May 2008
Translated by Lee Ambrozy

Silence please. No clamour. Let the dust settle, let the dead rest.[9]

Extending a hand to those caught in trouble, rescuing the dying, and helping the injured is a form of humanitarianism, unrelated to love of country or people. Do not belittle the value of life; it commands a broader, more equal dignity.

Throughout these days of mourning, people do not need to thank the Motherland and her supporters, for she was unable to offer any better protection. Nor was it the Motherland, in the end, who allowed the luckier children to escape from their collapsing schoolhouses. There is no need to praise government officials, for these fading lives need effective rescue measures far more than they need sympathetic speeches and tears. There is even less need to thank the army, as doing so would be to say that in responding to this disaster, soldiers offer something other than the fulfilment of their sworn duty.

Feel sad! Suffer! Feel it in the recesses of your heart, in the unpeopled night, in all those places without light. We mourn only because death is a part of life, because those dead from the quake are a part of us. But the dead are gone. Only when the living go on living with dignity can the departed rest with dignity.

Live frankly and honestly, respect history, and face reality squarely. Beware of those who confuse right and wrong: the hypocritical news media so adept at stirring passions and offering temptations; the politicians parlaying the tragedy of the departed into statecraft and nationalism; the petty businessmen who trade the souls of the dead for the false wine of morality.

When the living stray from justice, when their charity is only meagre currency and tears, then the last dignified breath of the dying will be erased. A collapse of will and a vacancy of spirit render that fine line between life and death's realm of ghosts.

This emptiness of collective memory, this distortion of public morality, drives people crazy. Who exactly died in that even bigger earthquake of thirty years ago? Those wrongly accused in the political struggles of recent history, those labourers trapped in the coal mines, those denied medical

treatment for their grave illneses – who are they? What pain did they endure while alive, what grief do they provoke, now dead? Who before them cried out for these suffering bodies, these troubled souls? Where are the survivors who belong truly to them?

Before we let murky tears cloud our already unclear vision, we need to face up to the way the world works. The true misfortune of the dead lies in the unconsciousness and apathy of the living, in the ignorance of the value of life by those who simply float through it, in our numbness toward the right to survival and expression, in our distortions of justice, equality, and freedom.

This is a society without citizens. A person with no true rights cannot have a complete sense of morality or humanity. In a society like this, what kinds of responsibility or duty can an individual shoulder? What kinds of interpretations and understandings of life and death will he or she have? The samsara of life and death in this land – has it any connection to the value of life in the rest of the world?

As for all those organs of culture and propaganda who subsist on sucking the blood of the nation – what difference has their largesse from larceny? No one wants the charity of parasites; their greatest kindness would be to let themselves die off, just one day sooner.

Does the Nation Have a List?
Posted: 28 July 2008
Translated by Lee Ambrozy

The headlines this morning read: 'Wenchuan has announced it will establish an earthquake memorial.'

The Vietnam War had a profound effect on the United States; it caused the kind of pain that cuts deep; and ten years after the conclusion of the war, they erected a memorial bearing the engraved names of more than 58,000 departed soldiers on a field of grass in Washington, D.C. As for the affairs here, all we get is a statement from the top such as the one above, and the excited clamouring of a pack of expert bastards kicking up a fuss. As you can imagine, this memorial isn't preparing to accurately record the actual events. Historical facts were altered even before they were allowed to run their full course.

Even more impossible would be holding a memorial service for those who died as a result of carelessness. A dessert course of covering errors and singing praises will follow this feast of a disaster. The casualties are countless, except for one 'tenacious pig' who emerged after surviving under quake rubble for forty days. No one asks about the shoddy 'tofu-dregs engineering'; instead, we blindly accuse 'running teacher Fan'.

Nationalism is only a fig leaf for the feeble-minded, a tricky manoeuvre that prevents everyone from seeing the complete picture. As for those who have perished in the calamities over history, their survival or their deaths will only be forgotten, and forgotten in disgrace, even though such disgrace is deserved more by those who survived them. Justice is only selectively upheld, and tears may flow only seasonally. Hypocritical and exaggerated tears add to the charitable contributions, but cannot in the slightest amount abate the penetrating numbness and ignorance that comes with life, they cannot pardon the hypocrisy, those despicable things that course in their blood.

How many people were actually killed and wounded in the Wenchuan earthquake? How did they perish, and who should shoulder the blame? Confronted with this question, the responsible Ministry of Education and Ministry of Architecture are refusing to answer; they want to eternally play dead.

The parents of those schoolchildren are helpless, even though everyone now knows what happened, and why death descended upon those children. All this was predestined: this was their reality, the only reality they might encounter. In their reality, there is no alternative fate, no other voice or alternative hand that might lead them on the path to fairness, or extend to them even the slightest bit of justice. They are saying, 'It wasn't just a natural disaster', but who pays attention? The response is: 'We cried our eyes out when it was time, we donated with all of our strength, what else do you want?'

Pain comes not only from the loss of flesh and blood; it can also arise from an indifferent world refusing to help, or from the enormity of a hypocritical social hierarchy. In this hierarchy, personal feelings are negligible, are powerless victims of a necessary sacrifice, unrelated to the severity of the loss. Helplessness arises from the neglect and mocking of personal feelings, public opinion, morality, justice, and rule of law.

In this world, there are only two kinds of history and reality, two kinds of institutions and governments: the ethical and the nonethical. The standard for evaluation is the attitude with which we treat life. In a society without democracy, there will be no space for the masses to speak their minds, and no possibility of safeguarding the power of the people's livelihood – the result is a deceitful and degenerate reality. The masses don't need pity after injury; they need even more a strong institution of self-protection, they need to know the facts, and they need action, the power to participate and refute.

It's easy to say that democracy is good; it protects the weak. Within any other system, the majority of weak populations have difficulty gaining protection. Only in democratic societies is it possible to return power and dignity to the weak and impoverished. Don't make decisions on behalf of the people; let them take their own initiative. To give them back their rights is to take responsibility and return their dignity to them.

Who will answer for China the question of exactly how many students died as a result of these tofu-dregs schools? And to the villains in Sichuan: does this really require concealing state secrets? Is it really so hard to tell the truth, about even such things?

1. As the mysterious disease SARS was spreading in late 2002 and into early 2003, Dr Jiang Yanyong (b. 1931), chief physician at Beijing's 301 Military Hospital, sent an email to Chinese news sources breaking the news that SARS deaths were drastically understated by the government. His warning eventually spread to international news sources, and led to an eventual panic on the mainland. It is widely believed that Dr Jiang's exposure prompted the Chinese officials to deal actively with the spread of SARS, preventing it from becoming a pandemic.

2. According to Ai, this particular cultural forum was a roundtable discussion that brought together so-called 'left-wing scholars' to discuss current trends in culture and literature.

3. Shanghai's Xintiandi, literally 'new heaven and earth', is an outdoor shopping, eating, and entertainment district built in a district of refurbished traditional *shikumen* houses. Opened to the public in 2003, the area has been billed as one of the first 'lifestyle centres' in China, and hailed as an example of historical preservation for its adoption of the surrounding *shikumen* neighbourhood.

4. Zhu Dake (b. 1957) is a cultural critic, author, and blogger based in Shanghai.

5. Yu Hua (b. 1960) is a Chinese best-selling author. His books include *To Live* (1992), which was later made into a film by Zhang Yimou and banned on the mainland, catapulting the author to fame. Yu Hua's other works include *Chronicle of a Blood Merchant* (1995) and, most recently, *Brothers* (2005), a historical satire about the Cultural Revolution.

6. Xu Jinglei (b. 1974) is one of the mainland's most popular actresses and director of three feature films. She also maintains a highly influential blog and a successful online lifestyle-fashion portal. In May 2006, her blog (also hosted by Sina.com) held the number-one spot among Chinese language blogs for a few months.

7. 'SB' is internet usage for *shabi*, a vulgar expression insulting someone as ignorant or dim-witted.

8. Eventually, forum organizers turned off Ai Weiwei's microphone, so he threw it and stormed out, effectively leaving China's cultural elite shocked. This was Ai Weiwei's first and last such 'cultural forum'.

9. On Monday, 12 May 2008, an earthquake of magnitude 7.9 and lasting about two minutes struck Sichuan Province; its epicentre was in Wenchuan county, eighty kilometres north-west of the provincial capital of Chengdu, and thus it is known as the Wenchuan earthquake (*Wenchuan da dizhen*). Official figures (as of 25 April 2009) confirmed 69,225 dead, 374,640 injured, and 17,939 missing. The disaster also left an estimated 4.8 million people homeless, although some estimates put the number as high as 11 million. The Wenchuan earthquake was the deadliest earthquake to hit China since the Tangshan earthquake in 1976.

All posts from Ai Weiwei's blog were edited by Lee Ambrozy and published in *Ai Weiwei's Blog: Writings, Interviews, and Digital Rants, 2006–2009* by MIT Press in 2011.

A FAIRYTALE BECOMES REALITY

Fu Xiaodong

FX: Why 1,001 people?

AWW: I was mountain-climbing in Switzerland, and watched a huge number of Italian tourists pass by, dragged down by their small children. It made me think of taking a group of high-strung Chinese on a journey. That seemed like a more complete slice of cake, and such a slice would include all the special elements of the cake itself. This was also the reason why I didn't choose fifty or one hundred, the amount had to achieve a specified quantity. The features of status, age, and participants coming from almost every province and region influenced the characteristics of this cultural development exchange.

FX: Which of these participants are you most interested in?

AWW: I'm interested in all living people, anyone who can open their eyes, anyone who wants to go out and breathe fresh air, people who come home at night with sore feet, who want to add a blanket to their bed, people who don't want to feel cold; they are all

extremely interesting to me. The participants will also encounter the issue of how quickly they will find their place in a completely new environment. You should understand the community you are located in, and the relationships between different communities. You can only know what yellow people are like once you've seen white people or black people.

FX: The participants of *Fairytale* responded to a questionnaire of ninety-nine questions that touched upon religion, beliefs, East-West cultural differences, etc. Why did you set up such an examination?

AWW: The questionnaire was an interim practical procedure. I wanted to affirm to these people that we were earnestly at work, we weren't joking around. Leading them in by beginning to think about issues of Western cultural background and their own personal situations was related to the nature of the entire artwork. The farmers just wrote, 'I don't know', but as long as they complete the entire questionnaire and sign their name at the bottom, that illustrates that they are identifying with the activity. This must be voluntary.

FX: What other works have you developed in correlation with *Fairytale*?

AWW: With the participation of almost twenty directors from China and overseas, we completed a documentary that follows some of the interesting and daily experiences in China, and the various mental and physical efforts and costs that they expended over the course of their participation. This included their collective life experiences, their expectations and anxieties, their goals and present conditions, education, and families. The source material is already in excess of one thousand hours. We will also publish a book, a book of interviews with people who participated in *Fairytale*, to give them an opportunity to speak out on the Chinese plight during this time, and there is also a photographic record. I don't know what will become of it; I generally don't think too far ahead.

<u>Fairytale Luggage</u>, 2007
documenta XII, Kassel, Germany
Fabric, plastic, steel
Each suitcase: 57 × 22 × 38 cm

FX: And you also distributed matching suitcases to all the participants.

AWW: Right, we also designed some products. I don't want this to become a big art display, which would be paradoxical to the entire significance of the work. I want to disturb the day-to-day life as little as possible, preserving original habits and rhythms. At the same time, there should also be a feeling of consensus among the participants. There are a few necessities, such as beds, sheets, blankets, pillows, partitions, and we want to make the room into small private spaces. Living in this unfamiliar city, certain tools that constitute historical memory and special status are important; for example, 1,001 chairs, suitcases, and USB bracelets. These symbols that attest to their status are linked to a definite self-confidence and sense of pride. The details aren't important, but without them it would fall apart. There will be no identical experiences on this collective journey.

FX: After arriving in Kassel, none of the *Fairytale* participants were required to participate in any collective activities. Everyone thought this was strange.

AWW: I don't want to fall into any conventional patterns. The integrity and crispness of a work have continuity with its original motivation and the means by which you complete it; it lies in control. Choosing not to include something is more important than including everything. When we don't do anything, the work is extremely large; if we were to do something, the quality of the work would change.

FX: The media published a figure of 3.1 million in investments. How will you deal with reclaiming all that capital?

AWW: I signed a contract, which was in German, and although I still haven't read it, I know that it doesn't limit me too much. Until now, no one has inquired about my logic in using the funds. They trust in my art and gave me a lot of freedom; I

Fairytale Portraits, 2007
Participant 067
1,001 Chinese visitors, C-print

Fairytale Portraits, 2007
Participant 150
1,001 Chinese visitors, C-print

also respect their trust. Reciprocation is an issue that I will inevitably be forced to consider.

FX: The project has already been under way for five days. What will you do for the remaining month?

AWW: It seems like it's been so long, and it's only been five days. To tell you the truth, every day is quite dizzying; I don't have too many thoughts. This car will move forward for a bit longer, and will roll to a stop wherever it should.

FX: Why is *Fairytale* receiving so much attention from the Western media?

AWW: First of all, *Fairytale* was one of the 100 *documenta* projects that went public rather early. It was instantly public when I recruited people on my blog. Second, this work is predisposed to discussion; anything – including the participants' status, how they were chosen, the funding – all exceeded the usual scope of an artwork. The state of the participants, their reasons [for participating], and significance all directly touch upon society, politics, and cultural background, so it became an interesting

story for all major European newspapers, magazines, and television stations. There has never been such a great volume, such length of articles or depth of reporting. If you search '*documenta*' online, three out of every ten articles is about *Fairytale*. My friends all tell me that no work has ever received such positive reporting, most of it on its novel concept, the work's integrity, and how thoroughly it took shape.

FX: At the same time, this work has attracted tremendous curiosity from Westerners.

AWW: Even though none of it was premeditated, I have run into at least a hundred people who have expressed their interest to me. This work is so simple that anyone can understand it. The elderly, common citizens, ice-cream salesmen, all have said they like it, said it is interesting. One person said it was poetic. But I don't intend to have them say any more, or bring in any academicism. The artwork is a medium; that it gives pause to people with no interest in contemporary art is enough to make me amazed. This has evidently influenced their lives. The media is always hoping to find more possibilities, but they are still incredulous, even when I tell them I don't have anything else.

Fairytale Portraits, 2007
Participant 998
1,001 Chinese visitors, C-print

Fairytale Portraits, 2007
Participant 561
1,001 Chinese visitors, C-print

FX: What kind of effect will this discussion and dissemination have?

AWW: In my experience, living overseas for more than a decade, the intensity of dissemination far exceeds any effort at cultural exchange. There has never been such an interest in the Chinese people; when people talk about them, their eyes light up, and they have a different expression on their face. But all of this will be over soon, and in the end it will only be a legend … there was once a madman who brought 1,001 madmen here. Although the media are applauding, the significance of *Fairytale* has not yet been truly understood; every time, I still have to express my thoughts clearly. In the future, a long time from now, people will understand these implications.

FX: Do these Chinese masses from across different social strata reflect any social issues?

AWW: *Fairytale* is more oriented toward personal experience and individual awareness. The logo is written '*1 = 1,001*' because the personal experience, individual status, and imagination are the most

important, are irreplaceable. The work itself was designed for each person's participation; there was no added concept of the collective will. The majority of artists use crowds to accomplish a particular form, but *Fairytale* is the precise opposite. Later I realized this was also one of the characteristics that allowed *Fairytale* to achieve such broad identification. It doesn't require things to be represented in artistic form, but requires art to be life, normalized. This is an interrogation of art itself, and I finally have an opportunity to realize this.

FX: Compared to your previous works, *Fairytale* demonstrates an enormous transformation of form.

AWW: It has similar connotations, joining two or more elements together, but of course the materials and the scope that it touches on are completely different. This time it involves people: the producers and the appreciators of art have been merged into one. People have become a medium, and are also the inheritors, beneficiaries, or victims, and this adds to its complexity. But it is still consistent in asking fundamental questions about culture, values, and judgement. *Fairytale* is another kind of artwork. Can

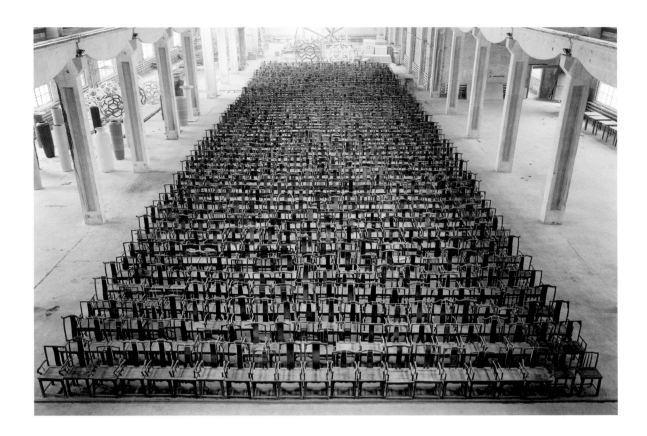

we continue to believe that art hasn't yet died? No matter if it's social or psychological resources, or our understanding of life and culture, people are all in a state of crisis. The desire to transform, redefine, or use alternative methods is already a normal state. I'm just thinking how I can continue on with my personal game. If you can't continue, no one will continue to be interested in how you play your game. This is all pretty normal.

FX: Are you satisfied with the work?

AWW: I'm dissatisfied with all my works. I'm not trying to please myself, and I'm not trying to achieve any goals. Artworks themselves inspire people with a sense of reality. For example, a criminal might commit murder in order to quench his desire to kill himself. Artists creating works are in a similar state.

FX: What is your personal role in this work?'

AWW: Usually I play a very active role in my works, that of a definite producer. *Fairytale* is the exact opposite. I cannot determine the state of each participant; I'm not acquainted with most of the people, and even if I were, I don't understand them.

This is also what I like about it. This is the first time one of my works has such a great sense of uncertainty, potential for development, unpredictability, and an uncontrollable nature. Every day I have to solve new problems, things that I've never considered before. I'm not a producer, or leader; it's more like I'm an observer who watches what methods are changing the work. I'm a student, and I'm more alert than others.

FX: *Fairytale* is a work embracing various cultures, religions, and concepts. What standpoint are you maintaining?

Left:
<u>Fairytale Chairs</u>, 2007
1,001 Qing Dynasty wooden
chairs (1644–1911)
Different groups spread over
documenta XII exhibition venues
Dimensions variable

Above:
<u>Fairytale Dormitory</u>, 2007
1,001 Chinese visitors
Gottschalk-Hallen, ladies dormitory
Mixed media

Fairytale Dormitory, 2007
1,001 Chinese visitors
Gottschalk-Hallen, ladies
dormitory
Mixed media

AWW: I don't have a standpoint. I'm just very willing to watch a group of contradictions naturally emerge. Just like dusk, which is inevitably in relation to your position on earth, and the rays of the sun, the clouds, and air humidity are all contributing elements. Though that's not to say that dusk is meaningful, only that people can endow it with significance.

FX: From the early *White Cover Book* and *Black Cover Book* of the 1990s, which saw Chinese contemporary art begin its feral state of affairs, to the *Fuck Off* exhibition of 2000, when art in China achieved its legal status, is it possible that *Fairytale* will represent a crucial turning point when art from China captures the international stage?

AWW: I think that for a work to become a cultural event, it must possess numerous independent elements. Whether it is the way you express the form and language, or the basic vocabulary that constructs it, all should possess their own individual characteristics. Although *Fairytale* is an enormous work, it still manifests the will of a place, and the way that it expresses personal existence could even be

described as anti-global. The majority of the people participating don't understand the Anglo-German language system; they don't have any knowledge of contemporary art, and are anti-cultural. These two contradictions comprise the enormous core conflict this work has with contemporary global culture, politics, and economics.

FX: Do you think there is any continuity between these?

AWW: There are two features: the first, although I say I'm not concerned, expresses some doubts about the cultural plight and about culture itself. With the second, everything is discussing the initiative and possibility of the individual within the larger context, presented in an extremely individualized tone, and in the final analysis is searching for individualized means. Of course, as soon as you present distinctive features, limitations appear.

FX: What are your thoughts on the backdrop that this era provides?

AWW: We are living in an era that is completely different from any before. This era will ruin all the former systems, powers, centres of discourse, and thus produce a complete system. Via digitization, the internet and other new methods of propagation, via the consequences of a political economic structure of globalization, the relationship between individuals and the system of rights will see fundamental change. Similarly, the art of human consciousness and emotion will also face new language methods.

FX: What political standpoint do you want to express with this work?

AWW: My political standpoint, if I have one, is individualism, anti-power, and anti-value standards that have been formed around profit. The best mutual value systems at work in the world are often accomplished on the basis of some kind of profit.

In most circumstances, they are all simple and crude, and they are unconvincing, whether they are economic or cultural.

FX: Can you talk about your work with the doors in *Template*?

AWW: It's better to talk about just one work; we could continue discussing *Fairytale*, to discuss it more intact, otherwise, we'd talk about everything, and that's irritating. Maybe next time we can do an entire interview on *Template*. There's not much to talk about with sculptural installation works, they're not that interesting; it's just a thing, even though a lot of people are saying this is the work with the most impact in the exhibition. But I think it's pretty boring; whether or not the work is my own, I'm not that interested. I suspected that it might fall, or lightning would strike it or something, or it would burn down …

This interview was originally published on Ai Weiwei's blog on 20 July 2007, and was reprinted in Lee Ambrozy (ed.) *Ai Weiwei's Blog: Writings, Interviews, and Digital Rants 2006–2009*, published by MIT Press in 2011.

A TALK WITH AI WEIWEI

Mathieu Wellner

MW: You described yourself as 'a person who does different things': sometimes it ends up being art, sometimes architecture – you can't control it, and you only realize later looking back on what you did. If you think about the last few weeks, what was your dominant occupation?

AWW: Last week, my dominant preoccupation was Fanfou, the Chinese Twitter. You write posts on events maybe every second, you make comments, talk to friends, you discuss. I'm immensely attracted by it, because you always have to be ready. It's very intense and you have to know what's happening on the outside on different levels. It can be very personal or it can be very political. It's like an individual broadcast. Last week, the officials shut off ten of my IDs on Twitter because I was receiving too much attention. The moment I got into it, I had thousands of people following me. I broke the record in term of numbers … In the beginning, I had two IDs that they shut off, so I used another identity. After a while they found out – they shut it off. So after ten different IDs, I'm still alive, but suddenly you realize that there are forty, fifty people named like me on Fanfou. Like: 'Ai Weiweiwei', or 'Weiwei Aiai', or 'Wei Aiai'. They all use my image, so they make the whole system very, very confusing. Nobody knows which one is really me.

MW: Blogging seems in general much more popular in China than it is in Europe. In democracies, the media monitor politics. In China, the media weren't effective in doing this, so the blogs took over their role to spread information and to discuss politics. You have a powerful voice that the government is trying to shut down. You were even arrested by the police – how was the tea at the police station?

AWW: Ha! That was a funny situation. But it's also sad what is happening in China, because our society is lacking platforms. It is very different from Europe: You have public and private. We have neither a public nor a private life. We don't have a choice – we're always ignored. That's very frustrating. Only since 2000, for the first time, have we had the means to really get information and to speak up with our own voice and discuss with people. It is absolutely outrageous.

The police came to me here and tried to use the old-fashioned way to convince me of their views. But they did not have any legal documents. So I told them, 'You have no right to talk to me.' It's worse than driving without a driver's licence. But nobody dares to check them — they are so powerful, like a secret police. So I called the police station, dialling 110, and made a complaint. I told them, 'I have a person in my house without identification. I want him to be out, but he refuses. Can you come over?' So they came. It was very funny, because of course they knew each other. 'It's our boss, here,' they said. 'Okay, so if this is your boss, you have to take him to the station. How about the two of you show me your identification?' The two guys acted very nervous. I asked them to show me their police badge, but they did not have one either. They said something about their jackets that were at their houses, so they would have to drive back to get them.

The whole night, we went back and forth. Four hours later, I walked out of the station. This guy didn't have the chance to tell me what he wanted to tell me — that was it. I wrote on my blog: 'Don't try to take me out for tea. I don't want to talk to you. We don't have common ground for discussion because our worldviews are really too different. If you want to see me, make sure you have the right to arrest me, make sure you bring handcuffs, and I will go with you.' They never came back.

MW: But this is still dangerous — the police could come anytime with legal permission.

AWW: It is dangerous, but if I don't react, it's also dangerous, because they can always bother and intimidate you. I'd rather use the tool of blogging to expose everything, to show it to all. It's like they're still hesitant on that matter. They have to find a good reason.

MW: Your father was a famous poet loved by common people. Is this maybe also protecting you?

AWW: I don't think so, because I am consciously trying to cut myself off from my father's past, my family's past. But it could be possible, because everybody knows who my father was. They all know he was the one who influenced many people to join the revolutionary fight for the independence of this nation, for justice and fairness, for change. So that could be an underlying reason.

MW: But maybe it's a combination: the myth about your father and the fact that you are known in the Western world?

AWW: Yes, I am very, very publicized in the West, but also in China. Not because of my art — I never really showed my work here. But a lot of magazines come to interview me; I am still one of the most interviewed people in China. They are not always asking me about political matters, but more about art, about architecture, about culture, design, or fashion. This makes me a public figure, and also, being quite successful as an artist, the government is a little bit hesitant because of that. People would ask why they were doing something to me.

MW: Still, it is a totalitarian system …

AWW: But you know, they are famous for making mistakes, so I don't take it for granted.

MW: Could you imagine leaving the art world for politics?

AWW: I don't think I could entirely stop doing art for politics, but I can imagine using my artistic skills entirely for politics ends. When we went quiet on the internet recently, we did it as an artistic expression. I know that in our constitution we are allowed to strike. In reality, China has not had a strike in the past sixty years. So we held a strike on the internet, and nobody could do anything about it because it was virtual, it was just us. So it was very personal and it wasn't something you could see. It really taught everybody

how you can react by restraining yourself, which is a very important act. I take the constitution and the political situation in China as a readymade. I transform it in my own way to show people the possibilities of this reality and a way to change. That, I think, is directly related to my art; it's the same thing for me.

MW:: You take it as a readymade because you know the constitution – maybe that is the point. Others don't say anything, don't question or criticize, because they don't know.

AWW: It's all about investigating the questioning. At the same time, there is a role reversal in order to make the impossible work – to make the function disappear. That is what I always do in my art, but it is absolutely a new way for me to practise it.

MW: Art and architecture are what you make for a living. But your civic engagement is what you do as a person?

AWW: For example, we did an investigation to find out about these dead Sichuan students. Who died, and why they died. And this investigation went into a very protected territory; it was like a national secret. We did it openly on our blog and posted the results every day. The whole nation was shocked and touched by the act.

MW: You are talking about the victims of the Sichuan earthquake in 2008?

AWW: Yes. People knew students had died, everybody knew that something was wrong – but nobody knew any facts or looked carefully to find out the names of the children who died: which school they were in, at what level, how old they were, female, male. Whatever we found out we posted on the blog. That already caused a revolution in the minds of people: you know, we found out over 5,000 names, by having 200 civil volunteers going door-to-door to talk to the parents. The volunteers got arrested

over thirty times by local police, they took their fingerprints and photos. But the volunteers kept diaries of everything, which I posted on the internet. This investigation will be remembered for generations as the first civil rights activity in China. So to me, that is art. It directly affects people's feelings and their living conditions, their freedom and how they look at the world. That's very important.

MW: Maybe the installation about the Sichuan earthquake that you are developing for your exhibition in Munich this autumn is a good example of how you combine the different levels of your work. As so often is the case, everything is linked: your political activities, your art, your blog, everything. Could you briefly explain the Sichuan tragedy and, from there, how you express this on the facade of Haus der Kunst.

AWW: The Sichuan earthquake happened in May 2008. During the earthquake, the most tragic part was that many schools collapsed with the children still inside. These dead kids reminded me of those fish you put in a can.

MW: Sardines?

AWW: Yes, sardines. It was exactly like that – hundreds, thousands – because of mistakes in the construction of the school buildings.

MW: Who is responsible? The state?

AWW: Yes, the state. The government made big mistakes – not intentionally, but everything is very corrupt. And on my blog I kept asking the same questions: 'Who is dead? How many? What are the costs? Where are the bodies?' Nobody ever answered.

MW: Not even the local press?

AWW: No, nobody. I thought: this is too much, this is not fair. These were children and they were part of us – how could we let it be? I had to ask those

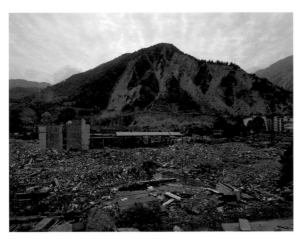

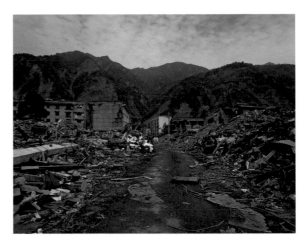

Sichuan Earthquake Photographs, 2008
C-prints

questions. I was vaguely thinking that I should do something for my exhibition at the Haus der Kunst, but I didn't know how to include it, didn't know how to present a tragedy in an artistic way. It's kind of difficult, but that is the reality for artists like me who are so concerned with social change. So, not to touch upon that topic was impossible – it would have made my actions seem questionable, separating my artwork from my struggle. So I thought about that very, very seriously, and I see the Munich show as the best answer I have to offer. The decision was made to find out for ourselves if the government would refuse to tell us the truth. We are the ones who demand the truth, and we can do it by ourselves, to show people how it can be done. Before we started we made over 200 calls to different levels of government ... always asking the same question: 'What are the numbers?'

MW: How many deaths?

AWW: Yes: 'How many, please tell us, we have the right to know.' And they said, 'No no no, you don't have the right. Who are you?' We would answer, 'We are individuals,' and they said, 'Individuals have no right to know. It is a state secret.' So we recorded those 200 phone calls and put them on my blog.

I only asked for one small act. As an artist, I'm always dealing with what I am familiar with, what we think is

safe, what we consider safe ground, but things are never what they seem. After that, I put a note on my blog: 'We are starting a citizens' investigation.' We said, 'Respect life, bear the responsibility to exercise our rights, because we can't wait for anybody else to do it.' And by doing it ourselves it became a reality. The effort to find out the number of the dead was our struggle for the dignity of life. We asked volunteers to sign up. Then we sent them to Sichuan, from home to home, to collect the names of the missing children. I immediately found 300 people who wanted to join. They came from very different professions, very different locations. I didn't want them to be too emotional, so I designed a questionnaire with twenty-nine questions. Questions such as, 'Are you afraid of the dark? Are your stomachs ready for Sichuan food? Can you live by yourself in very uncertain conditions? Are you afraid of authority? Do you know what you're doing? Do you think that truth is important?' And the last question was: 'Are you sure this is what you want?' So we got very positive people and we made a selection, because some understood the local language and some didn't. We gave them money, just for their basic needs. Some refused it, but we initiated this and we'd rather bear the costs. The project was very successful; each day they sent back the names they found and still are doing so today. The names are very touching: You start to know who, what age, which gender, which school, and their parents, their telephone numbers ...

Sichuan Earthquake Images, 2008
C-prints

We eventually posted more than a hundred articles containing thousands of names on my blog. The whole nation was shocked, because people knew that there was something wrong, people knew that so many are dead, that it is unfair and unjust.

But to use our skill or our craftsmanship to expose the injustice, make it visible and so clear, is an act that an artist can do well. And it educated the entire nation: everybody started thinking, questioning their own positions, examining their means and what could be within their power. That represented the first act of the civil movement. Yes, do not just talk, do the work. We still have people down there, but we have come to the end; we have located almost all the missing people, more than 5,000 now …

MW: 5,000 kids?

AWW: Yes, kids. It's very sad, from three years old to eighteen, nineteen years old. And they are all single-case families; their parents are all powerless farmers. They all have been detained and harassed, and forced to sign some kind of an agreement to not ask about the wrongdoings related to the earthquake; otherwise they cannot get new payments and they cannot get into the new housing projects. So this is really a shame and a crime. Our volunteers send their diaries on a daily basis. They are all posted on my blog and everybody can read in detail how they were treated and which parents they can talk to, what is on the parents' minds, what problems they are having – which is completely different from the official propaganda. So, the officials are so scared: Sichuan Province sent the top officials from the educational, civil, and construction sectors – the leadership, so to speak – to come to talk to me for hours, trying to stop me.

MW: Really, they came here to Beijing?

AWW: Oh yes. This is the first time in communist history that they came to see an individual to try and negotiate. They told me their position, why this is so damaging for them. I explained to them clearly why I am doing it, the political reason for me to do it. Of course, nobody could convince the other, so we still argue. Obviously, they have all the power, so they shut down my blog. We cannot post any names now, but we have other channels.

MW: So you have found an alternative blog and use Fanfou and Twitter. Do you still put the names online?

AWW: Yes, of course. We are still running the investigation, but at the same time we are taking the next step by investigating the technical mistakes of those buildings: We sent out architects and construction engineers to try to gather all the evidence. It is very difficult, but we are working on it.

MW: What exactly is the link between this tragedy and your work on the facade of Munich's Haus der Kunst, where you will display a large number of backpacks?

AWW: Right after the earthquake, I went there to experience the feeling of the ruins. And then I realized that everywhere were these school bags of the children scattered around. You could see a lot of pencils, little mirrors and schoolbooks all over. And nobody picked them up, nobody cared.

MW: They were part of the ruins …

AWW: Yes. Because the bags were so vivid and colourful, they made a really strong impression on me. They are so closely related to the physical condition of the kids. That was all they had actually, besides their names. So I wanted to design a work of art related to that. At first, I wanted to cover the whole facade of the Haus der Kunst with those bags, to bring history into the current situation: the kind of life and death and the propaganda and the ignorance we are facing here. Now I am using the bags to form a sentence, which was stated by a dead student's

mother who wrote to me. She said, 'Every day they are still holding meetings with us, trying to teach us to keep quiet and behave harmoniously.' They also took away five yuan from her salary which they had awarded her before for having only one child. And that child is dead. It's so crazy! She wrote: 'I don't want to have their payment, because I don't think my daughter's life is worth taking those payments. All I want is for her to be remembered.' The sentence we will put up in front of the building is: 'She lived happily in this world for seven years', a sentence from a victim's mother. She is very kind, she does not have much to say about all this and she just wants her daughter to be remembered. And of course we see all kinds of tragedies in this world, but I think the worst tragedy is disrespect for life. And the victims are always young children or women.

MW: The weak!

AWW: Yes, the weak. The ones that don't even know how they got involved in all these tragedies. So it's a political statement, but at the same time I wanted it to be accessible – that's why we chose the colours of Toys 'R' Us …

MW: A vivid colour range.

AWW: Yes. We made it very clear and simple. We are not too artistic about it. But I think it's a statement, yes.

MW: And with this exhibit, the Sichuan story will be discussed and remembered in Europe.

AWW: I hope so, and I think it should be discussed.

MW: You spread it worldwide.

AWW: I do my best. This morning I read the sentence: 'Because we are alive, we have to make our best effort to announce it – for them, but also for us, because we are inseparable.'

MW: Chinese culture is probably the greatest in history. But it has sustained some extreme blows in the last century: The protest of 4 May 1919, a second blow by Mao in 1949, and finally his Cultural Revolution 1966–1976. You were nineteen years when, in 1976, your father was 'exonerated', and a young student when, in the 1970s, some Western influences became important. Li Xianting, who is called the father of the Chinese avant-garde, was just starting out then, along with other artists. This was when you left for the USA. How would you describe your relationship with this part of Chinese art history?

AWW: I left in 1981. That's why I had no contact with this movement in the 1980s. But even in New York the same kind of mental state prevailed. It was after the Cultural Revolution, we were fighting for new ways that would intellectually suit us, to establish a new culture and to discover individual possibilities. I am very impressed with your summation of Chinese contemporary culture; it is very precise. 4 May 1919 was like the birthday for a new culture in China. At that time, they had the idea to invite Mr Science and Mr Democracy into the culture. Ironically, even today, we still don't have those two guys in our country … So eventually it was old bottles with new wine. The oath is not working. The system has collapsed. The culture still functions in parts, but the structure has collapsed. And the new has never been established. First we had Marx, then Mao, and now, on one hand it is very liberal – a crazy capitalist madness and liberalism – and on the other, we have a very old communist structure here.

MW: But this extreme commercialization is less than ten years old! Looking at your life, it seems like a weird odyssey through extreme situations and extremely different ways of living. The situation has nothing in common with the situation you grew up in as a kid. The 1980s must have been an important phase for China.

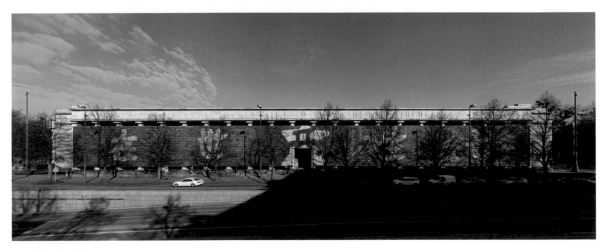

<u>Remembering</u>, 2009
Haus der Kunst, Munich
Backpacks and metal structure
920 x 10605 cm

AWW: For China, and for myself. This period prepared me mentally for all the possible struggles I'd have to face in today's contemporary world.

MW: But then came Tiananmen in 1989 …

AWW: Yes, and the results were so clear: The tanks and the bullets.

MW: I looked at this provocative series of you throwing down an antique Chinese vase. In the West you could go to jail for publicly destroying an object of cultural heritage.

AWW: In China, I did it while I am in jail. I always look at it that way.

MW: Are you also making reference to the Cultural Revolution with this? A time when there was a senseless destruction of old by the Red Guards.

AWW: Yes. You know, when we were growing up, General Mao used to tell us that we can only build a new world if we destroy the old one. That's the basic concept: destroying the old one to contribute to the new.

MW: Chinese art has been immensely successful during the past decade. The artist areas of Beijing, like the 798 District, became a part of the cultural map, they are on the tourist's circuit – they're kind of a Disneyland of the art world with cafés, restaurants, and fashion shows, where East and West meet. What do you think about these areas, and do you participate in any of them?

AWW: No, not even in 798. I don't go there at all for openings or anything. I think you have to look at them from two perspectives: First, we have had a strictly communist regime for more than sixty years – this year is the anniversary. Freedom of expression absolutely does not exist in the public space. If you want to open a gallery, you have to go

to a public security bureau, because it's classified as propaganda. Every image has to be shown to the security administration and they will say, 'Okay, that one', or 'Change it before the show.' On the other hand, we have an entirely capitalistic economy today, which is justified by 'anything that sells'. So you have these two conflicting viewpoints coming together that make these artists' areas attractive and create the demand of the Western world, which wants to see some kind of contemporary activity there.

MW: But it's a really weird situation. It looks like a Chinese SoHo, with artists working in public and their workshops accessible for everyone. But at the same time, there is a little Mao exhibition and the police are around.

AWW: The booming art scene is not real. They're pretending the boom. It is really trying to serve a dish to the observer rather than allowing true creativity, which can be much deeper and darker and unpredictable … It is heavily watched, and it's very nervous under the surface, even though the police don't know what they are looking for, but still. They think to maintain a kind of order is the mission of the state.

MW:: There were other areas, like the legendary artists' place next to the summer palace, the Yuanmingyuan, which used to be a free artists' space. It was different from the situation now.

AWW: Yes, but you know, to be an artist here back then was very difficult. You had no place to show, nobody talked about it and there was no way of selling work. That didn't necessarily make the art any better, but at least it made it much less tempting to sell out and much less commercial.

MW: Your work has been presented in many different ways: in your shows like at *documenta* or at the Haus der Kunst in Munich, you were given a lot of freedom and independence – a kind of carte blanche to do whatever you want.

<u>Sichuan Name List</u>, 2008–2011
B/W-print

AWW: I think traditional galleries, museums, or institutions that show art as such are like dead bodies of past wars. But the Haus der Kunst is showing the killing field.

MW: The what?

AWW: The killing field. The artist has to struggle, he may even hurt himself or do damage to others. The title of the exhibition is *So Sorry*. It's a beautiful title suggested by [director of the Haus der Kunst] Chris Dercon. It comes from how we look at the world: it's a world of rationality, a result of our logic, it's the result of results. It's everything … We are not really controlling it, even if we might think we are. It's about how we look at the world, how we look at it as humans or as artists functioning in the world – you know, your own performance and the performance of others. You want to be understood this way or that.

MW: Most of your projects are initiations. Is your work, as Hans Ulrich Obrist put it, 'art as an excuse for dialogue'? Do you enjoy the many collaborations with others?

AWW: I think art is an initiation, which means that you want to be the innocent one: you want to reach out your hand so somebody can lead you. The event can lead you somewhere and you can say, 'Let's go.' I think artists always play with people who want to walk into unknown areas, into uncertainty.

MW: You took this idea quite literally by bringing 1,001 Chinese to Germany for *documenta XII* in 2007; you opened up a new world for them.

AWW: Yes. However, to bring 1,001 Chinese to Kassel is one side of it. But to see how difficult it is for a mountain lady to get the permission for a passport; to see how they are worried about spending five yuan to go to the next town to take a passport photo and how nervous they were about taking that photo … Also, to see those ordinary citizens in Kassel, jumping off their bikes to talk to you and tell you that they don't know anything about art – I think that is a beautiful thing. That makes the project worthwhile. Nobody is a genius. It is just a suggestion until a taxi driver stops just to say something to you and then you realize: Oh, art does have this function of communicating and that is interesting.

A version of this interview was originally published in *MonoKultur* in Autumn 2009.

'THE NET OF LOVE CANNOT BE BLOCKED'

Daniela Janser

Ai Weiwei used to blog, and still tweets, only in Chinese. As such, his many and eloquent online statements do not open a window to the rest of the world and to the internet-loving West, but are addressed solely to a Chinese audience, or to those who understand the language. According to Ai himself, he spends up to eight hours a day online, mainly on Twitter. He began in 2005, when the Chinese website *www.sina.com* made him the offer of hosting a blog. It took some effort to persuade him, but once he embraced the new medium, he quickly became a prolific and enthusiastic blogger with a huge following. He covered a wide range of topics and text types, from architecture and town planning to portraits of fellow Chinese artists, from poems and aphorisms to social criticism, political dissent and polemical rants.[1] What is more, he posted reams of photographs on his blog.

In early 2009, his already enormously popular blog was closed down when he used it as a platform to urge investigations into the exact death toll of the earthquake that had rocked Sichuan province on 12 May 2008, in which many of the victims had been children buried under the rubble of shoddily constructed public-sector schools. Even before that, however, Ai Weiwei had been closely monitored and his blog heavily censored; the list of young student casualties of the earthquake that he had posted as a result of his 'citizen's investigation' was repeatedly deleted. When he sought to testify for one of the people who had been researching the issue, he was beaten by the police. Barely a month later, he had to undergo emergency brain surgery for a cerebral haemorrhage. Since the spring of 2009, Ai Weiwei has been microblogging on Twitter.[2]

The following outlines, in six thematically distinct sections, the writings that Ai Weiwei has published in his blogs and tweets. Given that he often posts as many as a hundred tweets a day, this is, of course, only a provisional inventory of sorts. For this reason, I wish to focus on placing his prolific online activity in context: Chinese media censorship and web

culture on the one hand, and, on the other hand, the political potential of these online platforms and the key differences between internet use in China and in the so-called Western world. A few theoretical, political and art-historical comparisons will be used to shed more light on Ai's blogs and microblogs.

It is far too simplistic to talk of 'China' and 'the West' as two more or less static and opposing blocs. Nevertheless, it is worth pointing out a few crucial differences that go some way towards explaining Ai Weiwei's internet enthusiasm and blogging activism. Whereas, in the 'Western world', increasing numbers of books and articles are warning of the dangers of excessive internet surfing and constant displacement activity online at the workplace – especially with regard to the so-called data-tsunami of emails, news and communications on social platforms such as Facebook and Twitter – the publishing, networking and information potential offered by digital communication is embraced with almost undiluted enthusiasm by Chinese activists. Bewildered ambivalence on the one hand meets boundless excitement on the other. In his polemical treatise *Payback* (2001), prominent German internet sceptic Frank Schirrmacher called for us to regain control over our thinking and our faith in free will. And he doubled down on that in an interview, saying that 'the internet messes up our brains'. Ai Weiwei, by contrast, can barely contain his delight: 'The net of love cannot be blocked' – 'Democracy and freedom are highest in efficiency, the internet is their guard' – 'What is freedom of speech? Twitter is.' Meanwhile, Twitter founder Jack Dorsey has achieved almost mythical status in China. Not only are these two viewpoints with regard to the internet in general (shaped, of course, by very different circumstances, respectively) diametrically opposed, there are also measurable differences in terms of content, on the level of individual tweets, for instance.

Whereas the 140-character limit on Twitter provides little leeway for expression in most languages, it is actually the equivalent of up to 140 words in Chinese. Needless to say, that allows far more complex messages to be sent than in, say, German or English. Indeed, a number of Chinese-language Twitter accounts (accessible only via proxy sites in China), including Ai's, are frequently used for purposes of political activism, revelations, and poetically veiled allusions to current issues, and thus go far beyond the scope of banal comments on everyday emotions and events.

When the first stirrings of a democratic movement began in China in the late 1970s, just a few years after Mao's death, tentatively promoted by a Politburo in the throes of change, the so-called Democracy Wall played an important role. The wall was located on busy Xidan Street in Beijing, where passers-by would post notices, comments and complaints about the political system. The critical remarks, however, soon became a thorn in the side of the regime: the wall was torn down and many of those who had posted their criticisms there were given lengthy prison sentences. At the time, the twenty-two-year-old Ai Weiwei was a member of the avant-garde The Stars artists' collective which organized open-air exhibitions as well as demonstrations at the

An image of Ai Weiwei as a one-year-old in the Dongbei region of China serves as the artist's profile picture on Twitter

Democracy Wall.[3] Many years later, he created virtual reconstructions of the Democracy Wall, first on his blog and later using his Twitter account: a public online notice board where people could exchange opinions and post commentaries and information.

While the Democracy Wall provided a political and historically specific blueprint for Ai's blogs, Hans-Ulrich Obrist has likened Ai's online statements to a form of social sculpture in the spirit of Joseph Beuys. It is a comparison that aptly places Ai within an expanded art context that defines the artist in terms of his social actions and public statements. Art and politics dovetail in a way that frames the blogger Ai as a social sculptor or, more precisely, as a sculptor committed to using words and thoughts as the materials, and online statements as the tools, with which his worldwide artwork of a 'better society' is hewn. Or, more succinctly, in Ai's own words, 'I think art won't have too grand or too much of a future if it fails to connect with today's lifestyles or technologies.'[4]

Karen Smith has fittingly compared Ai's blogs to a traditional public marketplace where everything that anyone might be interested in is available, from the education of their children to works of art, politics, death notices, news, gossip, business, advice, photos and sexual innuendo.[5] All can be exchanged in a huge, busy forum where people meet and strike up conversation. God Ai or Uncle Ai, as his Twitter friends affectionately call him, appears there not only as a mentor, like a real-life uncle whose advice is sought on all manner of life choices (whether or not someone's son should study in Germany, or what the future of China might be), but also as an astute self-publicist and one-man search machine who provides documents, images and information on sought-after topics for open debate in the tiny 'free republic' of his Twitter account. And given the amount of energy and meticulous attention to detail that goes into gathering and posting information and evidence about mysterious deaths and other suspicious incidents, Ai's Twitter account can also be regarded as a kind of miniature Wikileaks platform, with documentation and evidence countering the sanitized official versions of certain events (arrests, murky judicial processes, scandals such as those involving tainted milk powder or the 'tofu' school buildings in Sichuan). Other information that goes largely unreported by the state-controlled media is also posted: popular uprisings in other countries, internet censorship, riots, police violence and the surveillance of activists in China itself. And so the transparency of the internet places the surveillance state itself under surveillance.

Internet censorship in China is difficult to describe because the situation is constantly changing, sometimes quite suddenly. One thing, however, is certain: the Chinese state is very much a presence on the internet – not just in the role of censor, but also as author and hacker.

The excited barrage of motley tweets, often as lively as a Bakhtinian carnival, forming an anarchic and irreverent counterpoint to the prevailing order of things, can suddenly be transformed into a solemn memorial for the dead, when a list of the schoolchildren who died in the earthquake is published on their respective birthdays. A multitude, in the sense defined by globalization theoreticians Michael Hardt and Antonio Negri, has grouped around Ai's Twitter. It is an open network of individuals and text fragments by various authors forming a loosely woven tapestry of relationships that are creatively and collectively invoking a process of democratization in writing. And not just in China.

Cao Ni Ma, 2009

Internet censorship in China is difficult to describe because the situation is constantly changing, sometimes quite suddenly. One thing, however, is certain: the Chinese state is very much a presence on the internet – not just in the role of censor, but also as author and hacker. In many instances, Chinese censorship functions indirectly. In other words, Chinese blog and website providers censor their authors and users themselves – in accordance with Politburo instructions. 'Dangerous' words and names are consistently deleted, related text passages or even entire websites are blocked, and certain terms simply cannot be found through search engines. That includes not only obscenities and criticism of the state, but also names such as Mubarak at the height of the Egyptian uprising or the word 'jasmine' in connection with the Jasmine Revolution in Tunisia. In China, online statements can lead to imprisonment.

At the same time, the Politburo is also present online in the form of the so-called Fifty-Cent Army. These are the party rank and file who are paid to post pro-government comments on all manner of topics in an attempt to control the online debate. Each comment or report of undesirable opinions is allegedly rewarded by the authorities with fifty

cents. What is more, dissidents' email accounts and other sensitive data are hacked and monitored, and the online activities of 'dangerous' individuals are kept under surveillance.[6] Various foreign social networking sites – not just Facebook and Twitter, but even YouTube – are not accessible to Chinese users unless they have the technical ability and knowledge of English to access them through foreign proxy servers, as Ai Weiwei does with his Twitter account. The censorship on Chinese microblogging sites – including Ai's 'old blog' (closed down in 2009) – can be circumvented by avoiding the use of certain words and by using a cleverly coded vocabulary.

It is often said that censorship and repression can inspire creativity – a bold and often misleading claim, yet one that sometimes has a grain of truth. In order to avoid 'dangerous' words, Chinese internet activists, especially bloggers, use a poetic, clever and constantly growing arsenal of euphemisms, allusions and internet memes that can slip past the censors. They often use homophones, i.e. words that sound (almost) the same. Probably the most famous example of this is the 'grass mud horse', which has become something of a virtual mascot among bloggers who are critical of the regime. The

A portrait posted to Ai's Twitter account, 2010

trick is that, in Chinese, 'grass mud horse' sounds almost exactly the same as 'fuck your mother' or 'fuck your motherland' – which would be censored not only on grounds of obscenity. Then there are also 'river crabs'; this is a codename for the state censors, because the word sounds almost exactly the same as 'harmonious' or 'harmonize' – the official description of censorship. Ai Weiwei, on learning in autumn 2010 that his Shanghai Studio was to be demolished, held a 'river crab banquet'. It was a clear jibe at the censors, as are the popular cartoons showing grass mud horses (represented by alpacas) victorious in battle against the river crabs.

Needless to say, new words have to be invented constantly, because the codewords are eventually recognized as 'dangerous' and censored in turn. A small online lexicon at *http://chinadigitaltimes. net/space/Grass-Mud_Horse_Lexicon* gives an insight into the witty vocabulary of the activists, full of irony,[7] euphemisms,[8] puns,[9] and allegorical imagery[10] that recalls a far older form of evading censorship and criticizing authority: the ancient fables. Another reference is the use of animal names to describe dissidents during the Mao era. There is even an echo of one of the most famous terms in Jacques Derrida's deconstructivist theories: *différance* – in which the use of the letter 'a' makes a small but important distinction that can be seen only in writing, whereas the spoken

word sounds exactly the same as *difference* with an 'e'. The bloggers' play on words can be interpreted, with Derrida in mind, as a struggle and differentiation in writing as opposed to the spoken word. The cunning ploy of using alternative characters denotes a conspiratorial, subversive and covert (because it is inaudible) difference that sets the bloggers apart from the language of power and censorship.

When protests and uprisings broke out in various authoritarian states across the Middle East and Belarus (in 2010 and early 2011), the media repeatedly mentioned the crucial role that had allegedly been played by Twitter and Facebook – a role that used to be played to some extent by printed matter such as flyers, posters and pamphlets. Some even euphorically dubbed the revolutions in Belarus, Iran, Tunisia and Egypt 'Twitter-Revolution' or 'Revolution 2.0'. A more circumspect analysis, however, indicates with hindsight that the influence of the social networking sites was often considerably less important at local level than these euphoric initial reports suggested.[11] More 'traditional' means of communication such as mobile phones and SMS actually played a much more important role. Among other things, this was often because access to Twitter and Facebook is not always easy in some of these countries. Indeed, many people there simply do not have any internet connection, let alone a Twitter, YouTube or Facebook account or a smart phone with internet access that would allow them to communicate online while on the move. What is more, Twitter, for instance, is not really suitable for covert mobilization and conspiratorial exchanges of information because anyone with access to it can read everything that is posted. Subsequent analyses of Iran's 'failed' Green Revolution came to the sobering conclusion that almost all of the bloggers so frequently cited in the Western media had not even been in Iran during the protests, but had been blogging from outside the country – even though some of them did have telephone contact with local demonstrators. Videos and photographs

taken with mobile phones and posted online did undoubtedly play a role – primarily in publicizing the situation and raising awareness outside Iran. In Egypt and Libya, the internet was actually closed down at the height of the first mass demonstrations – and yet the uprising still continued. Events unfolded in different ways in different places. On the whole, however, it can be said that the influence and potential of the internet tends to be overestimated in the 'Western' world, presumably because it plays such an important role in our everyday lives.[12] For the moment, we can only speculate on the influence of the internet as an electronic multiplier and a platform for mobilization, information and organization before people actually took to the streets. Similarly, we do not really know to what extent the famous internet activist Ai Weiwei, with his many Chinese followers and his prolific online output (including his enthusiastic tweets commenting on the uprisings in other countries), may or may not be able to influence and change the political destination of his own country. 'Can an Artist Change China?' asks the subtitle of *Never Sorry*, Alison Klayman's new documentary about Ai. It is perfectly plausible that the internet can indeed become the creative forum of dissident information and organization for the politically marginalized, anti-establishment thinkers who perceive themselves as free international netizens, blogging united against their oppression as citizens of any one country.

1. Some of these blogs are now available in English. See Lee Ambrozy (ed.), *Ai Weiwei's Blog: Writings, Interviews, and Digital Rants, 2006–2009*, MIT Press, 2011. See also various excerpts from Ai's blogs in this book.

2. Ai also often quotes and comments on tweets and questions by his followers or by people he follows. Volunteers translate some of these tweets into English and the translations are published on another Twitter account as well as a Tumblr account (http://aiwwenglish.tumblr.com).

3. Evan Osnos, 'It's Not Beautiful. An Artist Takes on the System,' *The New Yorker*, 24 May 2010, pp.55–63.

4. Hans Ulrich Obrist, *Hans Ulrich Obrist: A Post-Olympic Beijing Mini-Marathon*, JRP Ringier, 2010, pp.9, 12.

5. Osnos 2010, fn.3, p.60

6. James Harkin, 'Cyber-Con', *London Review of Books*, vol.32, no.23, 2 December 2010. Harkin quotes internet scholar and blogger Evgeny Morozov who points out astutely that whereas in the past authoritarian regimes arrested and tortured people to find out who their activist friends and allies were, today they merely have to look at their Facebook account.

7. 'Don't understand the actual situation' is used by the goverment to ridicule demonstrators by suggesting that they do not know why they are protesting. Bloggers have turned it around to describe incompetent politicians.

8. The phrase 'drinking tea' is used to indicate that someone has been arrested for questioning, and demonstrations are announced by inviting activists to a stroll.

9. Instead of describing dangerous text passages as 'sensitive vocabulary', bloggers write 'sensitive porcelain' – both are pronounced the same.

10. The word 'monkeysnake' sounds the same as 'mouthpiece' in Chinese – generally used to refer to the mouthpieces (aka monkeysnakes) of the Chinese government.

11. See Harkin 2010, fn.6; Evgeny Morozov, 'Iran Elections: A Twitter Revolution?', *The Washington Post*, 17 June 2009; Jared Keller, 'Evaluating Iran's Twitter Revolution', *The Atlantic*, June 2010; Golnaz Esfandiari, 'The Twitter Devolution', *Foreign Policy*, 7 June 2010; and many others.

12. On 28 January 2011, when the internet was closed down in Egypt, the *Huffington Post* ran a headline – 'Egypt Goes Dark' – as though it were akin to a power outage throughout the country.

This essay originally appeared in *Interlacing*, edited by Urs Stahel and Daniela Janser, and published by Fotomuseum Winterthur and Steidl in 2011.

THE DANGER ARTIST

Wyatt Mason

In late July, I flew to China not knowing what to expect, with one exception: I was sure, regrettably sure, that I wouldn't be able to speak with the person I needed to speak with, a man named Ai Weiwei. Who he is – and there's no shame in your not knowing; I was among the unenlightened until recently, too – it was my ambition to comprehend. And if I failed to meet the man himself, I hoped, at least, to see enough of the world he called his own to make sense of a matter of no small interest: why it is that not a few people of discernment now consider him to be one of the most significant artists working today; and why it is that the People's Republic of China considers Ai Weiwei to be, without question, a very dangerous man.

Day by day, though, in the astonishing heat and unthinkable smog of Beijing's punitive summer, my investigations took on a hopeless tinge. The more I learned about Ai Weiwei and his world, the more desperate to meet the man himself I became. By the sixth of my ten days in China, in a state close to heatstroke or dehydrated near-collapse, I did something unseemly. I had heard from a friend of Ai's – family names come first in Chinese – that he liked to go to a particular restaurant for brunch, a place he'd take his little son, who's 2½, and the boy's mother, who's not his wife. If I went there at such and such a time, I stood a good chance of seeing the man.

And so, yes, like some unprincipled paparazzo, I did stake out a bistro in a pleasant residential neighbourhood, sitting with Zhao, the young woman I'd hired to be my translator, the two of us looking for all the world like a couple dining innocently alfresco – as we shot sidelong glances at every patron who approached and passed on by. Surveying the restaurant, I could see why someone who'd lived in New York in the 1980s, as Ai had, would form a sentimental attachment to the place, why he'd want to bring his kid there. The menu options weren't exactly standard-issue Chinese breakfast: eggs any style; buttermilk pancakes; 'cowboy' omelette. Coffee came in a mug. Mimosas and Bloody Marys.

There were lots of young families. Mothers with kids in *Toy Story* crocs awaiting fathers parking new BMWs. High-rent suburban Americana. And I felt ghastly sitting there, ogling a young woman and a little boy of two or three seated in the booth next to ours. The boy was attempting to fit the whole of his small fist into his apparently smaller mouth as his mother admired his industry. From self-portraits he'd made, I knew what Ai looked like — broad, stout frame; large head of short dark hair; wise-man's greying chin beard. His son's mother I wouldn't know on sight. This could be her. She was looking around, waiting for someone.

He arrived soon after. It wasn't Ai. I felt somewhat less Geraldo. Dutifully, though, I clocked two hours, waiting in vain, growing all the more convinced, as I marinated in the day's rising heat, that I wouldn't manage to catch even a passing glimpse of him in what time remained.

Ai Weiwei, 2009
Following surgery for a cerebral haemorrhage in Munich

That there was little chance I could meet Ai Weiwei was already a matter of history. On the morning of 3 April, Ai was going through customs at Beijing Capital International Airport with one of his many assistants. They were on their way to Hong Kong and then to Taiwan, routine business to discuss a possible exhibition. Before they could board, however, two or three officers took Ai into custody. Meanwhile, a police contingent was descending on his studio complex in Beijing's Chaoyang District, where, whether in preparation for the raid or coincidentally, electrical power to the neighbourhood had been severed. Once inside Ai's studio, the police seized documents and electronic equipment: laptops, hard drives, DVDs, cameras.

Ai's detainment came as little surprise to anyone who knew him. In fact, few of his friends, not to say his detractors, understood how he had managed to evade detention for so long. An internationally

Ai's detainment came as little surprise to anyone who knew him. In fact, few of his friends, not to say his detractors, understood how he had managed to evade detention for so long.

known artist whose work can command half a million dollars at auction; a painter, sculptor, architect, curator, photographer, installationist, and filmmaker — Ai was all these things. But it was also true, at least as it's perceived within China, that when set against his other activities as a blogger, tweeter, and citizen organizer, his artistic practice had been outpaced by his activism. It would be no exaggeration to say that no living

Stills from <u>Disturbing the Peace (Laoma Tihua)</u>, 2009
Video
1 hour 19 minutes

Chinese citizen had spoken out against the People's Republic of China (PRC) and its restrictions on free speech with such regularity, variety, creativity, and force as Ai Weiwei and gone unpunished.

To understand the size of Ai's daring and the originality of its expression, you'll need to watch how one of these baroque, many-headed battles unfolds. On Monday 12 May 2008, a magnitude-8.0 earthquake hit Sichuan province in central China. Current estimates put the death toll at nearly 90,000, but at the time, owing to the chaos, numbers were hard to

come by. One thing quickly became clear: throughout the province, schools seemed unusually prone to collapse, even as buildings around them often remained standing. Seven thousand schoolrooms were reduced to rubble and dust – and classes had been in session. A wail rose up from the parents of the dead, an outcry that the PRC heard and answered by promising to investigate. And yet, by the end of the year, the government hadn't produced a death toll of the children, much less a report that explained why so many schools had collapsed. In December, using his blog – a blog that had attracted millions of readers since he began it in 2005 – Ai called for volunteers to canvass the province and assemble a list of the names of the children. This, he felt, was the least that was owed them: the dignity of being named.

In March, another activist investigating the earthquake, Tan Zuoren, who claimed to have uncovered evidence that local municipal officials had allowed contractors to use substandard building materials in the schools, was detained. Unfazed, by April, Ai had collated a list of 5,212 names, which, in addition to scores of articles about the investigation, he published in full on his blog – which government censors had begun monitoring, going so far as to delete the occasional post. To one large wall of his Chaoyang studio Ai affixed eighty sheets of paper printed with the names of the children – a backdrop for interviews with the international media and, as you'll see, a sort of rough draft of an installation that he was beginning to conceive.

What follows over the next six months – and, essentially, to this day – amounts to an escalating series of tactical strikes between Ai and the PRC. The PRC finally released a list of the dead a few weeks after Ai released his and twenty days later shut down Ai's blog for good, deleting every post and millions of comments. To make sure that their message had been received, they stationed two security cameras, like those oriented on Tiananmen Square, on a pole opposite Ai's front door. Denied his

blog, aware that he was under surveillance, Ai turned to tweeting, a practice that has, to date, gotten him 100,000 followers to his 60,000 tweets – as many as a hundred tweets a day. That summer, tweeting all the while, still focused on the earthquake, Ai travelled to Chengdu to testify in the case against Tan Zuoren, the earthquake activist. But at 3 am, the night before the trial, police broke into Ai's hotel room and assaulted him. Ai made an audio recording of the attack as it unfolded. You hear the breaking down of the door, what sounds like a blow being struck, and then there's the dialogue, an absurdist script that life in a totalitarian state can't help but write:

AI: What are you doing?
POLICE: I'm not doing anything ...

AI: You're allowed to hit people? ... You brought all these cops to beat me? Did you see him hit me?
POLICE: Who hit you? Who saw it?

AI: Is this how police officers behave?
POLICE: Prove it!

AI: Is this how police officers behave?
POLICE: Who hit you? Where? Where's the wound? Prove it!

AI: I won't argue with you like this.
POLICE: Think you can argue with me? ...

AI: What's your name?
POLICE: What does it matter to you?

AI: You come to my room in the middle of the night – of course I want to know what your name is. Show me your badge!
POLICE: Did I enter your room? Am I in your room?

AI: Didn't you just break in?
POLICE: Who broke in? What do you mean by 'break in?'

The police wouldn't leave. They held Ai at a hotel through the next day, keeping him from going to court to testify. The same fate befell other witnesses for the defence; police prevented anyone from testifying on Tan's behalf. During the month after the beating, Ai had a constant headache. Even so, he was busy on Twitter. Because each character in Chinese isn't a letter but a word, you can say a lot more in one tweet. For instance:

Choices after waking up: 1. To live or to die? 2. To be true or to lie? 3. To be lively or to decay? 4. To love or to be forsaken? 5. To be wise or to be idiotic? 6. To smile or to be humiliated? 7. To denounce or to celebrate? 8. To be more courageous or to be more fearful? 9. To take action or to be brainwashed? 10. To be free or to be jailed? [5 September 2009, 08:50:36]

He was in Munich at the time, setting up an enormous retrospective of his work at the Haus der Kunst, when the headache got so bad it sent him to the hospital. After a series of scans, doctors found that blood was pooling around the right side of Ai's brain, the result of the blunt-force trauma inflicted the month before. Emergency brain surgery ensued, saving his life. Fresh out of surgery, Ai began tweeting pictures of a tube draining his bandaged head of blood. They appeared in newspapers around the world.

Upon his recovery, Ai returned to the Haus der Kunst to complete preparations for his retrospective, which included an enormous new piece – 10 metres high, 100 metres long, spanning the entire facade of the museum. Called *Remembering*, it consists of 9,000 children's backpacks, in bright colours, that spell out a sentence in Chinese characters. The sentence had been spoken by one of the mothers of the children killed in the earthquake: 'She lived happily on this earth for seven years.'

Ai's activism and his art were feeding each other, history forcing him to figure out a way to make art into a kind of propaganda that wasn't trivial or disposable but beautiful. And its growing presence on the international stage offered him a kind of protection: he had become too large for the PRC to punish as they had other activists. For shortly

after the show went up, the PRC sentenced another earthquake activist to three years in prison on the grounds of 'possession of state secrets'. Soon thereafter, Tan Zuoren was sentenced to five years, for 'inciting subversion of state power'.

While the 9,000 backpacks spelled out a damning rebuke, a reporter asked Ai why he continued to court such risks, both as an activist inside the country and as an artist exhibiting internationally.

'I have asked myself many times, "Should I do this?" The answer is clear,' Ai said. 'I have to act on my feelings.' And by April 2011, those actions, those feelings, had finally gotten him disappeared. During the first weeks of his detention, his family was told neither where he was nor how he was. Five days in, a Chinese official announced that Ai was being investigated for 'economic crimes', an allegation that you hear a lot if you start paying any attention to contemporary China. For when the PRC disappears someone, that investigatory pretext will often be raised, promulgated in China's state-run media (whether the state-run news agency, Xinhua, or the newspapers that run in lockstep with it) – a claim that is left to echo, unanswered, in a void. Essentially, to be accused of 'economic crimes' means that the PRC is going to hold you until they decide either to charge you or let you go. So it was with Ai: over the weeks that followed, anonymous sources and unnamed police officials were quoted in newspapers, offering reasons for Ai's confinement – tax evasion, destruction of evidence, trafficking in pornography. With Ai made unreachable for comment and despite his family's public statements to the contrary, the allegations steeped in the cultural waters.

On the eighty-first day of his detention, with no charges having been brought by the government and no word about his condition, his wife, the artist Lu Qing, received a call from the police. She could collect her husband. He was free to go. But it became clear rather quickly that Ai was not free, not truly. A

Brain Inflation, 2009
C-print
MRI image showing Ai Weiwei's cerebral haemorrhage as a result of police brutality in Chengdu, China, 12 August 2009
200 x 100 cm

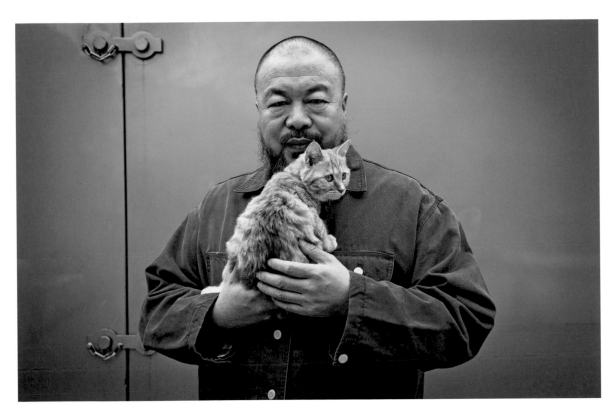

Ai Weiwei, 2011
Standing in front of his studio gate in
Caochangdi after his release

spokesman for the Ministry of Foreign Affairs, Hong Lei, gave the government's first official statement to international media. During the coming twelve months, 'Ai Weiwei is still under investigation,' Hong said. 'Without permission ... he is not allowed to leave his area of residence' – Beijing. And when asked why Ai had been released at this time, Hong confirmed that Ai had shown, as state news agency Xinhua put it, a 'good attitude in confessing his crimes'.

His first full day home, wearing a Comme des Garçons T-shirt, the design of which is a series of enormous black letters that spell out his name, Ai appeared at his studio door, where he was met by a throng of cameras and microphones. 'I can't talk about the case,' he said. 'I can't say anything.' And then, before closing the door, he asked everyone, politely, to leave.

As I said at the outset, I flew to Beijing in late July.

Before leaving for China, I had gotten in touch with Alison Klayman, a documentarian based in New York who, for the past three years, has been travelling around the world with Ai, shooting her documentary about him called *Ai Weiwei: Never Sorry*. She had spoken briefly to Ai after his release. It was clear to her that things around Ai were not at all business as usual. If I were going to be able to talk to anyone who was in touch with him, Klayman felt I'd only be able to make sense of that once I was in Beijing. 'It's a whole other thing, being over there,' she said.

Allow me to confirm that being over there is indeed a whole other thing. Beijing is not like any Western city I know. Ten days in Beijing can make even New York or Rome seem, in comparison, like a sleepy village that time forgot. Hyperbolic, yes, but hop a plane and see if you still want to argue about it when you get back. The city's vastness, the inhospitatility of that vastness, the sheer enormity

of its spaces, and the activity that swarms through it left me slack-jawed. But that wasn't the half of it. There was also the astonishing volume of cars – some five million – flowing through ten-lane-wide streets that, in addition to unholy truck traffic and bus traffic, are host to three-wheeled motorized vehicles of endless variety and quantity – overloaded with pipes, vegetables, sheet metal, pillows, water jugs – buzzing pokily along, motorcycles in hasty droves cutting in and out of fleets of helmetless bicyclists, the mass of it flowing into itself at intersections as if you're watching a citizen army mobilizing for a coming war and yet, at least for the benefit of this outsider, never seeming to cause the

request. Zhao explained that it was an unusual day for a walk: the sky was clear and a deep blue, whereas most summer days, though not overcast by clouds, were so smoggy that you would have supposed you were on the Scottish moors.

As Zhao and I discussed the calls I wanted her to make – most pressingly to try to reach someone at Ai's studio, FAKE Design – we made our way through a few sights that Zhao felt I needed to take in. First of these, oddly, was a gleaming new subway station. Bear in mind Ai's word 'torment'. When we got to the platform, it was ten deep with people at 11 am. When a train soon came, it was as full as any vehicle I've ever seen, the mass-transit equivalent of a circus clown car. The doors sprang open, and then nothing happened, except for a vibration that took hold of the passengers inside the car, who seemed to begin to shake as one body. As this

My stomach sank a little, hearing that answer. The head of the biggest, Westernest gallery, who would spend the next half hour of our talk claiming that China had become no different from the West as far as free expression in the arts went, was unwilling to talk about the exception that disproved his rule. But this was a fair reflection of Ai's strange position, both in China and the world.

accident that, at all times, seems to be on the brink of happening. And then if you look up from all that traffic, there's the looming, baffling hugeness of the buildings, the volume of construction. There's no skyline here so much as there are skylines, new ones each year. Consider what Ai wrote about the city on his blog, in 2006, when the city's population was eight million people fewer than the estimated twenty-two million living there now: 'Beijing can really torment people. There are countless large districts, and if you were to walk the circumference of any one district, you would die of exhaustion … The yearly increase in Beijing's buildings is greater than the sum total of all of Europe's new architecture.' On the morning of my first full day in the city, my translator took me on foot into Beijing, at my

happened, the people ten deep on the platform began to press forward toward the doors, where, at last, the vibrations of the passengers in the car became a convulsion until the dark crown of a head pressed apart the bodies that blocked its way, followed by a set of elbows, all belonging to a furious young woman who at last emerged fully from inside, screaming, as if newly born. She was followed by another set of elbows, and another, each angrier than the one before it, whereas all around the fury were smiling faces. Smiling on the train at the absurdity of the scene, smiling understandingly on the platform as we were jostled out of the way by the angry departed, whose nominal void some minim of the passengers on the platform attempted, through sheer force, to fill. I watched this repeat nine times

before we were at the very verge of the platform, a wave of people held back only by the understanding that mass death would otherwise ensue, as a train arrived and Zhao and I fought our way on.

The trip was actually quite pleasant. Everyone seemed to be in a jolly mood, as if we all understood that the only possible reason we were touching each other more intimately than some religious sects allow husbands to handle their wives was that we were being watched by celestial beings – aliens or gods – who had set up these ridiculous conditions for their amusement as they watched us safely from their dull home world. And frankly, I enjoyed every minute of it, as one enjoys a roller coaster that brings one to the point of sickness but not past it. But it should be understood that if I had to ride such a roller coaster to work every morning, my mind would quickly run to thoughts of revolution.

Apparently this was neither an original nor a radical idea. As we were ejected from the train, adopting the whirling-elbows strategy only briefly, Zhao said: I think it's going to happen next year.

I said: 'What is going to happen?'

'Something big.'

You mean … uh … revolution?

'I don't know exactly. But this can't go on.'

Unable to see Ai in Beijing, I wanted to see Ai's art in Beijing. I could write a piece as long as this one on all the art I saw, some terrific, some boring, some surprising, some very original, some very derivative, some very stupid, and some very beautiful. In other words, it was very much like seeing contemporary art anywhere. With one exception: At this point, if you want to see work by Ai Weiwei, try Switzerland or England or the United States. In July, there was no art by Ai Weiwei on exhibit in Beijing.

Curious about this, I spoke to Leng Lin, director of Pace Beijing, the Pace Gallery's foothold in China. We were in Leng's office in an old munitions building that they've turned into a mind-bogglingly pretty place to display art. Pace, if you don't know, is one of the world's major sellers of super-high-end fine art. Leng's office was fittingly grand and spare. Behind a huge desk was a work by Zhang Xiaogang, the Chinese artist most prized by collectors. He's been an active painter for thirty years. A piece of his from the 1980s, when Ai was in New York – a painting called *Forever Lasting Love* – sold at auction this past April, while Ai was being detained, for $10.1 million. Tall, with a boyish, prep-schooly haircut and sublimely delicate leather shoes, Leng speaks a stentorian broken English, bursts of syllables, very declarative, stretches of lucidity followed by mistier patches. He was most congenial, educating me on China's path to being a force in the art world and how there were no galleries until the late 1990s, when he, Leng, started the first one. He told me about a lot of firsts, most of which he seemed to be a part of: first auctions (he arranged them), first book on contemporary Chinese art (he wrote it), etc. You get the picture. When I made the mistake of going down a conversational path that didn't interest him (a bunch, if you want to borrow my tape), he would laugh, a big machine-gunny laugh that echoed in his big white, cold box of an office, and move on.

Such as: I asked him who he thought was the Chinese artist that Americans interested in the fine arts think of when someone says, 'Most famous Chinese contemporary artist'. Leng had no doubts: Zhang.

'No,' I said. Leng did his laugh. 'Ai Weiwei.'

'Oh. Of course. Ai Weiwei.'

A beat. Some hemming.

'You … recognize his role is different here from the other artists'.'

Surveillance Camera, 2010
Marble
39.2 x 39.8 x 19 cm

Different how?

'He is a ... You can interview with him directly. It's better.'

Machine-gun laugh.

'Do you want to talk about him?'

Stray gunfire.

'He's ... he is ... a good artist.'

My stomach sank a little, hearing that answer. The head of the biggest, Westernest gallery, who would spend the next half hour of our talk claiming that China had become no different from the West as far as free expression in the arts went, was unwilling to talk about the exception that disproved his rule. But this was a fair reflection of Ai's strange position, both in China and the world. While he was being detained, there was scant protest from mainland Chinese artists. Whereas all around the world there were protests, sit-ins, outcries by arts institutions,

and major artists who cancelled contracts and commitments with China. Governments spoke up, made his detention an issue. But in China, even my translator, in whom subway trains fomented thoughts of sweeping social change, told me that Ai Weiwei had been convicted of bigamy, which was another rumour/claim/allegation that was floated through the press and something that's, best I can verify, pure fiction. Which is not to say he might not owe taxes. Not for me to say. It's as Ai's close friend Uli Sigg, the former Swiss ambassador to China and the Chinese art, told me: 'What was important to the government was the war inside China. To ruin Weiwei's reputation and silence him for good: that was the goal of the whole thing.'

I mentioned earlier that I had asked my translator to call Ai's studio, FAKE. She had. It was baroque.

Messages were left but not returned. Eventually she reached someone there, someone who didn't seem to understand English or Chinese. She called again and tried to explain my situation, that I was hoping to talk to someone who knew Ai, someone who could tell me how he was doing. Apparently Zhao expressed all of this, and when she explained it was for GQ, the person on the phone didn't seem to understand what that was.

Which boded terrifically well. Still, I was told to write an email to the studio person directly, explaining GQ. This I did. Circulation, history. I'll spare you details. Basically, I said that I understood that this was – and I might as well go ahead and quote it – 'a very sensitive time for Ai Weiwei and I do not want to create any problems for him or for FAKE studio. I do not need to interview Ai Weiwei and do not need to ask anyone any questions if doing so will create problems. But because I have come to Beijing this week to work on the story, if I could visit FAKE and see some of Ai Weiwei's work that I could not see elsewhere, to see the studio itself, it would give me the chance to write a deeper portrait.'

It should go without saying that a reply was not immediately forthcoming. While waiting for it, while failing to see anything that had much more than a circumstantial relation to Ai, there were a number of strangenesses I endured or engendered. These included a routine bout of traveller's tummy and its travails, jet lag of a new and special kind that takes hold when the time difference is precisely twelve hours, and the experience of going to the fancy hotel spa for an après-four-days-straight-of-walking-around-museums-and-galleries-in-one-hundred-degree-smog massage and hearing, midway through it, 'You want massage ... here?' – then looking up to see that the international magician's gesture for hocus-pocus over a top hat in preparation for withdrawal of a bunny or a brace of doves was happening over my groin, whereupon I was informed that for 2,000 yuan (around $300) I could have my 'here' massaged really good, but not to tell hotel for against China rule and if you like we can go your room?

And yes, then, later, as I told you at the outset, I shamed myself by staking out an American-style family restaurant. Perhaps you will appreciate, then, that, late in the week, when I did receive an email from FAKE studio, I needed to read it a few times to make sure I grasped its meaning:

> Dear Wyatt,
> Thanks for your note. You are welcome to come visit the studio in the morning on any day, and Weiwei should be able to meet you as well.
> Do let me know which day you'd like to come.
> Best,
> Jennifer

On a Sunday morning in Beijing, I took a cab with my translator out of the city centre, just past its first five ring roads, to the Chaoyang District, toward the airport in the north east.

It was another blue day, clear but hotter, near one hundred degrees at 9 am. Our taxi, like many in Beijing, featured a framed print ad of a Caucasian woman, right hand on right hip, raised arm, at the elbow, gleaming. Her hair is up, revealing a long neck and a pretty but not distractingly so face, her face not meant to be our focus. We're seeing her from above, such that, owing to her blouse, a tight-fitting lacy number with a radically scooped neck, we are given an optimal view of her large, heaving, superbly round (just reporting) breasts.

I asked Zhao what the ad copy said.

'International breasts nutrition centre. Get rid of your bra quickly. Enlargement. Better shape. It's a national chain of breast enlargement.'

There was some joshing thereabout, but soon we fell silent, each of us staring blankly ahead. The breast-enlargement ad directly in front of me made an odd counterpoint to my thoughts. I was preoccupied by Jennifer's 'should': that 'Weiwei should be able to meet you'. Indeed he should, I thought. Of course he should. Why shouldn't he? And yet, after clear prohibitions from the state, why should he? It didn't make sense. As I stared at the woman's supposedly fake breasts, and as we drove supposedly to FAKE studio, I decided that we weren't going to meet him. That in fact we were going to arrive there and find nothing – no studio, no Jennifer, no Ai.

The drive ended, depositing us at number 260 Caochangdi, the address of FAKE being 258 Caochangdi. We were here. And yet we were not.

Thirty minutes passed as we walked up and down Caochangdi, a residential area with a variety of warehousy buildings, galleries, studios. The numbers on the buildings seemed to have been chosen more for their pleasing shapes than for any reason I could comprehend. There was no mathematical scheme. Numbers were not consecutive. Jennifer was called. Jennifer was now definitely not there.

We walked. A dog leapt from out of nowhere, lunged, snapped, but was yanked back by a leash. We found our way around one corner to another, to 256 Caochangdi, which was no closer to 258 than 260 had been.

We tried Jennifer again, who answered. We tried to tell her where we were.

She conveyed instructions, from Ai. He said, she said: Walk toward the sun. The sun was high in the sky.

He greeted us at the door, where we stood in plain view of the surveillance cameras mounted to a streetlamp across the road. Strangely, as we said our hellos, Ai and I didn't shake hands. My logic was somehow, I think, or I thought, that if I didn't touch him, I would put him less at risk, the weirdness of which sentiment I concede, but the truth of it I can't help.

Even my translator, in whom subway trains fomented thoughts of sweeping social change, told me that Ai Weiwei had been convicted of bigamy … Which is not to say he might not owe taxes. Not for me to say. It's as Ai's close friend Uli Sigg, the former Swiss ambassador to China and the Chinese art, told me: 'What was important to the government was the war inside China. To ruin Weiwei's reputation and silence him for good: that was the goal of the whole thing.'

He wore an aquamarine T-shirt, tan cargo shorts, black trainers. I knew he would be big, but I was surprised nonetheless. He led us into a vaulted room, twenty feet high, with one very tall window that rose to the ceiling. The room, the courtyard, the compound, all of it had been designed by him one afternoon and put up by builders swiftly, the first of his many buildings in China. It has a perfection to it, a simplicity, an ease. Brick, poured concrete, wood. Everything spare. A series of spaces. Boxes of light.

We sat at a table, he at the head, his back to the window. We spoke off the record for a few minutes. He asked my intentions. His English was fluid, colourful, sure. His voice had a cello's deep timbre. He mentioned what he didn't wish to discuss. And then, with an iPhone, he took photos: first Zhao, then me. He explained that he needed to report everyone who came to visit. I asked if I could record our conversation. He said: 'Let's get to work.'

How are you?

[A long pause.]

'I'm … okay. It's a kind of condition hard to really describe. But I'm okay. But I'm different. Not very normal.'

Different how?

'Well. I'm on bail. So-called bail. But I never got accused. Never got arrested.'

You were just held.

'Yeah. I was held for … eighty-one days. And there's no clear explanation about what's going on, so I … To me it's not real. Either the situation now is not real or that eighty-one days is not real. This is the reason that mentally I still struggle with that, because of those eighty-one days …'

It's a long time.

'It's not only a long time. It's extreme conditions. So it really convinces you that's the reality. You are part of it, and you know it is not a joke. At the same time, there's no reason, no clear reason — at least the people who hold you shy away from giving you a clear reason. But at the same time, they limit you even when you're out, so still you have to behave the way they wanted. And so the psychological warfare is still there, you know …'

[Footfalls. A small boy runs into the room from outside, over to Ai.]

'Da-da!'

[Ai speaks Chinese with him. Domestic sounds rise in the background. I see, a room away, Ai's wife, Lu Qing, tall, pretty.]

'It's my son … Oh, careful!'

[Under the window, a large rock. The boy is trying to pick it up. It's bigger than his head. He picks it up.]

'Hey …!'

Strong …!

'Very smart boy. Two years and five months. When I was there, they kept telling me: when you get out, he is over ten years old and would never recognize you. Every day they are telling me that. And that really hurt me a lot.'

[He speaks Chinese to him in a soft voice. His son responds. Ai laughs. The boy runs off. Ai looks at me.]

So they spent a lot of time talking to you and telling you things that were frightening?

'Fifty times. Over fifty.'

Interrogation, you mean?

'I think if you talk about interrogation … half of the time and half of the time it's more like education or brainwashing or psychological warfare. There's no real conversation. No real argument. Communication is very fragile, because they always force you with certain ideas or judgements.'

[One of his cell phones rings. I can hear a woman's voice. They talk for a few minutes. The call ends.]

'Sorry. It's a classmate from over thirty years ago from the Beijing Film Academy, a friend from before I got into art school. We used to study painting together. Some old friends … we never talk to each other for years … decades … They've started to call and come see me.'

Does that feel good?

'It's not good or bad. It's really … You start to think why the incident for them is important. Why every day people come even though people know there's a camera in front. They take photos of whoever comes, and also I have to report whoever comes. But today I think, especially now, everything starts to change quite dramatically. It's not my imagination. If you see this railroad situation?'

I've failed to mention this, but the week I was in China, two new high-speed trains collided south of Shanghai, killing scores and injuring almost 200. There was a controversy: it seemed that the government clean-up crews were burying the derailed cars, and people feared a cover-up. Within five days, Chinese citizens had posted twenty-six million microblog posts on the accident.

'You see the public start to openly discuss this incident,' Ai says. 'Even the media has let it ride. So finally this kind of government, this type of control, cannot last. It can never. It's gonna break, sooner or later. I think that they know it.'

How much, I ask him, is his environment determining the kind of art he makes?

'If you're on this track, you don't know that. What I know is, I devote myself in this total situation. At the beginning, people started to say: this person has become a dissident, or political, or critical of government. I worried. Because these are not words that people like to be called, especially in this kind of society. Now I don't care, because I think after a few years I fully exposed myself, not only to Chinese society but also in the West …'

The sound of a train rises through the room. We wait for the train to pass. Sunlight illuminates Ai brightly from behind. In that vivid light, I see that a tiny spider has cast a line of silk from the back of Ai's head down to his shoulder, beginning to spin a web, as if Ai weren't a man but, in his stillness, a statue of himself.

'I have no regret for whatever I have done. I don't really care if it's always art or if it's not, if it's politics or if it's not politics. I did it because I have to do it. I'm a person, an individual – that's always the bottom line. You're one, you come to this world, and you see what happens, and you relate to people, neighbours, friends, whoever, and you have a chance to speak. And you're facing a government which imposes this political power on one-fifth of the human race – which is a big deal. But at the same time they refuse to talk about those basic values, the value of life, of freedom of expression, which is essential for art or for artists or for anyone. Am I asking too much? I don't think so. For my father's generation – many generations, for the past 100 years – many people sacrificed their lives and their happiness trying to establish a lawful society for people. To establish some kind of dignified rights and basic fairness and justice and all those concepts. But still, they failed. Even today they cannot openly discuss those values, and people are still accused or given sentences or put in jail or beaten – only because they have different views on

the world or different ideologies or just different thoughts.

'I'm sorry, I have to … My brother is visiting me for the first time since my release.'

I say: I'm sorry to intrude.

'No, it's not intruding. My brother … We are very close still. I wouldn't say he's scared, but he doesn't know what to do; he feels very sad, but what can you do?'

A domestic space – a kitchen, I guess; I don't go in – adjoins the large room where I remain seated at the table. Ai and his brother are standing in the maybe-kitchen as the brother unrolls something from a large tube. Ai looks at what has been unrolled. Lu comes over and stands between the brothers, looks. They all chat a bit. The roll is given to Ai, put away. Laughter echoes, dies.

People come and go from the large room, have been coming and going all the while. A few boys, seemingly teenagers, all gangly; grapes that Ai said you can only get in Beijing; green tea. A little girl who seems to be Lu's daughter, maybe five, in a pink dress. The sound of Ai's son whooping in the courtyard.

Ai returns. This time he records the conversation on his own recorder. Or perhaps he recorded from the beginning and I hadn't notice. We talk about a range of things. About art and its value, and how easily it gets turned into mere merchandise; about the impulse to make things; about why children, so curious, so busy, with their hands, cease, at a certain age, to use them, to stop making.

'I think it's because society is so practical … The whole society is looking for security. It's the biggest misleading concept. You want to be secure. You have to learn useful knowledge. You have to meet the challenge. You have to be somebody. Immediately

Marble Arm, 2006
Marble
21 x 67 x 30 cm

prove you're smart. A few sentences. A work. This becomes so competitive in modern society; it sacrifices a lot of human nature. When you talk about making … making is so important. It's not the product that's being made. The product made us. Our technology really made us today. Through making, we realize who we are, and it tells people who we are.'

His little boy runs in again. Ai reacts with surprise, delight: the boy is naked, covered nose to toes in sand.

We break again. Jennifer says my translator and I are invited for lunch. She leads us to a bright, cheerful, simple, conference room with a long white table that could host twenty people or more. Half of it has been filled with large steaming bowls, platters of food. It smells wonderful. At the head of the table, a very pretty young woman, Ai's son's mother. She and the boy live nearby. Fresh from the shower, the boy is now swaddled in an enormous towel that capes him like a small king. He sits on his mother's lap briefly, scurries away. Liu Xiaoyuan, Ai's lawyer,

takes a seat, nine of us now, Lu poking her head in, checking on things, moving on. Ai is elsewhere, but Ai's brother, speaking in Chinese, pointing to the table, pointing to me, seems to be telling me to dig in.

I meet a young man named Inserk at the table, a German architect of Korean heritage. He works as one of Ai's assistants, has been in Beijing with Ai for six years.

I ask him how he likes life here.

'It's the best life.'

Why?

'I can't possibly imagine better.'

Again I ask why. He thinks for a good minute.

'It's like an idealized version of life, of creative life. Every project is great. You just create work all the time. You don't have to take care of your life here.'

Ai Weiwei standing in the courtyard of
his studio in Caochangdi in 2011

He gestures out the window, to a small courtyard where, I understand, there are apartments for the assistants.

'There's food. It's all perfect. Almost perfect. You really do what you want to do.'

I ask him how he thinks this year has changed the way the office works.

'There's no office. This used to be an office. There used to be people sitting here. All done.'

Temporary?

'I don't know. Everything is temporary.'

Ai soon returns, and you can feel the energy of the room shift towards him. It's quite clear that he's a point of gravity around which these objects orbit. Which, of course, is what you'd expect, but there's a feeling to it that is not what I expected. I would suppose it would be kind of chilly, everyone on tenterhooks. But the feeling in the household, Ai's household, with this dozen or so people around him, however diminished the number since his return, has an unmissable warmth, a climate that seems to bring comfort.

I don't mean to be vague. Here: at a certain point, as Ai stood, eating, and conversation bubbled, his son, at the distant end of the table, clambered up from the floor on to a chair and stood on the table's top. He had shed his grand cape of a towel and was once again nude. He walked his way down the table, scratching his member, towards the end where everyone was sitting, standing, eating, and now cooing and laughing at his approach. He toed gingerly around

the arrayed food, small feet evading large dishes. Ai
had his iPhone out, was tapping pictures of his naked
son as the boy crouched, reached into a dish with the
hand that had just chased an itch, and began, one by
one, handing each person at the table a dumpling. He
did so with care, as if selecting among them for the
most suitable for each of us, father mugging for his
son as he ate what he'd been given, as did we all.

'You make, but people watch you,' Ai had said
earlier. 'Some people watch you because they find
that what you make or say is meaningful. But the
government watches you because they find you to be
dangerous. I think whatever we think is meaningful
is somehow dangerous. It only becomes meaningful
because it's so fragile: It's so easy to be lost, and
we cannot replace it. If we can easily replace it,
we will never think it's valuable. So a sentence, a
writer, a line of poetry, or a piece of art, whatever
we think is meaningful, it's always because of that.'

If you ask me what side of Ai Weiwei I got to see
in China, I can only say that I saw him at home,
with his family. Everything he loved was there.

This article originally appeared in the December 2011 issue of *GQ*.

GOING VIRAL: THE MEMETIC WORLD OF AI WEIWEI

An Xiao Mina

It's a striking image: Ai Weiwei – revered art icon, cultural commentator, political activist – dancing absurdly in his studio with visitors and fellow artists to the tune of 'Gangnam Style', a wacky internet video by the Korean pop musician PSY. Activists of Ai's stature, who have suffered illegal detention and continued persecution from the Chinese government, are typically surrounded by gravitas, their lives discussed in the context of the government's heavy-handed abuses against human rights and free speech.

But as Ai and his associates flail and bounce around, most viewers probably can't help but giggle. Ai, clad in pink, makes references to PSY's popular moves from the music video, with the occasional 'horsie dance' – a skipping, trotting manoeuvre that looks absurd on a grown man – spliced in with footage from the original video. By the time Ai added his contribution, 'Gangnam Style' had been remixed countless times; it was, by many accounts, the most viewed video on YouTube in 2012. These remixes are often silly, joyful affairs, as everyone from high-school kids to US soldiers in Afghanistan dances along and posts their own version.

Ai Weiwei's interpretation, however, has a twinge of sadness. As he dances, he occasionally twirls a pair of handcuffs, a clear reference to the tight restrictions placed on his life. In one scene he dances while handcuffed to Zuoxiao Zuzhou, his friend and a rock musician who has faced increased scrutiny for his associations with Ai. Zhao Zhao, a protégé of Ai who has also been a subject of police inquiries, makes a small cameo but does not dance.

The video, which went viral on Western social media as soon as he released it but was quickly censored in Chinese social media, served as a fitting analogy for his political situation. While his official restrictions had been lifted one year after his release from detention, he still could not travel outside the country. All the while, he had yet to be officially convicted of any crime.

Ai's 'Gangnam Style' rendition is a welcome bit of comic relief in an otherwise disturbing political situation. But in the age of social media, Ai's video served another important function: it was memetic. A meme,

a term coined by social theorist Richard Dawkins, is, in short, a self-propagating cultural phenomenon. In contemporary popular culture, the word 'meme' often refers to a viral internet phenomenon, such as a dancing cat video or funny picture. But unlike, say, a video that is simply shared repeatedly, memes encourage co-creation. Like a biological virus, they morph and take on new forms as they pass through the hands of a networked community.

Within China, Ai's dance video was officially banned, but because it was memetic, it showed the same clever resilience that's key to how viruses spread. Given the enormous popularity of 'Gangnam Style', references to Ai's version could more easily slip past censors, cloaked amidst references to apolitical versions. Internet users posted their own commentary on the dance and shared remixed photos and screenshots. For a brief moment, clever users could also find the video under slightly different names that evaded keyword search algorithms. Importantly, it brought Ai's name and visage back to the online public consciousness – a jab at an official system that often successfully deletes the names of dissidents from collective memory.

Outside China, remixes of Ai's remix thrived in a show of solidarity. British artist Anish Kapoor, an active Ai supporter, led his own 'Gangnam Style' dance

Ai Weiwei takes a picture of the Dalai Lama and Aung San Suu Kyi on his Twitter feed.

in his studio, and he enlisted art world elites in a choreographed sequence that brought attention not just to Ai's plight but that of other political prisoners around the world. Clad in art-world black, staff from hallowed arts institutions like MoMA and the Brooklyn Museum released their own dances online as well.

It was a striking difference from the art world's previous shows of solidarity, which had taken the form of sober press releases, grave petitions and stonefaced public pronouncements. After years of witnessing the tragic consequences of Ai's clashes with authorities, the art world had learned what so many Chinese artists knew already: in the face of an absurd political situation, sometimes the best and only response is absurdity itself.

GRANDPA, TEACHER, UNCLE, AUNTIE AND GOD
As of print time, Ai Weiwei commands a following of over 210,000 on Twitter, which is officially blocked in China. Unlike other Twitter celebrities, who can quickly harness their followings into offline gatherings, Ai would be hard pressed to gather such a large crowd on China's streets. Chinese authorities regularly monitor public space and crack down quickly, often violently. Even social gatherings, like rock concerts and arts festivals, remain under the government's watchful eye. Some of the most iconic images of Ai's leadership show him sitting at his studio, hunched over a computer as he quietly types away.

Occasionally calling himself a 'Post-80s youth' – a reference to young Chinese born after 1980 – Ai Weiwei has taken quickly to the raucous, conversational culture of the internet. 'I live on the internet,' he told me over Twitter. Indeed, unlike most Twitter users of his renown, he is not content simply to issue pronouncements and clever observations. Rather, the vast majority of his tweets consist of conversations with his followers, addressing anything from the current political situation to more prosaic subjects like unrequited love and what he's eating for breakfast.

<u>Untitled</u>, 2010
This portrait, known informally among his internet followers as 'One Tiger, Eight Breasts', was the source of rumours spread by Chinese government officials suggesting that Ai Weiwei was involved in circulating pornography

To an outsider, Ai's decision to spend up to eight hours online everyday might seem odd at best. At worst, it is indicative of an undiagnosed addiction to the internet. His regular availability online has turned him into a father figure and familiar friend. Twitter users often call him 'Grandpa Ai', 'Teacher Ai' and 'Uncle Ai', a common sign of respect and affection in Chinese culture. They even call him 'God Ai', a play on an insult hurled at him during his altercations with police documented in *Laoma Tihua (Disturbing the Peace)*. This in turn inspired the epithet 'Auntie Ai', which sounds like 'God Ai' in Mandarin.

Contrast this regular presence with the government's usual modus operandi, which is to erase dissidents from popular memory, and, if necessary, spread disinformation. It worked successfully for the dozens of activists who'd been quietly disappeared in 2011. *New Yorker* writer Evan Osnos wrote of the disturbing silence around the events:

> Step by step – so quietly, in fact, that the full facts of it can be startling – China has embarked on the most intense crackdown on free expression in years. Overshadowed by

news elsewhere in recent weeks, China has been rounding up writers, lawyers, and activists since mid-February, when calls began to circulate for protests inspired by those in the Middle East and North Africa. By now the contours are clear: according to a count by Chinese Human Rights Defenders, an advocacy group, the government has 'criminally detained 26 individuals, disappeared more than 30, and put more than 200 under soft detention'.[1]

Ai Weiwei was the Chinese government's highest profile detention in 2011, and they followed the usual strategy, albeit with greater intensity. Not only did they censor his name from general conversation online, they also issued scathing editorials.[2] The so-called 'Fifty Cent Party', internet commentators paid by the state, spread rumours and disinformation on a variety of online channels, both within China and abroad. State police visited some of the more vigorous agitators for his freedom, including both local and foreign members of his studio; some were themselves arrested. It's a thorough and often successful strategy that enforces silence and fear.

awfannude.blogspot.com, 2011
Ai's Twitter followers, or
tuiyou, tweeted nude photos
of themselves in response
to pornography allegations
against the artist

THE WEIWEI EFFECT: DANCING AROUND CENSORSHIP
As the internet was growing more influential in
countries under repressive rule in the early twenty-
first century, Harvard theorist Ethan Zuckerman
noticed a pattern of activism which he elaborated
on in what he's called the Cute Cat Theory of Digital
Activism. In his theory, the twenty-first-century
internet – frequently dubbed 'Web 2.0' in the face
of widespread adoption of social media – exists for
the *purpose* of sharing pictures like talking cats and
dancing hamsters. In other words, user-generated
content, rather than professional and academic
content, rules the internet.[3] However, that same
system that allows for cute-cat photos to go viral
is also a system that allows any media to go viral,
including activist messages. And therein lies the rub:

> Blocking banal content on the internet is a self-
> defeating proposition. It teaches people how to
> become dissidents – they learn to find and use
> anonymous proxies, which happens to be a key
> first step in learning how to blog anonymously.
> Every time you force a government to block a
> Web 2.0 site – cutting off people's access to
> cute cats – you spend political capital.[4]

As the popular uprising against Egypt's government
in 2011 flared, the country's leaders signalled their
desperation by shutting down the internet. Per the
Cute Cat Theory, it was clearly a dying move. They
had lost control of the internet and were willing to
expend all their capital on stopping it, even if that
meant upsetting apolitical internet users as well.

But under the Chinese system, control is a central
feature. Western Web 2.0 tools like Twitter and
Facebook are blocked, while the servers for local
corollaries are centred in the mainland. Social
media platforms are therefore controlled by the
government and government-sponsored censors.
Thus, theoretically, controlling activist messages
while allowing for cute-cat sharing is entirely
possible.[5] Employing extensive keyword search
algorithms and human censors, internet portals
present formidable challenges to potential activists
according to Zuckerman:

> Block access to the Web 2.0 tools hosted
> outside of China and you frustrate activists,
> who would like to use those tools, but you don't
> antagonize the average user, who is probably

better served by tools written in Chinese for a Chinese audience.[6]

In Zuckerman's theory, the cute cat – the meme – is a distinct entity from more serious activist messages. They coexist because governments typically don't have the ability to filter one message without the other. But the Chinese government's system is designed for just that: block only offensive messages without disrupting the ecosystem of active but apolitical users.

Over time, however, Ai and other activists have embraced memes and meme culture. In doing so, they have implanted their messages *within* the so-called cute cat. The obscure humour of memes and their ability to morph and change rapidly make them ideal vehicles in and of themselves for serious political messages. As with traditional political jokes and cartoons, the dose of humour makes the bitter realities of political repression easier to digest and discuss. And the fact that they live online means they have a networked power. The natural one-upmanship to develop a cleverer variation means that memes don't easily die. Internet users know they will immediately have an audience if they can develop a smart remix.

One benefit of memes is that, in the face of attempts at suppression, they often expand in much fuller force. This effect is popularly known as the 'Streisand Effect', named after the unwitting pop star who attempted to suppress images of her home from being disseminated online.[7] Her efforts at legal action only spurred a counter-reaction that led to the photos being distributed around the world.

The political version of this – when an authoritarian government attempts to censor information about an activist – might be called the 'Weiwei Effect'. Even with the vast resources actively to seek out and delete specific messages, the Chinese government has never fully removed messages

about Ai. Instead, their attempts backfired, as they tried to delete a man who had become a regular staple of the internet for hundreds of thousands of Chinese netizens.

Ai Weiwei's name has always been a sensitive political term in China, and it has faced regular censorship for years. Around the time of his arrest, internet portals in China began censoring his name with greater tenacity, making it extremely difficult to talk about him directly. To avoid search algorithms, his followers began using the phrase 'Ai Weilai,' which means 'Love the Future'. When censors discovered that phrase and blocked it, other euphemisms like 'fat man', 'sunflower seed salesman', 'bearded guy', and others emerged.

Images of Ai – whose portly, bearded figure looks like many Chinese deities and sages – have also popped up, embedded and remixed within a breathtaking variety of forms: traditional comics, street-art stencils, Chinese door gods and even traditional communist propaganda. In the vast multimedia sphere of Sina Weibo, these images slipped past human and machine censors alike, as they often resembled popular imagery.

When his face and name were too sensitive, netizens could post a picture of a sunflower seed – a coded reference to his iconic installation at Tate Modern. By themselves, the sunflower seeds were apolitical, a common street snack across China. Any one image was harmless. But at scale, they sent a message that a community of people were thinking about him. It was a brilliant strategy, but not one person – not Ai Weiwei, not anyone at his studio – told them to do this.

EMBRACING THE GAME
The most compelling facet of memes is what NYU internet theorist Clay Shirky once observed. Speaking about cute-cat videos, Shirky noted that even something as simple as creating and sharing a 'lolcat'

Confiscated items, 2011
Materials confiscated by police following
Ai's arrest and the raid of his studio in
Caochangdi

– a cat picture with a caption that makes people giggle – is a profound shift from the broadcast model of television:

> The interesting thing about lolcats, about these cute cats made cuter with the application of cute captions, is that when you see a lolcat, you get a second message which is: You can play this game, too. All right, when you see something on television, the message is: You could not do this, you can only consume this.[8]

Ai encourages this in many of his online works, including the documentary projects that his studio posts to YouTube. With his resources, he could develop clean, sophisticated videos akin to his most complex architectural creations. Instead, he chooses a direct cinema style shot on simple cameras and only loosely edited. This decision sends a message to anyone watching: it doesn't take a lot of work to document civic injustices and speak out.

The efficacy of this approach was visible shortly after Ai's release from prison. As the government sought to try him on specific charges, they began investigating him for distributing pornography. They'd announced the pornography charges while he was still in custody, but the new investigation included bringing his assistant, Zhao Zhao, in for questioning. The image in question, commonly referred to as 'One Tiger, Eight Breasts', showed him and four young women posing naked. It was not unlike other naked photos he'd posted online, something he clearly enjoyed doing.

A number of internet users immediately knew these were trumped-up charges. In response, many online supporters started stripping naked in homage to the original photo. It started with a few men. Then dozens and dozens of men and women, Chinese and foreign, posted pictures of themselves naked as a show of solidarity. Some posed with the infamous grass mud horse, an obscene pun against internet censorship that sounds like Mandarin for 'fuck your mother'. Others raise their middle fingers, a direct reference to his *Study of Perspective* series. One young woman proudly declared, 'I love freedom and I love my body.'

WeiweiCam, 2012
Four web cameras on
http://www.weiweicam.com
Ai Weiwei's Studio, Beijing

Despite its absurdity, this meme was a brave stand against government corruption, and not simply because the participants were exposing themselves to the general public. In addition to their genitals, many also exposed their faces, placing them at considerable risk of government scrutiny. Collectively, without clear leadership or well-defined instructions, they developed a catchy, hilarious, unforgettable way to send a serious, sober message to the government and anyone watching.

FROM JOKES TO ACTION

Are memes impotent jokes, or can they lead to real political change? Visual culture has always had a role to play in social change. Memes like posting photos of sunflower seeds bear semblance to the buttons and flags of twentieth-century social movements, while others like the naked meme resemble street-theatre tactics like sit-ins and vigils. Especially in a country that cracks down heavily on large political gatherings, these memes are a form of digital public assembly.

There are hints in China that participating in political meme culture can be a gateway to broader political engagement. When Ai faced $2.5 million in tax evasion charges, his supporters collectively gathered to show support. Arriving at his studio in waves, they each began donating small amounts to help him pay the fee. This represented an important shift from online space into offline space. The act of visiting his heavily surveillanced studio and giving money – sometimes literally tossing it as paper airplanes over the walls – became a meme in itself, with much greater personal risks than simply posting a photo online.

Asking whether memes lead to real political change misses the highly censored and propagandized context of China's internet. Until recently, the so-called Great Firewall has worked incredibly well at ensuring that the average Chinese citizen would be hard pressed to identify the name of a single prominent activist. But Ai's popularity online has only grown in the face of the government's efforts to stamp out his name. In the face of a government relentless and innovative in its efforts to control

media images and messaging, internet users have been equally relentless and innovative in employing a variety of image remixes, puns and other memes to speak out about the artist.

To a citizenry regularly told by their government what they cannot do, the act of speaking out is a powerful political act in and of itself. It is already a significant change. Ai's embrace of internet culture sends a simple, powerful message to other concerned citizens. You can get naked. You can make a silly pun. You can Photoshop a sunflower seed on a grown man's face. You can do a horsie dance against the government. You can make a short documentary about injustices you've witnessed. You can criticize your leaders. You, too, can play this game.

1. Evan Osnos, 'The Big Chill', *The New Yorker*, 1 April 2011, http://www.newyorker.com/online/blogs/evanosnos/2011/04/china-crackdown-arrests-liao-yiwu.html, accessed 15 October 2013.

2. David Bandurski, 'Global Times attacks Ai Weiwei and the West', *China Media Project*, 7 April 2011, http://cmp.hku.hk/2011/04/07/11340, accessed 15 October 2013.

3. Ethan Zuckerman, 'The Cute Cat Theory Talk at ETech', 3 March 2008, http://www.ethanzuckerman.com/blog/2008/03/08/the-cute-cat-theory-talk-at-etech, accessed 15 October 2013.

4. Zuckerman 2008.

5. Ethan Zuckerman, 'Cute Cat Theory: The China Corollary', 3 December 2007, http://www.ethanzuckerman.com/blog/2007/12/03/cute-cat-theory-the-china-corollary, accessed 15 October 2013.

6. Zuckerman 2007.

7. Charles Arthur, 'The Streisand Effect: Secrecy in the Digital Age', *The Guardian*, 20 March 2009, http://www.theguardian.com/technology/2009/mar/20/streisand-effect-internet-law, accessed 15 October 2013.

8. 'What Happens When People Migrate to the Internet?', *NPR*, 11 June 2010, http://www.npr.org/templates/story/story.php?storyId=127760715, accessed 15 October 2013.

STUDY OF PERSPECTIVE

1. Philip Tinari, 'Fingered with a Camera: Ai Weiwei and Photography', in Ai Weiwei, Urs Stahel, and Daniela Janser, *Interlacing*, Steidl, 2011, p.73.

In 1995, Ai Weiwei lifted a finger to the portrait of Mao Zedong that hangs above the Forbidden City's Gate of Heavenly Peace. Dubbed a *Study of Perspective*, wryly referencing the use of one's thumb or forefinger to gauge the relationship of distant objects, the photo was the beginning of a series of images in which the artist would assess icons of power with an air of disdain. As stand-alone acts of transgression, these initial 'studies' might hint of superficiality, resonating as childish gimmickry or riskless affronts to authoritative structures. Yet, as the earliest works produced upon Ai's return to Beijing, the *Study of Perspective* series is less a collection of individual protestations than the initial articulation of a philosophy, advancing an ethos of resistance against corruption, tyranny and power that would unfold over the course of his career.[1]

Though dormant for many years after their initial publication, the photographic series reappeared with the activation of Ai Weiwei's Sina blog (2005–2009). Among his hundreds of digital uploads each evening, Ai's middle finger emerged as a frequent and conspicuous presence. Featured regularly on his international trips, the collection of images aggregated into a puckish travelogue, simultaneously affirming the tourist's documentary impulse – proof of 'being there' confirmed by foregrounding oneself in front of an iconic monument – while simultaneously, and irreverently, flipping it the bird. Like most photographs on Ai's blog, the images reflect little concern for the technical constraints of the medium. Ai's process places greater enthusiasm in collecting images as temporal fragments. Rather than presenting an individual image for its encompassing singularity, this process values the sheer volume of their production. The seriality of *Study of Perspective* as an ongoing and seemingly indiscriminate project takes place whenever and wherever Ai deems fit. Adopting the internet as their gallery, the series' unpredictable informality and its universal messaging make it one of the most accessible facets of the artist's production.

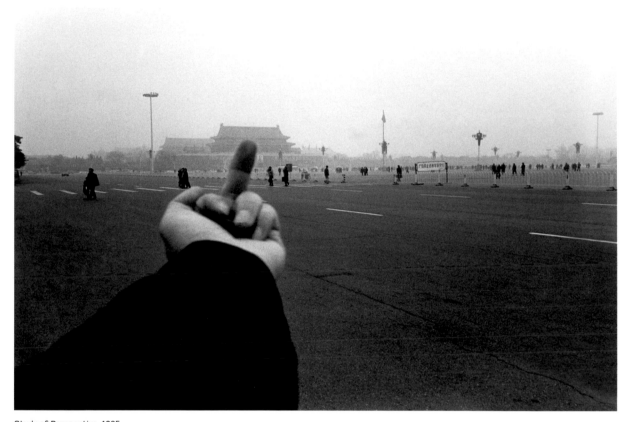

Study of Perspective, 1995–
Tiananmen Square
Gelatin silver print
38.9 x 59 cm

a

b

c

d

e

f

g

h

i

j

k

Study of Perspective, 1995–
C-prints and B/W-prints

a. Xinjiang, PRC
b. Parliament, London, Great Britain
c. National Parliament, Berne, Switzerland
d. Turpan, PRC
e. Sydney Opera House, Australia
f. Tokyo, Japan
g. Schaulager, Basel, Switzerland
h. *Mona Lisa*, Paris, France
i. Sagrada Familia, Barcelona, Spain
j. Massachusetts Institute of Technology, USA
k. Colosseo, Rome, Italy

If the early photographs indicated the initial articulation of Ai's personal philosophy, one which positioned the artist against hegemonic regimes, the quantity and breadth of subject matter covered in the blogged *Studies* demonstrate how Ai has leveraged the work to instigate a participatory forum that prompts viewers to evaluate their unquestioned deference to forms of establishment. Following Ai's detention, the *Study* became an internet meme, taken up by netizens who posted pictures of themselves raising their middle finger in a show of solidarity. Rather than aimed at artefacts of iconic significance, these gestures made motion towards the camera itself, simultaneously acknowledging that their actions were being noted by Chinese internet censors, while more universally signalling an appeal for free speech, action, and the productive enthusiasm of a vocal dissent. In this final transformation, the gesture no longer negates a particular object of disdain, but signals an open mind.

Study of Perspective, 1995–
Central Park, New York City, USA
B/W-print

Next page:
Study of Perspective, 1995–
Victoria Harbour, Hong Kong
B/W-print

DOCUMENTARIES

On 12 August 2009, Ai Weiwei travelled to Chengdu, a central Chinese city in Sichuan Province to testify on behalf of Tan Zuoren, an environmentalist accused of inciting subversion of state. Like Ai, Tan had been an unrelenting publicist of the 12 May earthquake's human toll. He had spent months compiling an independent list of the victims' names and detailed evidence of shoddy construction at collapsed school buildings. The substandard 'tofu dreg' construction had not only accounted for the deaths of thousands of schoolchildren crushed in the rubble, but reinforced suspicions of corruption among the regional government's public works officials.

Accompanying Ai in Chengdu was an entourage of assistants, including one who recorded video of the trip. Ai had suspected – rightly, it turned out – that the presence of Tan supporters would lead to conflict. Indeed, soon after his arrival, Ai confronted a surveillance tail outside his hotel that had conspicuously followed him throughout the day. Around 3 am, in the early morning before the trial, local police arrived at his hotel and demanded to enter into his room under the guise of an identification check. Undeterred by his repeated refusals, the armed officers burst into Ai's room. In the short fracas that followed, Ai was struck in the head, resulting in an injury that would later require emergency surgery to drain blood from his brain. For the next eleven hours, Ai and his assistants were held in the hotel to prevent him from appearing in court. Four of Ai's studio volunteers were taken in by authorities and held in an undisclosed location. The entire incident was caught on tape.

Laoma Tihua, named for the local pork knuckle soup that Ai and his assistants dined on that first evening, is alternately known by its English title, *Disturbing the Peace*. It captures, in detail, the hours preceding the police conflict and Ai's struggle afterward as he and his legal team attempt to file an official report against their attackers. Vacillating between terrifying and the absurd, Ai's complaint is reported to, and initially denied by, the very

Still from <u>Hua Lian Baer (Box Your Ears)</u>
2008
Video
1 hour, 18 minutes

Stills from <u>Hua Lian Baer (Box Your Ears)</u>, 2008
Video
1 hour, 18 minutes

Stills from <u>Laoma Tihua [Disturbing the Peace]</u>, 2009
Video
1 hour, 19 minutes

Stills from San Hua, 2010
Video
1 hour, 8 minutes

Still from <u>Laoma Tihua (Disturbing the Peace)</u>
2009
Video
1 hour, 19 minutes

authorities who approved his short detainment. As the Kafka-esque documentary unfolds, it reveals the bizarre set of circumstances surrounding the attack, and the Byzantine structure of Chengdu's police hierarchy. The film also elucidates the broader hurdles posed to activists working against China's suppression of basic rights. After Ai has taken great pains to successfully submit his report to police and secure the release of his assistant Liu Yanping, the documentary descends in chaos again as Ai is confronted by officers for taking a picture of the police station that he has just left. In the shoving match that ensues, officers attempt to confiscate a camera from Ai's videographer, Zhao Zhao, while his diminutive lawyer, Liu Xiaoyuan, is caught in the middle yelling legal admonishments. Foregrounding the futility of the whole endeavour once again, *Disturbing the Peace*'s cyclical narrative is both a powerful representation of China's sometimes surreal bureaucracy and a testament to the stamina of the activist's ethos as a loyal and unrelenting opposition.

The video is one of many documentaries born of Ai Weiwei's almost incessant self-documentation, an activity that he conducts as a transparent record of his daily travails. In some films, the artist serves as a catalytic protagonist whom events inevitably confront. In others, he is content to remain off-screen, offering only a director's eye to curate footage gathered by assistants. Ranging from short interviews to in-depth explorations of topical and often controversial events, the films often give voice to the deeply personal struggles of average citizens struggling against the indignity of oppression. In *A Beautiful Life,* he follows the story of Feng Zhenghu, an academic and human rights activist who was forced to remain at Tokyo's Narita Airport for ninety-two days when China refused to readmit him into the country. *San Hua*, meanwhile, provides a scathing insight into the illegal trade in cat meat. Other films are more politically sensitive, such as the three-hour-long *Remembrance*, in which Ai invited thousands of volunteers

to read the names of the children who died in the Sichuan earthquake as their names scroll against a black background. *One Recluse* is a film about Yang Jia, a young Beijing resident who killed six Shanghai police officers in 2008 after he was beaten and insulted while under arrest for riding an unregistered bicycle.

In a surveillance state, citizen documentaries serve a powerful and subversive role. Wresting the power of narrative from the control of state media outlets, the documentaries form an alternative record that contests official accounts of conflict or, through the advancement of an independent analysis, gives voice to underrepresented and suppressed stories. These documentaries are disseminated via YouTube and internet download, and Ai willingly mails DVD copies to anyone who requests them. As in *Study of Perspective*, the act of recording is as much an articulation of resistance as the actual content of the films. As the state watches over the entrance to Ai's studio, he responds by placing the camera back on them, a gambit in which the artist reveals that he has far less to hide.

Ai's approach is decidedly uncultivated, varying between *cinéma vérité*'s first-person antagonism and the more indirect approach of direct cinema. Stripped of slick editing and shot on handheld cameras, their amateurish quality reaffirms the importance of the uncomfortable questions they ask and the cohesive yet unlaboured narrative they form. Adding to the approach's stylistic authenticity, this low-tech approach has a subtler ulterior message for China's internet generation. Unlike his finely produced sculptures or hand-painted porcelain, the documentaries' everyday style transmits a firmly democratic message: that by even the most basic means, anyone can, and should, do this too.

Still from One Recluse, 2010
Video
3 hours

Malu, Jiading, Shanghai, PRC
2008–2011

JIADING MALU
(SHANGHAI STUDIO)

Some buildings resonate within society's collective memory precisely because they no longer exist. These buildings take on a mythology independent of and far outlasting their material presence, lamented not only as lost artefacts of history, but because their demise becomes symbolic of the very forces which impelled their destruction. Loss often pays testament to a failure of will or perverse injustice. Yet, for it to hold significance, demolition must not only make evident the vulnerability and mortality of all things standing, but ignite post-mortem narratives that span the broader cultural appreciation. These buildings, whether intentionally or not, are seeded with a latent potential, perhaps even a destiny, for an abrupt and dramatic end.

Ai Weiwei's Shanghai Studio may be one such building. In 2008, the Shanghai city government invited Ai to build a studio in the nearby suburb of Jiading. Offering him resources that far exceeded those necessary for his typically modest buildings, the officials proposed that he design a more elaborate work of architecture. Sitting at his dining-room table, the officials described the studio as a catalyst, the seed from which a vibrant new cultural district would spring to transform an agricultural area known for its grape farms. Ai turned the offer down.

'The first words that came to me – you can ask my assistant – were "we don't deal with the government"', Ai would later recall. Already disdainful of the use of the Bird's Nest for state propaganda, the artist may have rightly been sceptical about the government's growing warmth for the arts. In the years preceding the Olympics, officials had become increasingly fixated on culture's political salience as a demonstration of the nation's openness to free speech and artistic discord. Leveraging their economic potential as vibrant tourist destinations, these districts not only blunted potentially subversive forms of artistic production through their gradual commodification – a shift that corresponded with growing market euphoria for Chinese art – but constituted a keen urban policy which defined space within

Engage

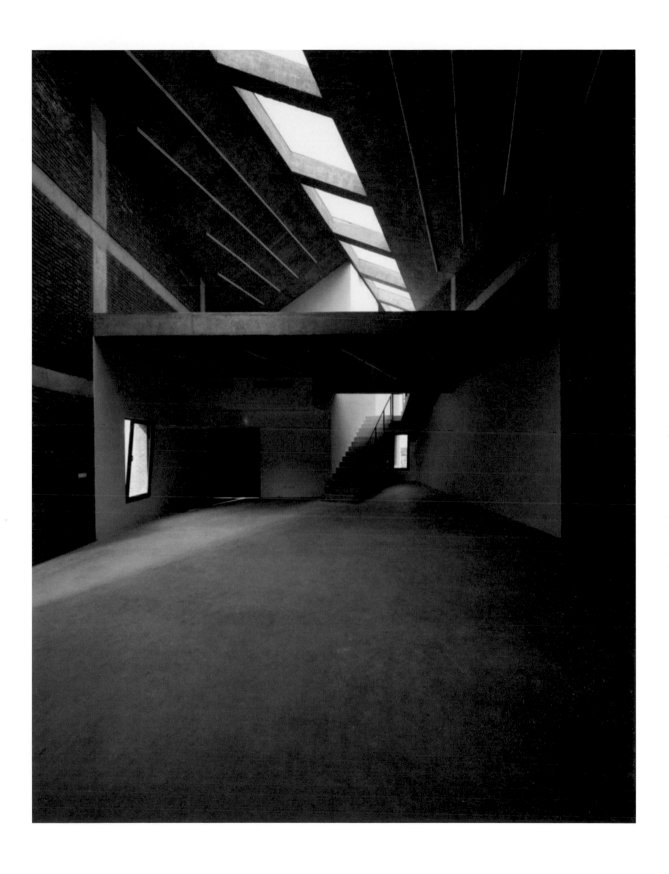

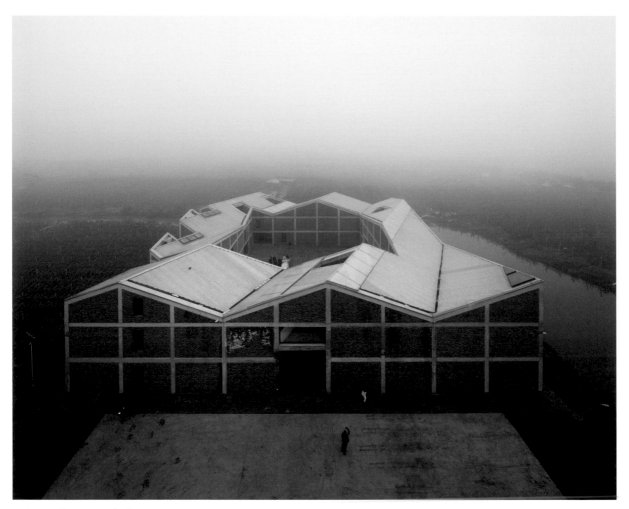

Jiading Malu (Shanghai Studio), 2010
Eastern perspective

Previous page:
Jiading Malu (Shanghai Studio), 2010
Shanghai, PRC
Interior

the city for acceptable levels of dissonance. Steering the exhibition and, to a lesser extent, the creation of artwork into monitored enclaves, officials challenged the artwork's social and political efficacy, firstly through its acceptance as a cultural activity, and secondly through its recasting as a practice outside of daily life.

To that extent, Ai's change of heart may have come as a surprise. Explaining his reasoning, Ai stated that the repeated efforts of a particular official convinced him to go forward with the project. 'This official made a very personal effort. He would come visit me in Beijing and he was a very sincere young man with some vision. Finally, I said, "Okay, let's build one last one."'

When it was completed in late 2010, the Shanghai Studio stood as Ai Weiwei's most virtuosic individual display of architecture. Combining his preference for simple geometries with the shallow, repetitive pitch of a diagonally oriented roof, the studio exhibited both the artist's modest disposition as well as a more expressive turn in his architectural sensibility. Echoing his proposal with Herzog & de Meuron for the Jindong New Development Area master plan (2003), the distinctive roofline exacts a measure of difference against the orthogonal rigidity of the architectural mass. At the Shanghai Studio the effect is singular, giving it a distinguished character which can be perceived from afar across the agricultural landscape. Absent of any significant context,

Jiading Malu (Shanghai Studio), 2010
Second-floor interior

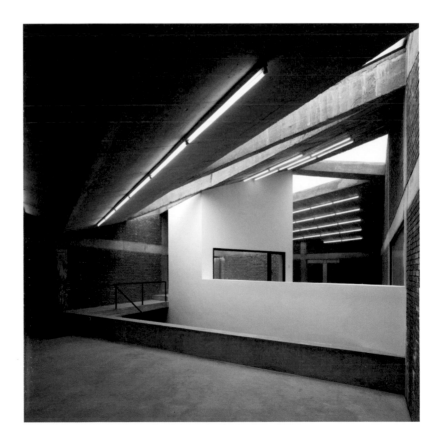

the studio maintains a strictly inward focus and is organized around a central courtyard. The interior elevations reflect the logic of the roof seemingly imposed on the building – a tension that only accentuates its beauty.

With little in the way of programmatic requirements to shape the interiors, the floor plans are largely open and undefined by use. On the north side of the building, a series of deep courtyard recesses provides light and access to private studio-residences. Oriented at a diagonal to align with the direction of the roof, these units alternate between single-storey apartments and double-height units with mezzanine overlooks. In the studio's gallery spaces, expansive skylights gashed at the apex of the converging roof planes create instances of sublime drama. Establishing a sense of repetition through the studio's triple-height galleries, the rooflines revel in moments where their orderly diagonal rhythm comes into conflict with the orthogonal floor plan. At the intersection of these discordant angles, the building mediates between the roof, walls, and floor to create unique spatial compositions, while elsewhere vertical atria create voyeuristic moments where adjacent interiors are seen through the shafts of exterior space.

The studio's geometric operations are even more apparent against the series of extended fluorescent lights latched to the roof's underside. These linear tubes, which elongate the sense of space, accentuate the dynamism of a material palette otherwise composed of brick, concrete, and white walls. The interplay of these effects can be seen often. On one occasion, the roof's vertical undulation terminates against a windowless white cube. Its abnormal angles produce an intriguing faceted enclosure. In another, the skylight, soaring above the two-storey room in alignment with the interior walls, draws natural light from above to almost divine effect. At the end of the room, an exposed concrete slab hangs above the open interior, providing a contemplative perch from which to observe the otherwise quiet and unfilled room.

Plan: First Floor
Scale: 1 : 800

Plan: Second Floor
Scale: 1 : 800

In the nearly two years that followed the project's inception, Ai's prominence as a government critic grew with his increasing willingness to publicize politically sensitive issues. Harassed, and on one occasion beaten, Ai's tepid relationship with officials following the Olympics had turned cold by 2010. In August, shortly after the studio's completion, local authorities announced that it lacked the proper permits and would be demolished after the New Year. What exactly prompted the studio's demolition remained difficult to discern. Though it was an obvious form of political retaliation, Ai never received information on who ordered the studio to be destroyed, nor the specific action for which he was being punished. It was, however, a clear signal that Ai should withhold his criticism.

Despite the intensifying pressure, Ai insisted on needling officials once more. In response to the demolition notice, he announced that he would hold a banquet at the fated studio in early November and promised to attend in person. Followers flocked to Twitter and other social media outlets to announce that they would join him, attracting the attention and concern of local authorities. Equally worrisome was the banquet's fare, *hexie*, which is both the Mandarin word for 'river crab' and a popular internet pun playing on the word 'harmony', a Communist Party euphemism for internet censorship. On the morning that Ai was supposed to depart for Shanghai, police arrived at his home and urged him not to attend the feast. As they lacked an arrest warrant or any form of official decree, he refused. Spurned, the police left, only to return soon after, again without an official order. This time, they reasoned, Ai should simply announce that he was under house arrest as an excuse to his guests. Ai again refused. Finally, as Ai prepared to leave for the airport, police arrived at his house a third time, issuing a warrant placing him under house arrest for a period of twenty-four hours to prevent him from attending the party. Speaking to reporters, Ai later said, 'This is the general

Plan: Third Floor
Scale: 1 : 800

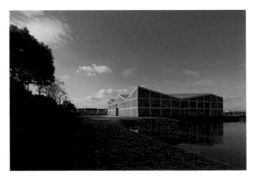

Jiading Malu (Shanghai Studio), 2010
South-western perspective

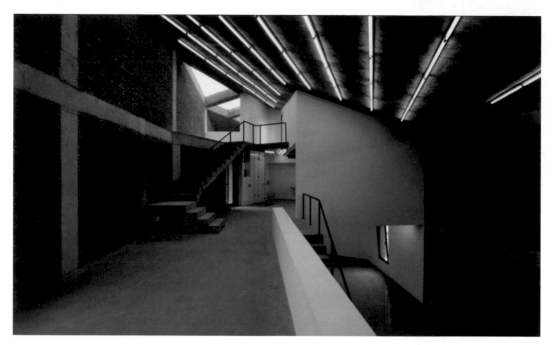

Jiading Malu (Shanghai Studio), 2010
Second-floor mezzanine

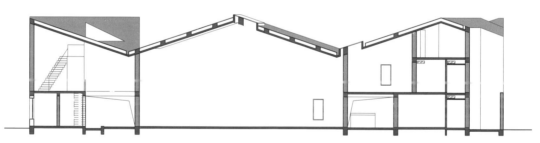

Section A–A
Scale: 1 : 500

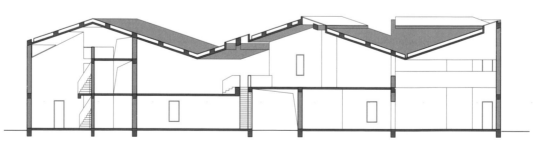

Section B–B
Scale: 1 : 500

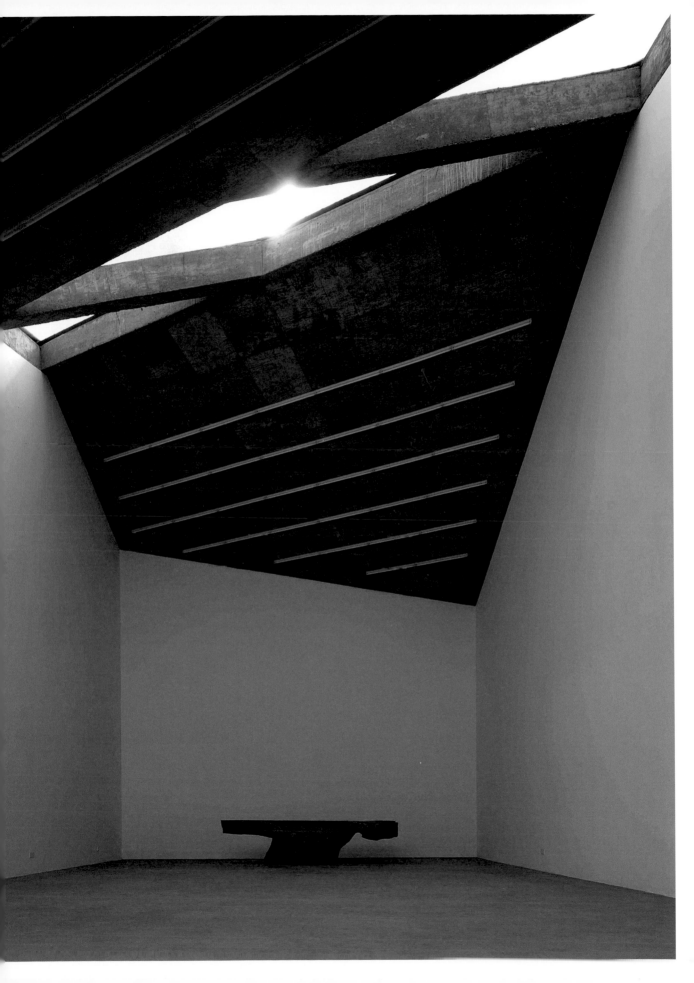

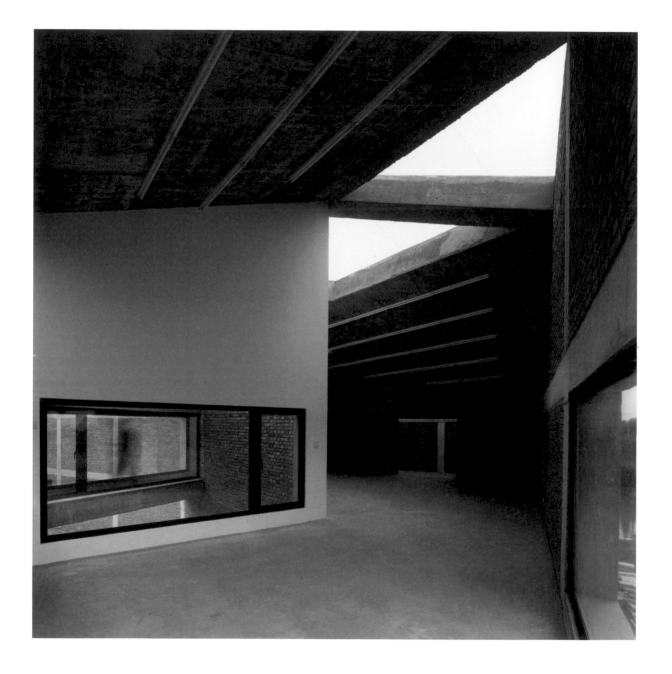

Engage

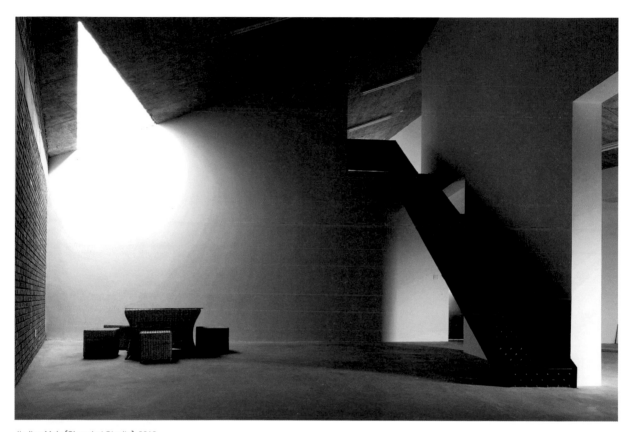

Jiading Malu (Shanghai Studio), 2010
A double-height space in one of the
studio-residences

Left:

A vertical atrium cuts through a
second-floor interior

Jiading Malu (Shanghai Studio),
2010
Interior of a studio-residence

tragedy of this nation. Everything has to be dealt with by police. It is like you use an axe to do all the housework because this is the only tool you have.'[1]

Even with Ai's absence, the river-crab feast successfully filled the studio with party-goers who delighted in large plates of stewed beef, pork and asparagus, fresh bread, white rice and 10,000 local river crabs. As the crabs were served, guests chanted, 'For a harmonized society, eat river crabs.' Later, supporters serenaded Ai Weiwei with songs and politically themed chants via Twitter and Sina Weibo. It was a peaceful protest, one that was broadcast worldwide in near real-time. As hundreds of images flooded the net, they showed attendees holding posters bearing Ai's visage and political slogans. The scene was a clear indication that while it was Ai who had drawn them to the studio, the attendees were also there for something much larger. Dedicated followers, who had arrived from all corners of China, did so with full knowledge of the personal consequences their presence could bring. As ordinary citizens, they were guaranteed none of the protections Ai enjoyed because of his celebrity. Despite this palpable undercurrent, the atmosphere remained jovial, especially from Beijing, where Ai tweeted his gratitude to all who had attended.

The significance of the river-crab feast lies not in the artist's impudence or his disavowal of the government's supposed omniscience, but in its very affirmation of the architectural object. Ai Weiwei knows that to lack evidence is to surrender the truth to the narratives of a powerful or

1. Tania Branigan, 'Ai Weiwei Under House Arrest', *The Guardian*, 5 November 2010.

controlling interest. Countering such narratives, the river-crab feast was an act of verification. As a demonstration that solidified the studio's brief presence within a collective memory, it served to establish the studio as the site of importance and also allowed visitors to verify its very existence in the first place. The physical, tactile interaction with Ai's building of the hundreds of participants who served as witnesses formed the basis of a counter-history that could contradict official party lines and the tactics of erasure.

Ai understands well the Freudian notion of negation, in which acts of brutality reveal the perceived threat – and thus an inherent value – that certain objects, ideas, or beliefs pose to an oppressor's hold on power. The studio's destruction, then, did not spell its complete loss, but its elevation from the status of mere architecture to something more potent – a site of resistance. Absent a historical marker or the force of an enduring narrative, razed buildings typically fade into the uncollected realm of individual memories. In preemptively memorializing the studio's loss, Ai's river-crab feast rendered the studio's demolition as a kind of historical event. It also elevated the importance of the studio to a wider audience. For supporters, the studio's demolition affirmed the discontentment that had brought them to the feast in support of Ai. The international press, meanwhile, furthered narratives of government suppression and intolerance. Using the conventional power tactic in which narratives are compressed on to objects to render the two indistinguishable, Ai utilized the demise of the Shanghai Studio as a medium for activism by appropriating it as an artefact whose destruction galvanized attention and sentiments worldwide.

The use of social media as the river-crab feast's primary organizational tool comprised an important facet of Ai's strategy and allowed the artist to test the possibilities of informal communication networks. 'I am constantly trying to figure out how this virtual reality becomes real,' Ai says. 'I

North elevation

East elevation

South elevation

West elevation

Construction progress at the <u>Shanghai Studio</u>

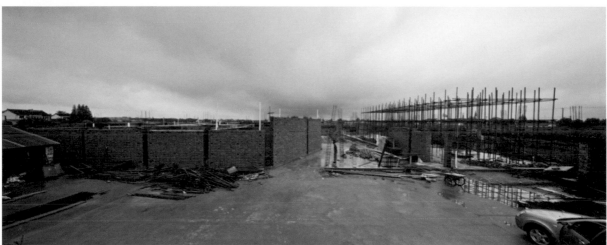

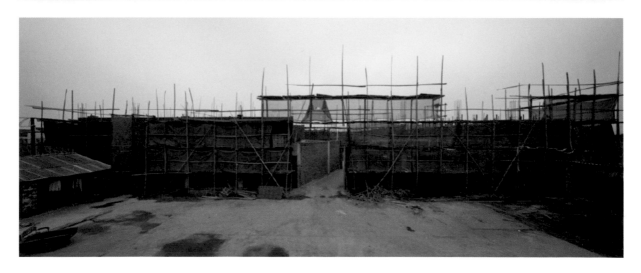

Jiading Malu (Shanghai Studio)

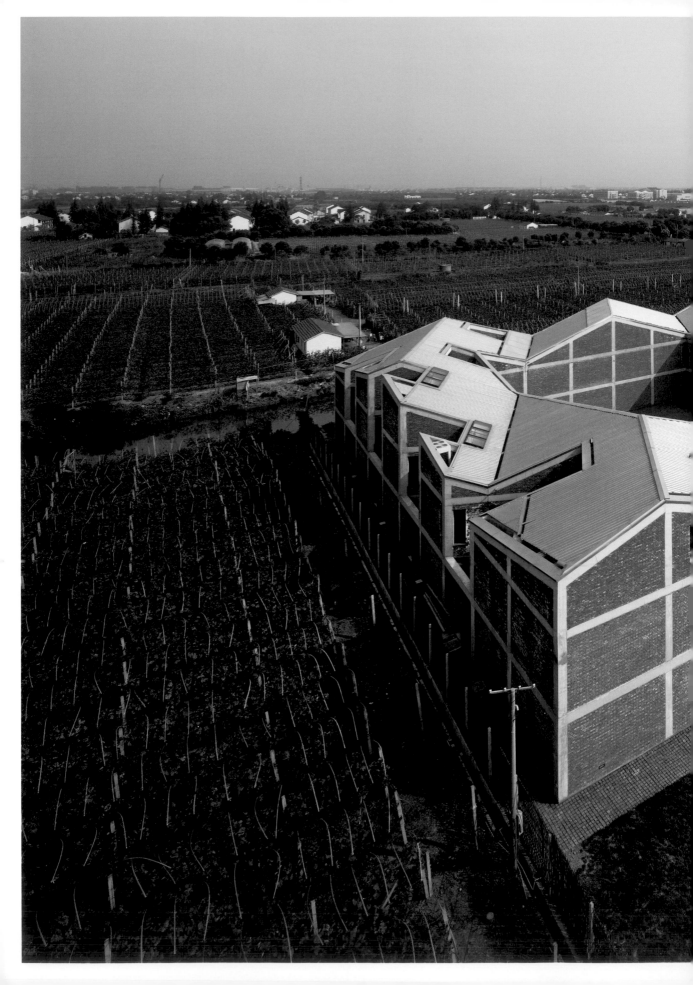

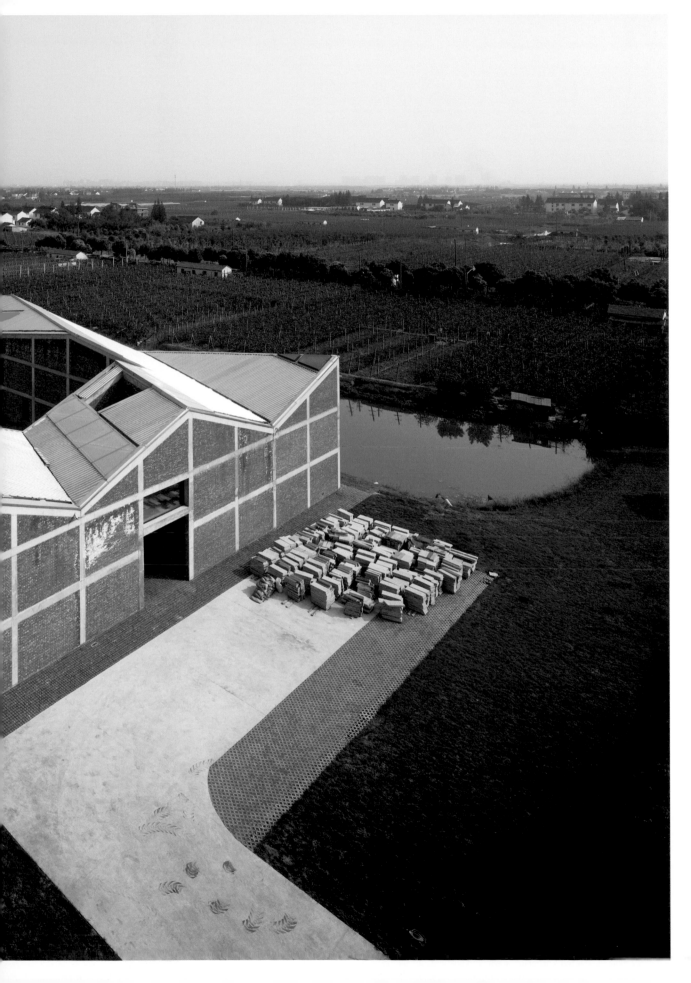

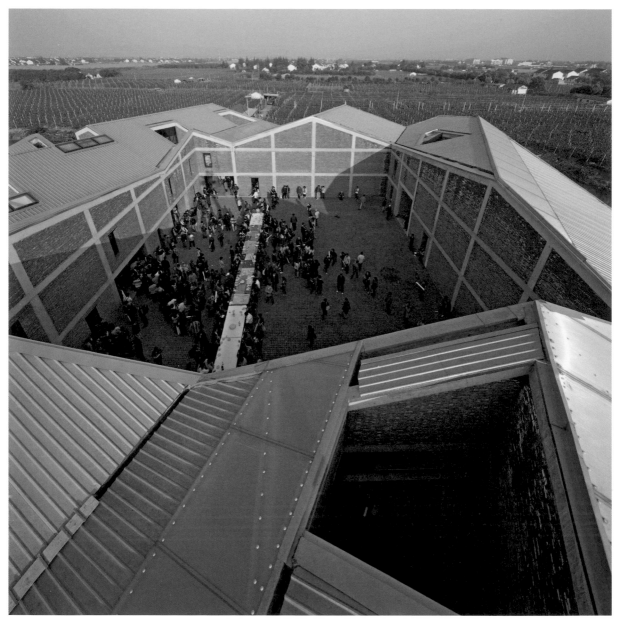

River-Crab Feast, 2010

Previous page:
<u>Jiading Malu (Shanghai Studio)</u>, 2010
Completed exterior

want to know if people trust it and for what reason … I think it will be a great tool for social change.' Within the realm of memory and action, French philosopher Maurice Halbwachs identifies the need for 'contact with a human society that can guarantee the integrity of our memory'.[2] Social media, while providing tools for efficiently managing one's acquaintances and even making new ones, rarely forms the personal bonds which result in high-risk activism.[3] In addition to assembling a gaggle of witnesses, the river-crab feast solidified the weak ties of an informal community that shared both an admiration for Ai Weiwei and a mutual political disposition against the country's oppressive totalitarianism. In strengthening these ties through introductions and interaction, Ai's event bridged the divide between the virtual and the physical in the name of social and political activism.

It took less than forty-eight hours to clear the rubble from the site formerly occupied by the Shanghai Studio. Nearly a year in construction, the building's demise was ordered by the same government that had commissioned it. If it was intended as an act of retaliation, the studio's demolition badly missed its target. Rather than discourage Ai Weiwei, it was a welcome conclusion to a career in architecture that he never meant to start. The building was, after all, virtually unnecessary to Ai himself. Only the attention it focused on the government's tactics and the interactions it facilitated between the feast's participants gave purpose to the previously unknown structure. When the bulldozers arrived, the studio's striking image, its spatial virtuosity and soaring interiors, remained in the public consciousness. For those with little knowledge of Ai or his architecture, the demolition seemed senseless. Ai, however, remained content: 'If I think back, this building served its purpose. It doesn't have to stay any longer after it was viewed. This is all part of the architectural process – to destroy something, to vanish – although I never imagined it would happen to me. The moment it is built, it is already successful.'

2. Maurice Halbwachs, *On Collective Memory*, trans. Lewis A. Coser, University of Chicago Press, 1992, p.41.

3. Malcolm Gladwell, 'Small Change: Why the Revolution Will Not Be Tweeted', *The New Yorker*, 10 October 2010.

Engage

Demolition of Ai Weiwei's
Shanghai Studio in progress
on 11 January 2011

Engage

Demolition of Ai Weiwei's <u>Shanghai Studio</u> in
progress on 11 January 2011

Next page:

The cleared site of Ai Weiwei's <u>Shanghai Studio</u>,
two days after demolition commenced

MERMAID EXCHANGE

In March 2010, crowds of Danish citizens gathered along Copenhagen's Langelinie Promenade to witness the removal of Edvard Eriksen's iconic bronze statue, *The Little Mermaid*. Hoisted by crane, crated and shipped to Shanghai for the 2010 World Expo, the statue honouring Hans Christian Andersen made its voyage to China under diplomatic auspices. Dispatched as a symbol of the Dane's historical contribution to global culture and an artefact of Copenhagen's contemporary civic life, the sculpture served as the centrepiece of the Danish exhibition, neatly resting in a shallow pond at the heart of its helix-shaped pavilion. Offering an intertwined collection of distinctly Danish vignettes – a bike track, a nature playground, and a harbour bath – the Bjarke Ingels-designed pavilion was, in effect, a condensation of Danish culture, an exported miniature of Copenhagen meant to espouse 'national virtues' as part of the global pageantry.

In the context of this cultural exchange, Ai Weiwei's work in Copenhagen could only be understood as deeply ironic. Though unaffiliated with the proceedings in Shanghai, the commission to replace *The Little Mermaid* during its hiatus positioned Ai as China's de facto representative to Denmark, and his temporary video installation, *Mermaid Exchange*, as the Chinese recourse for the statue on loan. The work itself consisted of little more than an oversized video screen. Installed in the mermaid's original location, it provided a twenty-four-hour live feed of the relocated statue in Shanghai, transmitted from a conspicuously placed camera mounted within the pavilion's atrium. *Mermaid Exchange* was Ai's most elaborate effort to date that attempted to monumentalize, and make a mockery of, the Chinese surveillance state. Contemporaneous with works such as *Surveillance Camera* (2010), a marble reproduction of the eponymous device, it asserted a critical posture through the cynical elevation of the surveillance camera as a distinguished artefact of Chinese culture. Monumentalizing this condition through translations of scale and material effects, the objects are

Installation of <u>Mermaid Exchange</u> at the Danish Pavilion in Shanghai, 2010

Above:
Mermaid Exchange, 2010
Video installation
Langelinie, Copenhagen, Denmark

1. Isabelle Brajer, 'A
Question of Authenticity
– The Little Mermaid in
China', *International Council
of Museums: Committee
for Conservation*, 30 May
2010, http://www.icom-cc.
org/forums/viewtopic.
php?f=24&t=153, accessed
16 October 2013.

held up within the wry-humoured tradition of Duchamp, reducing the tenets of domestic reconnaissance – anonymous, covert, and omnipresent – into caricatures of themselves.

In *Mermaid Exchange*, the television screen pays testament to the monument's contested state in contemporary civic life. Keenly aware of the use of urban monuments to affirm and solidify cultural narratives in support of national unity, the projection of the mermaid's image pokes gentle fun at Danish anxiety over the statue's loss. For many, the decision to loan the statue had been a question of authenticity, with a vocal contingent proposing to send a replica instead.[1] The statue at Langelinie, however, has always been a replica. The irony of the reverence for the copy, whose monolithic appearance is in fact an assemblage of prosthetic components resulting from multiple acts of vandalism, further complicates the value assessment of material objects. As an oversized projection of this insecurity, the screen pays homage to the overprotective regard for the mermaid's value, but also the willingness to attach national narratives to objects as a form of cultural validation.

Ai has always understood that for these critical stances to take hold, his work must have a more universal appeal – a basic allure. Keen to avoid the narcissistic entrapments of personal narrative, the screen is understood as both an object simultaneously projecting and creating the public exchange that forms around the spectacle of the vacant pedestal. There is an unquestionable enjoyment in it all. From the statue's former spot on Langelinie Promenade, Danes could view the gathering crowds of Expo visitors taking pictures and swimming in the pavilion's shallow water. For those who couldn't visit the statue in China or via Ai Weiwei's installation in Denmark, many more on the internet could simply tune into a special website to see the live feed. As the exhibition took on further life in the Twitter-sphere, one user wrote: 'Without the need to attend the World Expo, we're watching constantly, and are being watched.' In reply, Ai simply wrote, 'I've done it for you.'

Mermaid Exchange, 2010
Video installation
Danish Pavilion, Shanghai, PRC

Engage

AI WEIWEI AND SOCIAL MEDIA

On 24 June 2009 at 8:08 am, Ai Weiwei issued his first tweet, declaring that he had no taste for climbing over the Great Firewall. The 'firewall' was, of course, not a physical barrier, but its implications were no less defined by geography. As a kind of geopolitical boundary within the digital realm, the Great Firewall is the primary agent limiting website content and internet material to all computers within China's borders. The decision whether or not to 'climb the firewall' described precisely Ai Weiwei's predicament at that moment. In May 2009, his Sina blog was permanently shut down after entries on his investigation into the deaths of schoolchildren in the Sichuan Earthquake were censored and deleted. Until then, he had also spent considerable time on Zuosa and Fanfou, Chinese microblogging equivalents to Twitter, where he maintained multiple accounts to evade the authorities attempting to erase his digital persona. If he wished to maintain his prolific online presence, mounting censorship made clear that he could only do so from the other side of the wall.

Scaling the wall was not without its drawbacks. Though it would allow Ai to disseminate his particular mixture of wit, vitriol, and pleasantries unabated, he would be traversing one of the internet's major territorial divides. Crossing to the other side is made possible only by using an internet proxy server – a programming tool that allows internet users to register their computer's virtual address far from its actual position, giving it the appearance of connecting from a jurisdiction with free-speech protections. In order to use Twitter, Ai must in effect leave China, at least digitally. In order to read his tweets, so too must his followers.

By moving his communiqués to Twitter, Ai ensured that the content of his microblogging would reside on servers outside of China so that authorities could no longer delete messages or control his account. Although the site cannot be viewed within the mainland, any Chinese internet user with the proper software can log on, begin conversing with Ai and see his

messages. Today, the use of proxy servers and other mechanisms of geographic misalignment are commonplace throughout China, effectively ensuring that Ai could maintain his strong domestic following. By December 2009, Ai began using Twitter with increasing regularity and in the ensuing years he rapidly ascended as one of the service's most prolific users, publishing over 60,000 tweets – an average of 370 tweets daily – and amassing a following of over 210,000 individual users. His is one of the most followed Chinese-language accounts on Twitter and his tweets have become increasingly popular internationally. Ai Weiwei spends as many as eight hours a day on Twitter, chatting with followers as soon as he wakes up and then joining them again before he retires in the evening. Subjects range from the exchange of simple pleasantries – Ai typically signs on by tweeting 'Good morning' – to intense criticisms of the government. Much of the content is cordial, even domestic in nature. He offers advice and succour to young people – most of his followers are of the 1980s and 1990s generation – worried about love or college entrance exams. He tweets about his dogs and cats, the guests who visit, and his travels. He debates and cajoles. He even tweets about visits from the police and conflicts with the law.

What sets Ai apart from most famous personas on Twitter is his prolific social engagement. The vast majority of his tweets follow a 'retweet' structure common amongst Chinese speakers on the web. He takes a message directed at him, copies it, and appends an 'RT' (short for 'retweet') to the beginning. He then adds a comment before the tweet. Thus, while most Twitter users of his stature are content to broadcast their thoughts and opinions, the vast majority of Ai's tweets involve direct engagement with anyone who sends him a message. In effect, he is in constant dialogue with his followers, who know to expect him at certain hours of the day.

Ai is not content to remain a remote figure. On occasion, he's organized large-scale, online-only events to build community. In June 2010,

1. Charles Merewether, 'The House of the People: Forms of Collaboration', in Mori Art Museum (ed.), *Ai Weiwei: According to What?*, Tankosha, 2010, p.179.

2. Karen Smith, 'Giant Provocateur', in Karen Smith, Hans-Ulrich Obrist, and Bernhard Fibicher (eds.), *Ai Weiwei*, Phaidon, 2009, p.53.

he began *State Your True Name*, a short campaign to encourage his circle of followers to declare their birthname on Twitter for all, including the nation's censors, to see. Declaring that 'each time one chooses to be anonymous is an acquiescence to power', the campaign was a challenge to both the broader Chinese cultural preference for anonymity, and, especially among his followers, a decision to take refuge in anonymity out of fear for government retribution. Underscoring the intimacy of this interaction, Ai acknowledged each person individually, sending out so many messages that his account was automatically frozen by Twitter for exceeding its rate limits. *State Your True Name* further emphasizes the importance of identity and individualism within Ai's work. Charles Merewether notes that, 'both *Fairytale* (2007) and Ai's work surrounding the Sichuan Earthquake are about naming of ordinary people – in one case giving them a name, an identity, and in another, coping with having that name obliterated'.[1] In *State Your True Name*, both are true, as his followers' user handles, which serve simultaneously as a veil of anonymity and an alternative persona in digital society, are shattered in a single instant.

To this day, followers feel close to Ai Weiwei. They affectionately call him 'Uncle Ai', 'Grandpa Ai', 'Teacher Ai', even 'Auntie Ai'. They regularly ask if they can stop by the studio, a request he rarely turns down. Some ask if they can live or work there. Once, Ai gave out his phone number only to receive dozens of calls from nervous supporters who weren't sure if it really was him. Largely stationary in Beijing and censored by the state, his incredible reach around China, and the world, has pioneered a twenty-first-century style leadership augmented by social media.

The following selection of Ai Weiwei's tweets has been translated into English and dates from the establishment of his Twitter account until his detention in April 2011. Disseminated through the handle, @aiww, the feed mirrors the divergent tactics of the force-of-change agenda which courses through all of Ai's work. This agenda, the historian Karen Smith notes, deviates wildly in style and subject matter, yet is united by 'qualities of disquiet, subversion, quiet rage against passivity and resignation, and sheer exuberance at the human spirit'.[2]

The term 'internet donkey tyrants' refers to the censorship software Green Dam Youth Escort, which the Chinese government regulated must be pre-installed on all new computers before sale. Disregarding tonal differences, the word for 'green dam' is a homophone for the word, 'donkey tyrant'. The term is commonly used as a derogatory name for the software.

14 JUN 09 8:29 PM

@aiww 强奸被人抓住了说是反华，孩子死了质问建筑质量是反华，食品有毒被曝光了是反华，打打 杀杀被曝光了是反华.卖孩子、卖艾滋血、黑煤窑、公检法犯法、假新闻、贪污腐败、违宪侵权、网络驴霸只要是你说你就是反华.你要是不反华那你还是人吗？

@aiww Catching someone for rape was said to be anti-China; children died and queries about building quality were anti-China; the food had poison in it and exposing the news was anti-China; the revelation of beatings and killings was anti-China. Selling children, selling blood with AIDS, underground coal mines, public security, prosecutors and judiciaries violating laws, fake news, corruption, going against the constitution to invade rights, internet donkey tyrants: if you just speak about those you are anti-China. If you are not anti-China, are you still human?

02 AUG 09 1:45 AM

@aiww 结束语是这样的：是这些晚上不爱睡觉的人，在荧屏前用指尖的敲击结束了最后一个黑暗时代，堪称奇迹.

@aiww The concluding remarks are as follows: it's these people, who don't like to sleep at night, that ended the last dark age by hitting [the keyboard] with their fingertips in front of the screen. It should be called a miracle.

12 August 2009: Appearing in Chengdu in defense of Tan Zuoren, Ai Weiwei was beaten and detained in his hotel room by police seeking to prevent his testimony. Shortly after the attack, Ai took this photo of himself in the hotel elevator

03 AUG 09 10:08 PM

@aiww 谭作人如果有罪，那我至少是同罪，谭作人如果被惩罚，我也同理应罚.

@aiww If Tan Zuoren is found guilty, then I am at least guilty for the same charge. By the same logic, if Tan Zuoren is punished, I should receive the same punishment.

03 AUG 09 2:39 PM

@aiww 极权之下的生活技巧：1.不在被奴役和被伤害之前，进行自我奴役和伤害.2.不合作、不相信权力的鬼话.3.有自尊，为他人说话.4.不犬儒，不信邪.5.在知耻的日子里快乐.6.每天做一件小事证明正义的存在.

@aiww Skills for living under totalitarian rule: 1. Don't practise self-slavery and self-injury before being enslaved and injured; 2. Don't cooperate, don't believe in bullshit from those in power; 3. Have self-respect, speak for others; 4. Don't be a coward, don't be superstitious; 5. Be happy while knowing shame; 6. Do something little everyday to prove the existence of righteousness.

24 AUG 09 3:28 AM

@aiww 这是为什么我们寄希望于互联网，我们只有将一个人的情感价值与所有人的情感价值自然生长在同一个时刻的同一个地方，才能形成最大的善，唯有这个善可能战胜无处不在的邪恶.

@aiww This is why we pin our hopes on the internet: the greatest good can only be formed when one's own emotions and values merge with everyone else's emotions and values, and the same place. This is the only way to a maximized form of goodness that defeats evil that is everywhere.

@aiww 他们能对我做什么呢？
无非是驱逐、绑架、监禁、或制
造人间蒸发，他们没有想象力创
造力，缺少快乐和飞翔的能力，
这样的政治集团是可怜的.

@aiww What can they do to me?
None other than exile, imprisonment or
fabricating a disappearance. They don't
have any imagination or creativity, and
they lack happiness and the ability to fly.
Such a political group is a pity.

The forward slash in this tweet is not a typo, but another tactic to avoid the term being filtered on the internet.

03 SEP 09 8:45 AM

@aiww 在我们微博上的每一
次快活就是专/制和极权的一
次死亡.

@aiww Every time we're delighted by
our microblogs, it's one count of death
for des/potism and totalitarian power.

'Zuosa' and 'Sina' are both microblogging sites in China. It is interesting to note that Ai Weiwei does not call Sina by its official name, which means 'new wave'; he plays with homophones and call it 'stinky waves'. Likewise, his use of 'Zuosa' here is a pun for 'do something'.

05 SEP 09 8:50 AM

@aiww 早上起来的选择：
1.是生命的一部分还是死亡的一
部分 2.要真实还是要谎言 3.是快
乐 的还是腐朽的 4.爱还是被遗
弃 5.智慧还是脑残 6.微笑还是屈
辱 7.声讨还是庆典 8.多一点勇敢
还是多一点恐惧 9.做啥还是腥浪
10.自/由或是囚徒.

@aiww Choices to make in the morning:
1. To live or to die? 2. To be true or to lie?
3. To be lively or to decay? 4. To love or to
be forsaken? 5. To be wise or to be idiotic?
6. To smile or to be humiliated? 7. To
denounce or to celebrate? 8. To be more
courageous or to be more fearful?
9. Zuosa or Sina? 10. To be free or to stay
captive?

29 DEC 09 2:44 PM

@aiww 我的祖国，如果一定要
有一个，那就是互联网，她足以
满足我对空间和疆界的想象，其
它的所谓国家，你都拿去好了.

@aiww My motherland, if I have to have
one, would be the internet. She is enough
to satisfy my imagination about spaces
and boundaries. All the other so-called
countries – you can take them all.

The post was written when Google announced its intended exit from the Chinese market, in reaction to censorship, by April 2010 – a move that reportedly angered the Chinese government.

13 JAN 10 2:17 AM

@aiww 从谷歌之退看到的现实
是悲喜交集，赢者知其赢，输者
不知其输，荣者知其荣，耻者不
知其耻. #GoogleCN

@aiww What I can see from the reality
of Google's exit is a mix of tragedy and
happiness. The winner knows about his
win, but the loser doesn't know his loss.
The glorious one knows his glory, but the
shameful one doesn't know his shame.
#GoogleCN

Tan Zuoren was tried for investigating the death of schoolchildren during the Sichuan Earthquake.

09 FEB 10 8:42 AM

@aiww 四川政府不理解的是，
谭作人是我们的一部分，最好的
那一部分与我们同在，我们不会
把他交出去. #tanzuoren

@aiww What the Sichuan government
does not understand is that Tan Zuoren
is a part of us. The best part is going to
stay with us. We will not hand him over.
#tanzuoren

Zhao Lianhai is the parent of a child who developed kidney stones as a result of melamine-tainted milk. Along with other parents, he initiated an investigation into the cause of the kidney stones and announced the scandal to the public. He was subsequently sentenced to thirty months in prison for disturbing the social order.

14 MAR 10 9:49 AM

@aiww 你如果希望了解你的
祖国，你已经走上了犯罪的道
路.#zhaolianhai

@aiww If you are hoping to understand
your motherland, you have already been
led into a life of crime. #zhaolianhai

16 APR 10 10:07 PM

@aiww 这个国家所做的一半努
力是，切断人们获取信息和交流
的可能，另一半是将有正确答案
并愿意告诉他人的人关进监狱.

@aiww Half of this country's energy is
spent on cutting off possibilities for people
to gain information and exchange. The
other half is spent on sending people who
have the correct answers, and who are
willing to share them, to jail.

28 MAY 10 11:14 AM

@aiww 富士康的死亡奇迹是
每一个使用中国制造者的合力
积累完成的，只是你不知或假
装不知.

@aiww Foxconn's death miracle has been
collectively, accumulatively accomplished
by every user of products made in China,
but you have no idea, or pretend to have
no idea.

10 JUN 10 5:41 AM

@aiww 1.谭的家属和他的立场一致 2.公民调查是我和谭在互不认识的情况下分别做的. 3.它使我成为一匹快乐的草泥马. **@piscespaigu**: **@aiww** Eros 问下 1.谭作人的家属对整件事有什么反应 2.公民调查是你组织的家属有怪你么 3.这件事对你以后的工作有甚影响?

@aiww 1. Tan's family stands in line with Tan himself. 2. Without knowing each other, Tan and I carried out citizens' investigations separately. 3. It has made me become a happy grass mud horse. **@piscespaigu**: **@aiww** Eros, I'd like to ask 1. How did the family of Tan Zuoren react to the entire incident? 2. You organized the citizens' investigation, did his family blame you? 3. From now on, how is this incident going to affect your work?

State Your True Name: This was a short-term Twitter action in which Ai encouraged his followers to post their legal names online, flaunting their disregard for China's ban on Twitter use and exposing themselves to the nation's censors and internet monitors. Over the course of twenty-four hours, Ai received such an overwhelming response from his followers that his account was suspended four times through the day for exceeding the maximum number of tweets one can post in a given time.

12 JUN 10 4:42 PM

@aiww 每一次匿名都是对权力的一次示软.

@aiww Each instance of anonymity is a surrender to the power.

12 JUN 10 6:06 PM

@aiww 专制的每一分骄横无不建立在匿名者的怯懦之上.

@aiww Every hint of arrogance of dictatorship is established upon cowardice of anonyms.

12 JUN 10 11:44 PM

@aiww 勇敢的你. RT **@huangchanning**: **@aiww** 响应, 我是黄昌宁

@aiww Brave you. RT **@huangchanning**: **@aiww** Answering the call, I'm Huang Changning.

13 JUN 10 12:01 AM

@aiww 朱晨好. RT **@Dear_Ai**: 大家好 我是朱晨 RT **@aseede**: 未未好, 周樱 好, 我是江莎莎 RT **@aiww**: 周樱 RT **@Ashas7021**: **@aiww** 未未你好, 我是周樱.

@aiww Hi, Zhu Chen. RT **@Dear_Ai**: Hi everyone, I'm Zhu Chen. RT **@aseede**: Hi Weiwei and Zhou Ying, I'm Jiang Shasha. RT **@aiww**: Zhou Ying. RT **@Ashas7021**: **@aiww** Hi Weiwei, I'm Zhou Ying.

15 JUN 10 8:35 PM

@aiww 我也可以爱国, 但前提是我必须说服自己要先爱吃屎, 爱鞭子抽, 爱被踩在脚下, 爱被遗忘和涂改, 爱上暴力和欺骗, 爱上说谎和偷盗, 爱上懒惰和愚蠢, 背叛我的草泥马啊, 这样我就可以大言不惭地说, 我爱国啊.

@aiww I can also love this country. However, the precondition is that I convince myself to love eating shit, to love being whipped, to love being stepped on, to love being forgotten and falsified, to love violence and cheating, to love lies and theft, to love laziness and stupidity, to betray my grass mud horses, then I can shamelessly say, 'Oh I love this country.'

24 JUN 10 5:53 PM

@aiww 四川都江堰公安不断骚扰遇难学生家长, 近日抓捕、扣押、殴打, 说你们不要与艾未未联系, 他是境外反华势力.

@aiww The Dujiangyan police officers from Sichuan continuously harass the parents of victims killed in the Sichuan Earthquake, there are recent arrests, detentions, and beatings, they are also being told not to contact Ai Weiwei, who is an overseas anti-China force.

#512Birthday: Each day, Ai Weiwei commemorates the birthday of the children who passed away in the Sichuan Earthquake by tweeting their names, once as a group and a second time to recognize the age, gender, school, and classroom of the individual student. Given the Twitter hash tag #512Birthday, the project is both a digital memorial to the deceased and a wilful assertion of the event into the Chinese collective consciousness, effectively resisting the historical impulse to expunge traumatic events from the official record.

26 JUN 10 9:00 AM

@aiww 六月二十六日. 今天是7个遇难学生的生日, 他们是: 董兴瑞, 段莹, 苟明树, 李阳, 杨阳, 陈飞, 陈凤月. #512Birthday

@aiww June 26. Today is the birthday of seven students who died. They are Dong Xingrui, Duan Ying, Gou Mingshu, Li Yang, Yang Yang, Chen Fei, Chen Fengyue. #512birthday

25 JUN 10 2:48 AM

@aiww 虚名支撑恐怖. RT **@lihlii**: 来, 你列一下在狱的政治犯, 有名有姓的, 都是实名被抓的. 你知道个屁! > **@loujerry** 现实是残酷的, 但在中国或海外的反对专制的人士

@aiww Pseudonyms support terror. RT **@lihlii**: Here, make a list of the political criminals that are currently jailed, they all have a name and a family name, all arrested because they announced their real names. You know a fart! > **@loujerry**

中，是实名者影响大，公信力强呢还是假名者？@aiww @fzhenghu

Reality is cruel, but in China or among the people against despotism overseas, do people with real names have more influence, more credibility or those with pseudonyms? @aiww @fzhenghu

Ai frequently claims to be part of the generation of the Post-80s, the colloquial term referring to the generation born between 1980 and 1989. Many of his readers tease him about his true age.

14 JUL 10 5:24 PM

@aiww 你是假的？@lame_chen: @aiww 艾老，80后唉，起来的比真80后还早！

@aiww Are you a fake? @lame_chen: @aiww Old Ai, post-80's huh? You get up way earlier than the real post-80's!

08 AUG 10 2:24 AM

@aiww 8月8日凌晨一点'美人鱼交换'夜间潜水，世博丹麦馆因停电出现直播技术事故，全球直播间断八小时.http://is.gd/e8i4S

@aiww At 1 am on 8 August, 'Mermaid Exchange' took a dive at night. The Danish Pavilion at the World Expo had technical issues with its live feed due to a power outage, and the global broadcast was interrupted for eight hours. http://is.gd/e8i4S

03 SEP 10 12:38 PM

@aiww 少谈六四不是因为党不让谈，是我更羞于说起.

@aiww I rarely speak of 4 June [the Tiananmen Square protests], not because the party doesn't allow it, but because I am ashamed to bring it up.

'Liu' here refers to Liu Xiaobo, one of the key authors of Charter 08, a manifesto advocating for reforms in China, including an end to the one-party system. Jailed for eleven years for inciting subversion of state power, Liu reached international prominence when he was awarded the 2010 Nobel Peace Prize. He was the first Chinese citizen to receive the prize and only the third in the prize's history not able to attend the award ceremony personally due to imprisonment.

09 OCT 10 3:10 AM

@aiww 因为诺奖不是奥运项目.@Yangandwu: @aiww 当我看到意大利文报纸说刘获诺贝尔奖的时候 那是相当的激动 我对意大利同学说中国人得诺贝尔奖了 但政府不承认

@aiww Because the Nobel Prize is not the Olympic Games @Yangandwu: @aiww I felt really excited when I read in an Italian newspaper that Liu had received the Nobel Prize. I told my Italian classmates that a Chinese got the Nobel Prize but the government won't acknowledge it.

28 OCT 10 11:16 AM

@aiww 是滴 RT @c06658: 你都成反华势力了，不拆你拆谁？哈哈 RT @aiww: 今天上海方面官员来谈工作室拆迁事宜，结论清晰，必拆.我对此早已没有幻想，还是给了一个由他们最后说出的机会.

@aiww Yes RT @c06658: You have already become a part of the Anti-China force, who else's place is there to demolish? Haha RT @aiww: Today the officials from Shanghai came to discuss studio demolition, it was a clear conclusion, that the demolition is certain. From early on I have no wishful thinking about this, but I still gave them a last chance to say it out loud.

31 OCT 10 4:54 PM

@aiww 11月7号艾未未工作室拆除河蟹盛宴，上海嘉定马陆艾未未的工作室资料：http://is.gd/gslBP 地址：上海嘉定区马陆大峪村刘村村路240号：13901892420 小吕

@aiww On 7 November, the Ai Weiwei Studio will have a river-crab feast for its demolition. Information of the studio: http://is.gd/gslBP Address: No.240, Liu-cun Road, Dayu Village, Malu, Jiading District, Shanghai. Contact number: 13901892420 Ms. Lv

05 NOV 10 12:48 PM

@aiww 2010年11月5号，12:30北京国保和朝阳国保前来宣布了上级的决定：艾未未即时起至7号12：00行使软禁，不得离开住所.草场地258号门外留有警察看守.请关心上海嘉定马陆艾未未工作强的推友和前来河蟹盛宴的草泥马们接受我的最大的歉意.

@aiww 5 November 2010, 12:30. The Beijing State Security and Chaoyang State Security have come to declare the decision of their superiors: Ai Weiwei, immediately until 12:00 on the 7th, is under house arrest. He may not leave his residence. Outside the door of Caochangdi 258 [Ai's studio] the police are standing guard. Please take care of the Twitter friends of the demolition of Ai Weiwei's studio in Malu Jiading, Shanghai and the grass mud horses who have come to the river-crab feast. Accept my greatest apologies.

@**aiww** 蟹宴家.RT
@**weihewang**: @**aiww** 艾先生，您给自己定位？比如画家？导演？还是XX艺术家？

@**aiww** Crab-banquet-ist RT
@**weihewang**: @**aiww**: Mr. Ai, where would you place yourself? As for instance a painter? Director? or XX-artist?

@**aiww** 我遵守禁令.RT
@**delicious724**: 问问艾神
@**aiww** 很多同学很关心你，问艾神是不是还在家禁足呢？是不是可以自由吃饭呢？

@**aiww** I observe the prohibition. RT
@**delicious724**: I want to ask God Ai
@**aiww** A lot of classmates are concerned about you and ask if you are still forbidden to leave your home? Are you free to eat or not?

@**aiww** 问候前来马陆的朋友们，感动，真了不起.

@**aiww** Greetings to friends who came to Malu, I'm touched, you are outstanding.

@**aiww** RT @**zxtm2000**: 中国史上最大的一次行为艺术正在艾未未工作室展出，最有趣的是反对这次展出的人也是这次行为艺术一部分.应该也给他们发只螃蟹.

@**aiww** RT @**zxtm2000** The biggest performance art show in China's history is the ongoing show at Ai Weiwei Studio. Perhaps the most amusing part is that those who opposed this show are now also a part of the performance art.

@**aiww** RT @**Suyutong**: RT @**wentommy**: 午夜12点，艾未未@**aiww** 在鞭炮声中走出草场地258号. 接受路透社记者采访.‘互联网的时代，我被囚禁的每一分钟，都跟马陆的网友在一起. 将这会终结一个不明不白的机构绑架一个明明白白的公民的时代.’

@**aiww** RT @**Suyutong**: RT @**wentommy**: At midnight, Ai Weiwei @**aiww** exited 258 Caochangdi in the sounds of firecrackers. Interviewed by journalists from Reuters. 'In the era of the Internet, I was together with my friends at Malu for every minute that I was detained. This will end the era of an ambiguous institution kidnapping citizens with clear conscience.'

@**aiww** 2010年11月9日收到上海市嘉定区马陆镇人民政府对艾未未（上海马陆）工作室‘限期拆除违法建筑决定书’http://is.gd/gRo3u

@**aiww** On 9 November 2010, I received a 'Decision Statement for Demolition of Illegal Construction within Fixed Period' from the municipal government of Malu Town, Jiading District, Shanghai, to the Ai Weiwei (Malu, Shanghai) Studio. http://is.gd/gRo3u

@**aiww** RT @**duyanpili**: 从现在开始 (2010.11.12) 到 @**aiww** 上海马陆工作室被拆除期间，网友可前往参观. 工作人员接待，纪念品. 路线图 http://www.douban.com/note/98885567/

@**aiww** RT @**duyanpili** Starting today (2010.11.12) netizens can visit @**aiww**'s Shanghai Malu Studio until it's demolished. Studio staff will be receiving guests and [there will be] souvenirs. Route map: http://www.douban.com/note/98885567/

@**aiww** 我的电话被停机了，办公室的网络被掐断了，中国移动和中电华通网络都拒绝给出真实原因，嗯，国家机密.

@**aiww** My phone has been suspended, the office's internet connection cut, China Mobile and China CC Net both refuse to give the real reason, hmm, national secret.

@**aiww** 门外监视的无牌面包又停在原位，两个年轻人在里面摆弄着手机.

@**aiww** The surveillance vans without plates are stopping at their original positions outside the door again, two young people are playing with their cell phones inside.

09 DEC 10 6:13 AM

@aiww 今天中国的作为实在是腐朽没落的范儿，为了避免我在未来两天接受采访，限制出行还不说，居然会会悄悄的掐断网络和电话，我要说的早就都说完了，这下又添了新的话题.

@aiww The actions of China today have arrived in a state of decay. To prevent me from accepting interviews in the next two days, not only did they prevent me from travelling, they cut off my internet connection and phone line without notice, I have finished what I needed to say much earlier on, now with this they added a new topic.

11 JAN 11 8:26 AM

@aiww 能逗你的女儿，我愿意有一百所各色房子被拆呢. RT @Junelight: @aiww 艾神艾神不难过，我三岁的小女要帮你盖新房子呢. 他们最终会认识到，拆红房子惹来的麻烦比留着红房子多太多了. 恭喜上海政府明早上国际各大媒体头条.

@aiww If I could make your daughter happy, I'm willing to demolish a hundred buildings in assorted colours. RT @Junelight: @aiww God Ai, God Ai, don't be sad, my three-year-old would like to build a new place for you. One day they will realize the trouble they will get for demolishing the studio will be much more than leaving it in place. Congratulations to the Shanghai government for going on international headlines tomorrow.

12 JAN 11 7:02 AM

@aiww RT @elaoda: 艾未未的上海工作室被当局提前拆除 From BBC中文网主页：以敢言著称的中国艺术家艾未未的上海工作室在未通知艾未未@aiww本人的情况下被当局提前拆除.

@aiww RT @elaoda: Ai Weiwei's Shanghai Studio has been demolished ahead of schedule by authorities, from the homepage of BBC's Chinese website: Outspoken Chinese artist Ai Weiwei's Shanghai Studio has been demolished ahead of schedule without any notification for Ai Weiwei @aiww.

12 FEB 11 4:35 PM

@aiww 民主自由是最大的效率，互联网是她的保障，一个崭新的国家开始了.

@aiww Democracy and freedom are highest in efficiency, the Internet is her guard, a new country is beginning.

23 FEB 11 6:58 PM

@aiww 本来不关心茉莉花的，可是害怕茉莉花的人，频频送来许多茉莉如何有害的信息，让我意识到了茉莉花是他们的最怕，好一朵茉莉花.

@aiww I didn't care about the jasmine flower at first, but those who are afraid of the jasmine flower kept sending messages about the harms of the jasmine, and made me realize that they are most afraid of the jasmine flower. What a jasmine flower!

<u>28 February 2010</u>: The presence of surveillance vans parked across the street from Ai Weiwei's studio in Caochangdi became increasingly common in 2010. He frequently posted images of them, acknowledging both his dire personal situation and the maladroit reconnaissance of his secret observers.

28 FEB 11 6:20 AM

@aiww 这次不同的是，有两辆监视的车辆停在门外很多天了，人睡在车里，因为即将到来的2会吗.

@aiww The difference this time is that the two surveillance vans have parked outside for many days, and the people sleep inside the cars. Is that because of the Lianghui that are about to take place?

06 MAR 11 6:31 AM

@aiww 我也纳闷呢，出入也自由 @netbug_cc: 现在多了一辆啊 RT @aiww: 门前停着两辆便衣监视的车，不近不远，告诉我和威胁我的政治的距离 @huashibaisha: @aiww 两会与我的直接关系，就是每年两会（及其他敏感日子）我家宽带都会默认掉掉几天.

@aiww I'm frustrated too, but I can freely leave and enter the house @netbug_cc: There's another car now RT@aiww Two undercover surveillance vans are parked in front of my door, not too close and not too far, it's the political distance between notifying me and threatening me @huashibaisha: @aiww The direct relationship between Lianghui and myself is that during Lianghui (and any other sensitive days) every year, my home's broadband internet would quietly drop for a few days.

1 April 2011: Shortly before Ai's arrest, police conducted three searches of his studio and recorded the names of assistants present.

06 MAR 11 4:35 PM

@aiww 总是和茶混在一起的一种白色小花 RT @xiaohehe: @aiww 艾神怎么看茉莉花?

@aiww It's a little white flower that's often mixed with tea RT @xiaohehe: @aiww God Ai, how do you see the Jasmine Flower?

08 MAR 11 5:49 AM

@aiww 他们想让我认为我是被关注的 @Maggie9009: @aiww总有警察在默默的关注着你吗? 他们会请你喝咖啡吗?

@aiww They want me to think that I'm of their concern @Maggie9009: @aiww Are there always cops quietly watching you? Will they invite you to coffee?

19 MAR 11 7:33 PM

@aiww 最后一次机会向卡扎菲行告别礼, 永别了, 三军上校.

@aiww It's our last opportunity to bid farewell to Gaddafi, auld lang syne, colonel.

20 MAR 11 5:17 PM

@aiww 利比亚的内政就是当战斧导弹来了, 将卡扎菲和妇孺百姓绑在一起.

@aiww The internal politics of Libya is about tying Gaddafi together with the women, children and ordinary folks when the Tomahawk missile arrives.

31 MAR 11 7:07 AM

@aiww 带了两个女警呢, 是奔你来的 @duyanpili: 朝阳分局的人好有闲情逸致啊, 大晚上带着摄像机亲自来查身份证. @aiww: 朝阳分局. @pearlher: 这个稀奇, 到人家家里查身份证. @mreggpain: 警方强行登记身份证 - http://moby.to/y18o2l

@aiww They brought two female officers, as if they were coming for you @duyanpili: The people from the Chaoyang District Bureau are in such a leisurely mood, carrying cameras to check on identities late at night. @aiww Chaoyang District Branch Bureau. @pearlher: This is strange, entering other people's houses to check IDs. @mreggpain: The police forcibly registered ID cards - http://moby.to/y18o2

31 MAR 11 7:52 AM

@aiww 我已经暴露了? RT @Valerie_Guo 同问候. 安慰摸. RT @wufake: @aiww 艾老师关心祖国这么多年以来以来警方首次名正言顺且来势汹汹的突访工作室. 这是一个标志性的事件. 问候艾老师及所有工作室员工平安.

@aiww Have I been busted already? RT @Valerie_Guo: Sending my greetings as well. Giving you a comforting caress. RT @wufake: @aiww After so many years of Teacher Ai's concern for the motherland, the police paid a visit to the studio for the first time, menacing and appearing perfectly justifiable. This is a landmark incident. Greetings and peace to Teacher Ai and all studio staff.

31 MAR 11 8:10 AM

@aiww 查火险却要登记身份. @zhi_fei: 如果火险多, 就责令停业? 真够关心到位. RT @aiww 昨天还查了消防, 也是一堆警察呢 RT @kunlunfeng: 这借口可真够新鲜. RT @aiww 十四个警察的阵势, 还有摄像. 理由是突击检查在我这儿的外籍助手的身份

@aiww It's a check on fire and safety, yet they need to register our identities. @zhi_fei: If there's too many fire hazards, then you'll be ordered to shut down the studio? They really care about you very much. RT @aiww Yesterday even the fire department came, also a group of policemen. RT @kunlunfeng: This is such a novel excuse. RT @aiww 14 policemen and a cameraman. The reason is to carry out a spot check on the identities of the foreign assistants here.

31 MAR 11 8:41 PM

@aiww 动作快 RT @feifei0621: 检查完了, 准备离开. @aiww 说: '我有个建议, 要不你们留下一个人跟我们这儿呆上一天?' 对方说: '不用, 不用, 你们也忙.'

@aiww A quick action. RT @feifei0621: Inspection is done, they're preparing to leave. @aiww said: 'I have a suggestion. Why don't you leave one person to stay with us for a day?' They replied: 'No need, no need. You're also busy.' http://ww4.sinaimg.cn/large/701db4eejw1dfsubxuilsj.jpg

505

@aiww 放心，我不孕 **@mozhixu**:艾神受惊了 **RT** **@langzichn**: **RT** **@aiww**: 现在朝阳分局再次前来登记身份证，已经是第三次了，看样子要有大的动作

@aiww Don't worry, I'm barren. **@mozhixu**: God Ai was startled **RT** **@langzichn**: **RT** **@aiww**: Right now the Chaoyang bureau branch has come again to register ID. This is already the third time. Looks like some major action is in store.

@aiww 基层警察很疲惫，也很无奈，在一个强大的机器中运转着，没有伦理和规矩，没有道德与法律的底线.

@aiww Base-level police officers are tired and helpless. They work within a powerful machine, in which there are no ethics nor rules, and has no moral or legal boundaries.

@aiww 2011年4月3日艾未未在北京首都机场过海关时被两名边检人员控制，将艾未未 **@aiww** 与助手分开，被两位边检工作人员带到另一地点，艾未未的手机关机，已经失去联系50分钟情况不明请大家关注. (注: 助手发推)

@aiww On 23 April 2011, Ai Weiwei was detained by two custom officers at border control at the Beijing Capital Airport. Ai Weiwei was separated with his assistant and brought to another location. Ai Weiwei's mobile phone is off, and he has lost contact for 50 minutes. His situation is unknown, and everyone please pay attention. (P.S. Assistant tweeting.)

@aiww 一小时前来了一批警察出示搜查令，来到艾未未工作室草场地发棵258号，带走了8个工作人员至北京朝阳区南皋派出所问话: 徐烨，钱飞飞，董姐，小伟，小谢，邢锐，蒋立，小胖侄子. 路青一人与警方在家，现在工作室前后门均有警察，无法进出. 艾未未在北京机场已被扣押3小时，无法联系. (未未助手)

@aiww A batch of police officers arrived at Ai Weiwei Studio (258 Fake at Caochangdi) an hour ago with a search warrant. 8 staff members were taken to the Beijing Chaoyang District Nangao Dispatch Station for questioning: Xu Ye, Qian Feifei, Dongjie, Xiaowei, Xiao Xie, Xing Rui, Jiang Li, and Xiaopang's nephew. Lu Qing stays at home with the police on her own. There are now police surrounding the studio, and no one can go in or out of the building. Ai Weiwei has been detained at the airport for 3 hours, and there is no way to reach him. (P.S. Assistant tweeting.)

CREDITS

Publication Info

First published in 2014 by order of the Tate Trustees by Tate Publishing, a division of Tate Enterprises Ltd, Millbank, London SW1P 4RG
www.tate.org.uk/publishing

First published in the United States and Canada by the MIT Press in 2014

MIT Press books may be purchased at special quantity discounts for business or sales promotional use. For information, please email special_sales@mitpress.mit.edu

Library of Congress Cataloging-in-Publication Data:
Ai Weiwei
Ai Weiwei : spatial matters : art architecture and activism / by Ai Weiwei; edited by Ai Weiwei and Anthony Pins.
 pages cm
ISBN 978-0-262-52574-9 (pbk. : alk. paper)
1. Ai, Weiwei—Criticism and interpretation. I. Obrist, Hans-Ulrich, author. The retrospective. II. Ai, Weiwei, author, editor. Works. Selections. III. Title.
N7349.A5A85 2014
709.2—dc23

Library of Congress Control Number: 2013039797

Editing and copywriting by Anthony Pins
Section editing and copywriting (Engage) by An Xiao Mina and Anthony Pins
Project management by Miranda Harrison
Production management by Bill Jones
Proofreading and text editing by Howard Watson
Assistance from Deborah Metherell

Twitter translations by Jennifer Ng, André Holthe, Zoe Teng, and An Xiao Mina. All translations have been edited by Jennifer Ng for accuracy

Designed by Anthony Pins
Typeset in Foundry Monoline, Univers and Heiti SC
Printed and bound in Spain by Grafos SA, Barcelona

Photo Credits

All images courtesy of Ai Weiwei Studio unless noted:

Courtesy Albion Gallery, London: p.64
Courtesy Albion Gallery, London. Photo Ed Reeve: pp.66, 68
Photo Iwan Baan (© Iwan Baan): pp.129, 130, 133, 239, 295, 297, 298, 200, 300, 302, 303, 304 (top), 305, 491
Courtesy Bottega + Ehrhardt Architekten GmbH, Giorgio Bottega, Henning Ehrhardt, Christopher Seebald: p.251
Courtesy Faurschou Foundation. Photo Anders Sune Berg: p.18
Courtesy Francis Field: p.419
Courtesy Galerie Urs Meile, Beijing: p.35
Gao Yuan: p.427
Haus der Kunst, Munich: p.417
Courtesy Herzog & de Meuron: pp.256, 258, 266
Courtesy HHF Architects: pp.296, 304 (bottom)
Doug Kanter/New York Times/Redux/eyevine: pp.246, 289
Courtesy Mary Boone Gallery, New York: pp.79, 80
Courtesy Mori Art Museum, Tokyo: p.45
Matthew Niederhauser/INSTITUTE: pp.431, 440
Courtesy PAD Inc./Sameer Hoot: p.293
Courtesy Pedrocchi Meier: p.293
Courtesy Preston Scott Cohen: p.293
Courtesy Queensland Art Gallery, Australia. Photo Natasha Harth: p.75
Courtesy Sherman Galleries, Sydney, Australia. Photo Paul Green: p.27
Courtesy Single Speed Design: p.251
Courtesy Taipei Fine Arts Museum: p.42
© Tate Photography: pp.95, 96, 104, 108, 109
Ludwig Wittgenstein Trust, Cambridge: pp.142, 144
Yutong Su: p.451
Zonesan: p.451

Acknowledgements

The editors wish to extend a very special thanks to the members of Ai Weiwei Studio, in particular Jennifer Ng, Marlene von Carnap, Liu Yanping, Lv Hengzhong, and Inserk Yang for their extensive efforts on this publication. Thanks are also due to Lee Ambrozy, Brendan McGetrick, and André Holthe for their assistance.

Anthony Pins would like to thank Caroline Constant, Robert Mangurian, Mary-Ann Ray, and Christian Unverzagt of the University of Michigan's Taubman College of Architecture and Urban Planning. Margaret Cahoon, Brittany Gacsy, Amanda Goldblatt, Jordan Hicks, and Michal Miller also deserve recognition for their efforts in support of this publication.

An Xiao Mina would like to thank a number of people for their feedback and support as she worked on this publication. She owes particular thanks to Tricia Wang, Clive Thompson, Sean Kolodji, Kenyatta Cheese, and Miru Kim, along with Ethan Zuckerman for helping her understand the beauty and power of creativity in internet activism.

In memoriam Kenneth W. Pins.